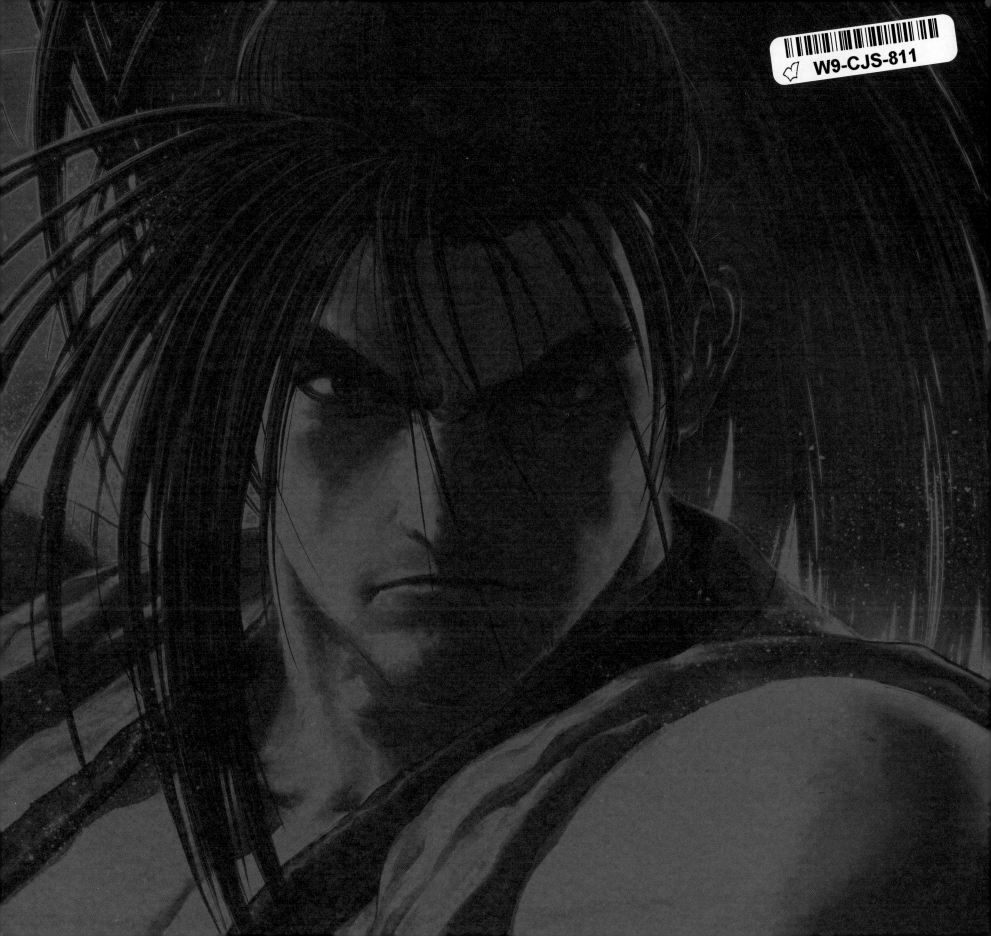

SAMURAI SHODOWN

DARK HORSE BOOKS

PRESIDENT AND PUBLISHER
Mike Richardson

EDITOR
Ian Tucker

ASSOCIATE EDITOR
Brett Israel

DESIGNER
Amy Arendts

DIGITAL ART TECHNICIAN
Ann Gray

SPECIAL THANKS
Cary Grazzini

PIX'N LOVE EDITIONS

PUBLICATION DIRECTOR
Marc Pétronille

EDITORIAL CONSULTANT
Benjamin Peray

INTERVIEWS
Benjamin Peray

ARTISTIC DIRECTION / LAYOUT
Luc Pétronille

EDITING
Christophe Delpierre

ACKNOWLEDGMENTS
Akiko Bessede, William Bessede, Vincent Chataignier, Alex Friend, Nobuyuki Kuroki, Adam Laatz, Sandy Li, Yasuyuki Oda, Yumi Saji, Laurent Vernézy, and all the staff at SNK who helped make this book happen

Published by Dark Horse Books
A division of Dark Horse Comics LLC
10956 SE Main Street
Milwaukie, OR 97222

DarkHorse.com
PixnLovePublishing.com

Library of Congress Cataloging-in-Publication Data

Names: SNK Corporation, author.
Title: The art of Samurai Shodown / SNK.
Description: First edition. | Milwaukie, OR : Dark Horse Books, 2021. | Summary: "This beautiful hardcover art book for Samurai Shodown is the perfect companion piece to SNK's return! Behold over 190 pages of behind-the-scenes artwork detailing everything you could ever want from Samurai Shodown!"-- Provided by publisher.
Identifiers: LCCN 2020042681 | ISBN 9781506722412 (hardcover) | ISBN 9781506725161 (epub)
Subjects: LCSH: Samurai Shodown (Game)--Pictorial works.
Classification: LCC GV1469.25.S26 S65 2021 | DDC 794.8--dc23
LC record available at https://lccn.loc.gov/2020042681

First edition: June 2021

Ebook ISBN 978-1-50672-516-1
Hardcover ISBN 978-1-50672-241-2

10 9 8 7 6 5 4 3 2 1
Printed in China

THE ART OF
SAMURAI SHODOWN

SNK® pix'n love EDITIONS

CONT

E N T S

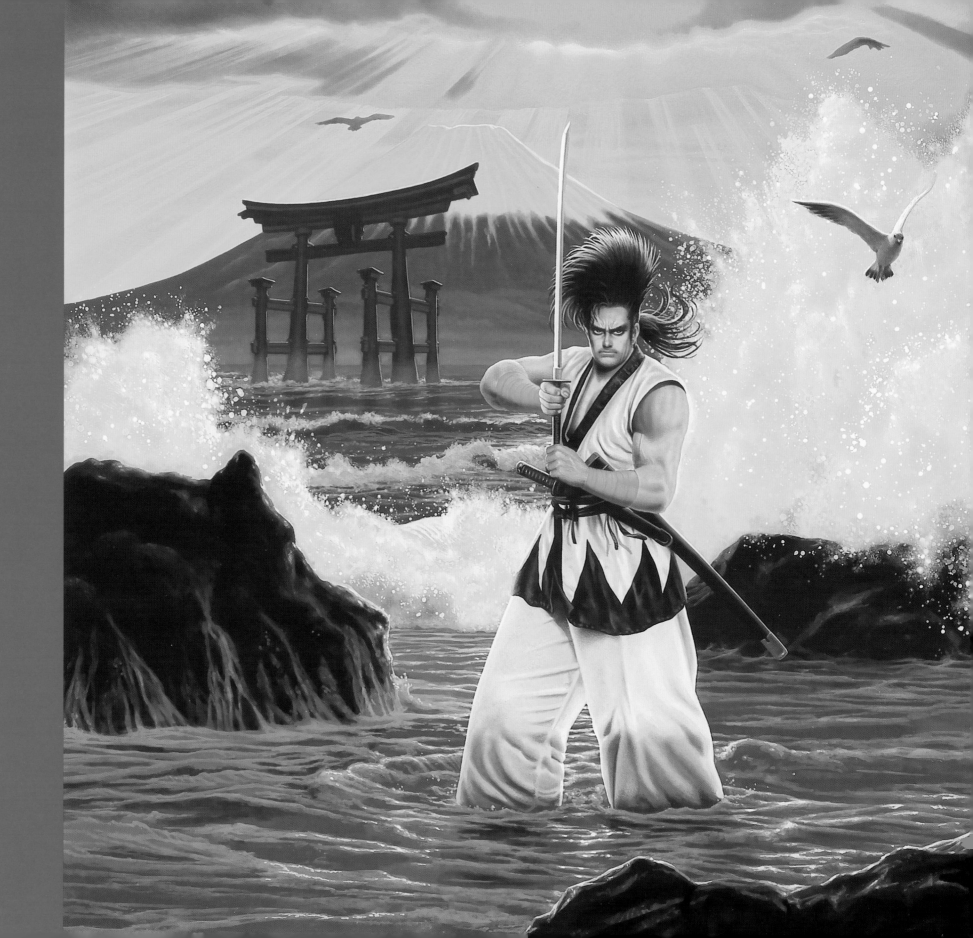

SAMURAI SHODOWN:
THE ORIGINS

Founded in 1978 in Osaka on the Japanese archipelago, SNK pioneered a new phenomenon in the early 1990s: the one-on-one fighting game. This extremely popular genre quickly flooded arcades around the world. It also reflected both the competitions between players and the competitions between the companies that created the games.

SNK's various products led to its position as a challenger on the market. They tested many new ideas and introduced major advances in gaming: special super attacks with gauges, taunting, dodges, and close-up shots are just a few of the innovations the company introduced.

With titles such as *Art of Fighting* and *Fatal Fury*, SNK's development teams helped create the language and environment that many of today's productions still draw from.

Despite its popularity, the genre, inspired by American cinema and entrenched in contemporary street fighting and underground tournaments, soon ran the risk of becoming stale. Something needed to change. The summer of 1993 brought a breath of fresh air to the gaming world, in the shape of a game that would, in fact, stand out from the rest of the video game landscape and would see unexpected critical and commercial success. Named *Samurai Shodown*,

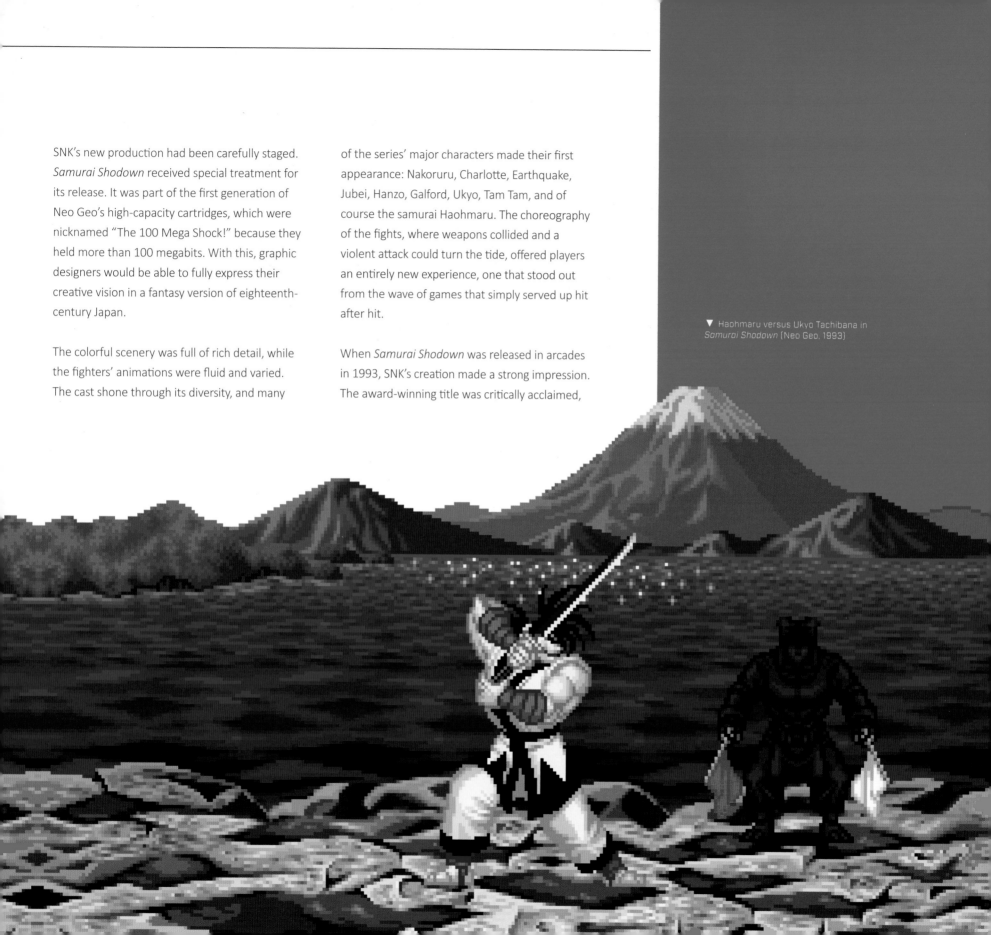

SNK's new production had been carefully staged. *Samurai Shodown* received special treatment for its release. It was part of the first generation of Neo Geo's high-capacity cartridges, which were nicknamed "The 100 Mega Shock!" because they held more than 100 megabits. With this, graphic designers would be able to fully express their creative vision in a fantasy version of eighteenth-century Japan.

The colorful scenery was full of rich detail, while the fighters' animations were fluid and varied. The cast shone through its diversity, and many

of the series' major characters made their first appearance: Nakoruru, Charlotte, Earthquake, Jubei, Hanzo, Galford, Ukyo, Tam Tam, and of course the samurai Haohmaru. The choreography of the fights, where weapons collided and a violent attack could turn the tide, offered players an entirely new experience, one that stood out from the wave of games that simply served up hit after hit.

When *Samurai Shodown* was released in arcades in 1993, SNK's creation made a strong impression. The award-winning title was critically acclaimed,

▼ Haohmaru versus Ukyo Tachibana in *Samurai Shodown* (Neo Geo, 1993)

ranked among the most popular games, and was one of the best-selling titles on the Neo Geo console. A legend of the fighting game genre was born.

It quickly became apparent that this title needed a sequel. From the very first arcade tests, SNK realized there was huge potential for this franchise and wanted to strike while the iron was hot. The sets and characters were completely redesigned, the gameplay was tightened and made more precise, and powerful special attacks were added to enhance the spectacle. The storage capacity

of the cartridge needed to be nearly doubled in order to store all this information, crossing the symbolic 200 megabits threshold in 1994. *Samurai Shodown II* also featured an emblematic swordsman, the charismatic Genjuro Kibagami, who served as Haohmaru's foil.

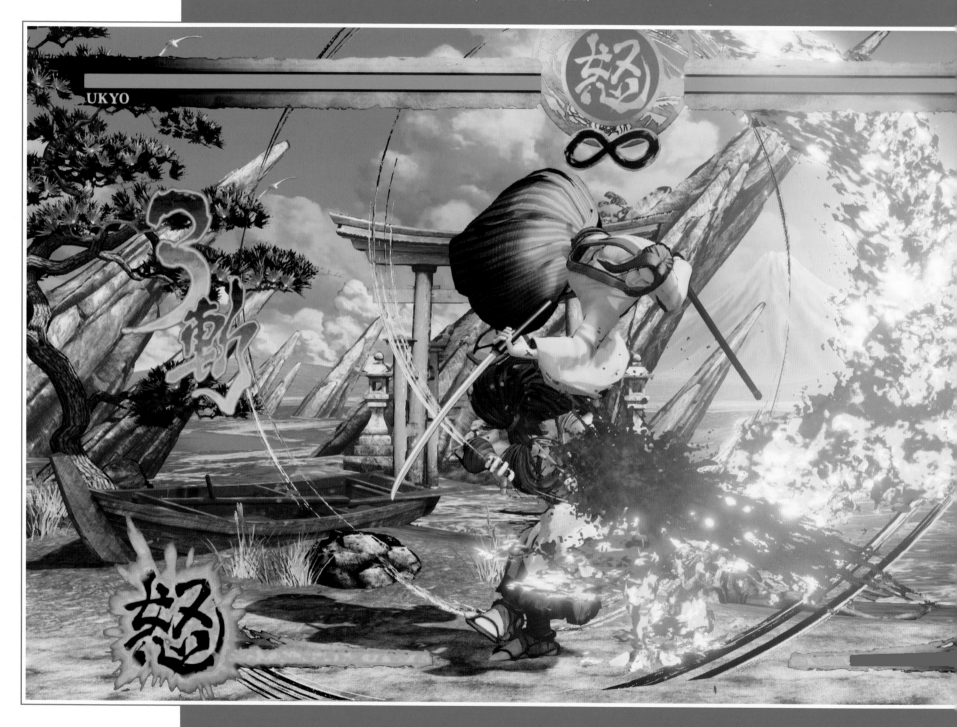

▼ Haohmaru versus Ukyo Tachibana in *Samurai Shodown* (PlayStation 4 / Xbox One, 2019)

HAOHMARU

These two major episodes met with a resounding success and would forge the foundations of a series that saw the birth of many arcade and console hits. SNK even tried their hand at 3D with *Samurai Shodown 64* in 1997 and introduced a mysterious woman with different-colored eyes—one red, one blue: Shiki, armed with a pair of katanas. But they didn't give up on 2D. In 2003, the Neo Geo welcomed *Samurai Shodown V*, which marked the first appearance of Yoshitora Tokugawa, a fighter with seven swords. In 2004, a special version of *Samurai Shodown V* was released and would be the last cartridge to officially appear for the Neo Geo, a system that was about to celebrate its fifteenth anniversary. In 2008, the series took a break. Fortunately, players weren't abandoned completely: the various consoles on the market saw releases of digital versions of the classic games.

In 2018, after a decade without a single new episode, SNK announced the return of the series with a game simply titled *Samurai Shodown*. This game rekindled fans' enthusiasm and challenged a new generation of players. This series reboot is a tribute to the entire saga and features a cast of emblematic fighters. In this episode, SNK's 2D expertise and mastery of 3D tools contribute to a game with distinguished artistic direction, punctuated by epic battles.

In summer 2019, players were finally able to answer the question they were asked in the very first trailers: are they ready to embrace death? ∎

MAIN
CHARACTERS

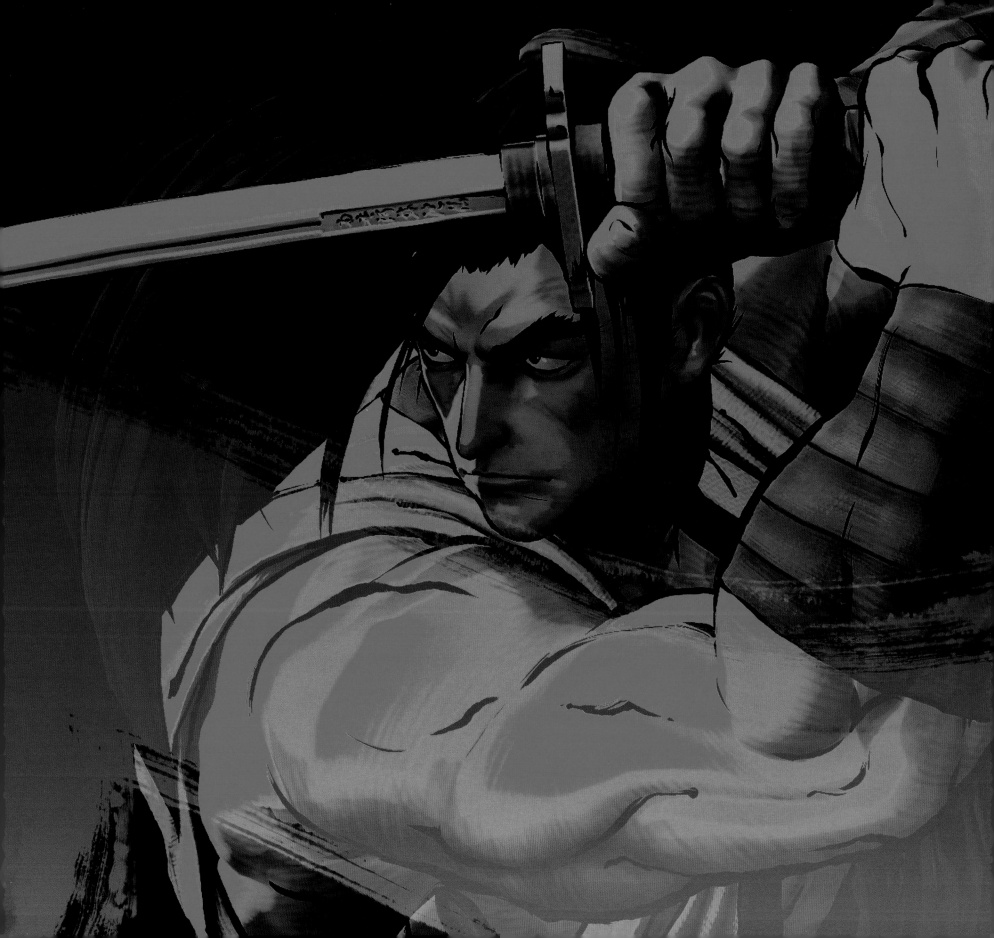

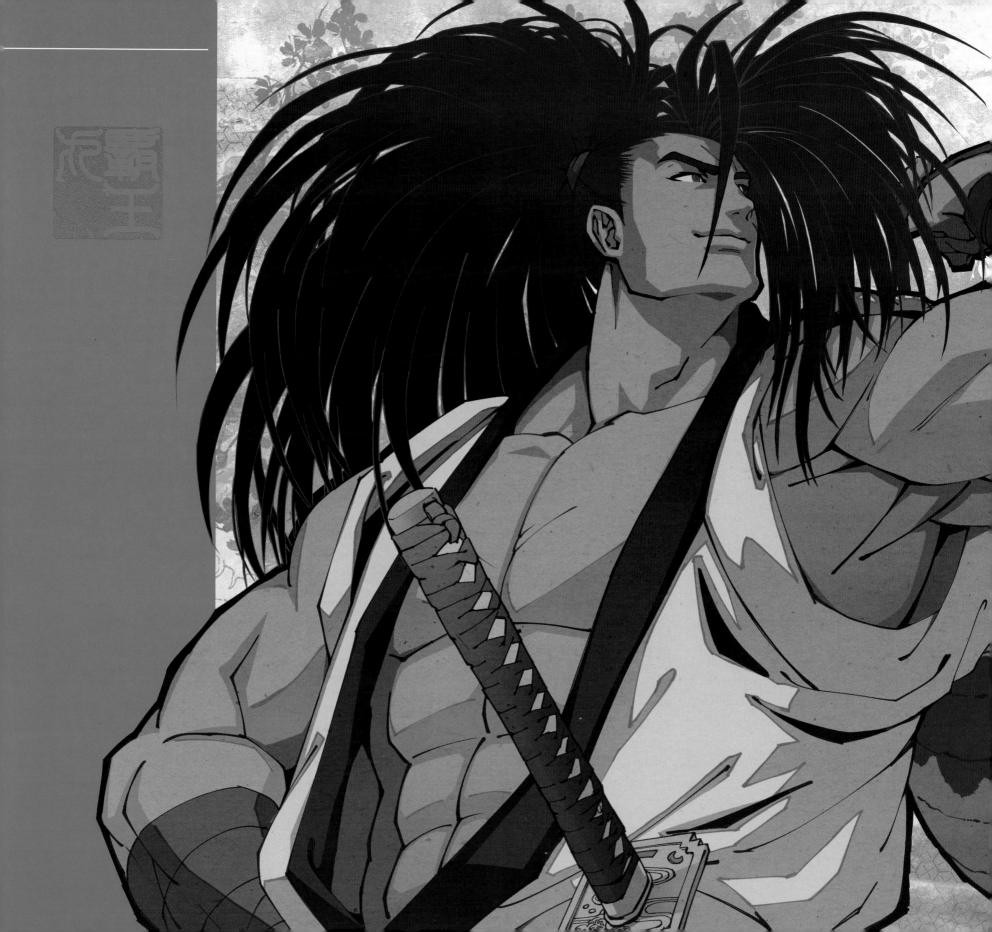

HAOHMARU

Voice Actor: Daiki Nakamura

The lone ronin Haohmaru rises up, determined to bring an end to a dark fate that plagues the land. Never one to accept the fickle fortunes of destiny, he is spurred to action by tales of the land's great warriors.

And so, ready to challenge the land's finest warriors, Haohmaru, armed with his trusty sword Fugodoku, leaps headfirst into the chaos ahead.

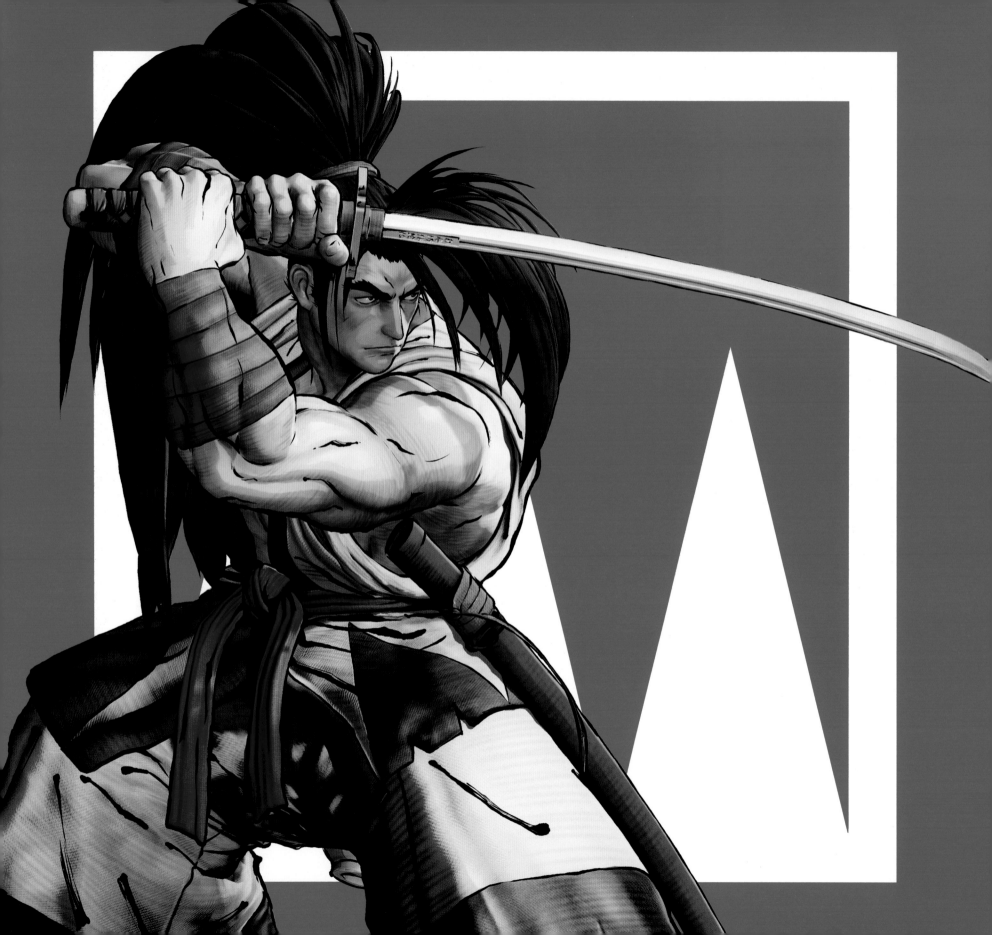

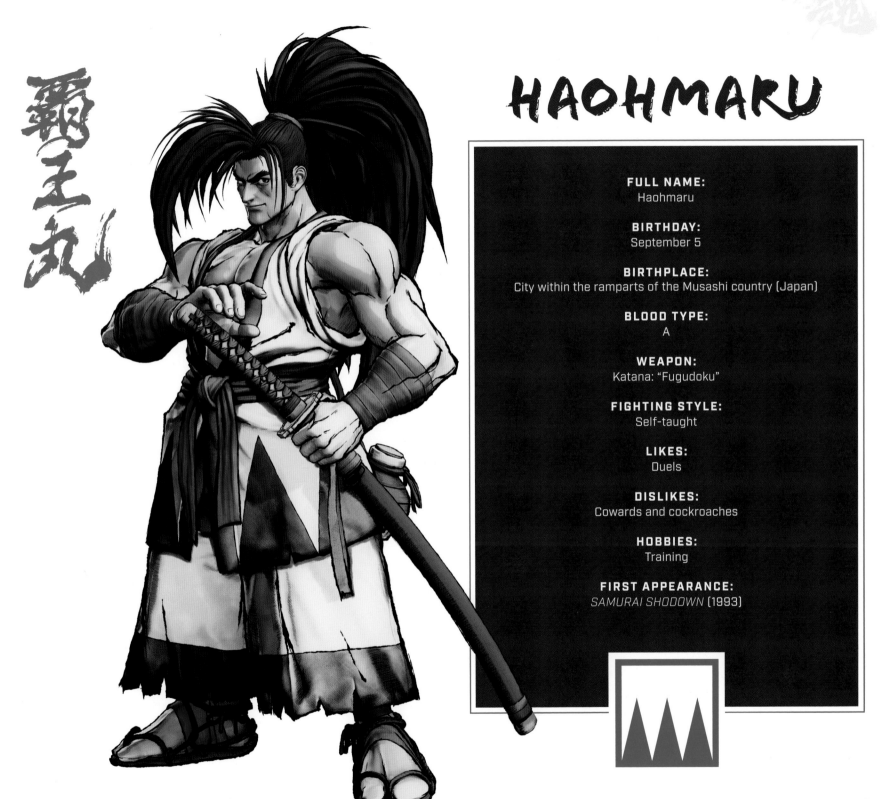

覇王丸

HAOHMARU

FULL NAME:
Haohmaru

BIRTHDAY:
September 5

BIRTHPLACE:
City within the ramparts of the Musashi country (Japan)

BLOOD TYPE:
A

WEAPON:
Katana: "Fugudoku"

FIGHTING STYLE:
Self-taught

LIKES:
Duels

DISLIKES:
Cowards and cockroaches

HOBBIES:
Training

FIRST APPEARANCE:
SAMURAI SHODOWN (1993)

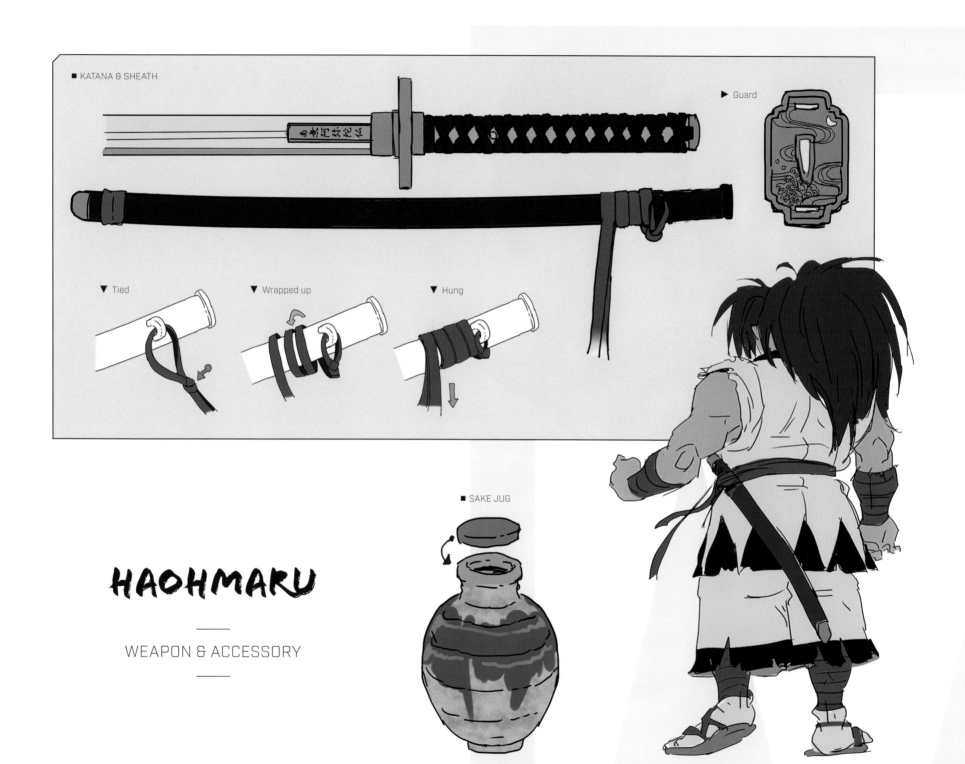

■ KATANA & SHEATH

► Guard

南　無　阿　弥　陀　仏

▼ Tied ▼ Wrapped up ▼ Hung

HAOHMARU

WEAPON & ACCESSORY

■ SAKE JUG

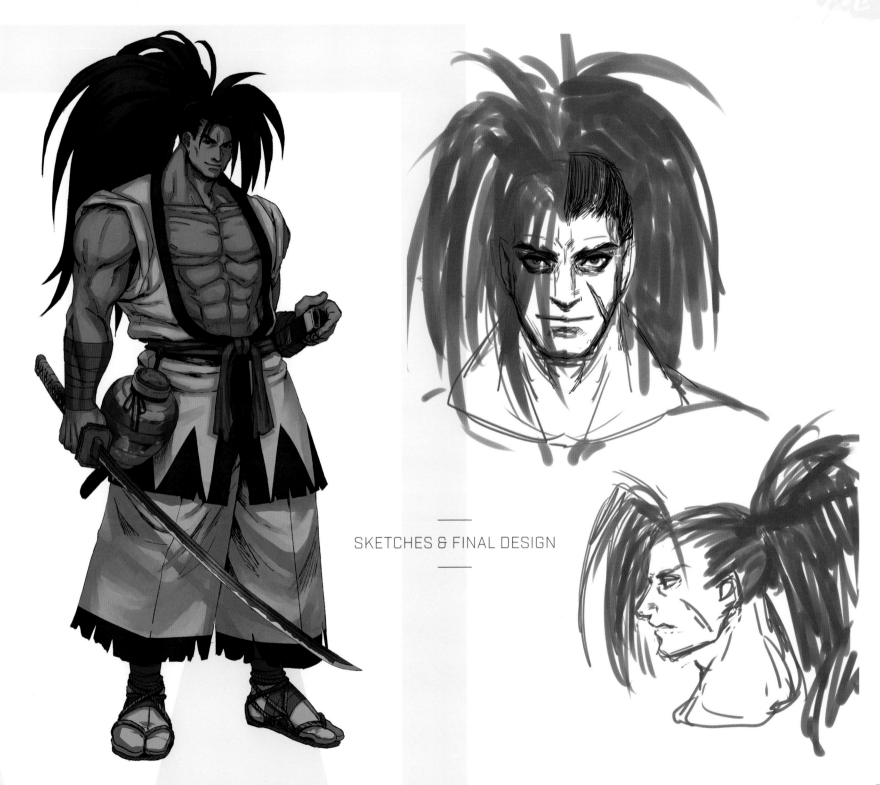

SKETCHES & FINAL DESIGN

EPILOGUE

C01

 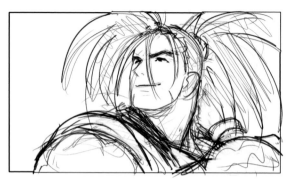

Haohmaru looks on as the evil leaves Shizuka Gozen's body and she passes into the next life.

As he escapes the malevolent realm, he is greeted by the glorious spectacle of a sea of beautiful cherry blossoms.

Taking in the beauty of her parting gift, he sips a bottle of sake in honor of her passing.

C02

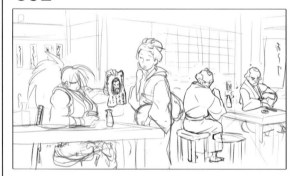

Several months have passed since Shizuka Gozen's reign of carnage. Haohmaru journeys to a town where a great swordsman is rumored to reside.

A villager would one day say this of his arrival . . .

"The fire in his eyes burned brighter than the midday sun. That was no ordinary warrior."

C03

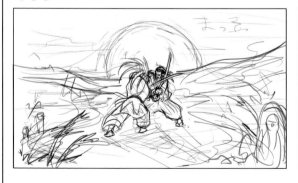 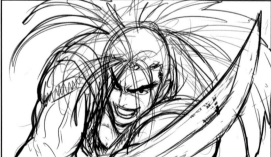

For Haohmaru, the journey continues, as a samurai and as a man, until no other fighter stands in his way of being the best.

"The way of the samurai is to know death. The way of shura is to know victory.

"I am the ultimate fighter, and all who stand in my way shall . . .

"FALL!"

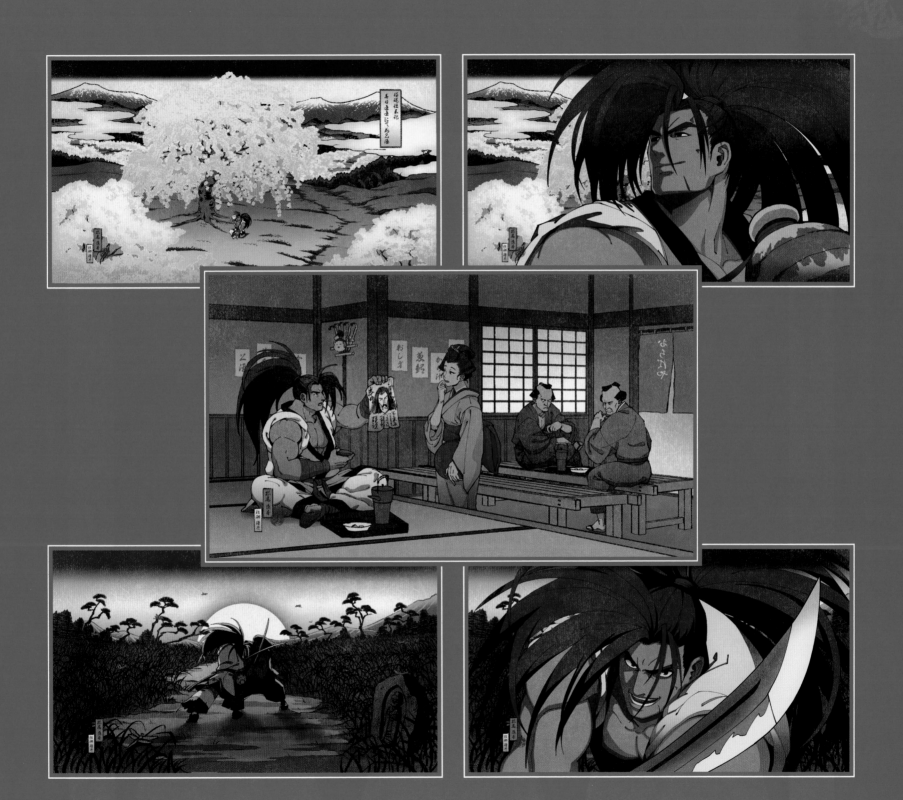

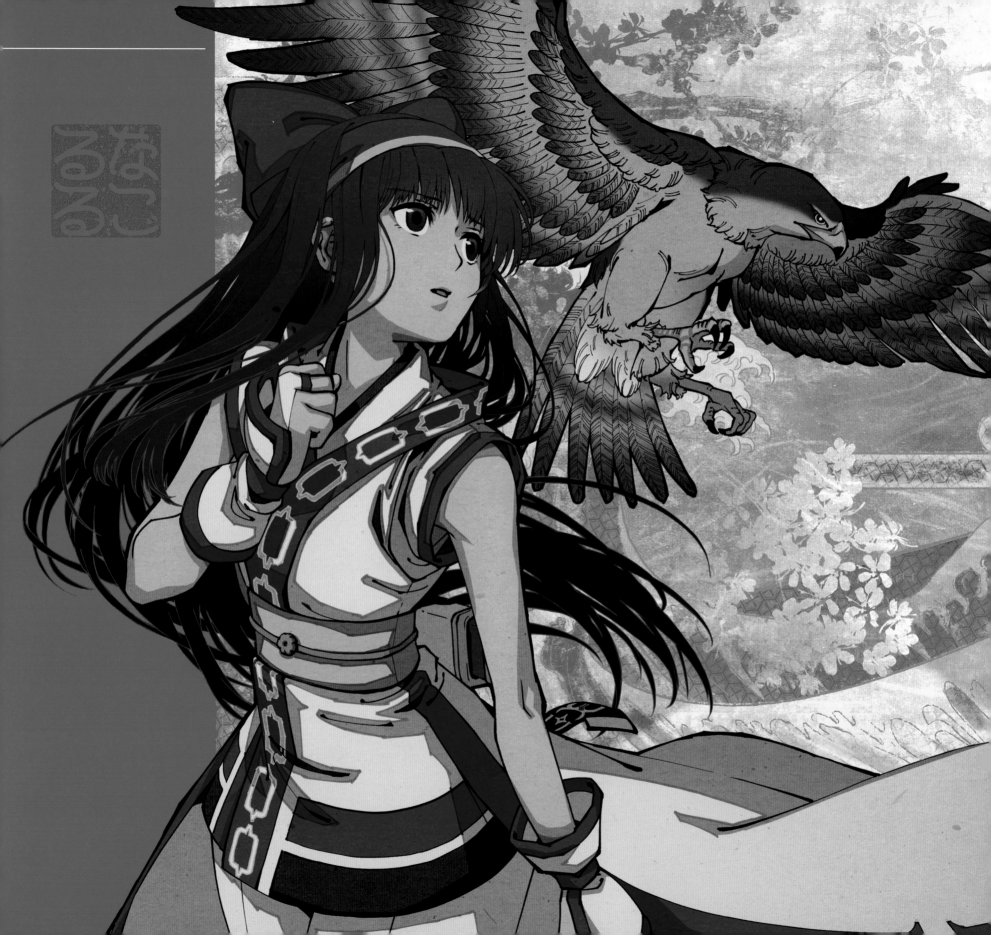

NAKORURU

Voice Actor: Mai Nakahara

The realm of man is not the only place to fall foul of this disturbance. The creatures of the forest stir and bristle as signs of the encroaching unrest reach the vast lands of Ezochi.

As nature's sworn protector, Nakoruru senses what is to come. With her treasured sword Chichi-Ushi in hand, she ventures beyond Kamui Kotan's borders to put a stop to the rising evil and restore balance.

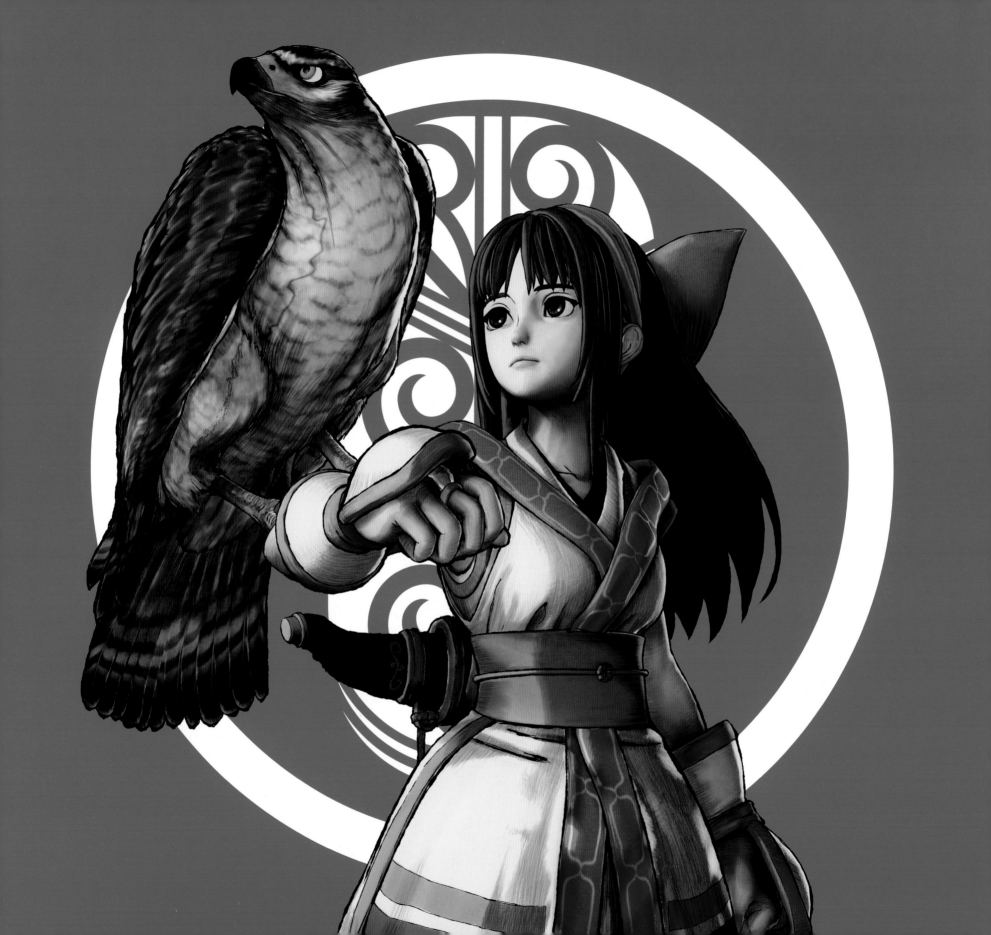

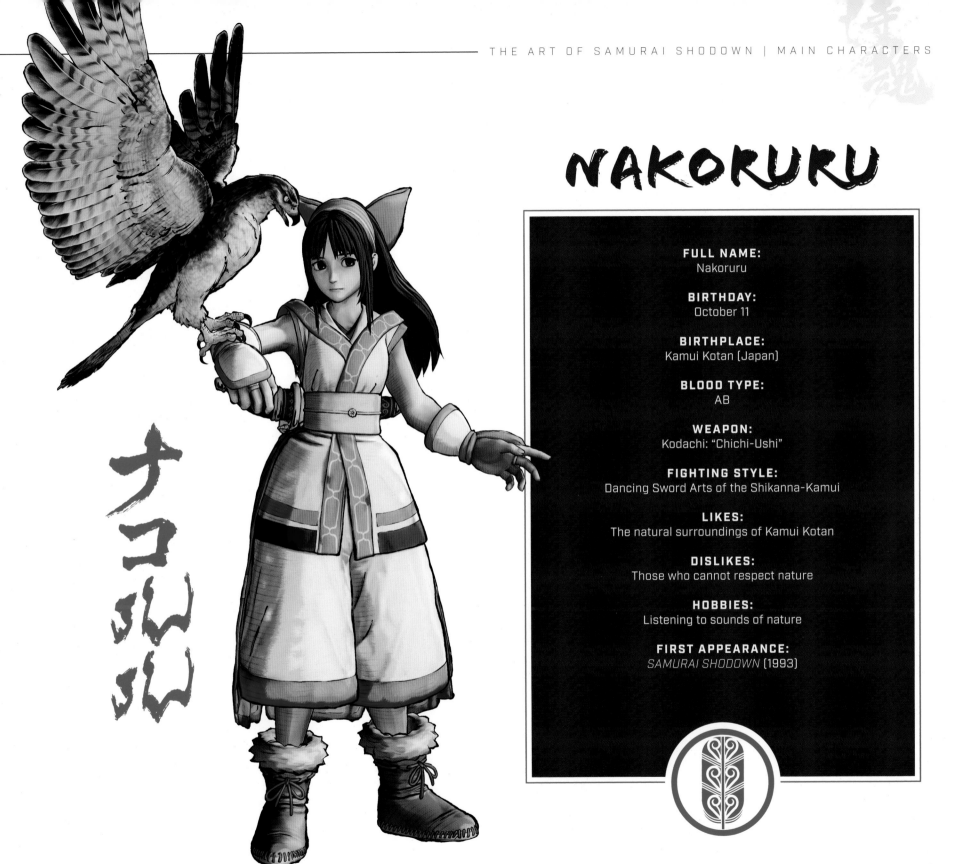

NAKORURU

ナコルル

FULL NAME:
Nakoruru

BIRTHDAY:
October 11

BIRTHPLACE:
Kamui Kotan (Japan)

BLOOD TYPE:
AB

WEAPON:
Kodachi: "Chichi-Ushi"

FIGHTING STYLE:
Dancing Sword Arts of the Shikanna-Kamui

LIKES:
The natural surroundings of Kamui Kotan

DISLIKES:
Those who cannot respect nature

HOBBIES:
Listening to sounds of nature

FIRST APPEARANCE:
SAMURAI SHODOWN (1993)

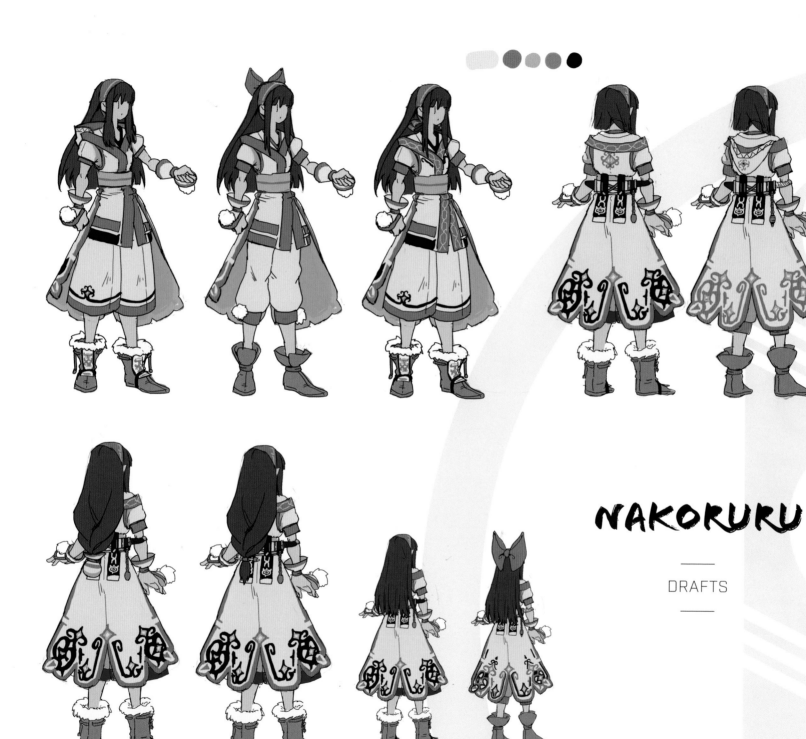

NAKORURU

DRAFTS

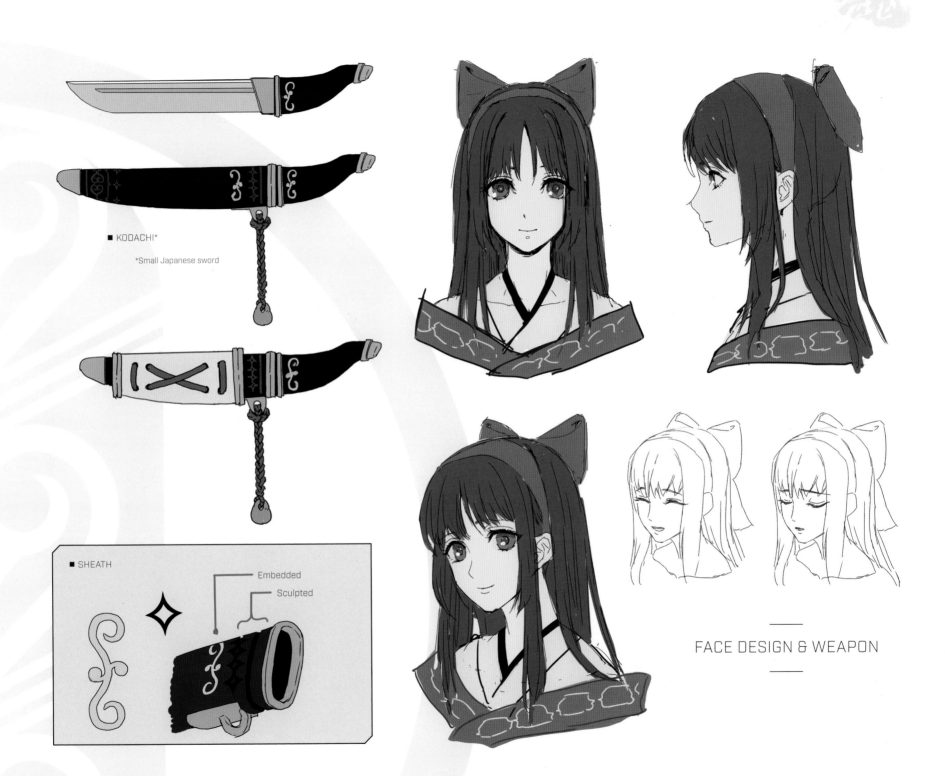

■ KODACHI*

*Small Japanese sword

■ SHEATH

Embedded

Sculpted

FACE DESIGN & WEAPON

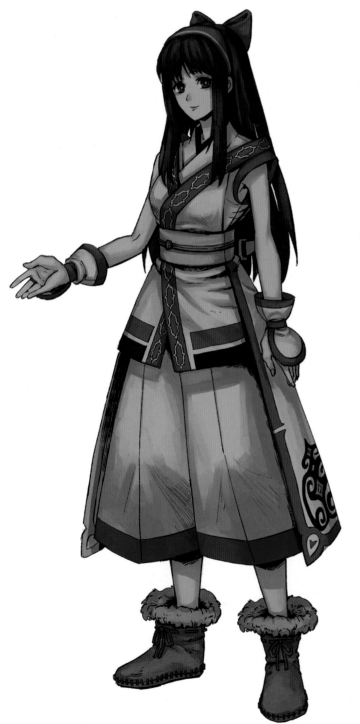

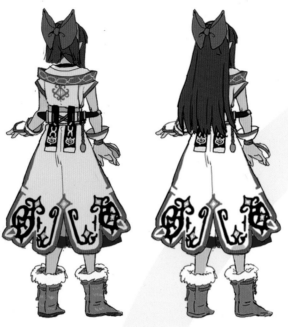

FINAL DESIGN & ACCESSORIES

▲ Pattern on the collar

■ OBIDOME*

It is made of jade, like the decoration on her sword, Chichi-Ushi.

*Decoration for obijime, a silk cord worn around the belt of a kimono

■ GLOVE

The gauntlet is bulky and not firmly attached to the forearm. The upper part is made of a thick fabric composed of several layers. It cannot be deformed.

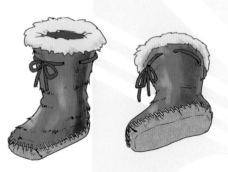

NAKORURU

CLOTHES & ACCESSORY

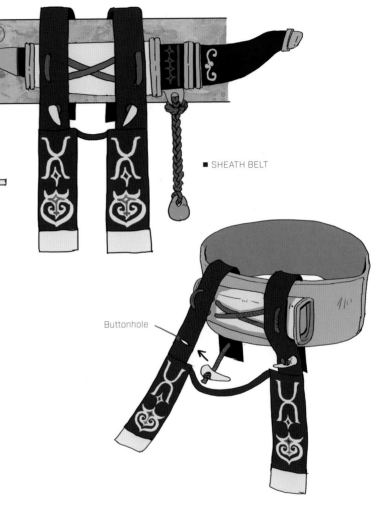

■ SHEATH BELT

Buttonhole

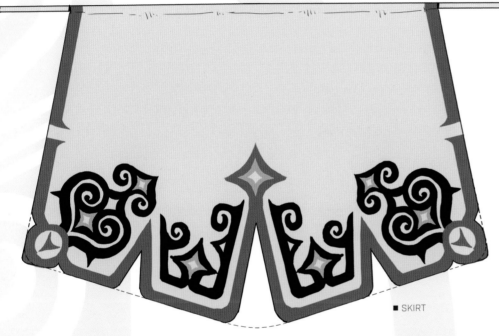

■ SKIRT

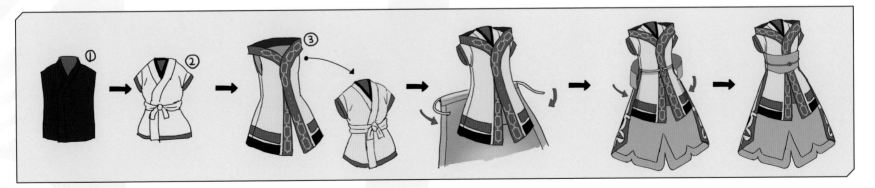

EPILOGUE

NAKORURU

C01

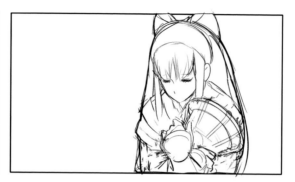

The demonic force inhabiting Shizuka Gozen thus dispelled, Nakoruru returns to this plane of existence.

She is greeted by a shower of cherry blossom petals as she notices a drum lying on the ground.

It contains the last remnant of Shizuka Gozen's essence in this world and Nakoruru feels its steady beat pulse through her.

The natural beauty of springtime invigorates her senses as she holds the drum close.

C02

The forests of Kamui Kotan have returned to their original state, surrounded by deep blue skies.

Nakoruru is welcomed by the animals of the forest as she once again looks over her beloved home.

She is greeted by her sister and grandparents in a loving embrace.

Surrounded by the warmth of those she holds dear, Nakoruru smiles and says, "I'm home."

C03

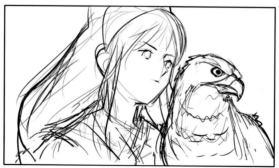

Months have passed, and all is right with Mother Nature and the world.

Yet evil still lurks among the shadows, plotting when next it may return to bring chaos to the calm, darkness to the light.

And should that time ever come, Nakoruru and her sword will be ready and waiting.

For this precious world and the souls that inhabit it will need their protector . . .

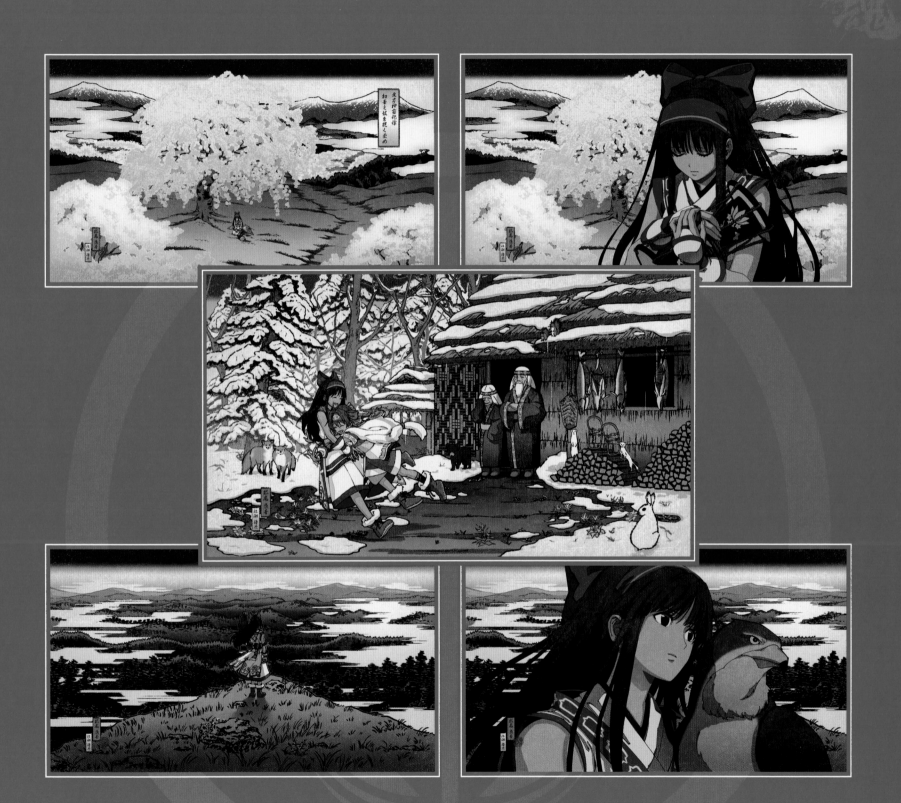

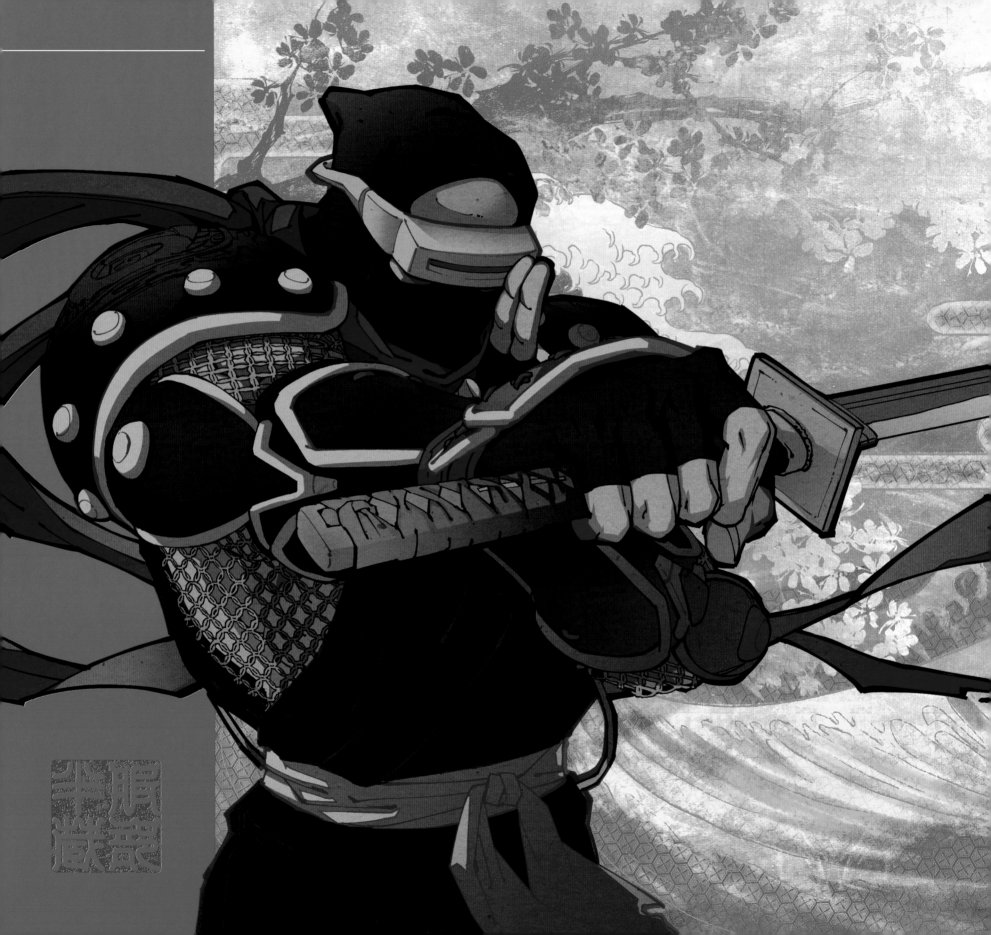

HANZO

Voice Actor: Tadahisa Saizen

Determined to stop the spreading chaos, the bakufu government orders that the culprits behind the evil be hunted down and brought to justice.

Tasked with uncovering the source of the evil and banishing it from the realm, Hanzo Hattori dispatches his ninjas to the far corners of the land, while venturing forth from Iga in order to personally face these turbulent times.

服部半蔵

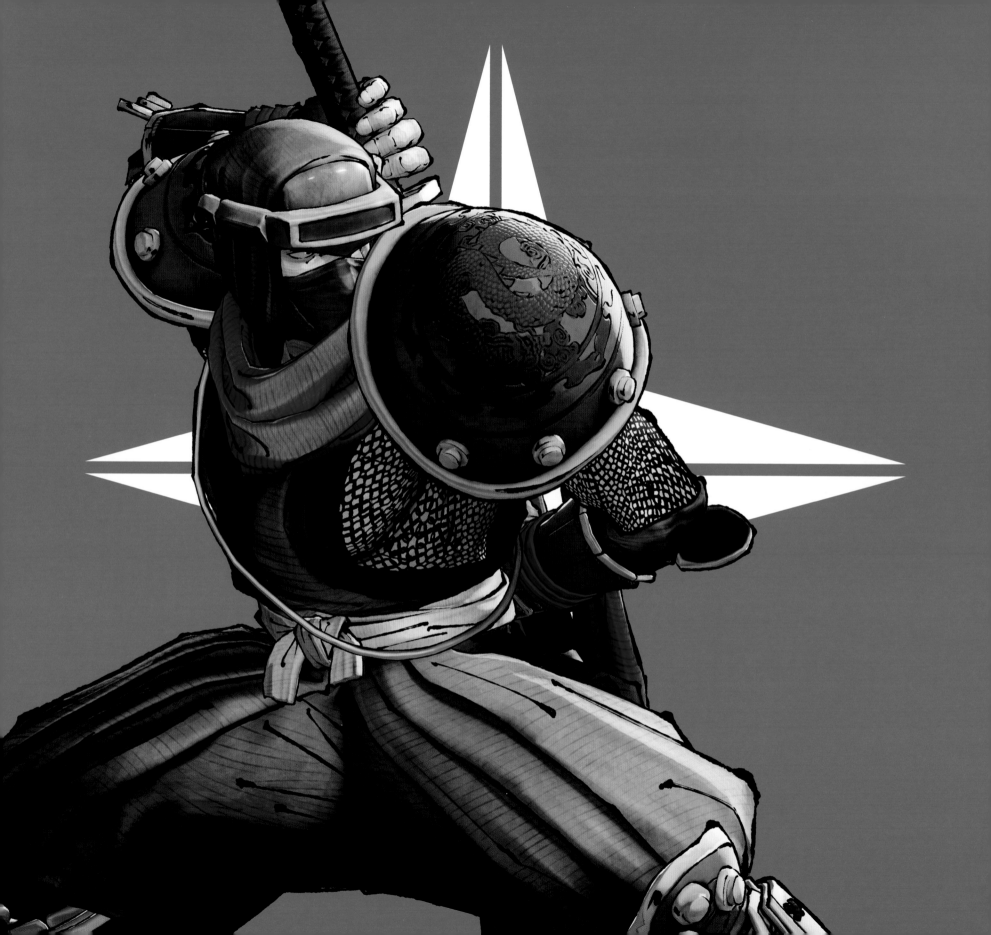

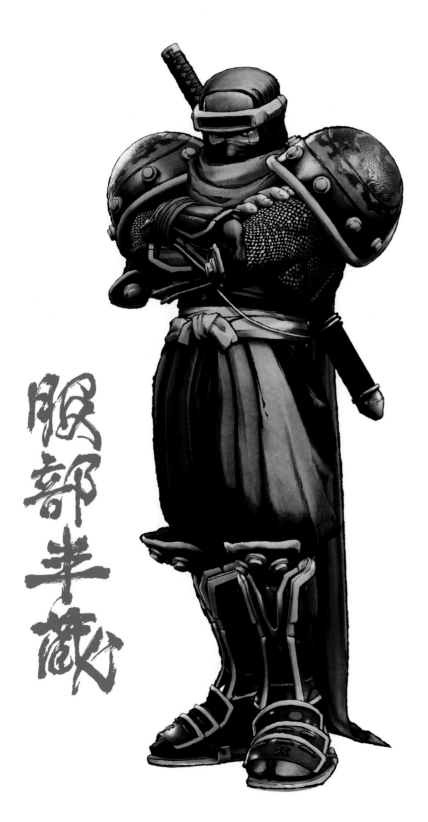

HANZO

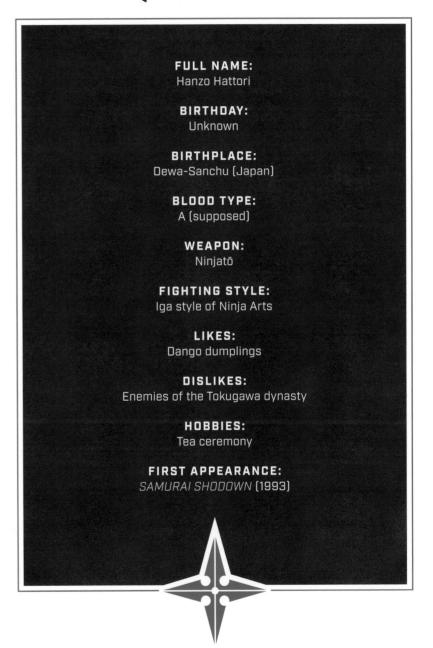

FULL NAME:
Hanzo Hattori

BIRTHDAY:
Unknown

BIRTHPLACE:
Dewa-Sanchu (Japan)

BLOOD TYPE:
A (supposed)

WEAPON:
Ninjatō

FIGHTING STYLE:
Iga style of Ninja Arts

LIKES:
Dango dumplings

DISLIKES:
Enemies of the Tokugawa dynasty

HOBBIES:
Tea ceremony

FIRST APPEARANCE:
SAMURAI SHODOWN (1993)

HANZO HATTORI

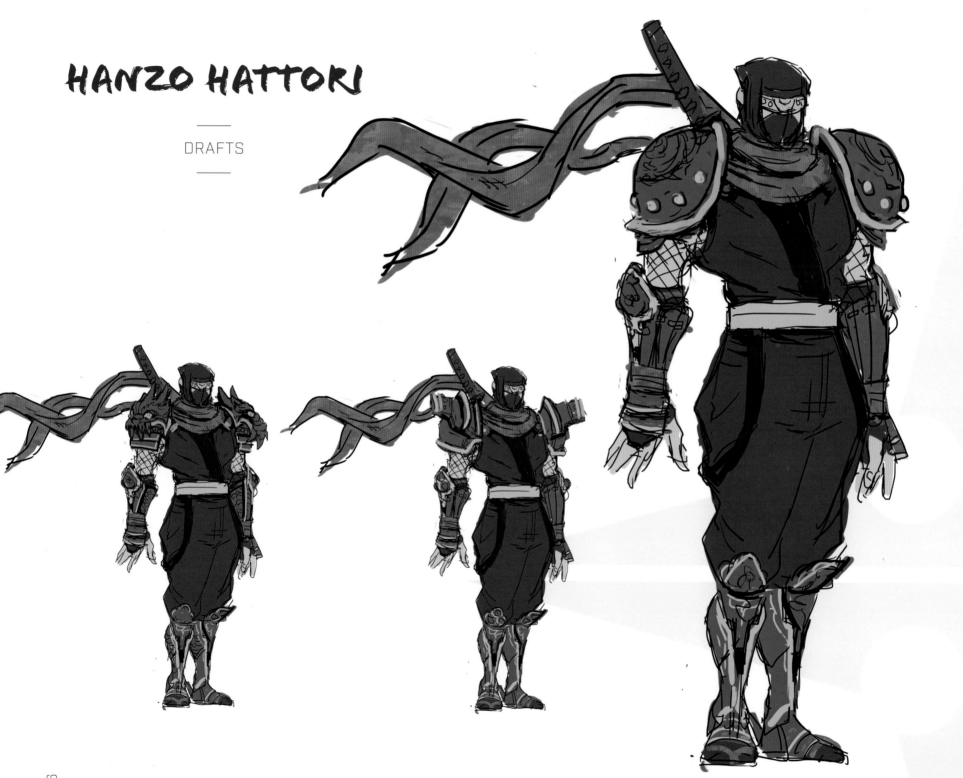

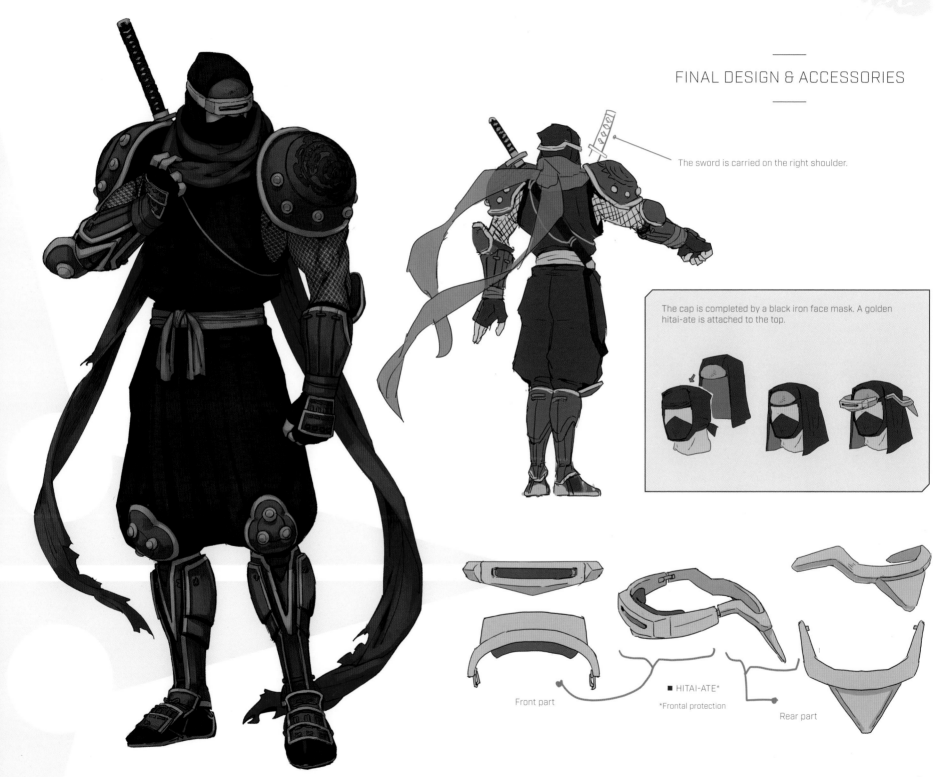

FINAL DESIGN & ACCESSORIES

The sword is carried on the right shoulder.

The cap is completed by a black iron face mask. A golden hitai-ate is attached to the top.

Front part

■ HITAI-ATE*

*Frontal protection

Rear part

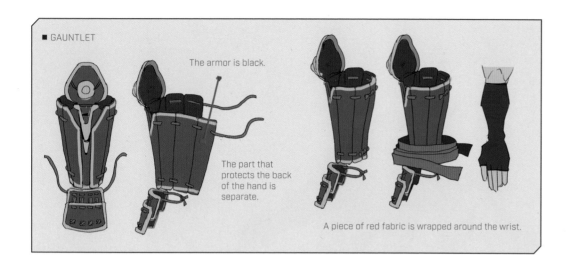

■ GAUNTLET

The armor is black.

The part that protects the back of the hand is separate.

A piece of red fabric is wrapped around the wrist.

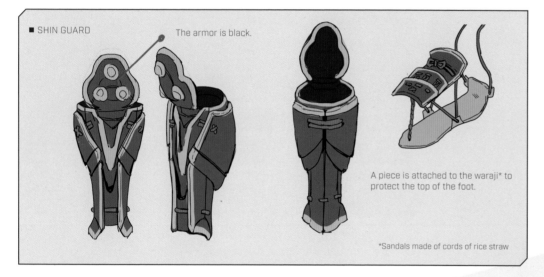

■ SHIN GUARD

The armor is black.

A piece is attached to the waraji* to protect the top of the foot.

*Sandals made of cords of rice straw

HANZO HATTORI

WEAPONS & ACCESSORIES

▲ Carved pattern on the shoulder pads (in reality, there is no color because it is simply a carved element).

▼ The color of the armor is identical to that of the gauntlet and shin guard.

▼ Sleeveless version of Galford's shoulder pads. They are attached to the shoulders with a cord.

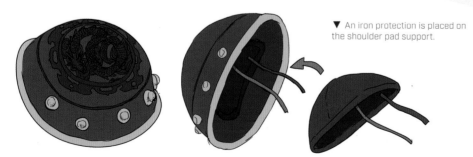

▼ An iron protection is placed on the shoulder pad support.

The arm goes through here.

■ NINJATŌ*

Unlike an ordinary uchigatana, the blade is smaller than the sheath.

*Sword used by ninjas

▼ Basic guard with a square shape and worn appearance

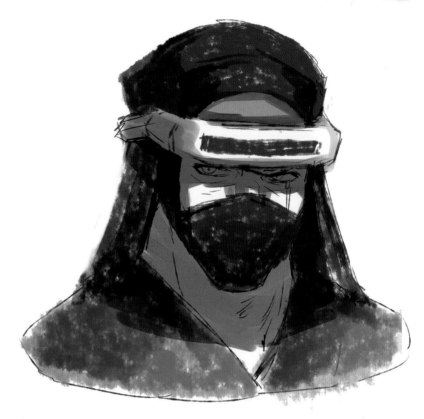

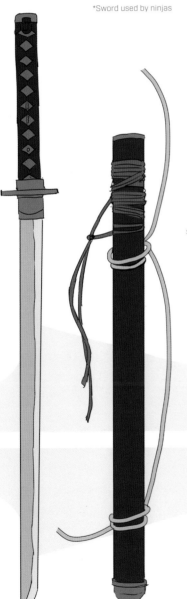

◀ The rope for carrying his sword has the same shape as Galford's. It is a thin gray rope.

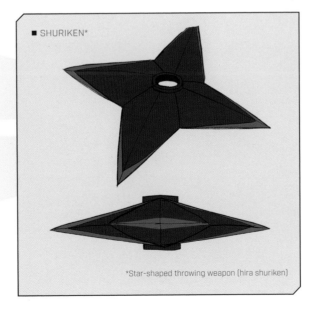

■ SHURIKEN*

*Star-shaped throwing weapon (hira shuriken)

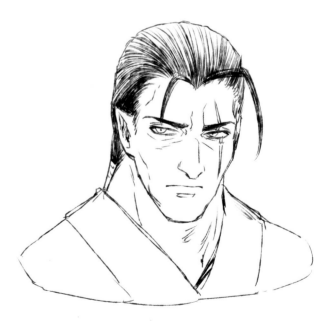

EPILOGUE

HANZO HATTORI

C01

 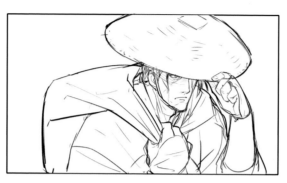

Shizuka Gozen is freed from her demonic affliction, causing evil to withdraw into the shadows once more.

Indeed, the chaos that assailed the Land of the Rising Sun leaves no sign of its presence in the wake of its retreat.

As his old friend Jubei returns to Edo with the task at hand complete . . .

So too does Hanzo, as he makes his way to his native Iga.

C02

Once home, Hanzo enjoys a night with his family.

As he listens intently to his eldest son's report on his trip west, he sees a finger appear over his shoulder.

It is his wife Kaede's. She lifts her finger to show him something . . .

A single cherry blossom petal.

"Spring is upon us once more, my love."

She offers a kind smile as she gazes into his eyes.

C03

Seven months later . . .

The carnage and upheaval left in the evil's wake have all but dissipated.

However, the scars on the land still remain, as does the pain of what transpired.

Hanzo, as a loyal shadow retainer to the bakufu, cannot sit idly by.

Once again, he sends his agents across the land to aid the bakufu in their pursuit of peace and prosperity.

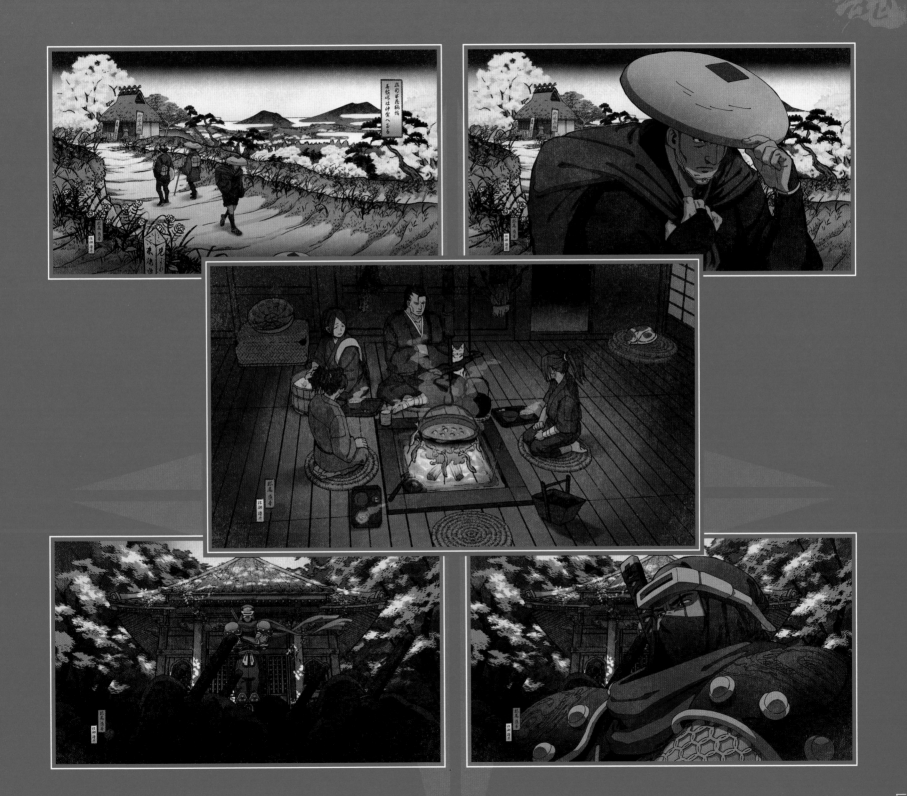

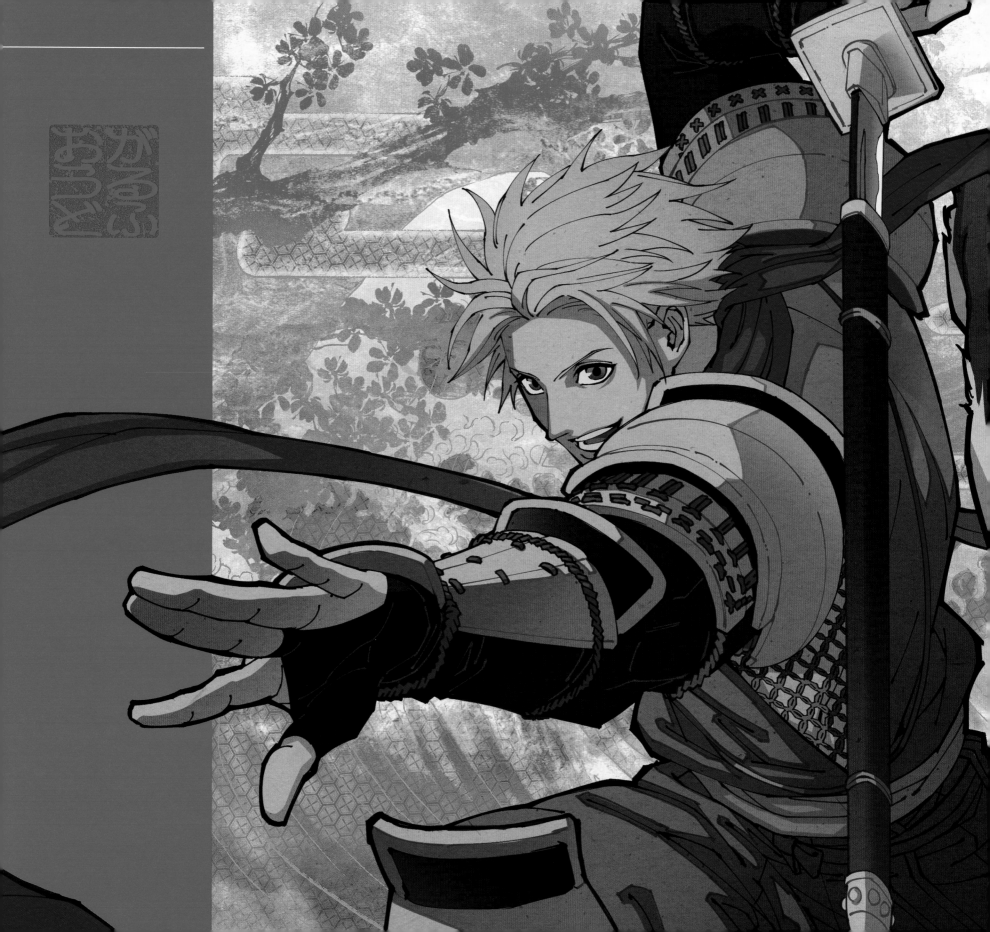

GALFORD

Voice Actor: Wataru Komada

Galford is no stranger to bringing evil to justice while traveling about the Land of the Rising Sun. However, the extent of the wars and strife that currently plague the land is nearly enough to give even him pause.

Yet, the duty to bring peace to the world as a ninja of justice is not one Galford takes lightly, so together with his pet dog, Poppy, he prepares to throw himself into the fray.

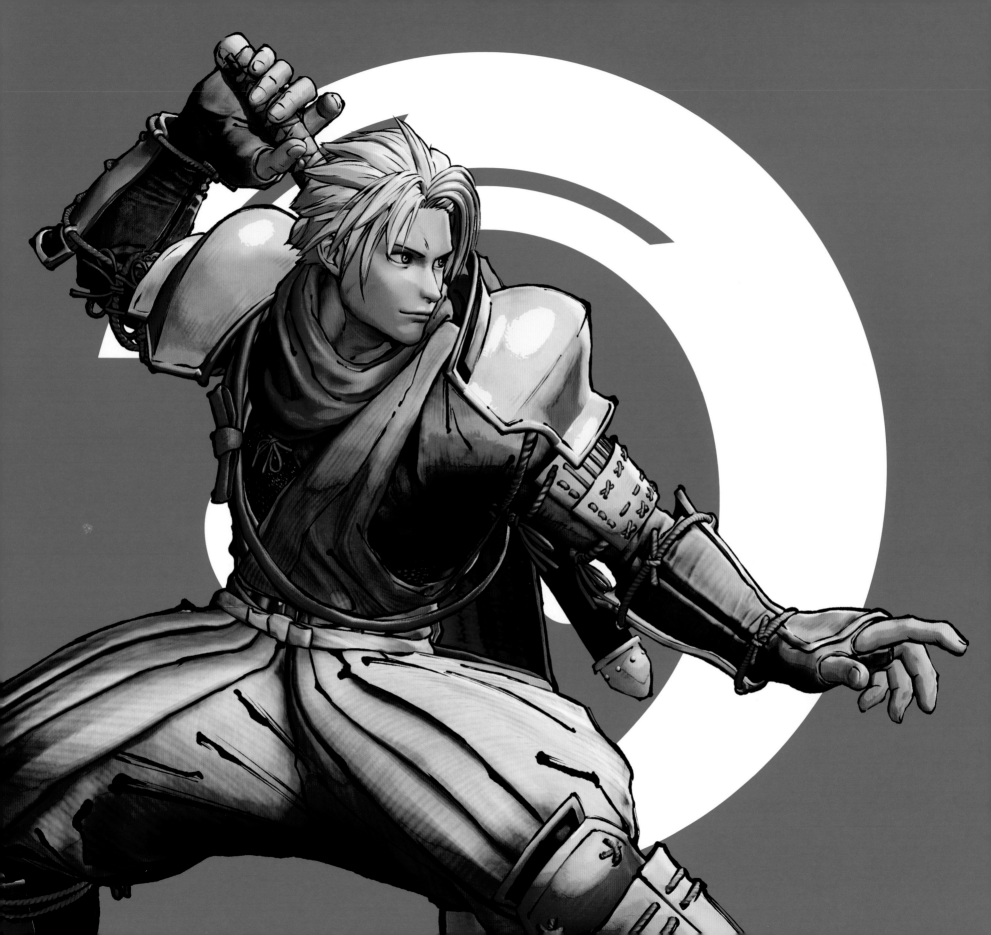

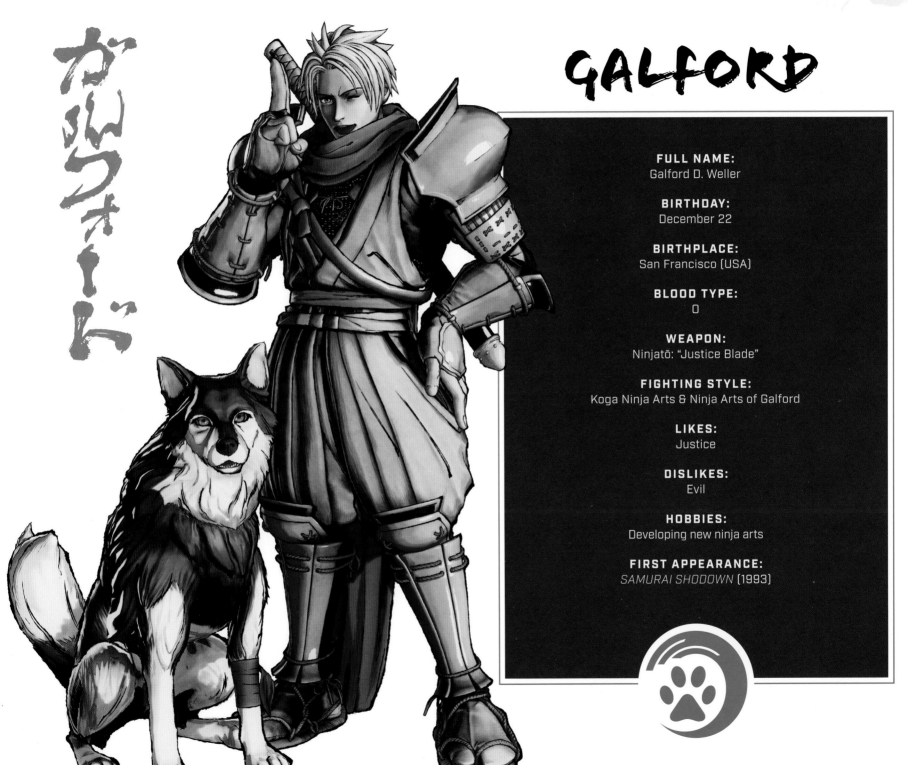

GALFORD

FULL NAME:
Galford D. Weller

BIRTHDAY:
December 22

BIRTHPLACE:
San Francisco (USA)

BLOOD TYPE:
O

WEAPON:
Ninjatō: "Justice Blade"

FIGHTING STYLE:
Koga Ninja Arts & Ninja Arts of Galford

LIKES:
Justice

DISLIKES:
Evil

HOBBIES:
Developing new ninja arts

FIRST APPEARANCE:
SAMURAI SHODOWN (1993)

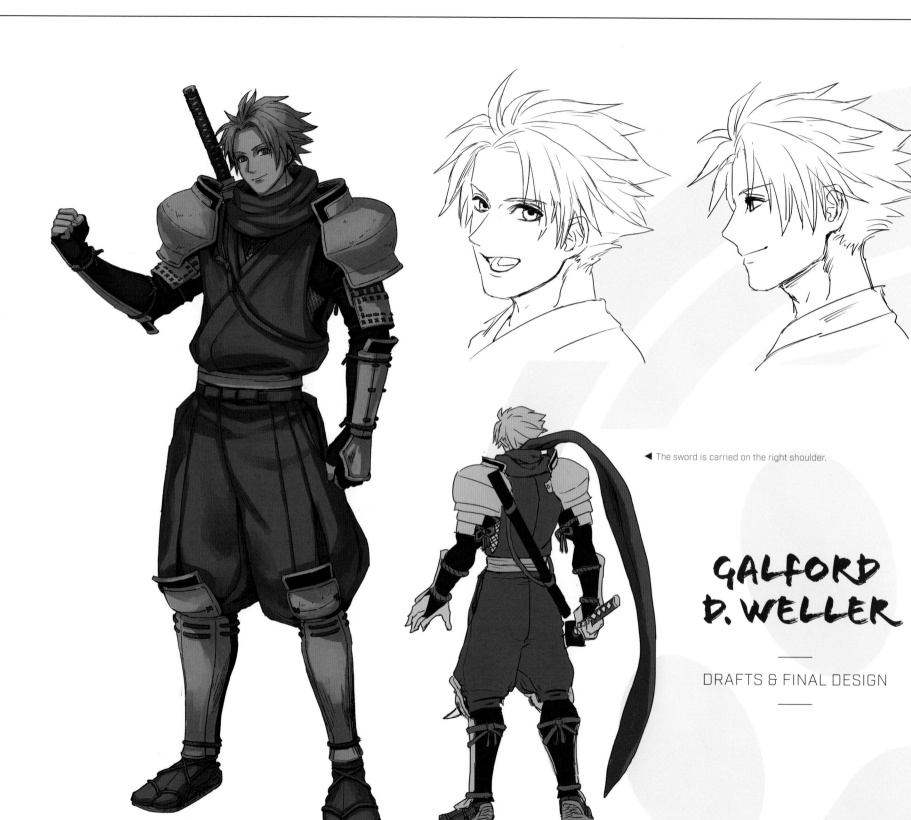

◀ The sword is carried on the right shoulder.

GALFORD D. WELLER

DRAFTS & FINAL DESIGN

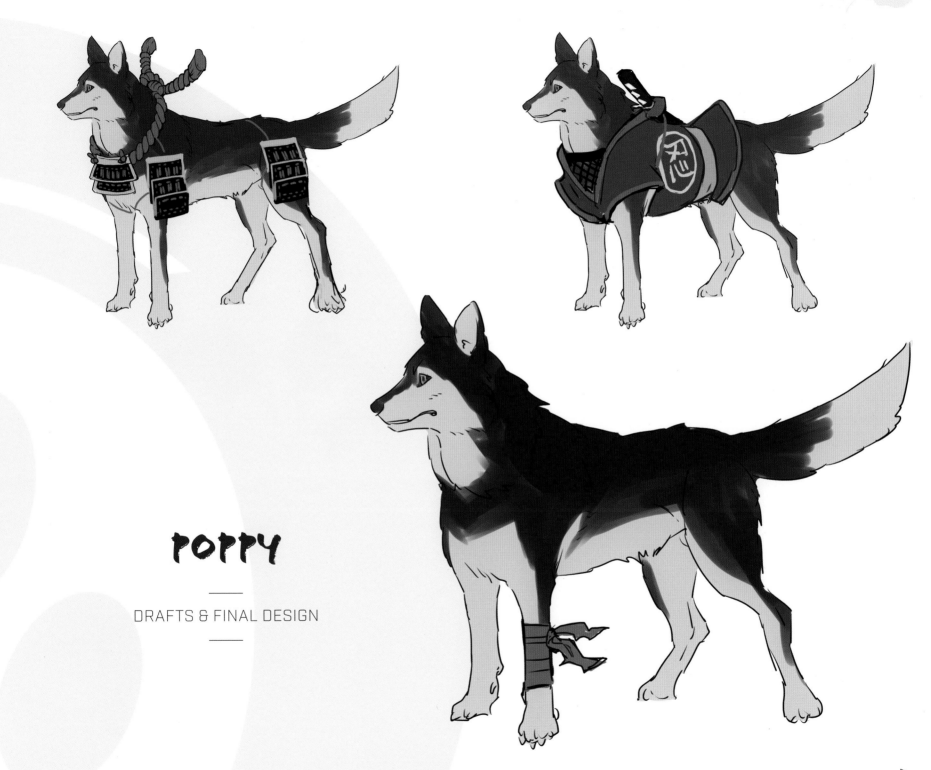

POPPY

DRAFTS & FINAL DESIGN

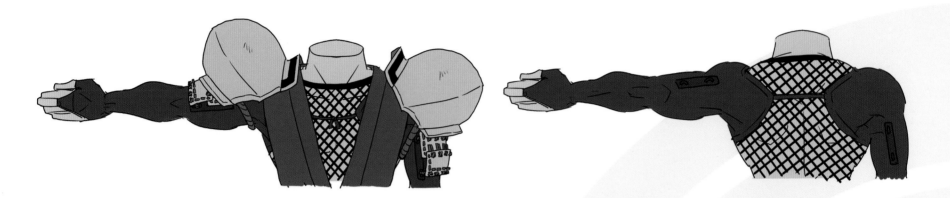

The seam position of the inner part of the crotch is a little higher than for an ordinary hakama.*

There is no rigid back piece.

The cord for the back arm protection is tied.

The gauntlet is attached over it.

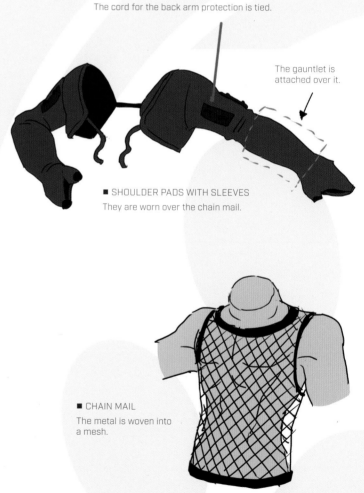

■ SHOULDER PADS WITH SLEEVES
They are worn over the chain mail.

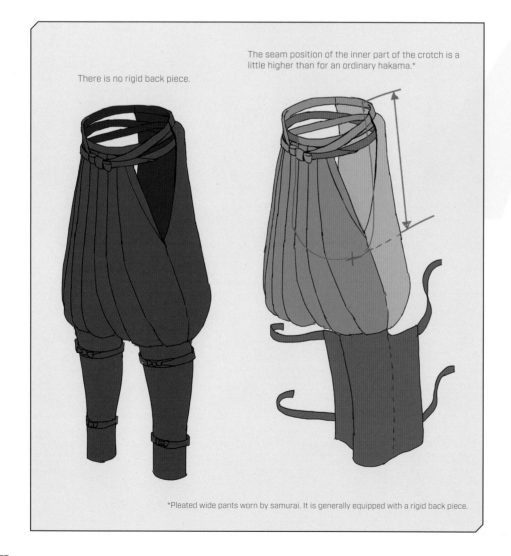

*Pleated wide pants worn by samurai. It is generally equipped with a rigid back piece.

■ CHAIN MAIL
The metal is woven into a mesh.

■ SHOULDER PAD

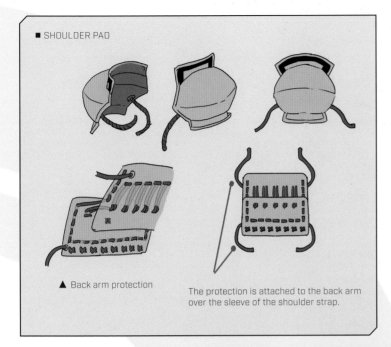

▲ Back arm protection

The protection is attached to the back arm over the sleeve of the shoulder strap.

■ KUNAI*

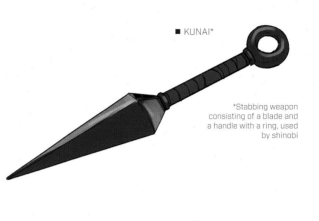

*Stabbing weapon consisting of a blade and a handle with a ring, used by shinobi

■ NINJATŌ*

Unlike an ordinary uchigatana, the blade is smaller than the sheath. A basic straight blade, without curvature.

*Sword used by ninjas

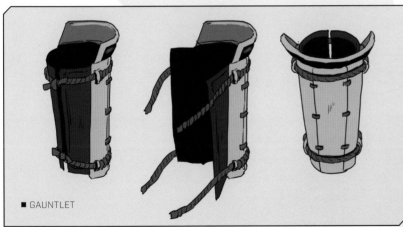

■ GAUNTLET

■ SHIN GUARD

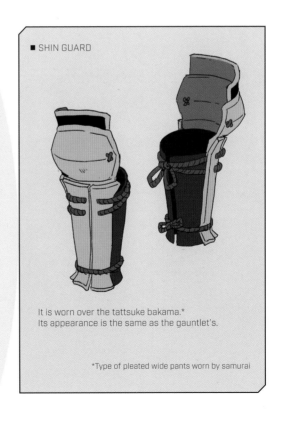

It is worn over the tattsuke bakama.*
Its appearance is the same as the gauntlet's.

*Type of pleated wide pants worn by samurai

GALFORD D. WELLER

WEAPONS & ACCESSORIES

EPILOGUE

GALFORD D. WELLER

C01

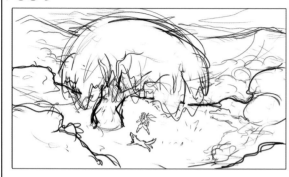
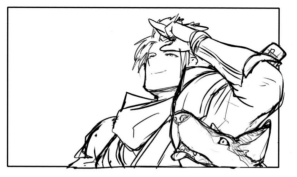

A graceful dance of cherry blossom petals unfolds before their eyes.

And just as quickly as Galford and Poppy are cloaked in their soft embrace, the petals drift away on the warm, gentle wind.

Turning to look at each other, they share a moment of joy as they bask in their achievement; the world is at peace once again.

Their thoughts return to Shizuka Gozen, however, as she fades into the light.

C02

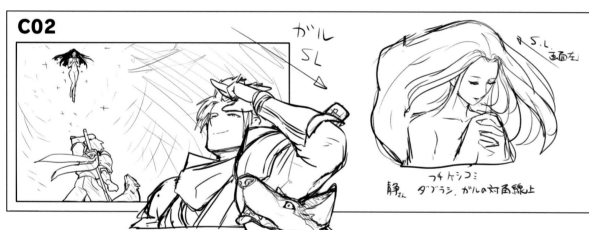

ガル
SL

R.S.L.
画面左

静さん つチケシコミ
ダブラシ. ガルの対角線上

She has been freed from the shackles of the bitter grudge that bound her.

They sense a true tranquility about her as she transcends into the hereafter.

For she was a victim of the malevolence, too.

"Thank you," she whispers as her parting words to the world.

Perhaps the blossoms are her way of leaving the world a reminder of her true essence.

C03

Galford and Poppy have saved Japan.

But the root of the evil still lingers in the shadows.

It is only a matter of time before the chaos returns.

And when that day comes, they will be ready.

Ready to restore peace to the world once more.

Until then, the ninja of justice and his trusty sidekick will continue their journey.

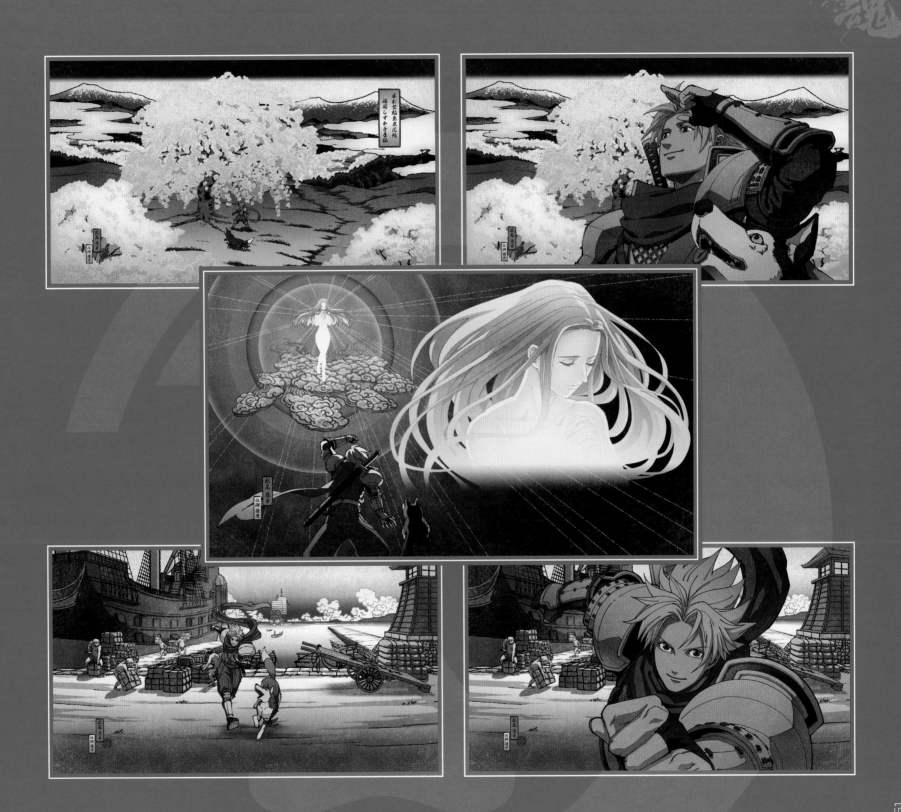

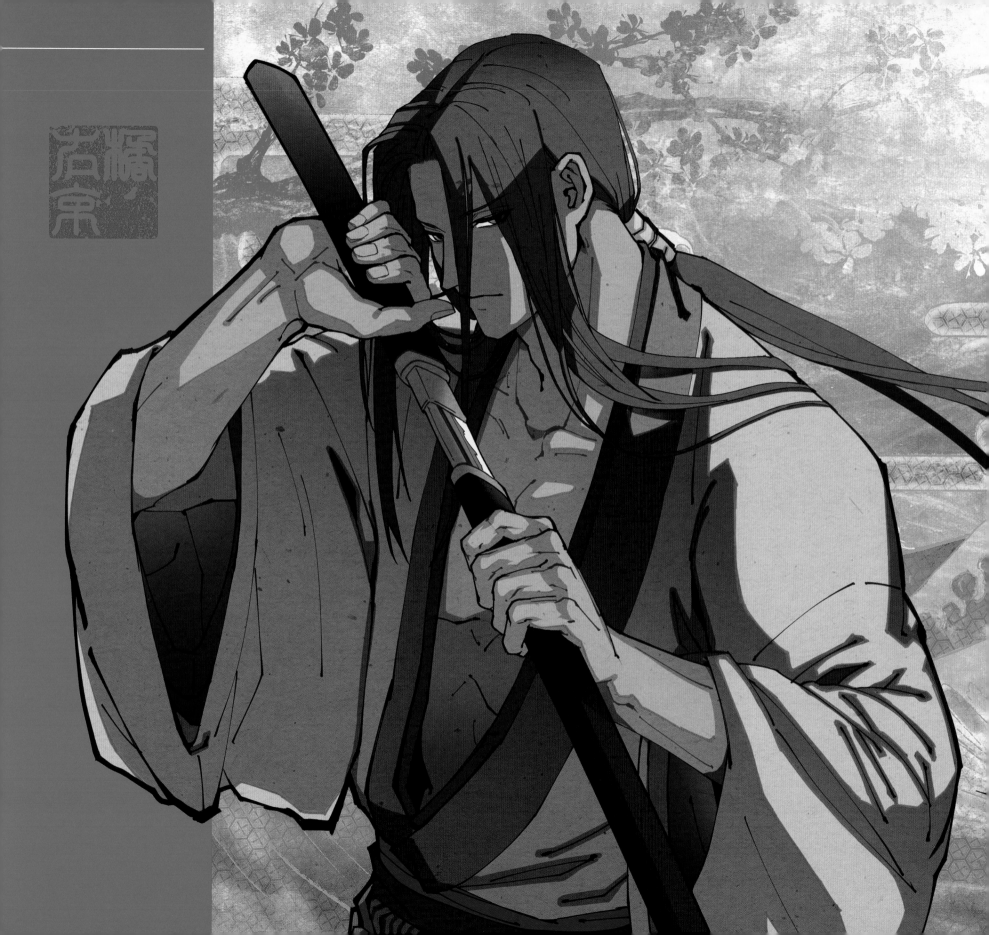

UKYO
Voice Actor: Shinjiro Sakurai

Ukyo Tachibana is journeying in search of a most precious flower fit for his darling Kei Odagiri when he hears of a mystical flower that only grows in the shadowy realm between this world and the next.

"Could this be the one true flower I so desperately seek?"

Ukyo, in a last-ditch attempt to see his wish fulfilled, sets out to reach the land where his dream may finally come true.

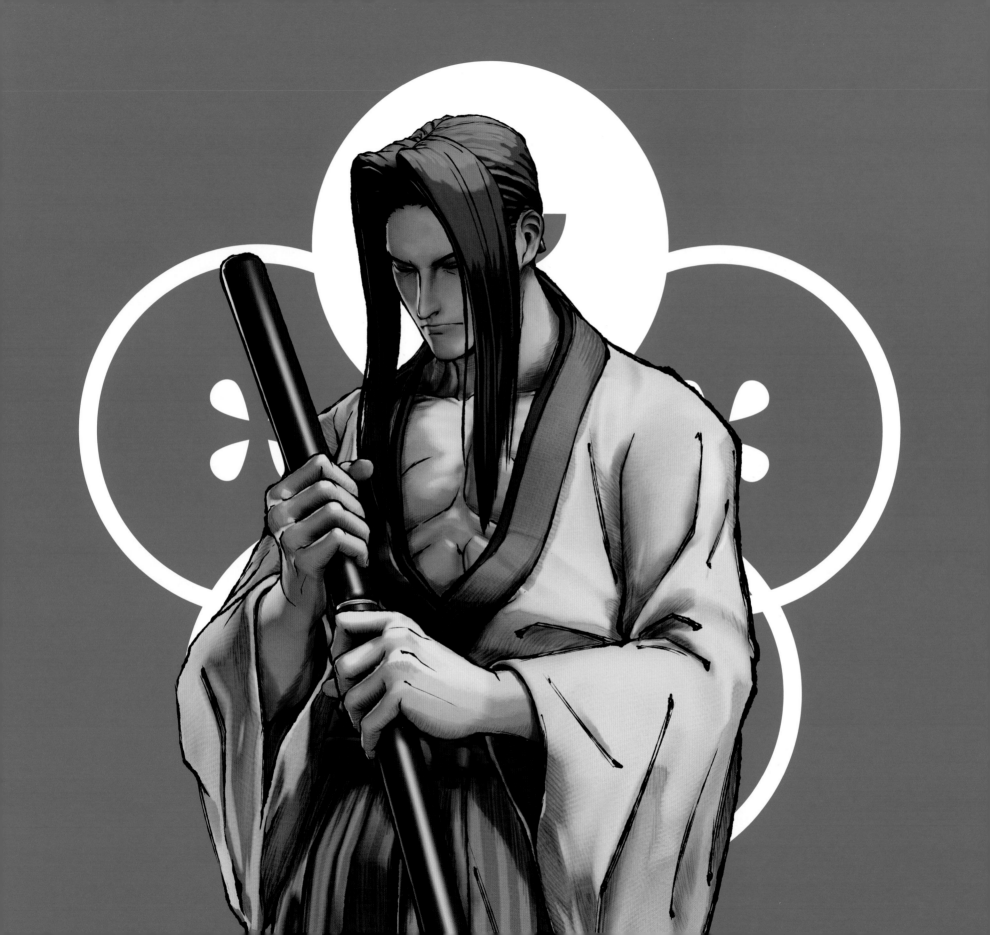

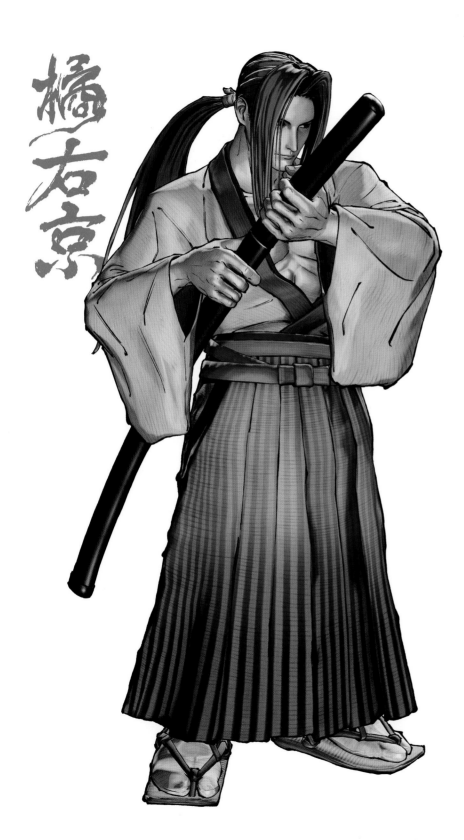

橘右京

UKYO

FULL NAME:
Ukyo Tachibana

BIRTHDAY:
September 20

BIRTHPLACE:
Umasugi-Mura (Japan)

BLOOD TYPE:
AB

WEAPON:
Nameless self-made sword

FIGHTING STYLE:
Shinmuso Itto style

LIKES:
Feeling alone

DISLIKES:
True solitude

HOBBIES:
Embroidery

FIRST APPEARANCE:
SAMURAI SHODOWN (1993)

■ OUTFIT

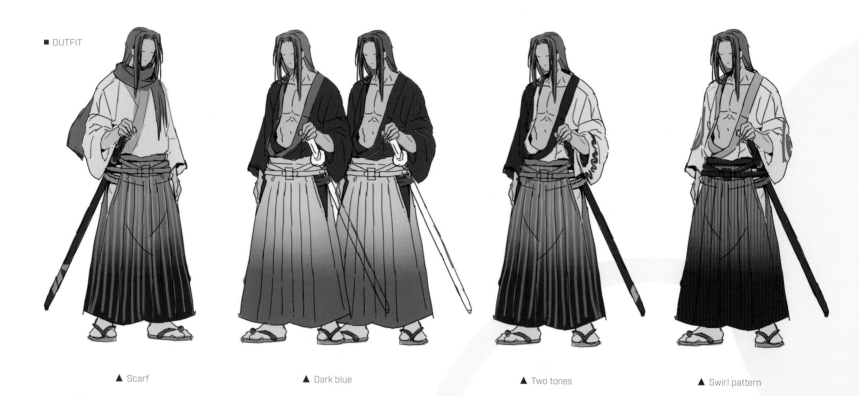

▲ Scarf

▲ Dark blue

▲ Two tones

▲ Swirl pattern

UKYO TACHIBANA

DRAFTS / UNUSED DESIGNS

■ HAIRSTYLE

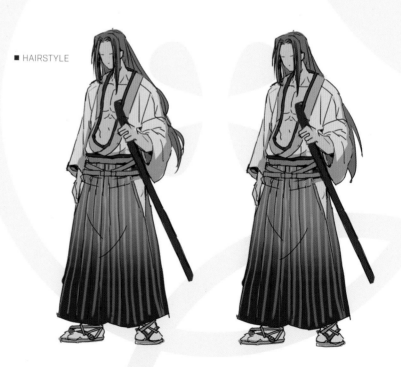

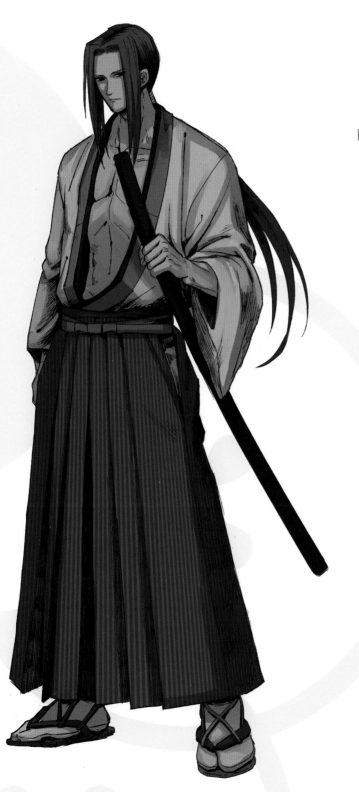

FINAL DESIGN

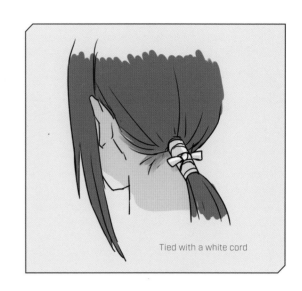

Tied with a white cord

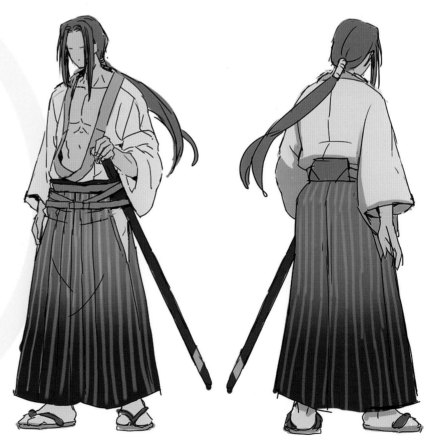

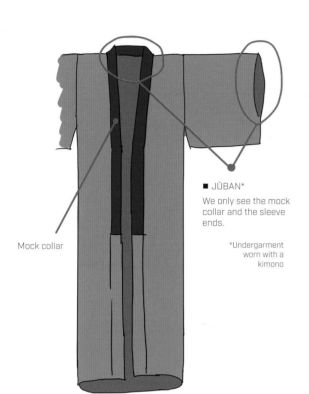

■ JŪBAN*

We only see the mock collar and the sleeve ends.

*Undergarment worn with a kimono

Mock collar

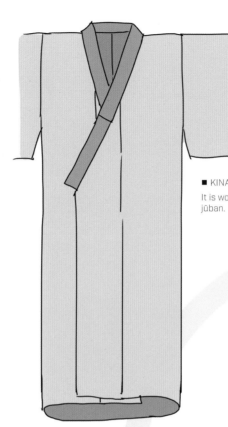

■ KINAGASHI*

It is worn over the jūban.

*Type of kimono

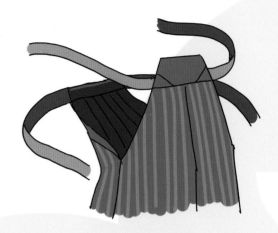

The knot of the obi sits under the hakama, giving it a rounded appearance.

The obi peeks out slightly.

UKYO TACHIBANA

CLOTHES

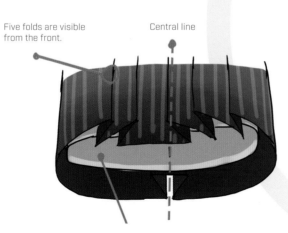

Five folds are visible from the front.

Central line

At the bottom, you can see the end of his kimono.

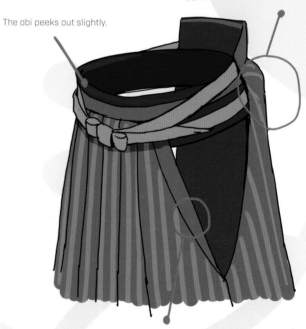

The folds in the shape of a bamboo leaf are only present on the front side.

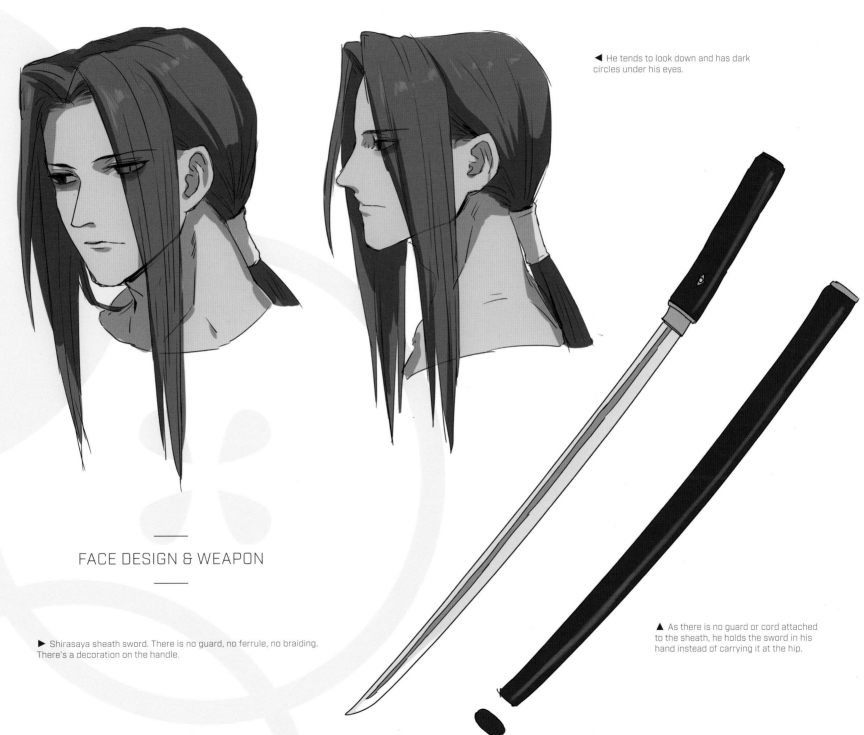

◄ He tends to look down and has dark circles under his eyes.

FACE DESIGN & WEAPON

▶ Shirasaya sheath sword. There is no guard, no ferrule, no braiding. There's a decoration on the handle.

▲ As there is no guard or cord attached to the sheath, he holds the sword in his hand instead of carrying it at the hip.

EPILOGUE

C01

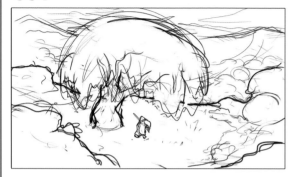 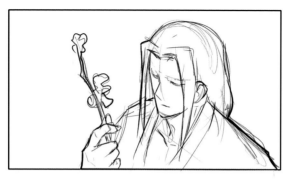

As if to soothe the passing of Shizuka Gozen's soul into the next life, a blanket of cherry blossoms covers the earth.

Having paid his respects, Ukyo prepares to leave, but not before he notices a small solitary tree branch.

From it stems the flower of legend, known to grow only in the realm between this world and the next.

It is the flower of perfection: the one he so earnestly seeks.

The lone flower, gleaming as pure as a pearl, sits delicately at the tip of the branch.

C02

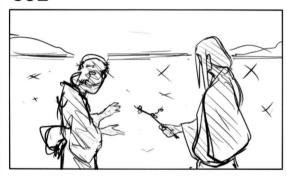

As Kei Odagiri sets her eyes upon the fabled flower, she can barely contain her joy.

Yet the very instant Ukyo places the flower in her hands, its delicate petals begin to tumble to the ground.

"Ahh . . . It has lost its petals. How sad."

As the sun sets, the wind steals away the petals while the two lovers look on in sadness.

C03

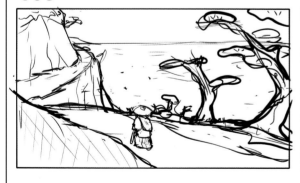

Months have passed since that day, and Ukyo has yet to find the perfect flower to gift to his beloved Kei.

Undeterred, Ukyo continues his search.

And though time is not on his side, as the illness that ravages his body steals what little life he has left . . .

The shadow of death is of small concern when the prize that awaits his success is a reunion with his precious love . . .

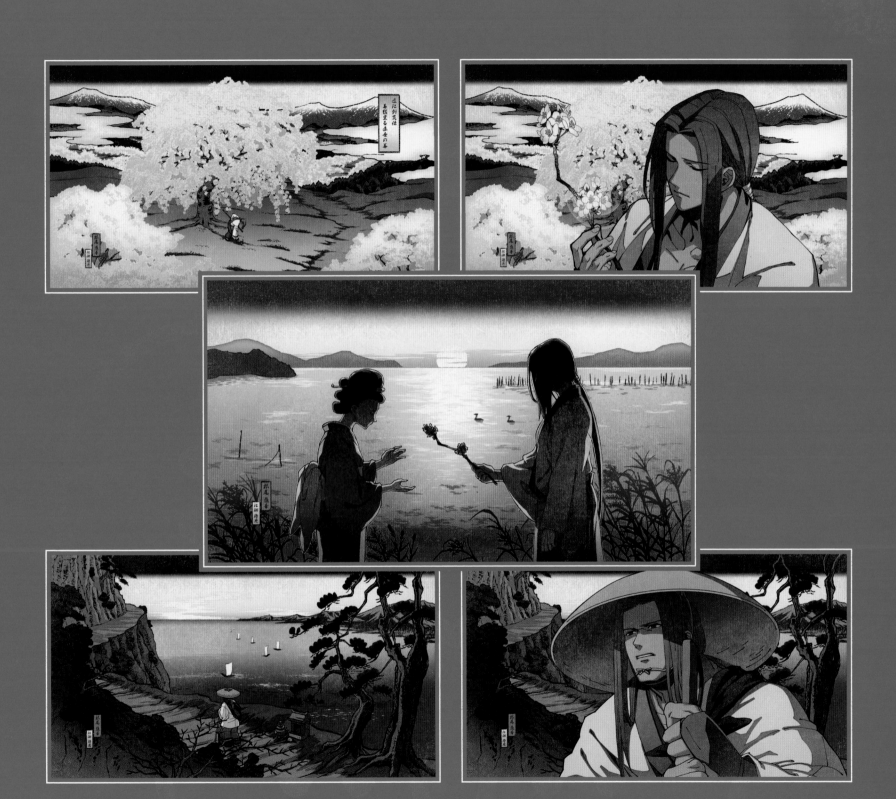

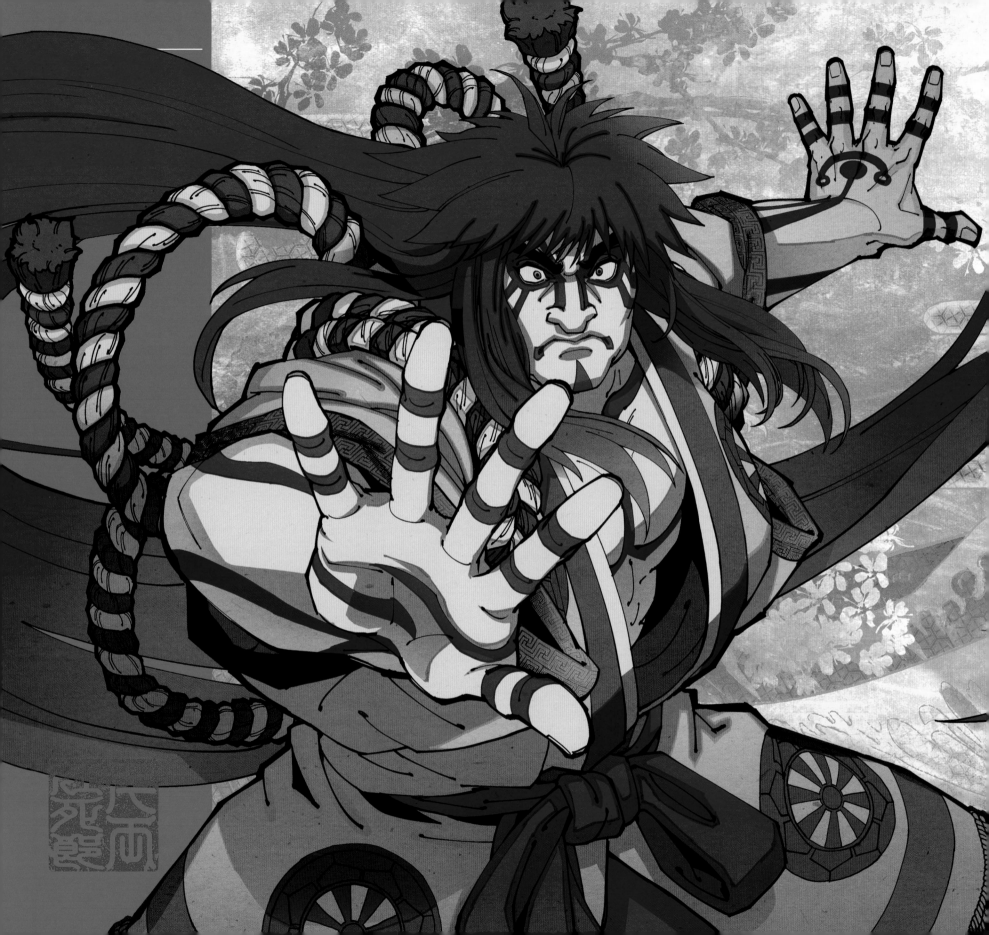

KYOSHIRO

Voice Actor: Monster Maezuka

The chaos has left Edo in a nearly unrecognizable state, yet what occupies Kyoshiro Senryo's mind is the acute awareness that his Kabuki form is far from where it needs to be. He knows that his audience must be free and happy to be able to enjoy his performances.

And so, relinquishing his role to his understudy, Kyoshiro sets out to hone his art and purge evil from the land, so that both may thrive.

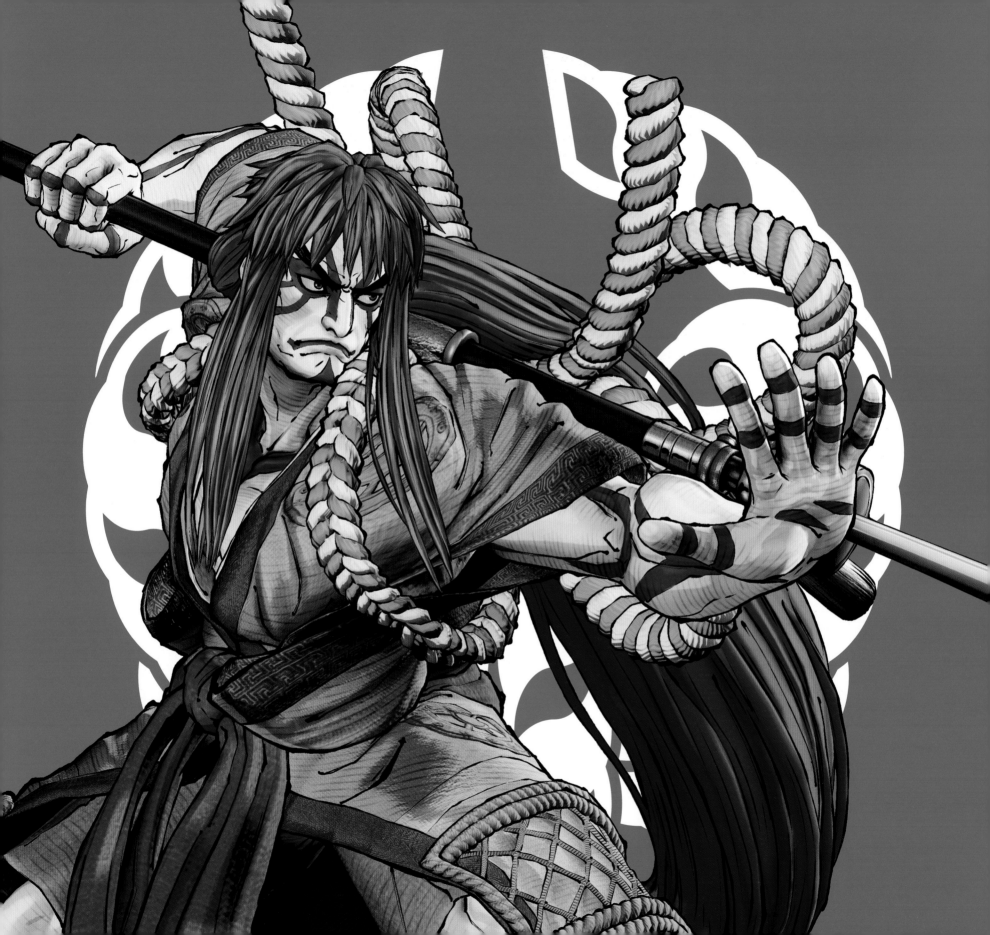

千両狂死郎

KYOSHIRO

FULL NAME:
Kyoshiro Senryo

BIRTHDAY:
December 14

BIRTHPLACE:
Edo (Japan)

BLOOD TYPE:
B

WEAPON:
Naginata: "Sewanyobo"

FIGHTING STYLE:
Dancing Battle Kabuki

LIKES:
Applause after dancing for the people

DISLIKES:
Dogs

HOBBIES:
Caring for his hair

FIRST APPEARANCE:
SAMURAI SHODOWN (1993)

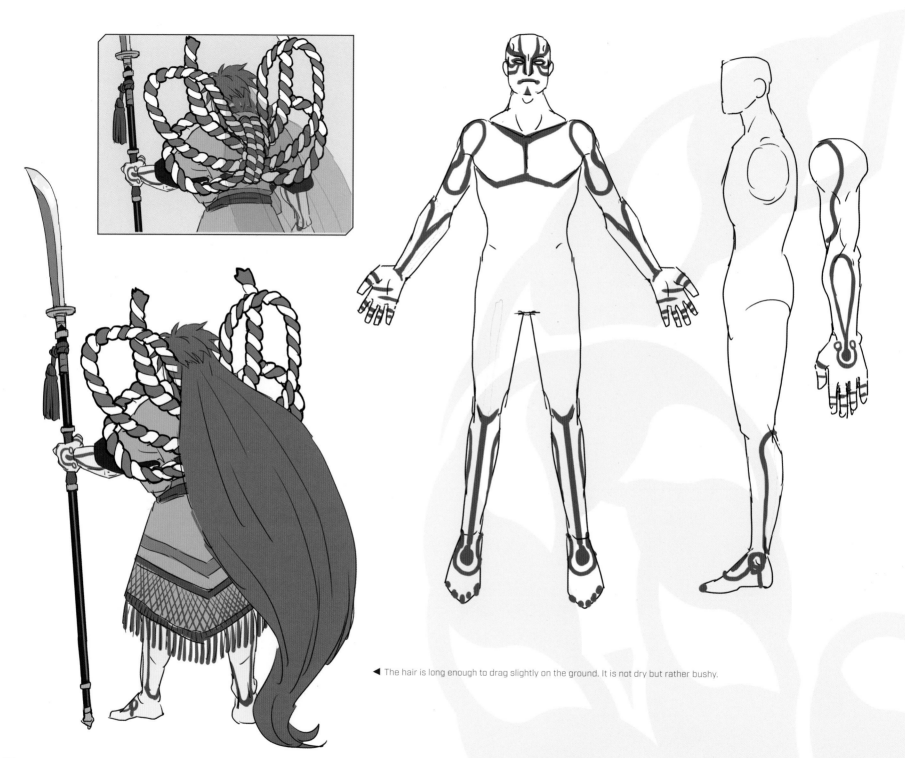

◄ The hair is long enough to drag slightly on the ground. It is not dry but rather bushy.

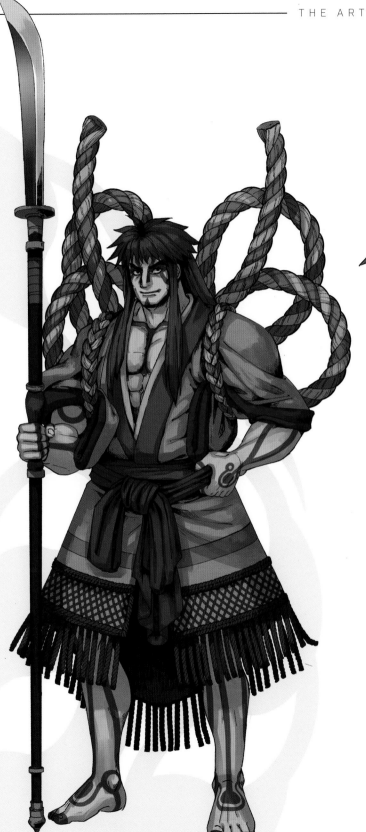

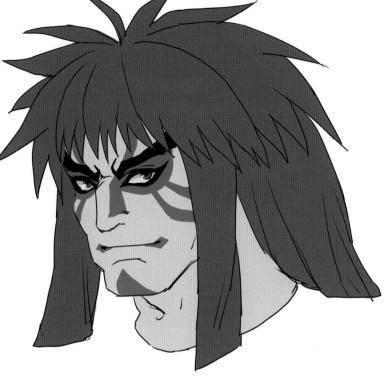

KYOSHIRO SENRYO

FINAL DESIGN

▶ Pattern representing thunder.
Present only on the sleeves.

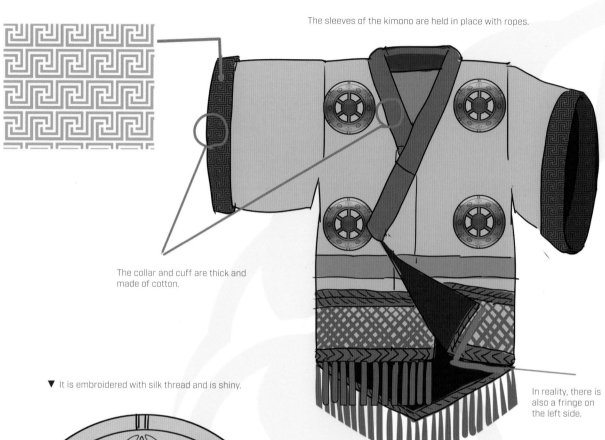

The sleeves of the kimono are held in place with ropes.

The collar and cuff are thick and made of cotton.

▼ It is embroidered with silk thread and is shiny.

In reality, there is also a fringe on the left side.

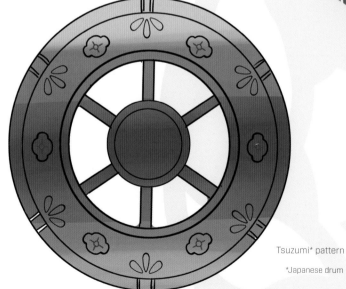

Tsuzumi* pattern

*Japanese drum

KYOSHIRO SENRYO

———

CLOTHES

———

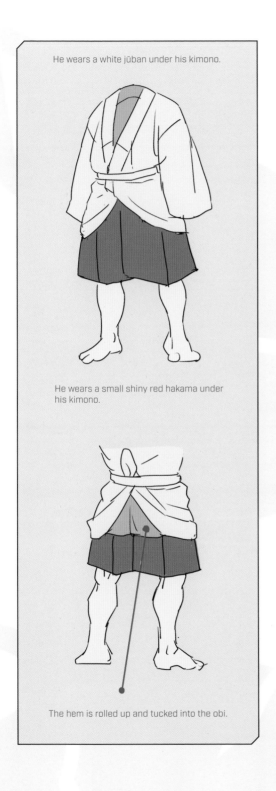

He wears a white jūban under his kimono.

He wears a small shiny red hakama under his kimono.

The hem is rolled up and tucked into the obi.

CLOTHES & SPECIAL ATTACK

◄ *Bufo japonicus* toad for the Gama Jigoku attack

EPILOGUE

C01

As Shizuka Gozen's soul is set free, Kyoshiro returns to find the earth covered with a spotless blanket of cherry blossom petals.

A flood of new rhythmic interpretations washes over his mind, ebbing away to reveal a fiery passion to return to the stage.

His eyes alight with inspiration, he makes haste for Edo.

C02

新しい舞台を
たて込み中
資材 つんでる

Like a bolt of lightning, he hurries home and shuts himself in his room, and with an intense scowl on his face, begins to write.

War could have broken out on his doorstep and he would not have heard it.

Refusing to sleep, Kyoshiro rehearses his routine day and night until the hour of his performance is at hand.

C03

Months have gone by since Shizuka Gozen's passing.

Kyoshiro's performances are now the talk of Edo.

Today, much like yesterday, people line up outside the theater.

Inside, Kyoshiro is commanding the stage to rapturous applause.

In a way, his work now serves as the ultimate homage to Shizuka Gozen . . .

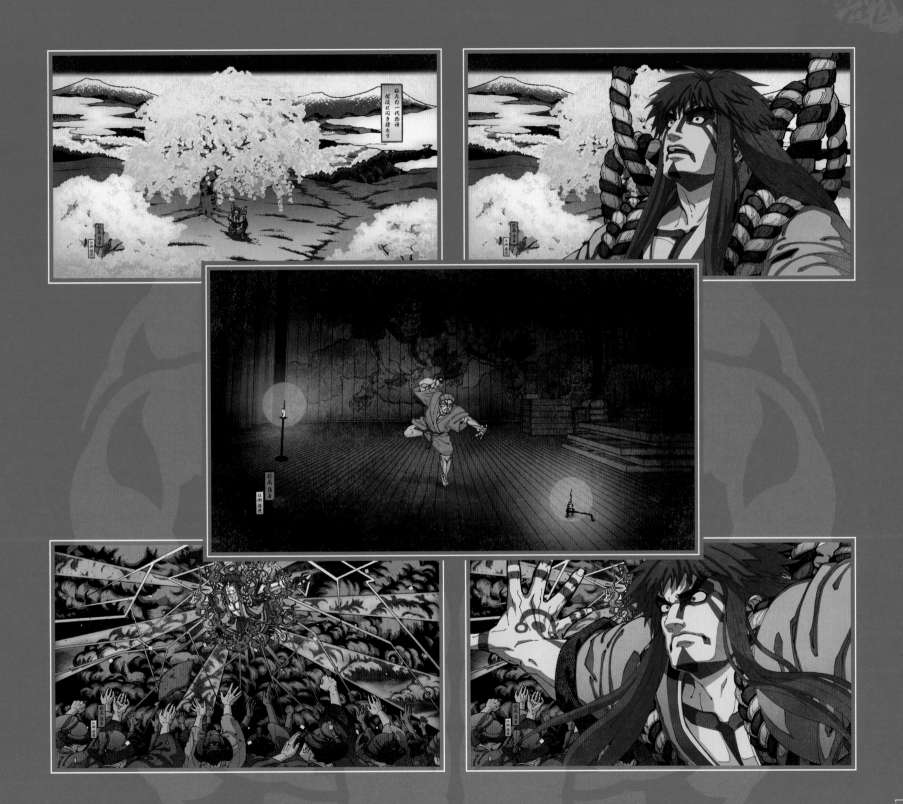

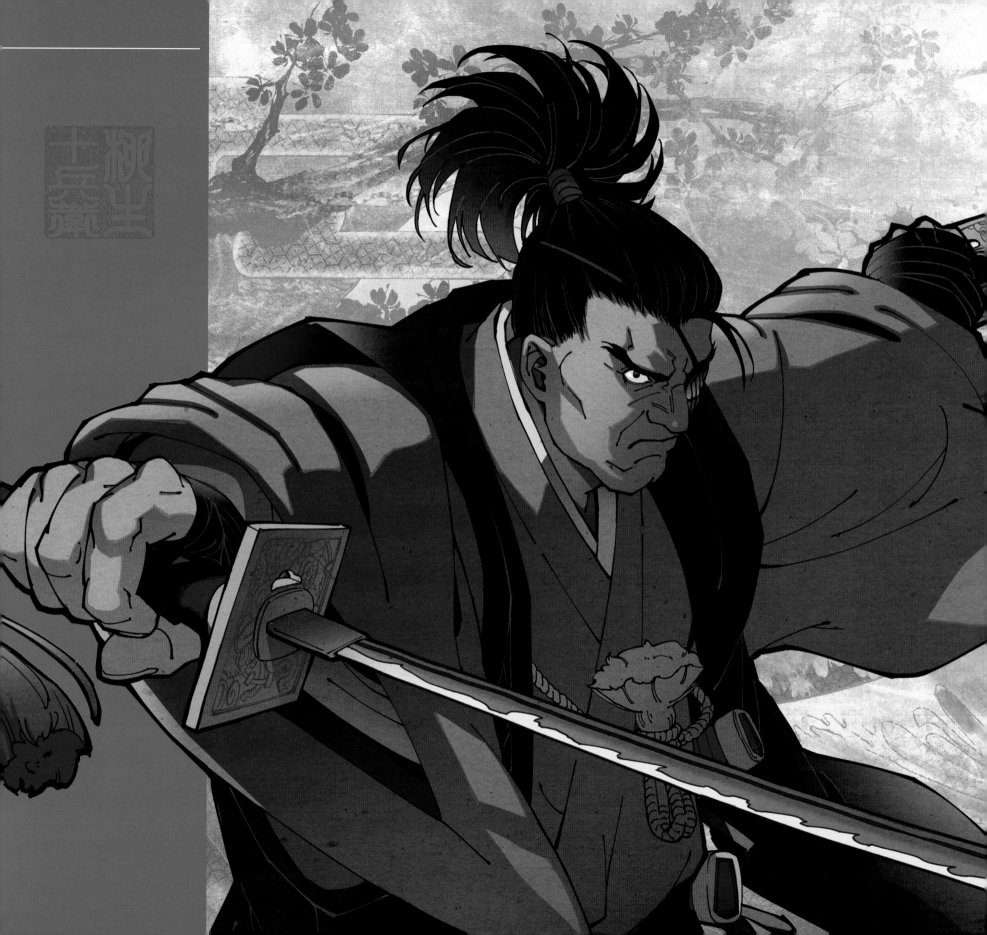

JUBEI

Voice Actor: Hiroshi Naka

Determined to stop the spreading chaos, the bakufu government orders that the culprits behind the evil be hunted down and brought to justice.

Undercover agent Jubei Yagyu receives orders to investigate the recent disturbance and punish those responsible for it. Unfazed by the turmoil around him, he sets out to boldly complete his mission.

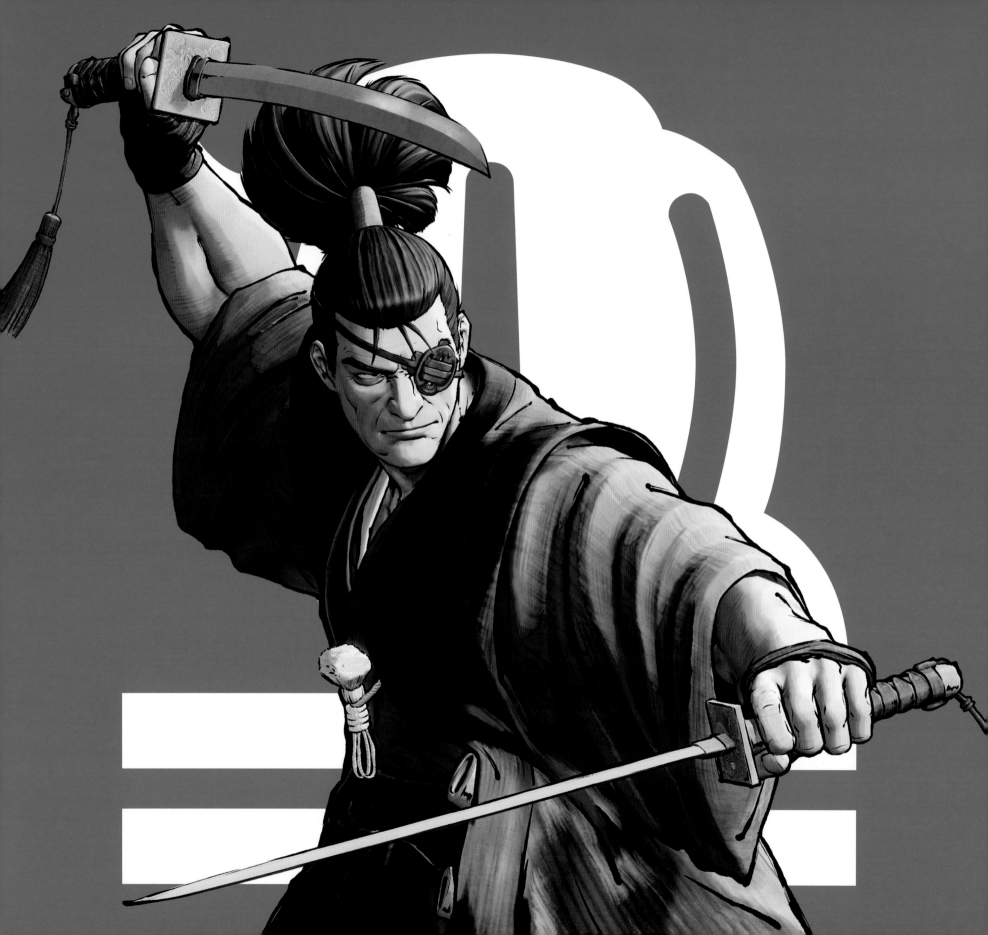

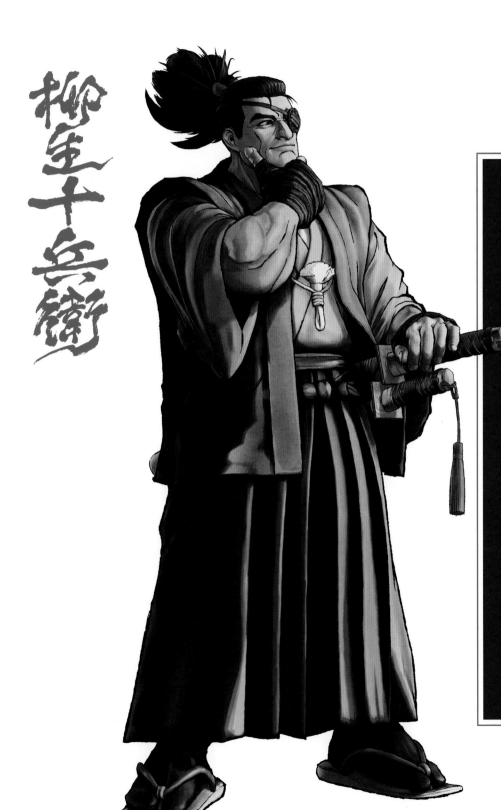

柳生十兵衛

JUBEI

FULL NAME:
Jubei Yagyu

BIRTHDAY:
March 6

BIRTHPLACE:
Tosa (Japan)

BLOOD TYPE:
O

WEAPON:
Uchigatana & wakizashi: "Kotetsu & Sukehiro"

FIGHTING STYLE:
Yagyu Shinkage style

LIKES:
Anmitsu agar jelly

DISLIKES:
Weaklings

HOBBIES:
Slashing

FIRST APPEARANCE:
SAMURAI SHODOWN (1993)

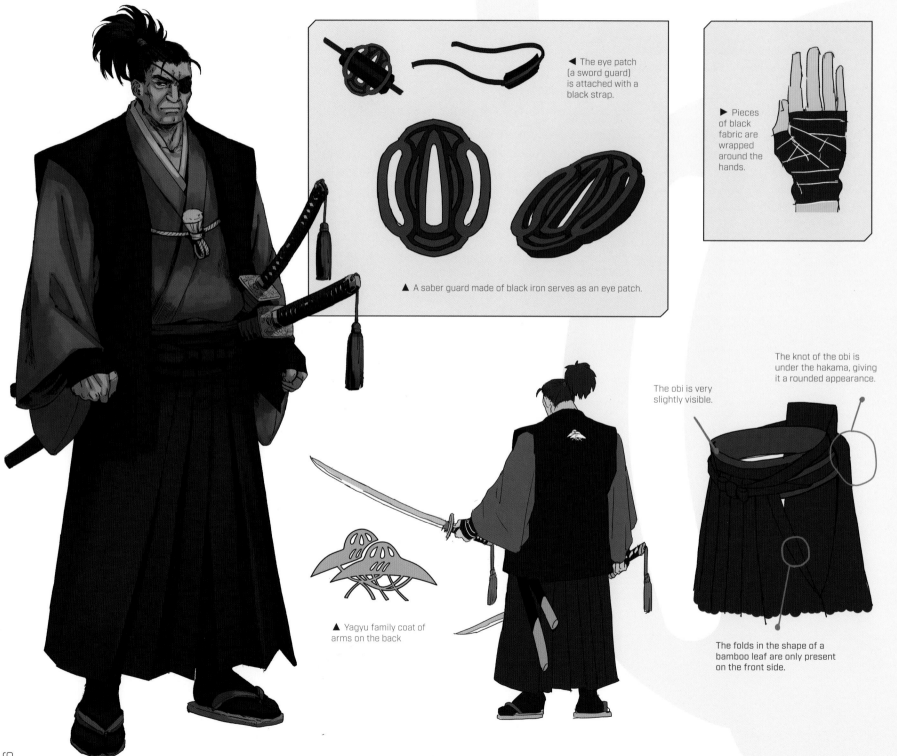

◀ The eye patch (a sword guard) is attached with a black strap.

▶ Pieces of black fabric are wrapped around the hands.

▲ A saber guard made of black iron serves as an eye patch.

The obi is very slightly visible.

The knot of the obi is under the hakama, giving it a rounded appearance.

▲ Yagyu family coat of arms on the back

The folds in the shape of a bamboo leaf are only present on the front side.

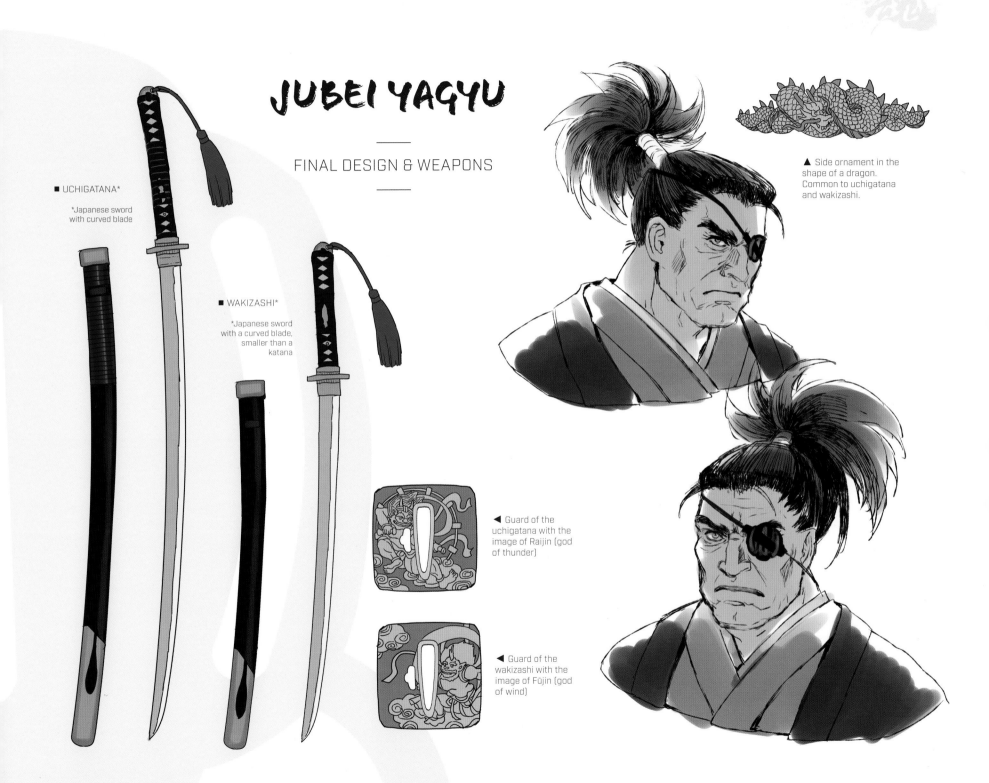

JUBEI YAGYU

FINAL DESIGN & WEAPONS

■ UCHIGATANA*

*Japanese sword with curved blade

■ WAKIZASHI*

*Japanese sword with a curved blade, smaller than a katana

▲ Side ornament in the shape of a dragon. Common to uchigatana and wakizashi.

◄ Guard of the uchigatana with the image of Raijin (god of thunder)

◄ Guard of the wakizashi with the image of Fūjin (god of wind)

EPILOGUE

C01

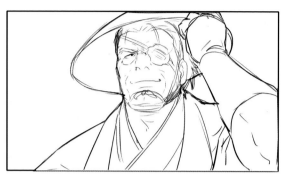

Shizuka Gozen is freed from her demonic affliction, causing evil to withdraw into the shadows once more.

Indeed, the chaos that assailed the Land of the Rising Sun leaves no sign of its presence in the wake of its retreat.

As Jubei welcomes the clear blue skies, his thoughts turn to the report he must deliver on what transpired here.

And so he bids Hanzo farewell and makes his way for Edo.

C02

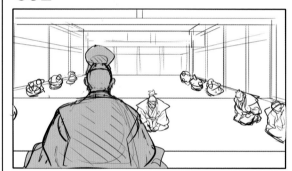

The newly appointed Matsudaira Sadanobu breathes a sigh of relief as he listens to Jubei's report.

Unfortunately, Jubei's account does not end on a positive note.

He warns Matsudaira that the evil responsible for the carnage that befell the land still lingers.

The bakufu's struggle has only just begun.

C03

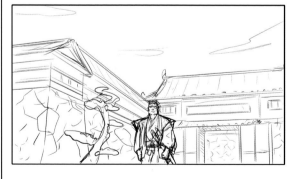
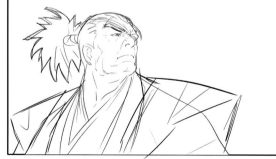

The threat of fire, ruin, and famine is never far away, yet the land is slowly but surely returning to prosperity.

As the sun's rays shine down on Jubei from above, his mind turns to the future.

He vows to never stop fighting so that the land may continue to enjoy its newfound peace.

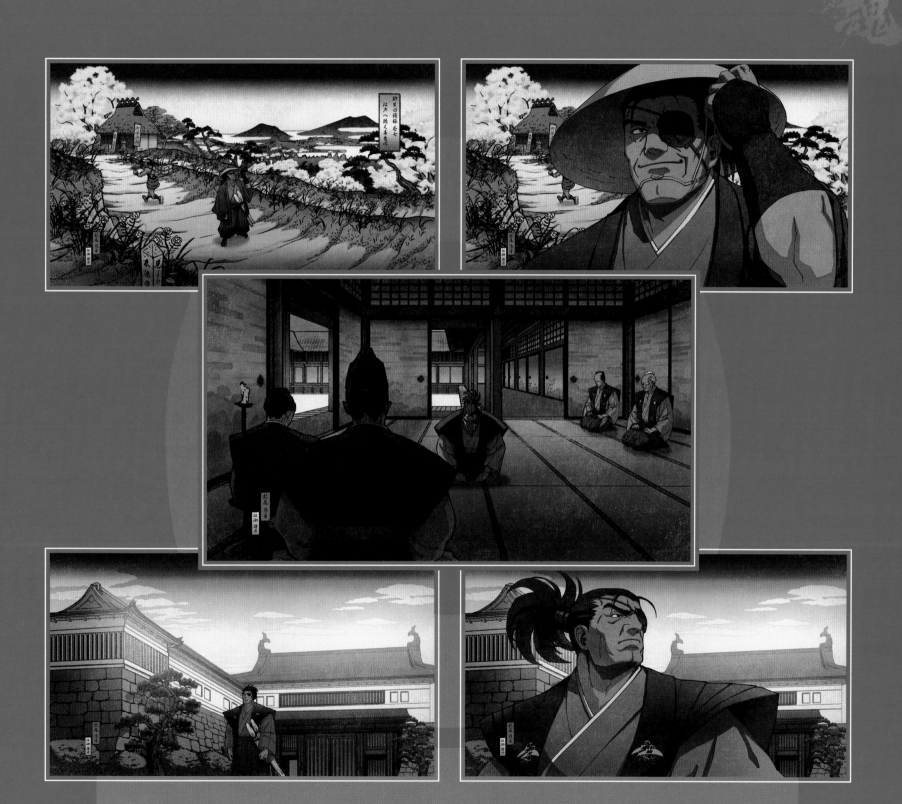

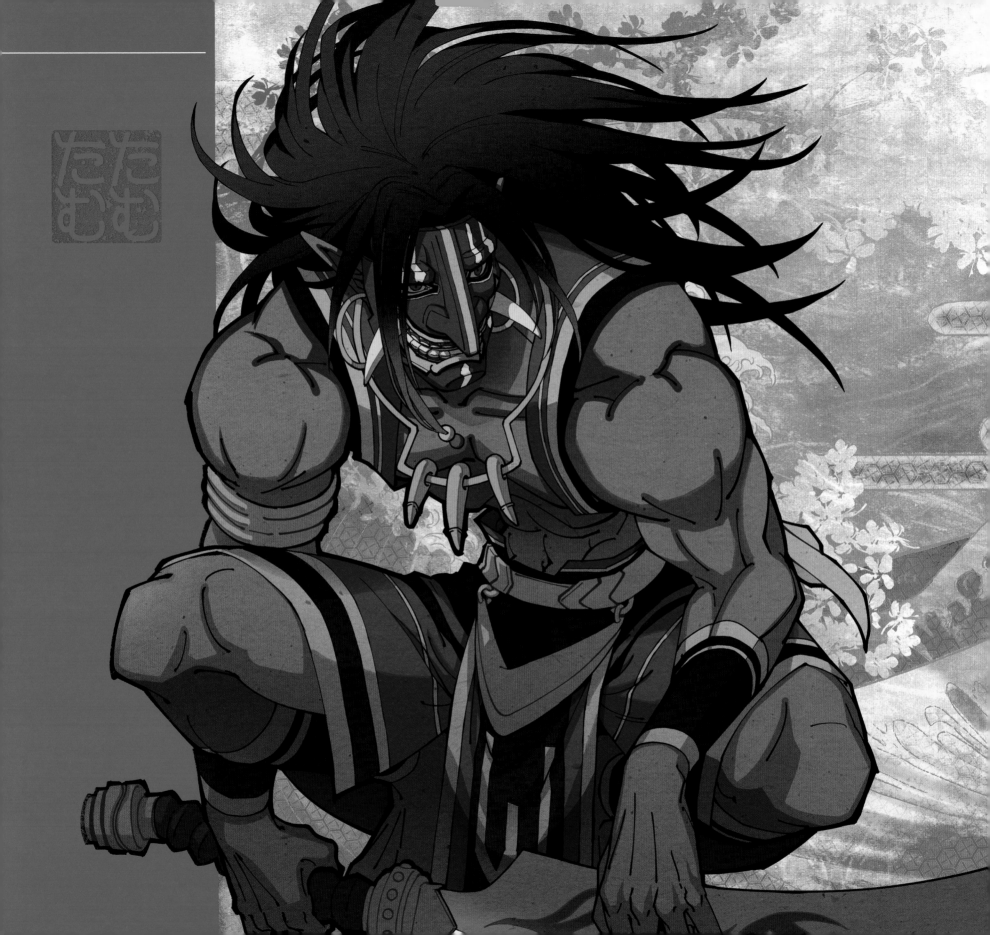

TAM TAM

Voice Actor: Ryosuke Morita

Tam Tam, a warrior hailing from Latin America, is roaming the world in search of a sacred gem stolen from his village when he is alerted to an evil force brewing across the eastern sea.

With an echo so faint that he barely senses its resonance in the air, the Palenke Stone informs him that it is trapped within the heart of the malevolence. With the end of his journey in sight, Tam Tam immediately sets sail for the land across the sea.

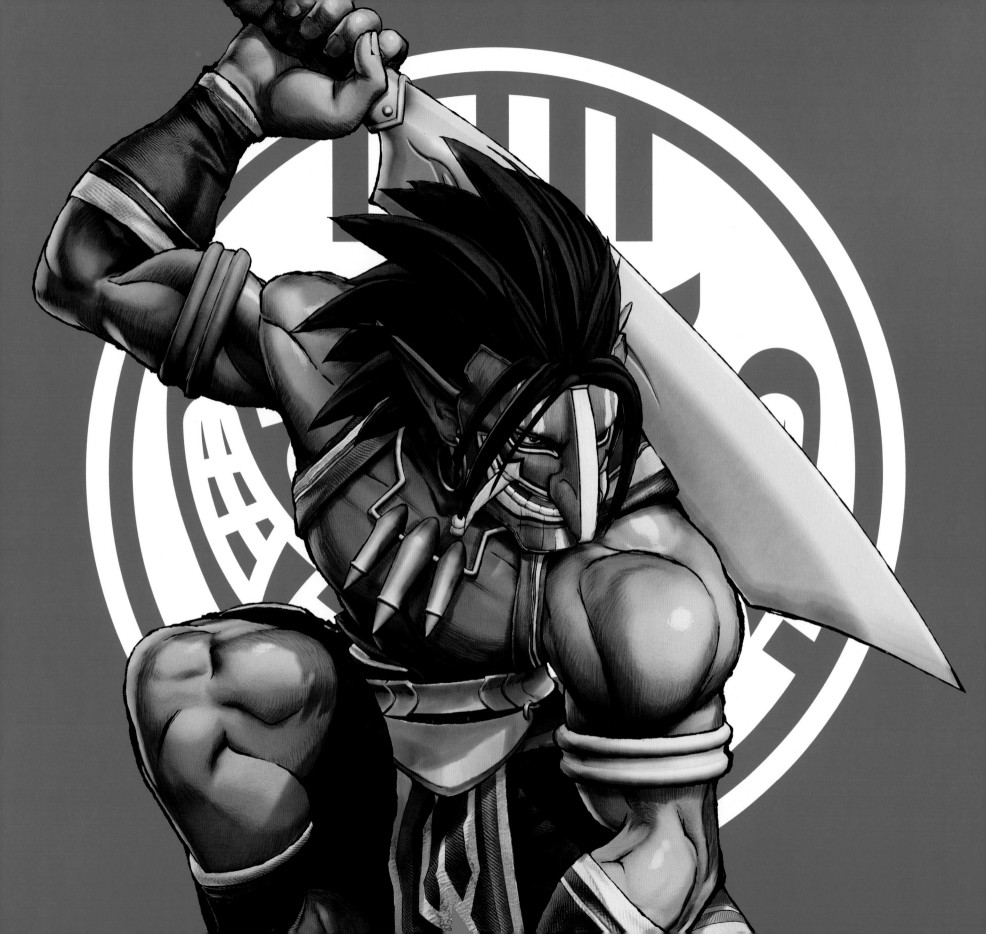

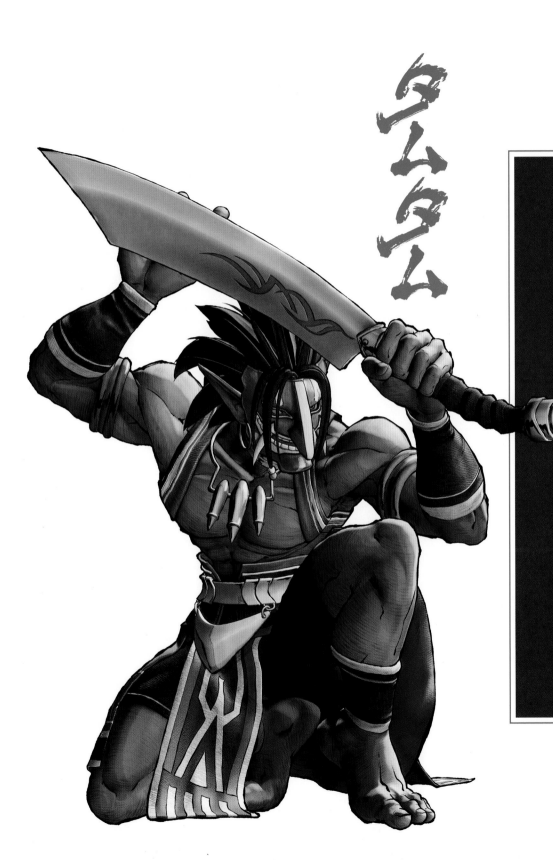

タムタム

TAM TAM

FULL NAME:
Tam Tam

BIRTHDAY:
April 1

BIRTHPLACE:
Green Hell (South America)

BLOOD TYPE:
Maya (N'myawa) Type A

WEAPON:
Mayan scimitar: "Henge Hange Zange"

FIGHTING STYLE:
The Way of the Maya

LIKES:
His sister Cham Cham

DISLIKES:
Kogetsuzan (Haohmaru's famous uppercut)

HOBBIES:
Beating up bad guys

FIRST APPEARANCE:
SAMURAI SHODOWN (1993)

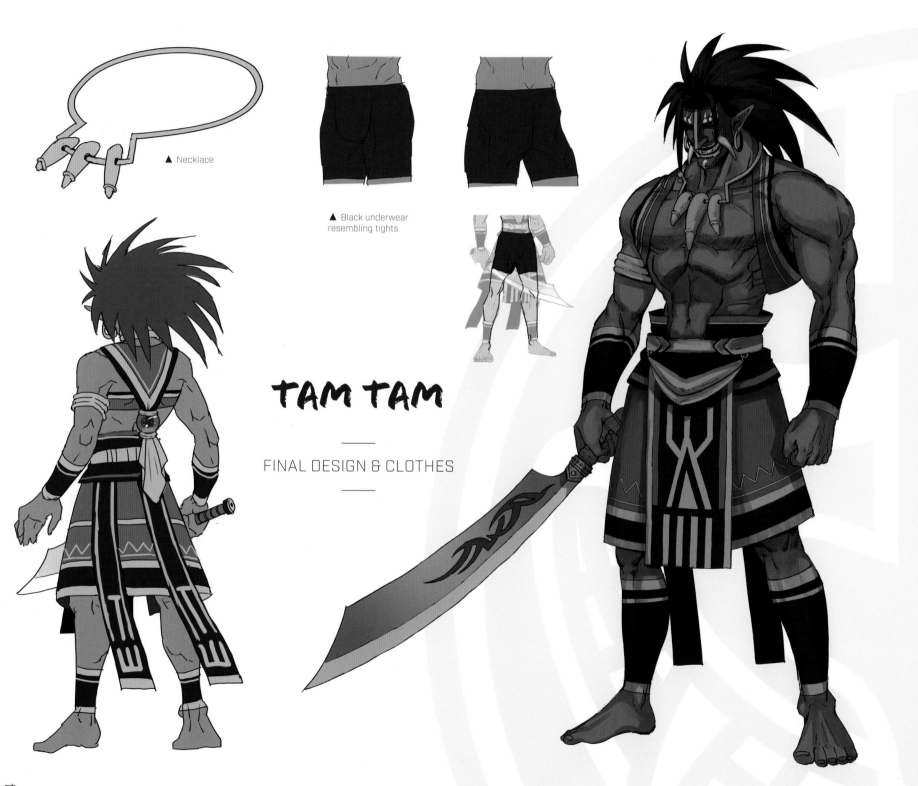

▲ Necklace

▲ Black underwear
resembling tights

TAM TAM

—

FINAL DESIGN & CLOTHES

—

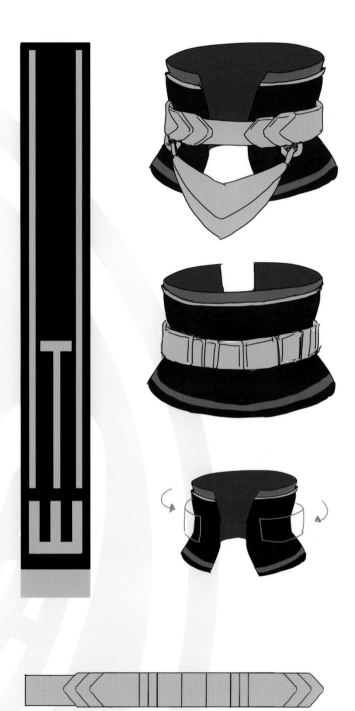

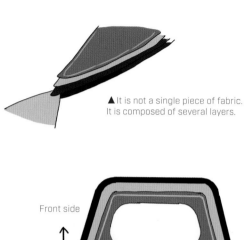

▲ It is not a single piece of fabric.
It is composed of several layers.

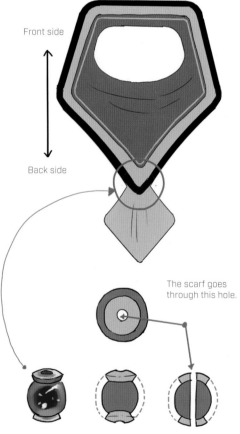

Front side

Back side

The scarf goes
through this hole.

▲ It is not patchwork but a black cloth
with gold and red embroidery.

▲ A metal piece is attached at the top and bottom.

■ MAYAN SCIMITAR

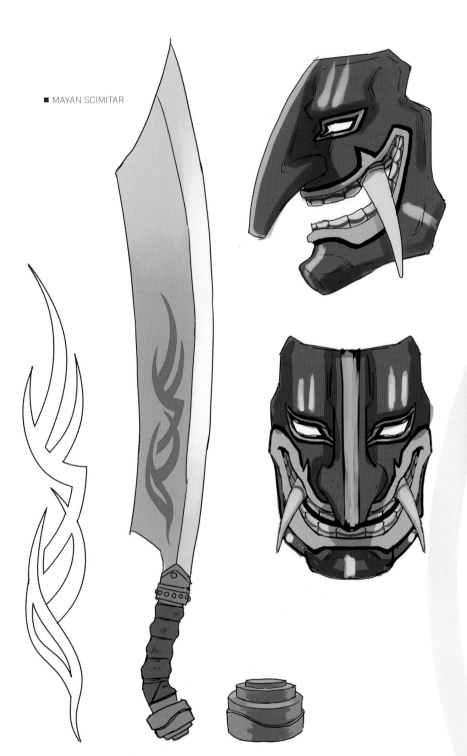

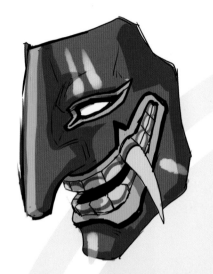

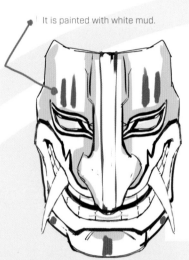

It is painted with white mud.

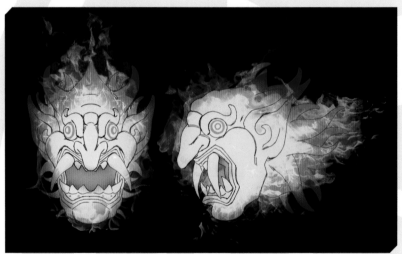

TAM TAM

MASK & WEAPON

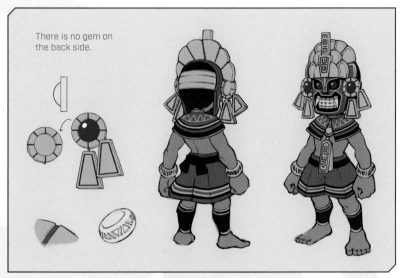

There is no gem on the back side.

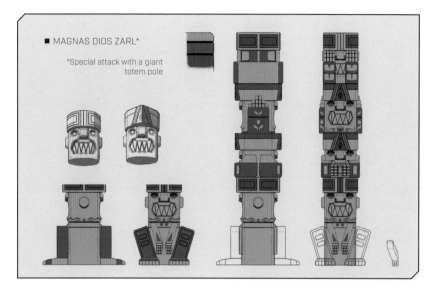

■ MAGNAS DIOS ZARL*

*Special attack with a giant totem pole

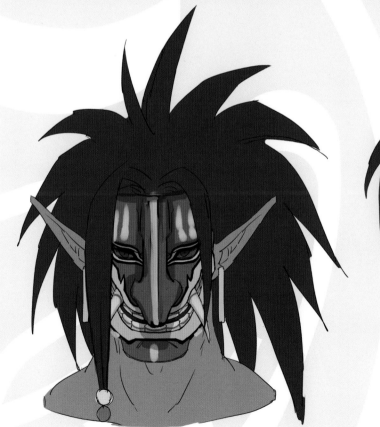

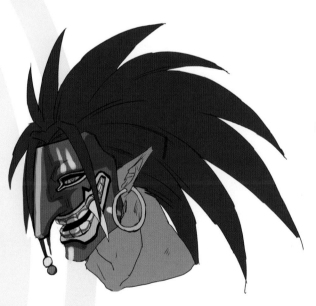

FACE DESIGN & SPECIAL ATTACK

EPILOGUE

TAM TAM

C01

 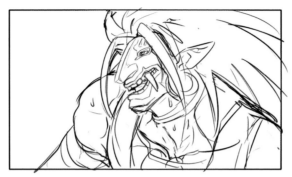

Tam Tam awakens to find himself staring at an unfamiliar sight.

The other world and the purifying light have gone, leaving only a magnificent view of cherry blossom petals.

But for all its beauty, it holds his attention for no more than a fleeting moment as he remembers what he truly desires.

Fumbling through the sea of petals, Tam Tam searches frantically, day and night, for his precious jewel.

But to no avail. The Palenke Stone is nowhere to be found.

C02

He removes his mask with tired fingers and sits in despair under the shade of a tree.

The battle has caused the mask to absorb much of his power, and he has no more energy left.

He wonders whether he'll ever find his village's sacred artifact here on this foreign soil.

But the doubt that seeks to extinguish his resolve soon withdraws, as he turns his mind to his beloved home.

C03

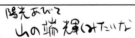

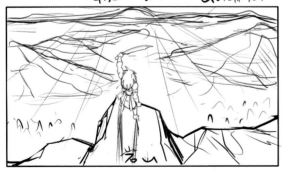

His people will continue to suffer as long as their cherished stone remains lost.

The sacred warrior Tam Tam is his village's last hope.

And so he stands once more, determined to protect that which is dearest to him.

He will find the Palenke Stone, and he will return peace and prosperity to his village.

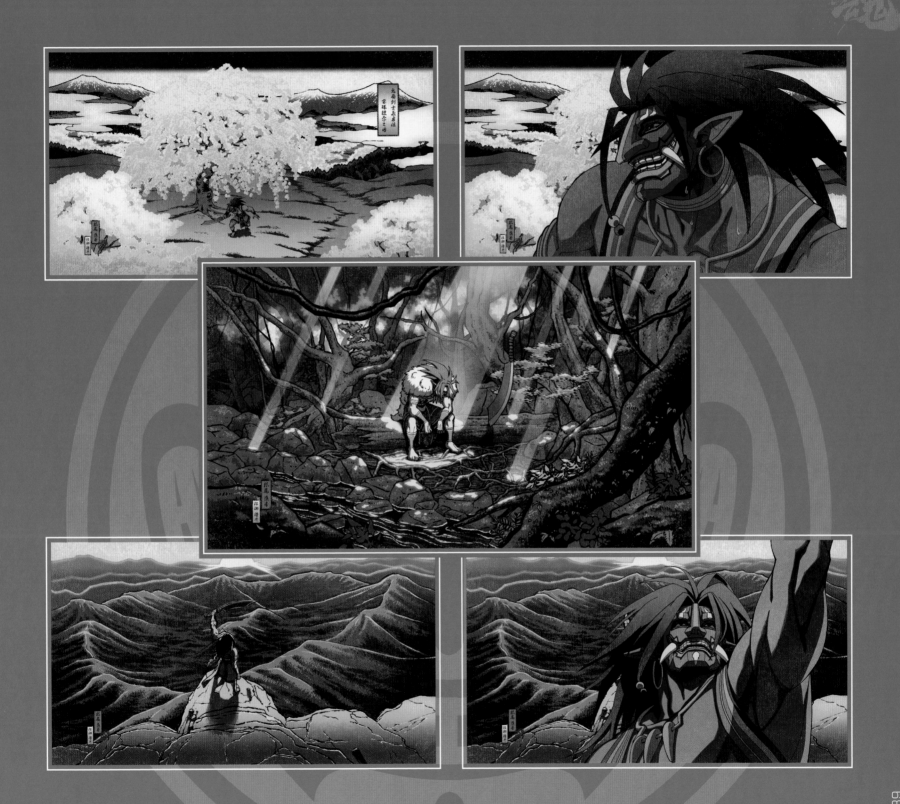

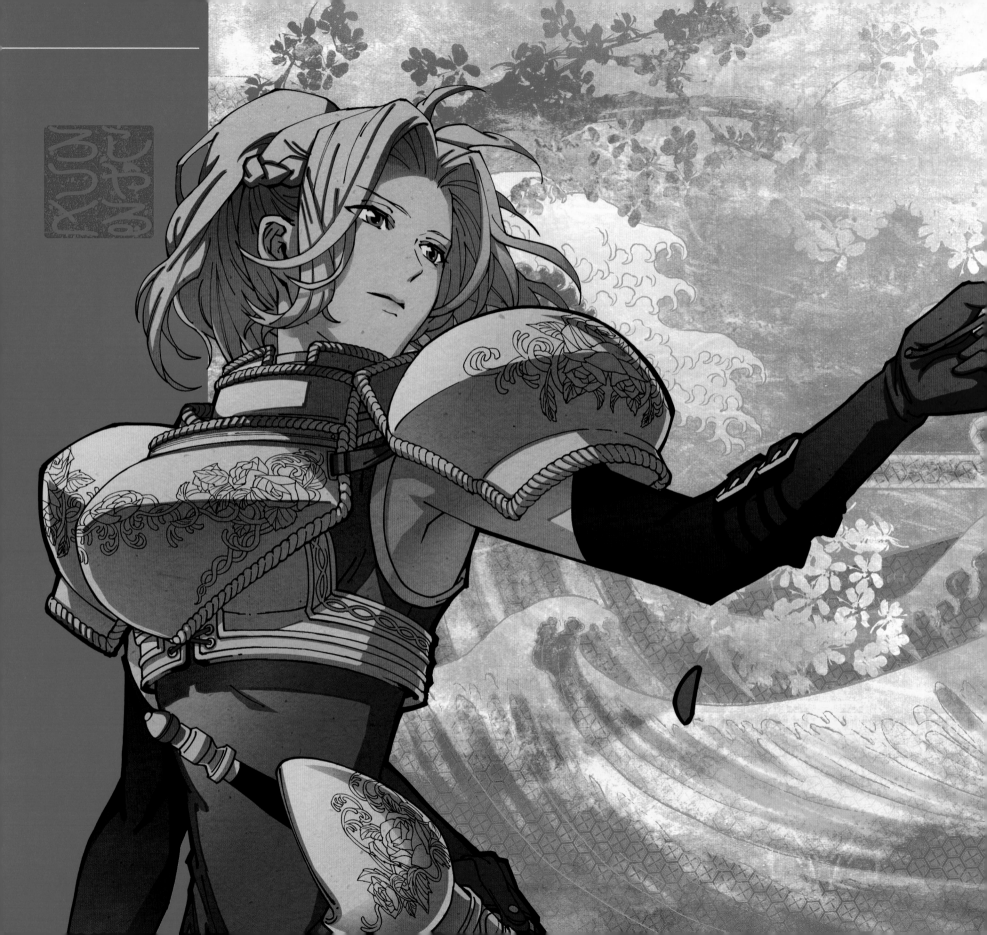

CHARLOTTE

Voice Actor: Afumi Hashi

Having survived the chaos in Japan, Charlotte is returning to her troubled homeland of France when she hears that Japan has once again become paralyzed by the blight of evil.

Charlotte believes that the cause of the disturbance in both lands is one and the same, and decides to return to Japan once more in order to bring peace to the benighted countries.

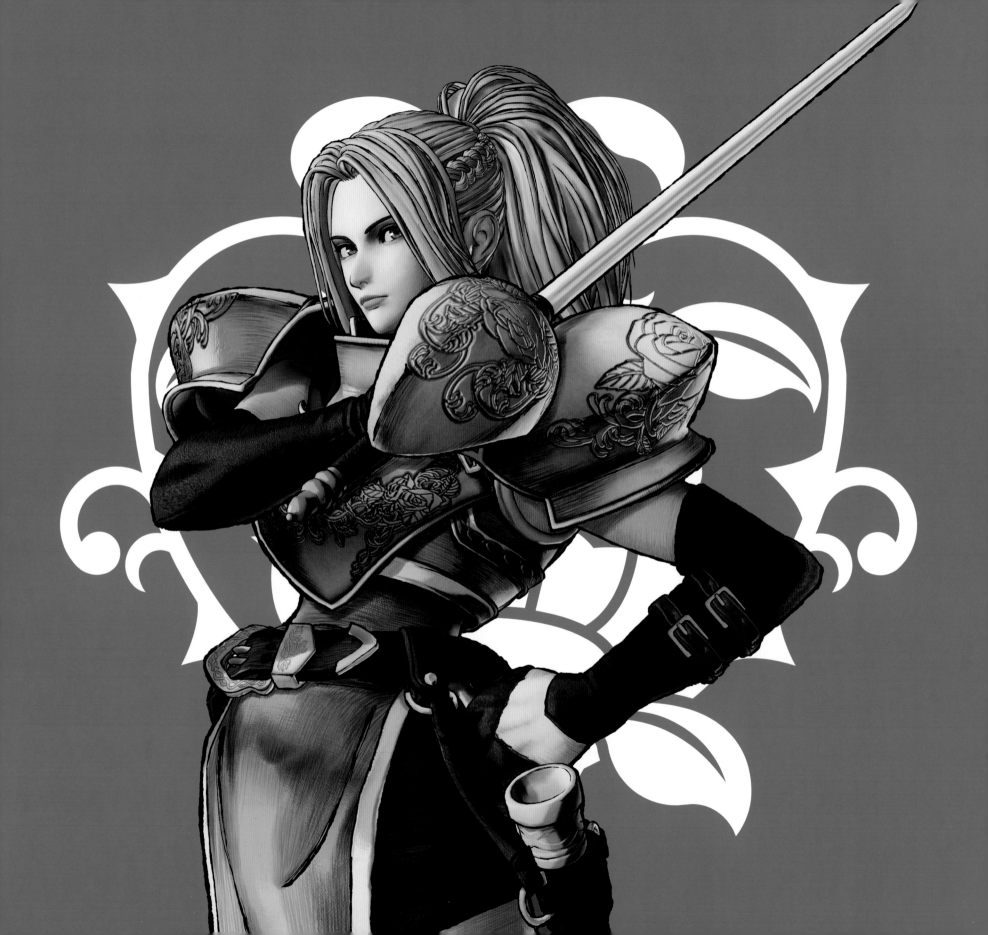

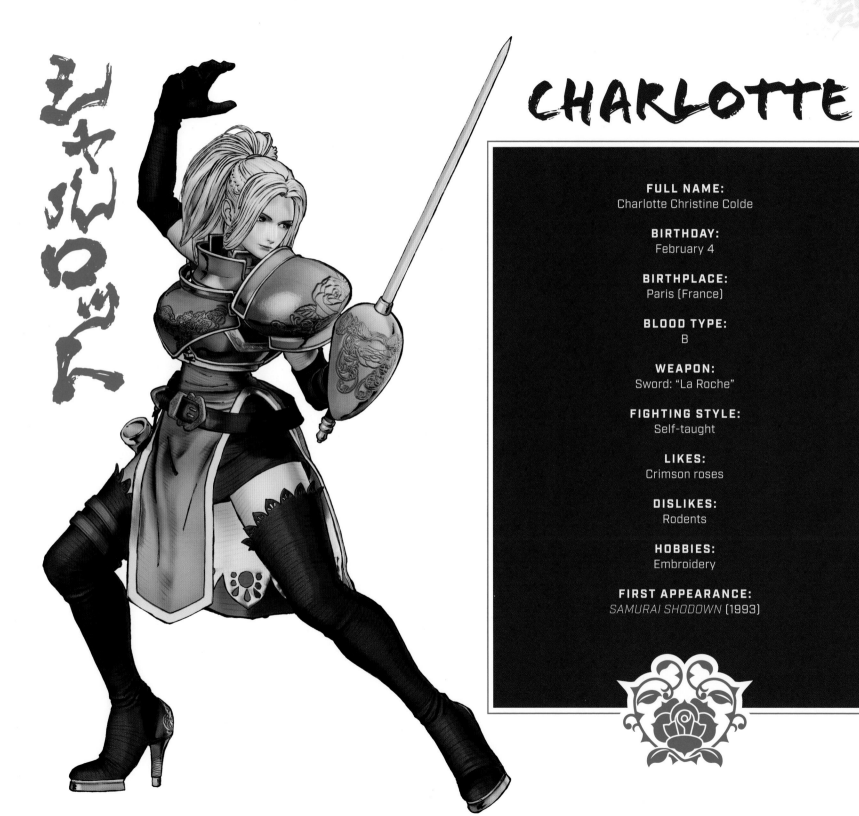

CHARLOTTE

FULL NAME:
Charlotte Christine Colde

BIRTHDAY:
February 4

BIRTHPLACE:
Paris (France)

BLOOD TYPE:
B

WEAPON:
Sword: "La Roche"

FIGHTING STYLE:
Self-taught

LIKES:
Crimson roses

DISLIKES:
Rodents

HOBBIES:
Embroidery

FIRST APPEARANCE:
SAMURAI SHODOWN (1993)

CHARLOTTE C. COLDE

DRAFTS & FINAL DESIGN

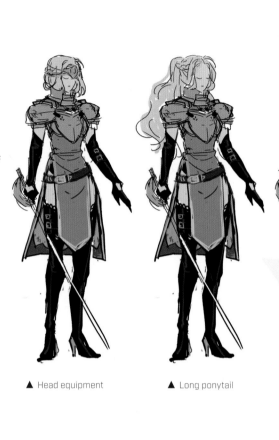

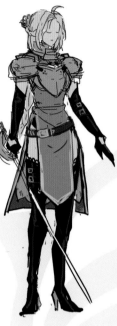

▲ Head equipment

▲ Long ponytail

▲ Long braid

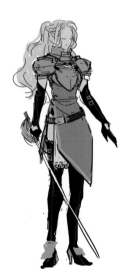

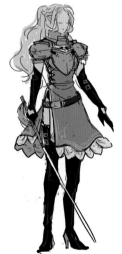

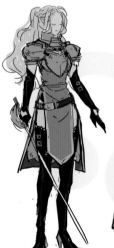

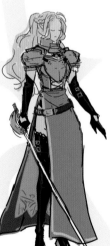

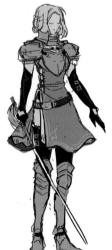

▲ Diagonal cut

▲ Short inner lace

▲ Short

▲ Midlength

▲ Long

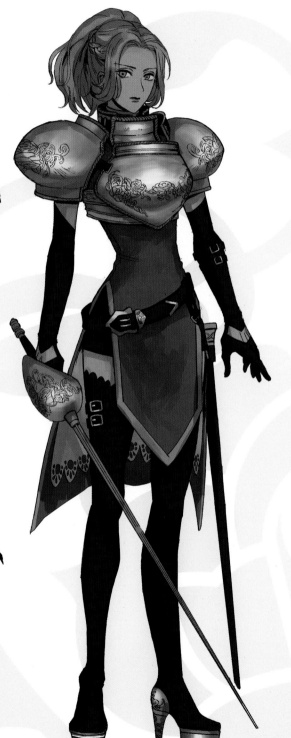

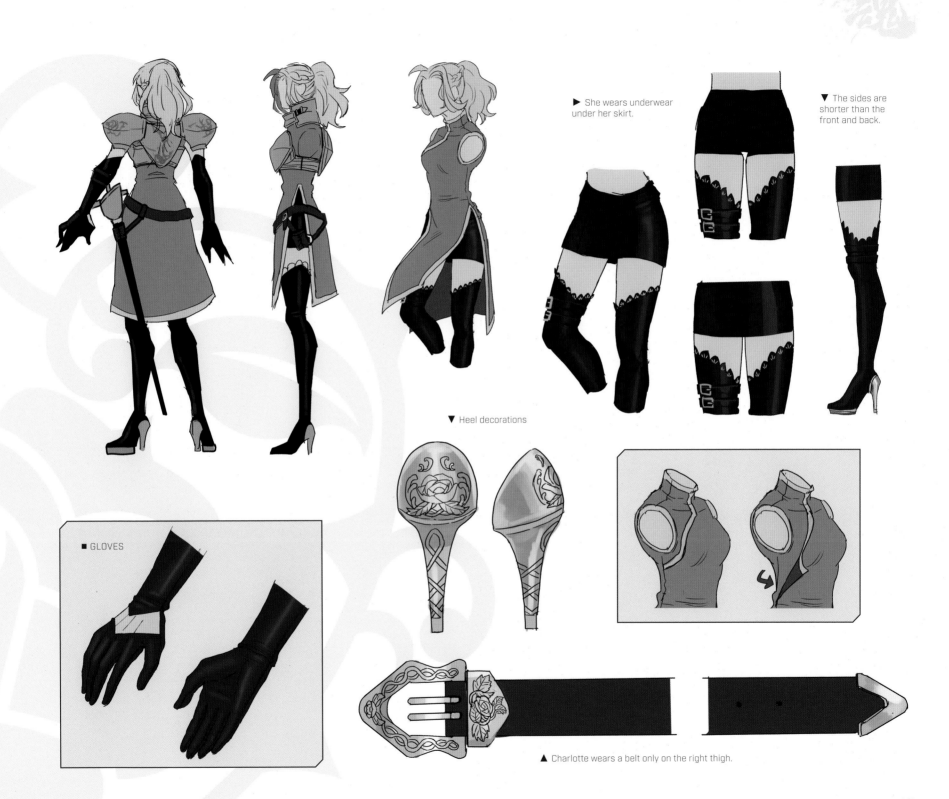

▶ She wears underwear under her skirt.

▼ The sides are shorter than the front and back.

▼ Heel decorations

■ GLOVES

▲ Charlotte wears a belt only on the right thigh.

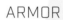

▲ Strapless bra

CHARLOTTE

ARMOR

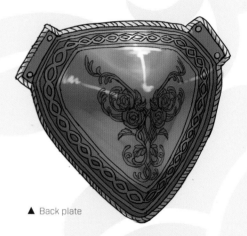

▲ Back plate

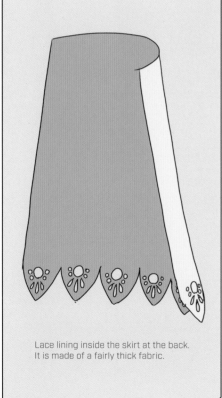

Lace lining inside the skirt at the back.
It is made of a fairly thick fabric.

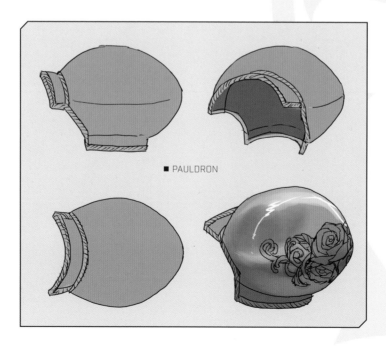

■ PAULDRON

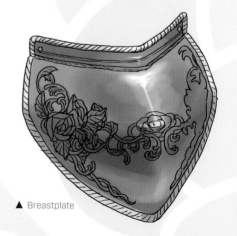

▲ Breastplate

FACE DESIGN & WEAPON

▶ Rapier guard

■ RAPIER

■ SWORD BELT
HARNESS

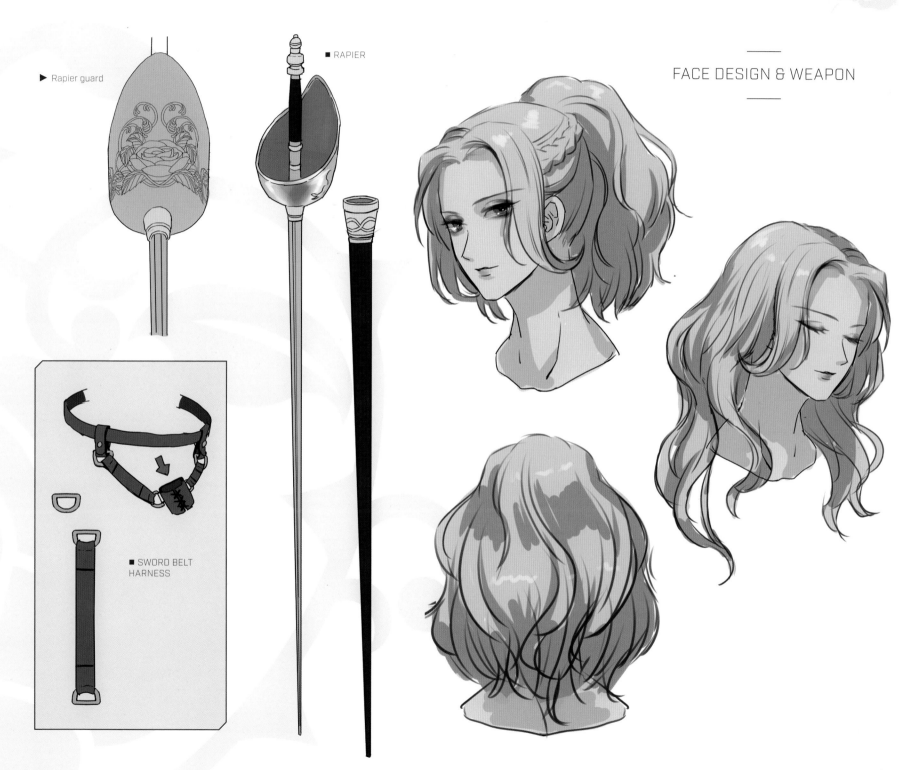

EPILOGUE

CHARLOTTE C. COLDE

C01

As the dark clouds give way to clear blue sky, the earth below is covered in a pure blanket of cherry blossoms.

Yet even the exorcism of the evil that possessed Shizuka Gozen is not enough to dispel the sense of unease with which Charlotte welcomes this victorious sight.

For there is a country still caught in the throes of evil—her beloved motherland, France.

Though Shizuka Gozen's path of destruction was almighty, Charlotte knows the source of her power lay elsewhere.

C02

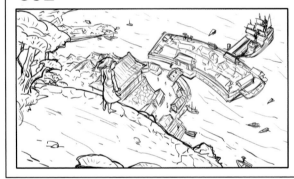

・船の特徴を
合わせる

・サンバシのスケール
合わせる

A month after her battle with Shizuka Gozen, Charlotte finally receives word on the current state of France.

It is as she had feared . . . The country is paralyzed by chaos and confusion.

Vowing to continue the fight, Charlotte clenches her fist with steely determination.

C03

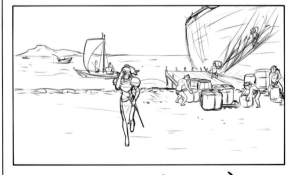

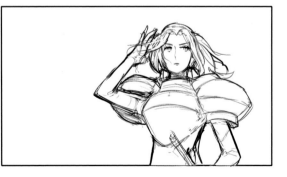

ガル 流用 (船 改造)

The white dove shall take flight in the skies once more.

Charlotte watches in silence as the fleet sets sail for her homeland.

But she does not allow her yearning for home to linger long. The journey ahead requires firm resolve.

For to find success, she must pierce the heart of the darkness that still lurks within the shadows . . .

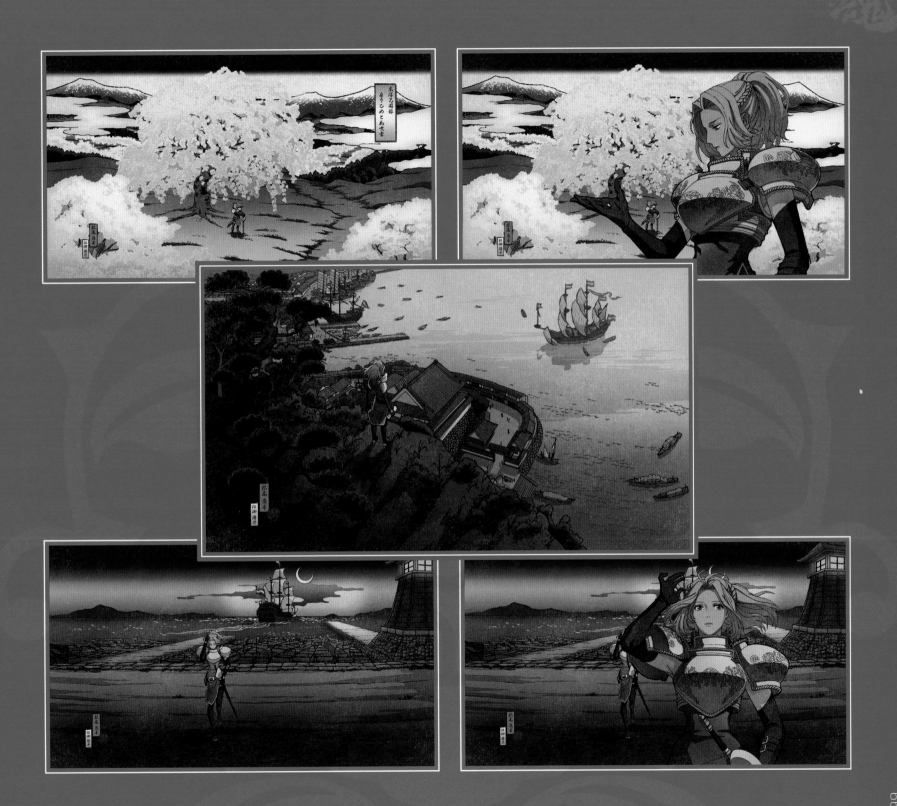

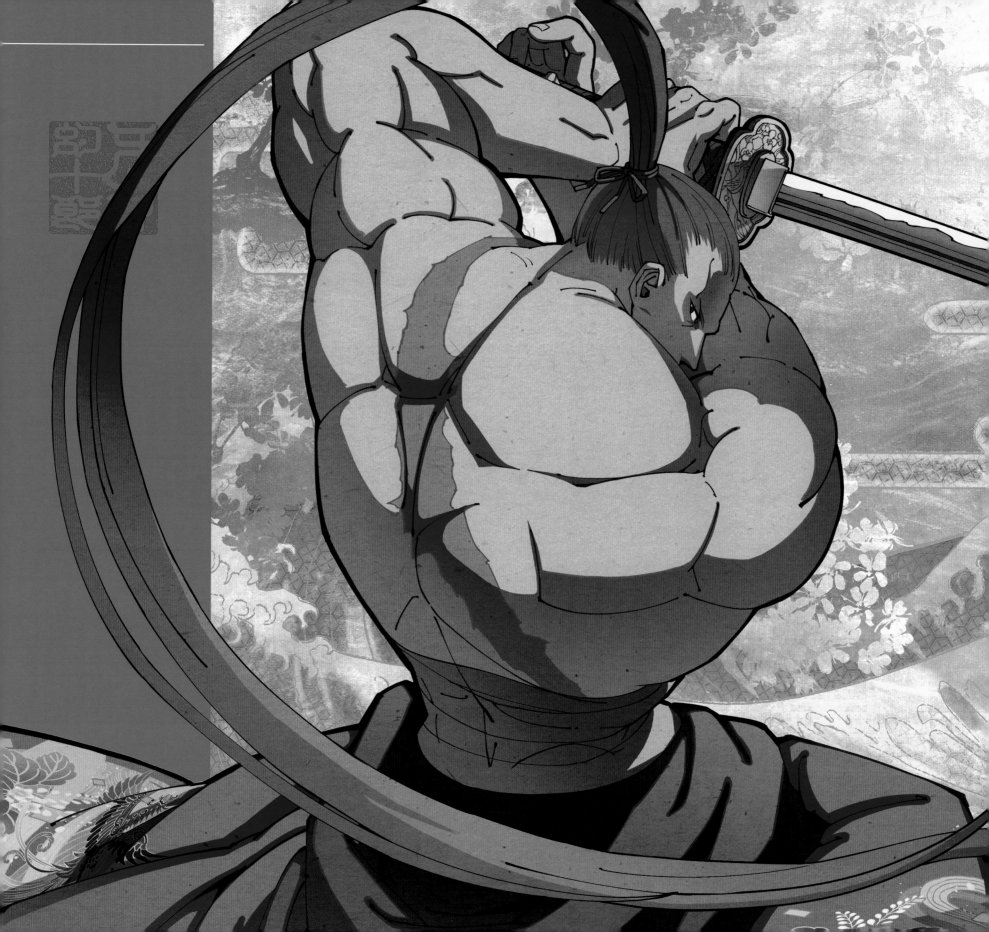

GENJURO

Voice Actor: Kong Kuwata

Unaffected by the calamity afflicting the land, Genjuro Kibagami whiles away the time by playing dice and indulging his various other vices. One man, however, takes exception to one of Genjuro's lucky streaks and reaches for his sword.

To those watching, it happens in the mere blink of an eye. Genjuro draws his sword and showers the other patrons in a torrent of the poor man's blood. Leaving the den of dice, he decides to journey wherever the wind may take him.

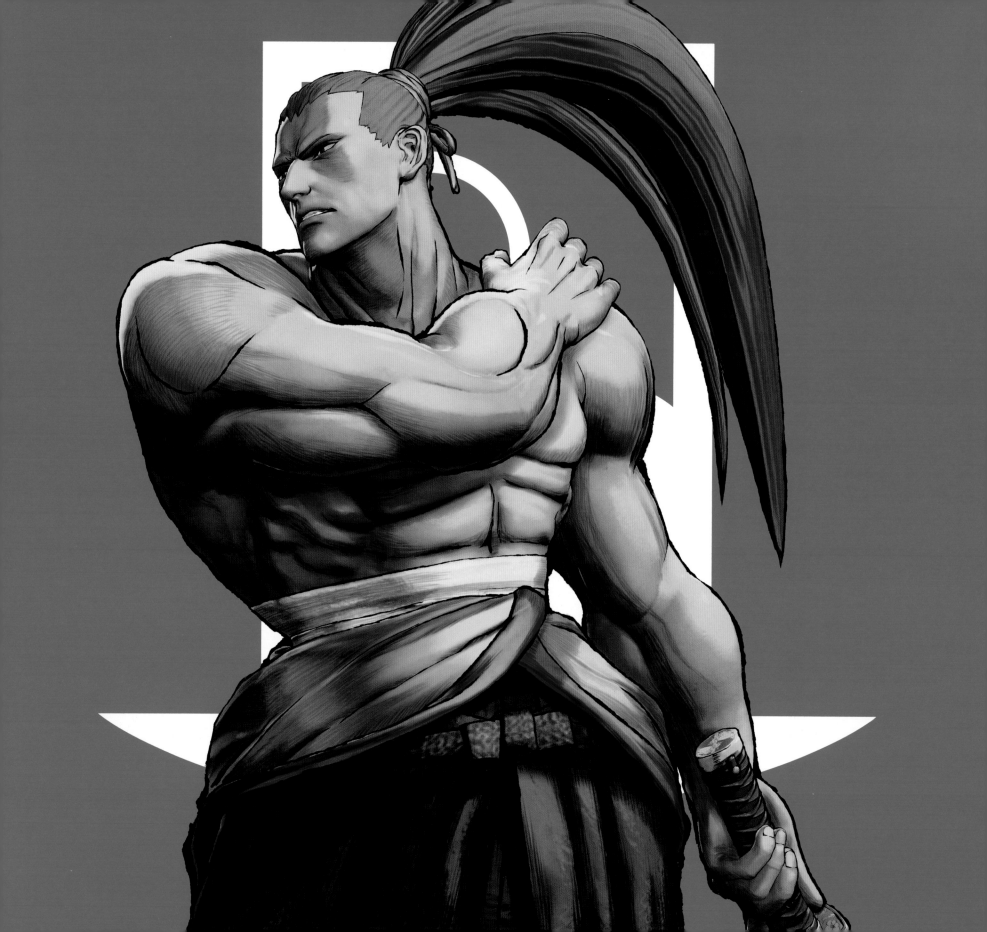

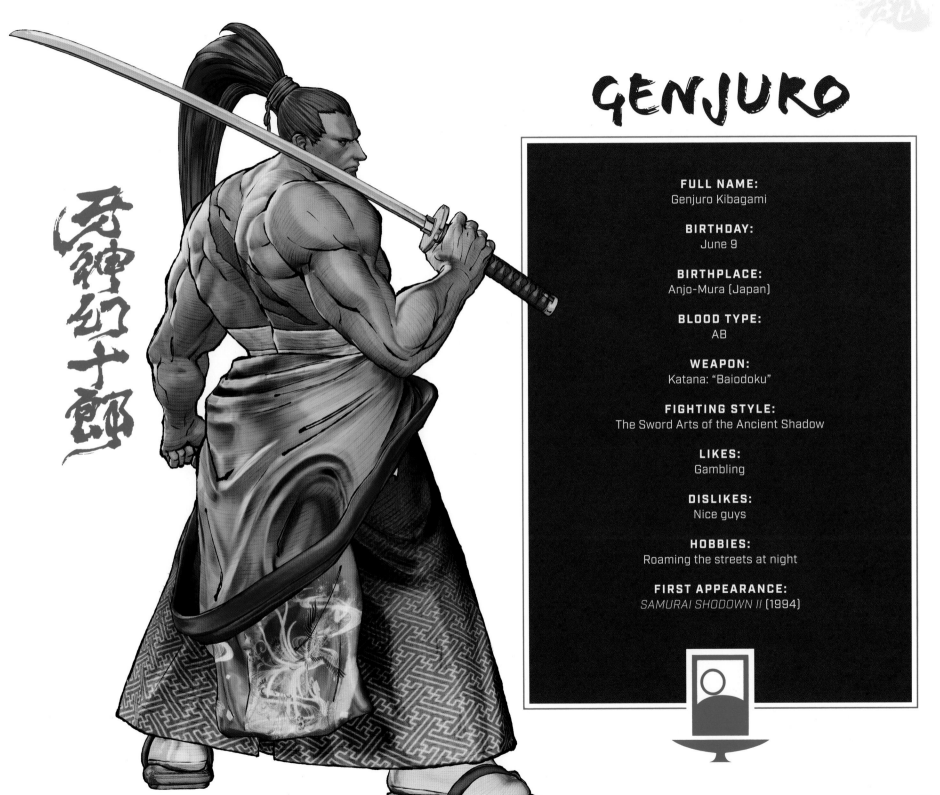

GENJURO

FULL NAME:
Genjuro Kibagami

BIRTHDAY:
June 9

BIRTHPLACE:
Anjo-Mura (Japan)

BLOOD TYPE:
AB

WEAPON:
Katana: "Baiodoku"

FIGHTING STYLE:
The Sword Arts of the Ancient Shadow

LIKES:
Gambling

DISLIKES:
Nice guys

HOBBIES:
Roaming the streets at night

FIRST APPEARANCE:
SAMURAI SHODOWN II (1994)

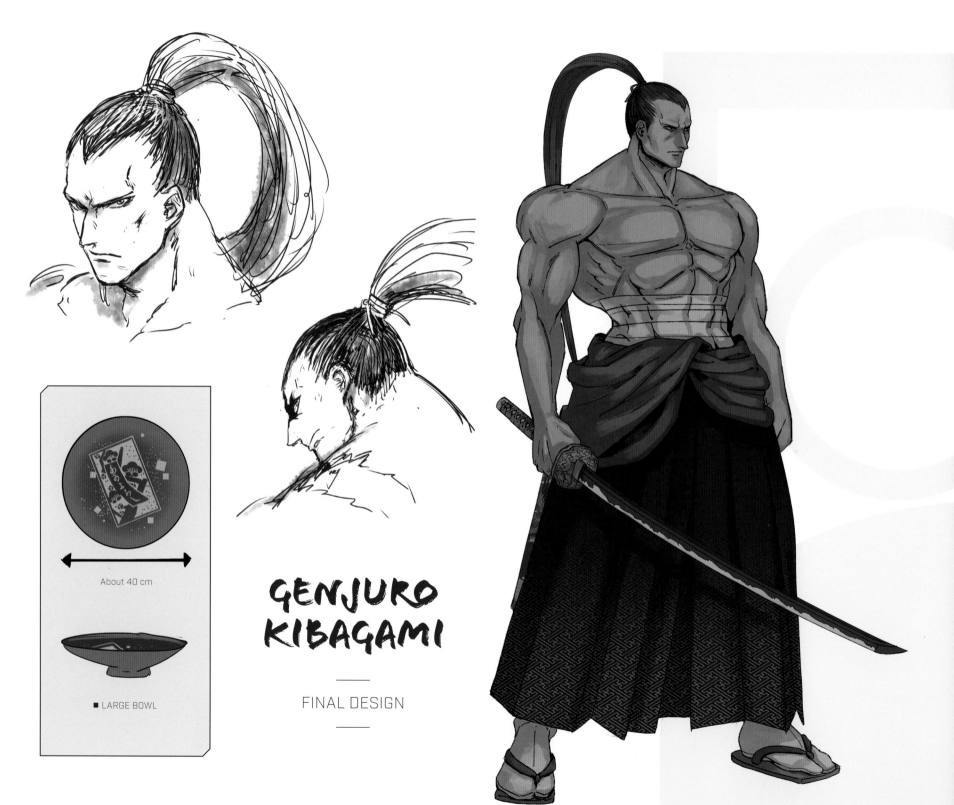

About 40 cm

■ LARGE BOWL

GENJURO KIBAGAMI

FINAL DESIGN

DRAFTS

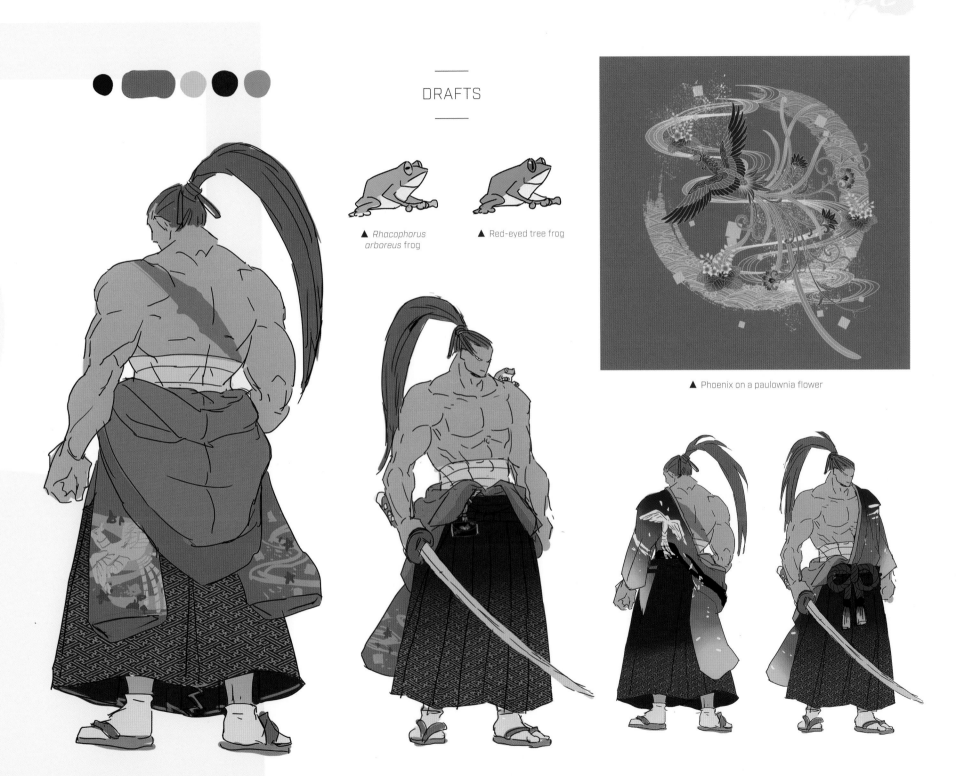

▲ *Rhacophorus arboreus* frog

▲ Red-eyed tree frog

▲ Phoenix on a paulownia flower

▼ Wild boar on a background of Japanese clover (shrub forming a bush with fairly soft stems covered with deciduous leaves)

■ CIGARETTE HOLDER

◄ Circle of Japanese clover

▼ Deer on a background of autumn leaves

Hole

■ KISERU*

*Traditional Japanese pipe

▼ Crane on a pine branch design

There is a raised pattern on the metal piece (there is no color).

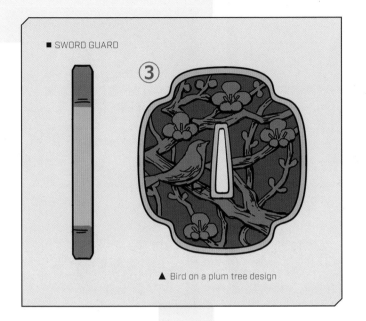

■ SWORD GUARD

③

▲ Bird on a plum tree design

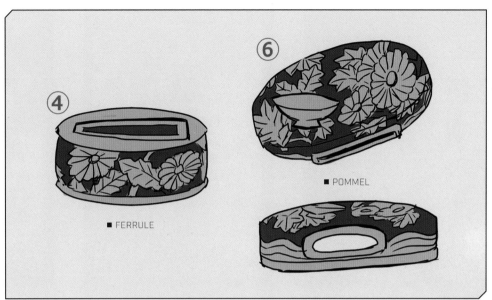

④

■ FERRULE

⑥

■ POMMEL

GENJURO KIBAGAMI

WEAPON

⑤

▲ Ornament: butterfly on peony flower

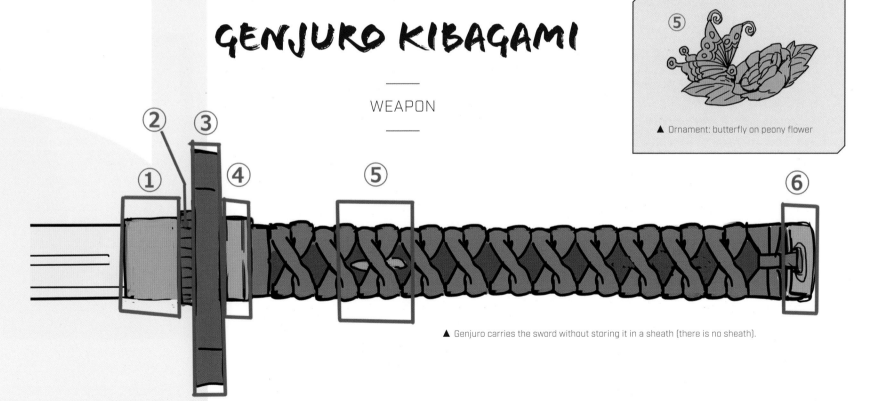

② ③ ① ④ ⑤ ⑥

▲ Genjuro carries the sword without storing it in a sheath (there is no sheath).

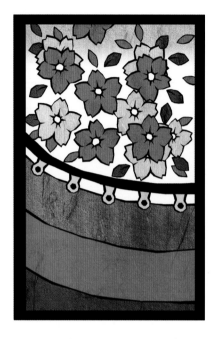

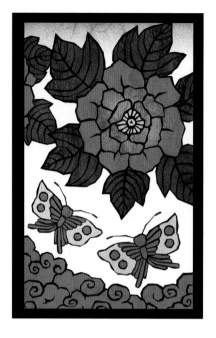

GENJURO KIBAGAMI

HANAFUDA CARDS

▶ The fifteen hanafuda* cards corresponding to Genjuro's special moves.

*Traditional Japanese card game

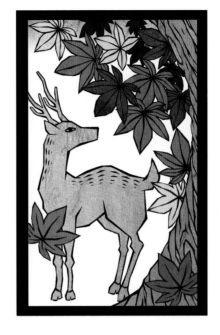

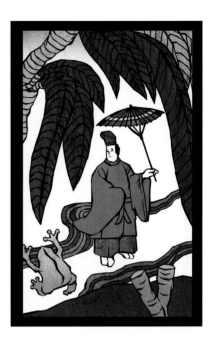

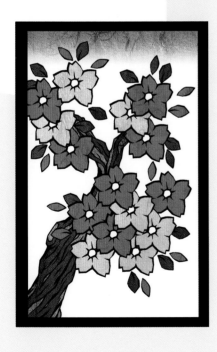

EPILOGUE

GENJURO KIBAGAMI

C01

Several months have passed since Shizuka Gozen was defeated.

And as with most of Genjuro's journeys, he finds himself back in the same old den of dice.

For what better way to stave off boredom than to gamble?

Just as on the night this all began, once again he whiles away the time with his vice of preference.

C02

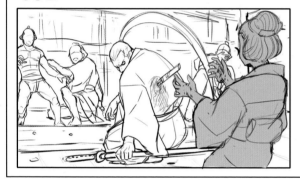

That is, until a sudden sharp pain begins to spread throughout his back.

He slowly turns around and finds the pallid white face of a girl, staring him down.

Instinctively he places his hand upon his sword.

Powerless, Genjuro watches as the girl takes a seat at the table while he stumbles outside.

C03

Soon enough, the moon takes its leave, and the darkened clouds and gloomy winds surrender to clearer skies.

The sounds of dripping blood ring out in the still night as the earth turns a sticky crimson.

Barely conscious as he struggles to control the delirious pain, Genjuro sees the figure of a man flash before his eyes.

Haohmaru . . . He will never know peace until Haohmaru is dead . . .

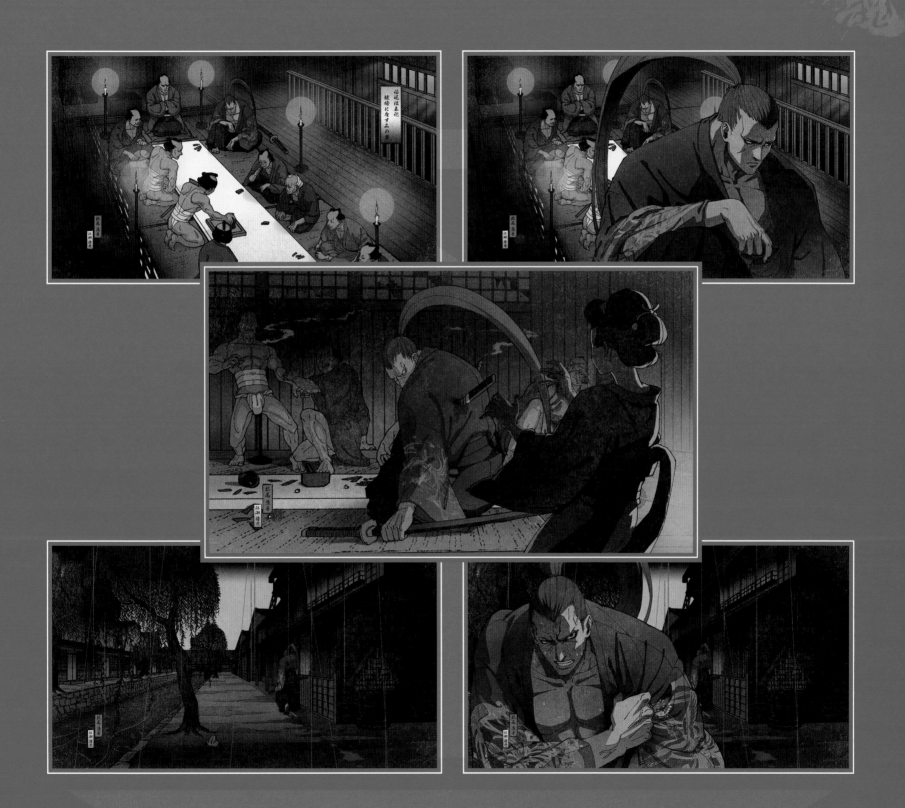

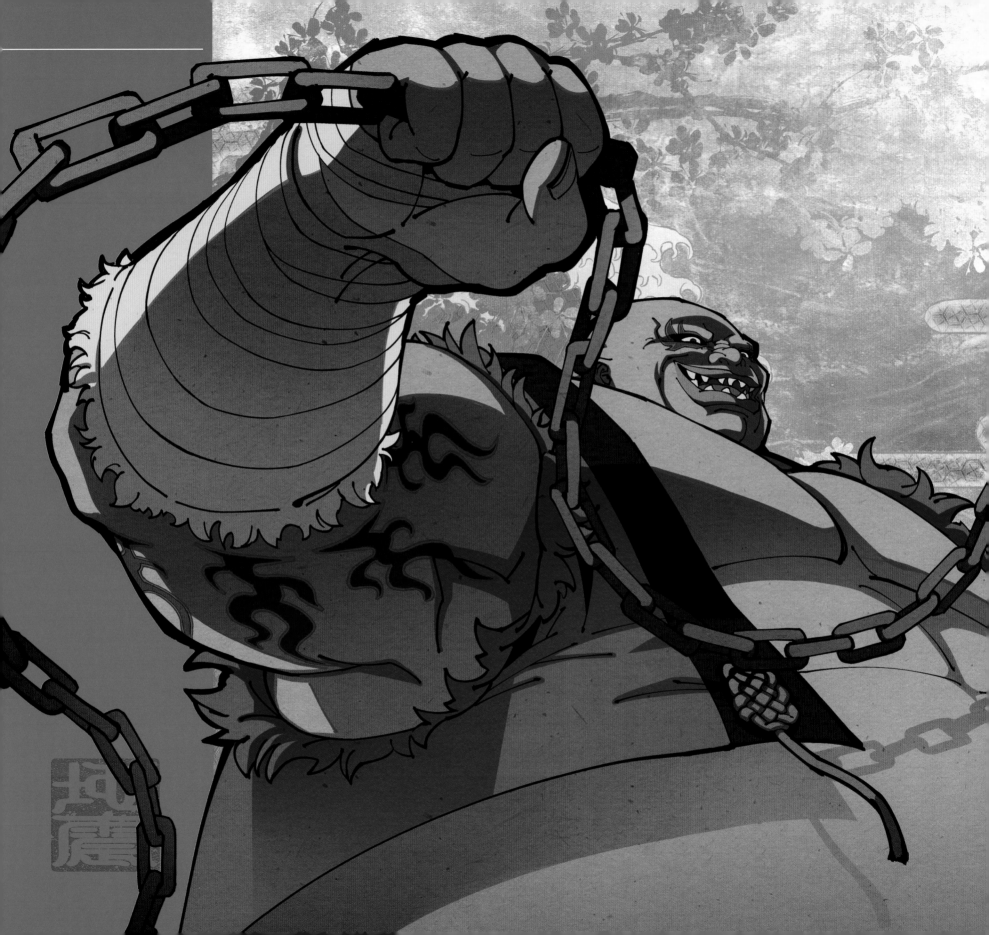

EARTHQUAKE

Voice Actor: Kentaro Tone

Word of the scourge befalling Japan quickly makes its way overseas. However, only one man greets the news with a sense of delight—nefarious delight.

The infamous bandit Earthquake knows the land holds treasures prime for plunder. And so with underlings in tow, he eagerly journeys forth into the darkness.

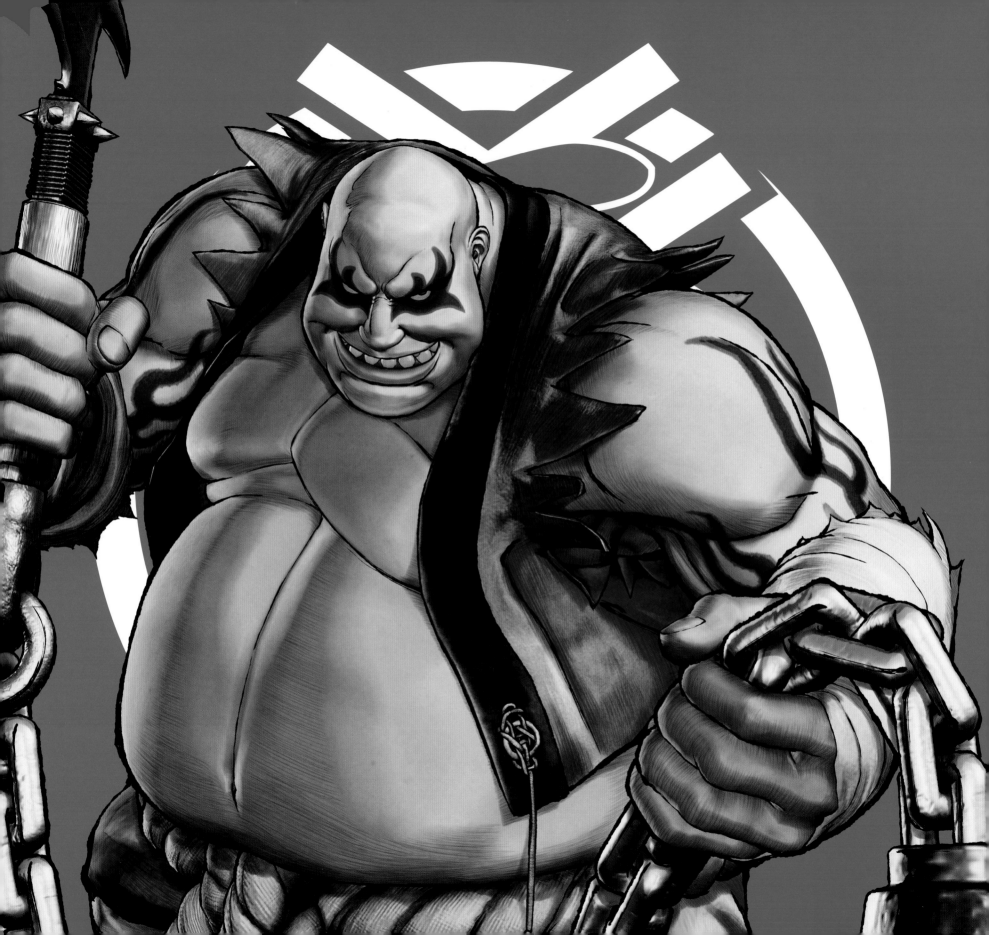

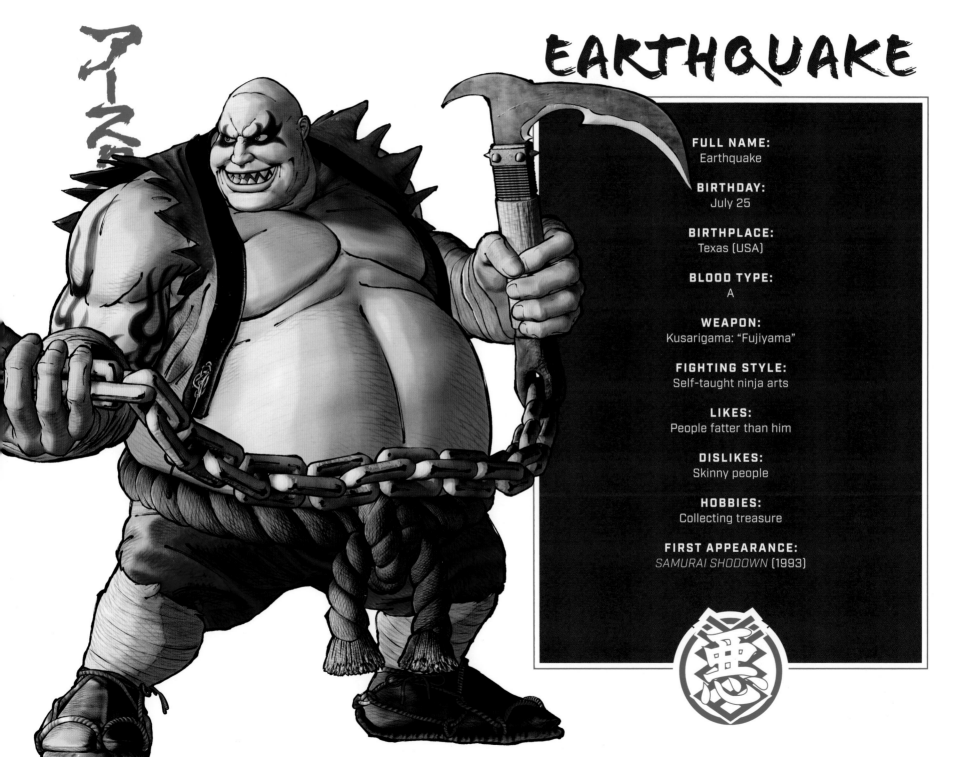

EARTHQUAKE

FULL NAME:
Earthquake

BIRTHDAY:
July 25

BIRTHPLACE:
Texas (USA)

BLOOD TYPE:
A

WEAPON:
Kusarigama: "Fujiyama"

FIGHTING STYLE:
Self-taught ninja arts

LIKES:
People fatter than him

DISLIKES:
Skinny people

HOBBIES:
Collecting treasure

FIRST APPEARANCE:
SAMURAI SHODOWN (1993)

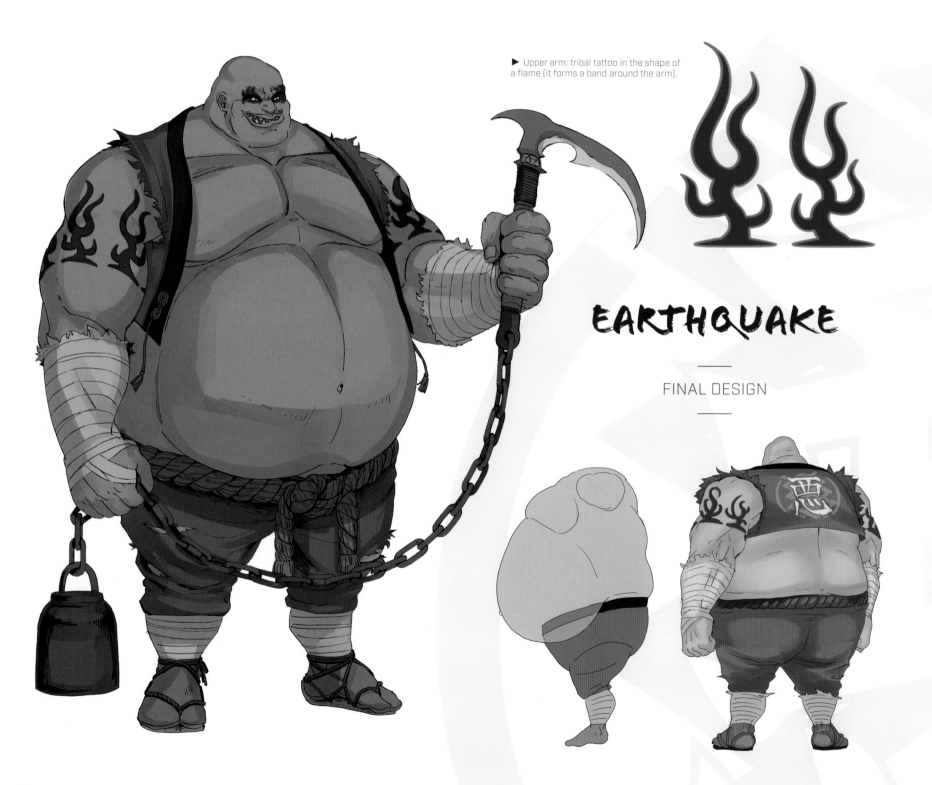

▶ Upper arm: tribal tattoo in the shape of a flame (it forms a band around the arm).

EARTHQUAKE

FINAL DESIGN

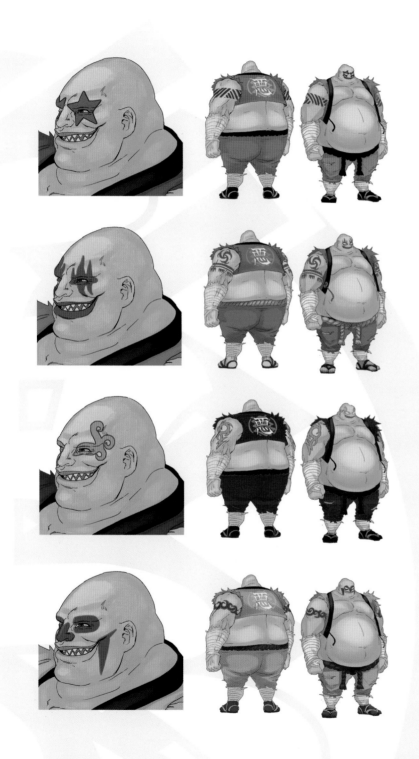

DESIGN VARIATIONS

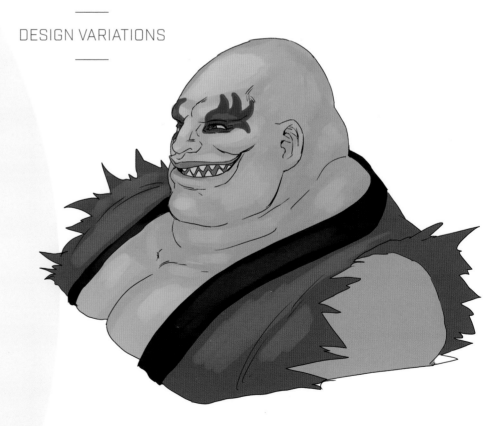

▼ The armhole is damaged and threads hang out.

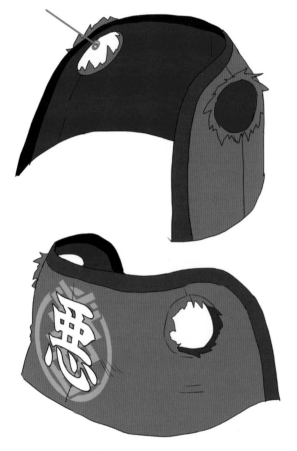

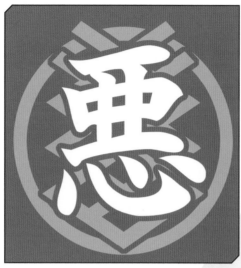

▲ Kanji written on the back of Earthquake's jacket means "evil."

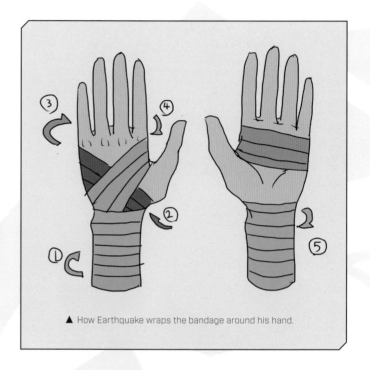

▲ How Earthquake wraps the bandage around his hand.

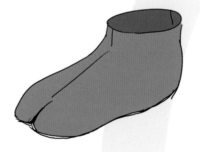

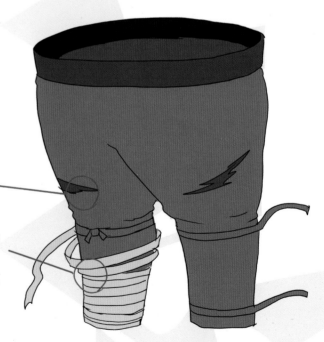

Random tears

A damaged bandage is wrapped around his kyahan.*

*Shin guards made of canvas

EARTHQUAKE

—

CLOTHES

—

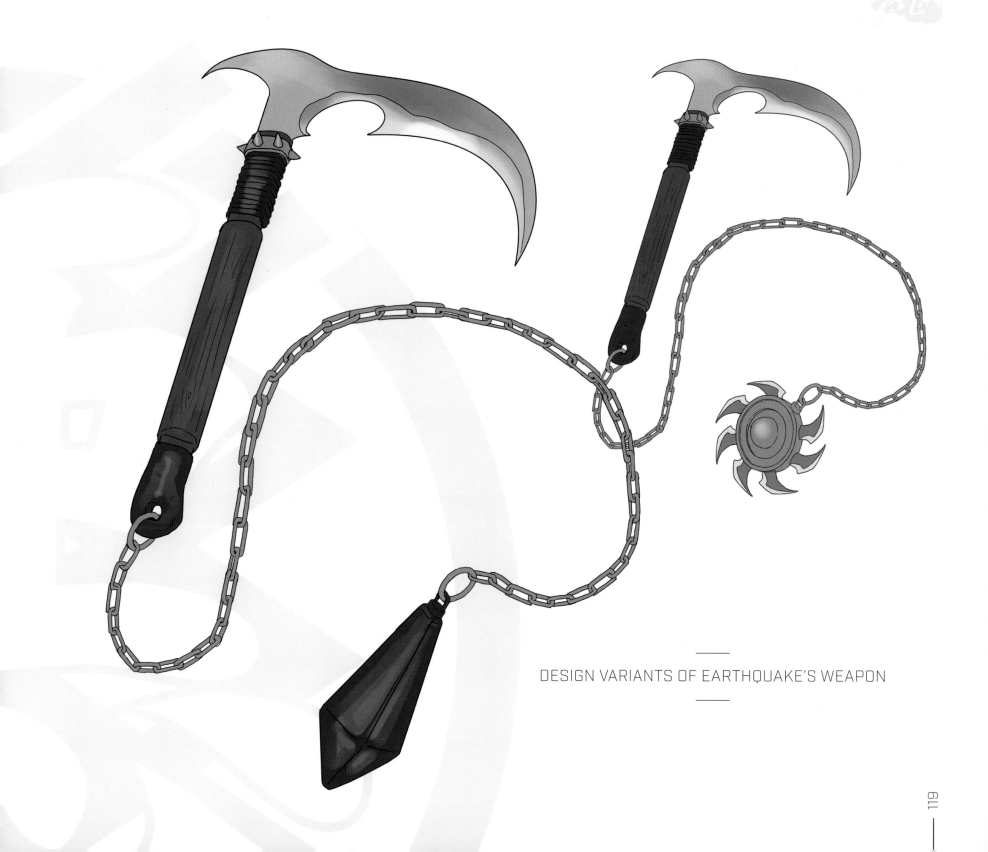

DESIGN VARIANTS OF EARTHQUAKE'S WEAPON

EPILOGUE

C01

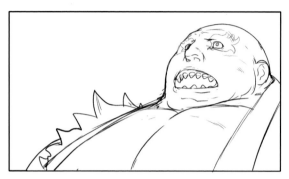

Earthquake can't believe his eyes.

He only blinked for a moment to shield his eyes from the flash of light, yet it was as if that otherworldly place never existed.

All he can see is the sheer beauty of the flower petals drifting to the ground.

Was that fight all a dream, or was it actually real?

As he doubts his own eyes and mind, he struggles to accept the events he experienced just moments ago.

C02

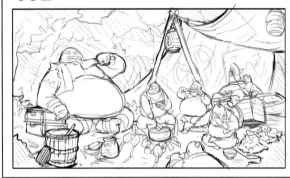

・4両箱とイスがかりにしてたり。

Later that night, in an effort to put it all behind him, he and his crew take stock of their newfound treasure trove.

There is nothing like gold, silver, and a full belly to take a bandit's mind off his troubles.

"Say, boss. What treasures will we seek next?"

So ask his eager band of now fat and merry men, as Earthquake's mind is still pondering their recent victory.

C03

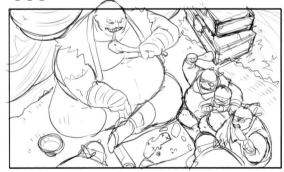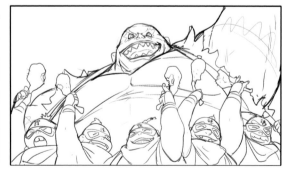

"This island nation of Japan is still ripe for the plunder.

"As long as there's treasure to be found, our lust for loot will never be satisfied!"

The eyes of Earthquake's men glitter like gold as he speaks.

And so they set their sights on plotting their next heist.

They have traveled the world in search of treasure, but for now, they will remain in Japan for a while longer.

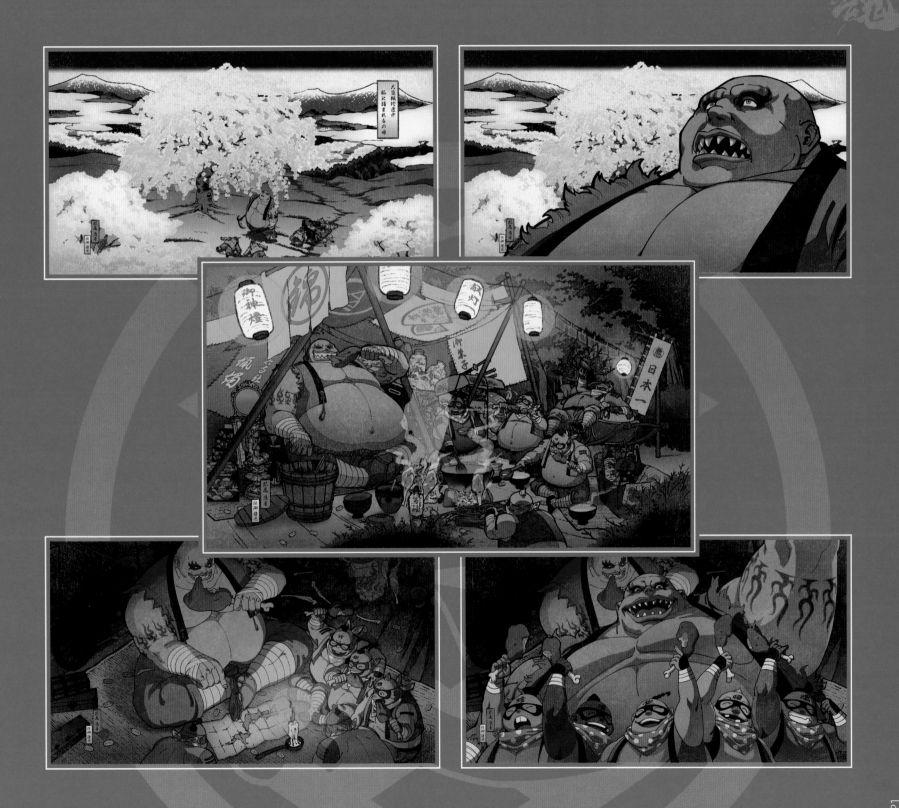

SHIKI

Voice Actor: Chitose Morinaga

In a cave buried deep below Mount Osore, a lone woman awakens in darkness to a sudden pang drawing her mind to a dark and distant disturbance.

Her own identity is a mystery to her. All she knows is that a mysterious voice echoes inside her head. It calls out to her faintly, and she responds, setting foot toward the light.

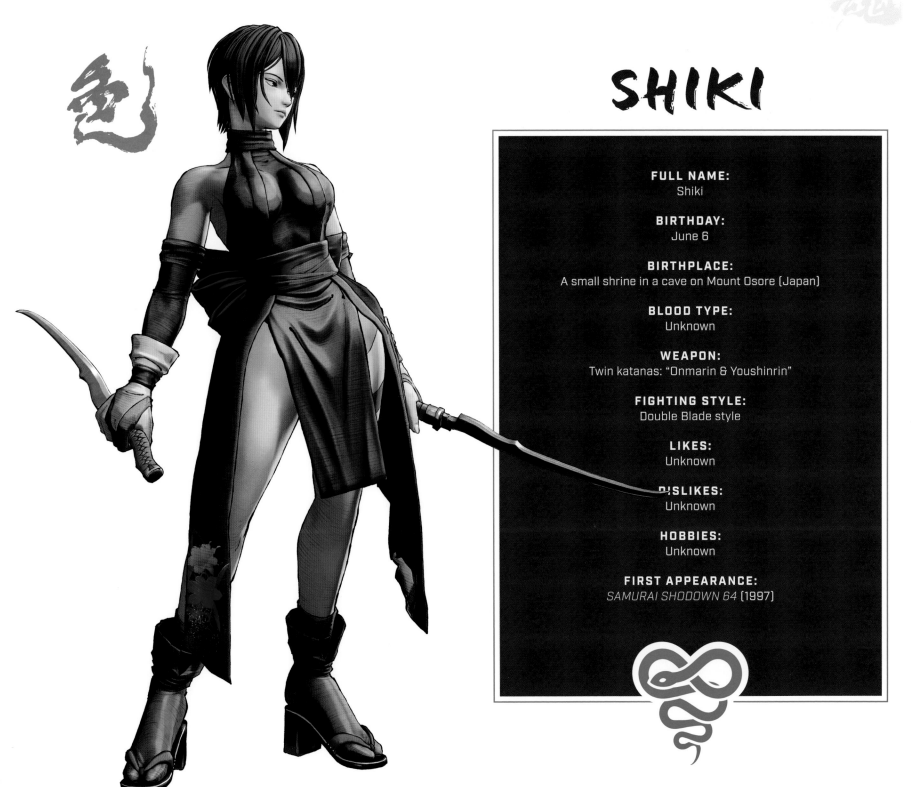

SHIKI

FULL NAME:
Shiki

BIRTHDAY:
June 6

BIRTHPLACE:
A small shrine in a cave on Mount Osore (Japan)

BLOOD TYPE:
Unknown

WEAPON:
Twin katanas: "Onmarin & Youshinrin"

FIGHTING STYLE:
Double Blade style

LIKES:
Unknown

DISLIKES:
Unknown

HOBBIES:
Unknown

FIRST APPEARANCE:
SAMURAI SHODOWN 64 (1997)

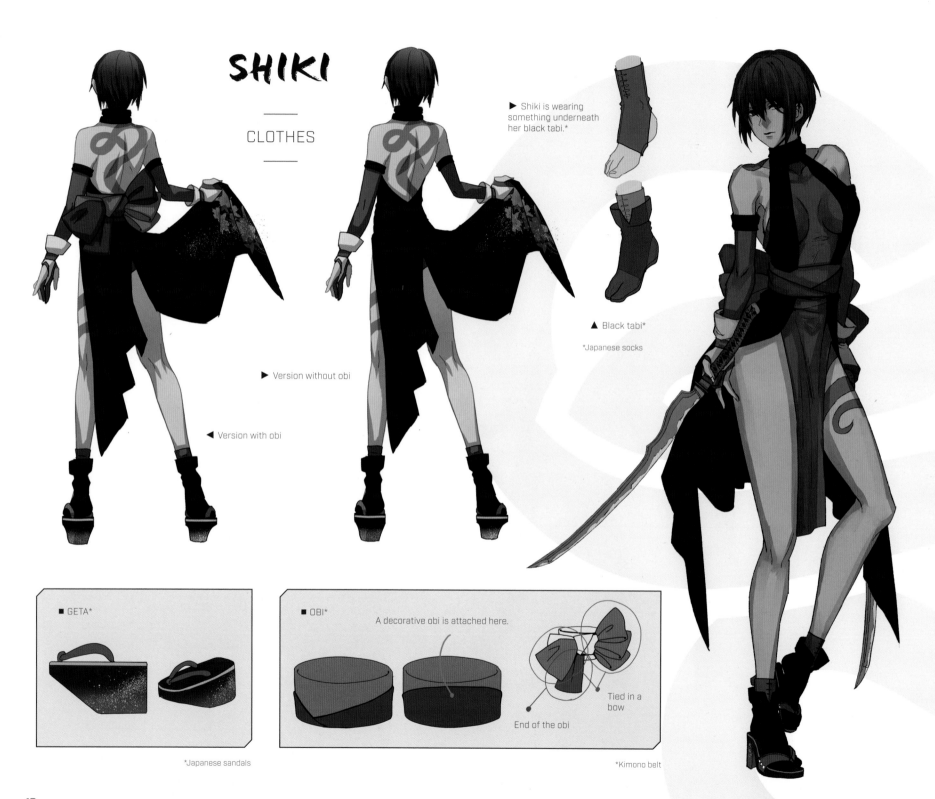

SHIKI

CLOTHES

▶ Version without obi

◀ Version with obi

▶ Shiki is wearing something underneath her black tabi.*

▲ Black tabi*

*Japanese socks

■ GETA*

*Japanese sandals

■ OBI*

A decorative obi is attached here.

Tied in a bow

End of the obi

*Kimono belt

► The handle is the size of an uchigatana* (proportionally large compared to the blade).

*Japanese sword wielded with one hand

► The size of the blade is identical to that of a wakizashi.*

*Japanese curved sword, smaller than a katana

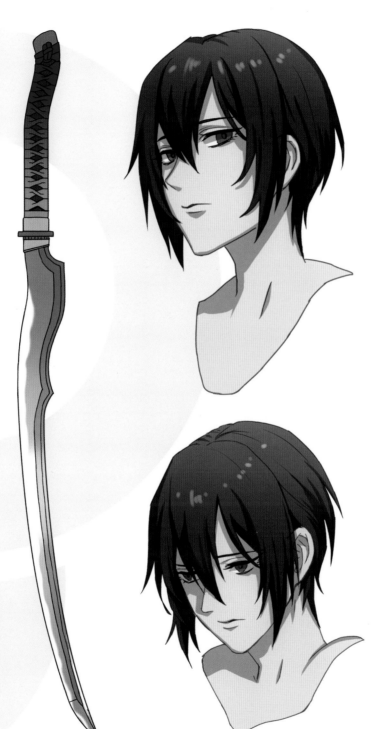

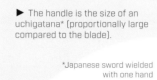

◄ Shiki has different-colored eyes. Her left eye is red, and her right eye is blue.

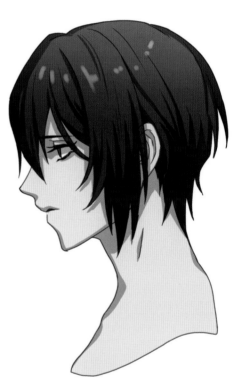

FACE DESIGN & WEAPON

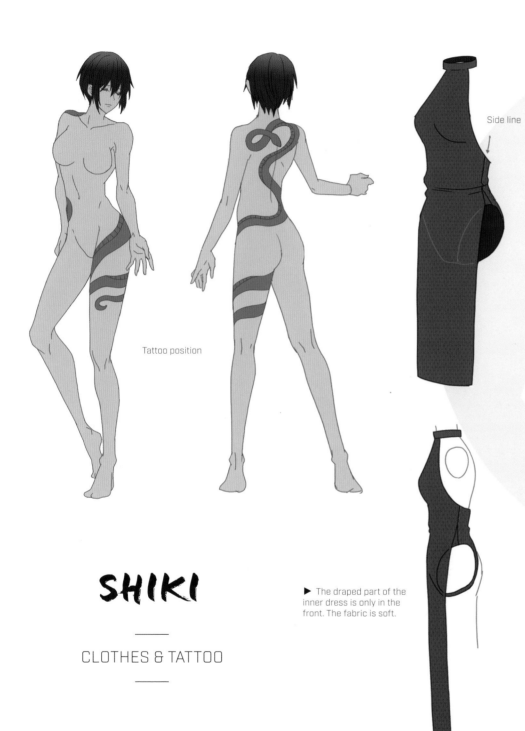

Tattoo position

SHIKI

CLOTHES & TATTOO

Side line

▶ The draped part of the inner dress is only in the front. The fabric is soft.

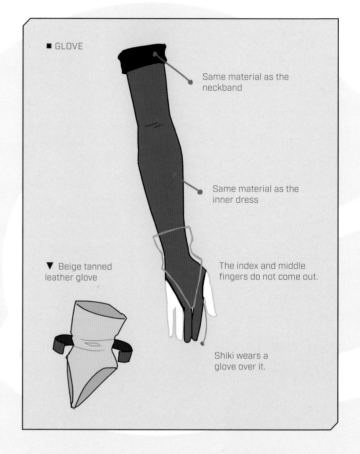

■ GLOVE

Same material as the neckband

Same material as the inner dress

▼ Beige tanned leather glove

The index and middle fingers do not come out.

Shiki wears a glove over it.

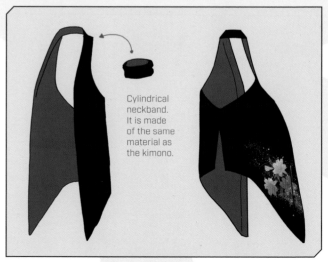

Cylindrical neckband. It is made of the same material as the kimono.

CLOTHING PATTERNS

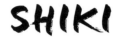

C01

The purifying wind rushes over Shiki's body as she stands alone among the trees.

Like the air after a rainstorm, her mind gradually clears.

As she gazes at the fluttering cherry blossoms, a stream of tears flows down her face.

But she could not tell you what made her cry in that moment.

C02

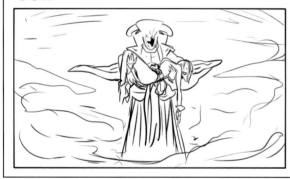

All she knows is the stinging pain behind her eyes as she closes them and weeps.

Overpowered by the intense anguish she feels, Shiki collapses in a heap at that very spot.

Then a man cloaked in black appears and picks up the motionless Shiki from where she lies, whispering, *"My dear half-shaded servant, now is not your time."*

With Shiki in his arms, the man quietly slips away into the darkness.

C03

Shiki awakes to find herself surrounded by nothing but darkness. No one can hear her cries.

She fails to fight the sudden urge to sleep, a sleep where thoughts of cherry blossoms become distant memories.

She is one with the darkness once again.

The silent darkness devoid of even a single ray of light, where she will remain until her destined time comes . . .

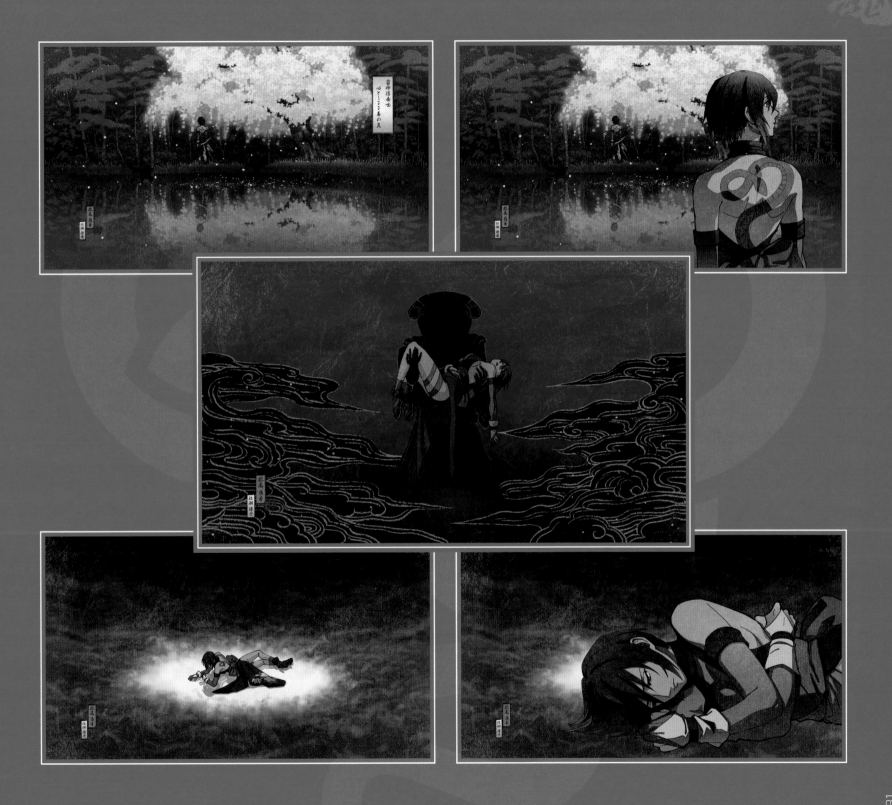

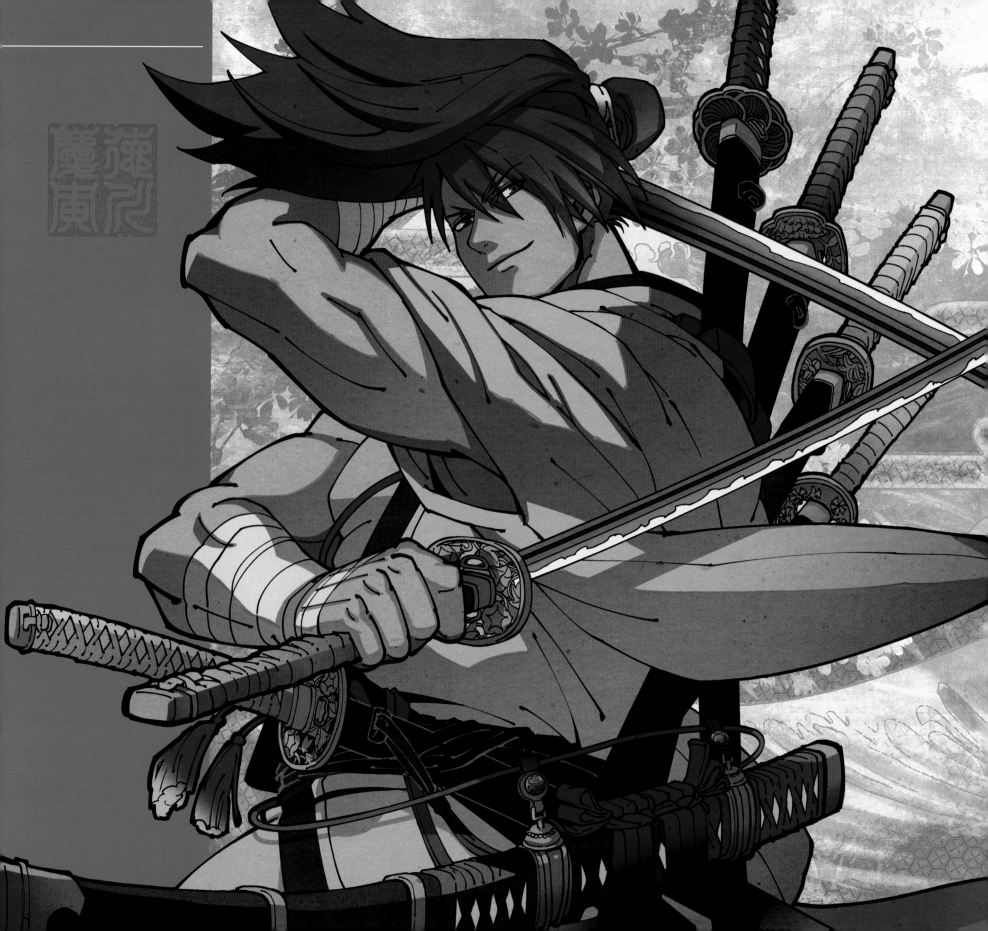

YOSHITORA

Voice Actor: Makoto Furukawa

Yoshitora Tokugawa knows only too well the burden the Tokugawa name places on a man's existence. That has never stopped him from living life according to his rules, however.

On hearing of the bakufu's plan to send spies throughout the land, he decides to investigate the matter for himself and journeys across the realm under the pretext that his six lovers can no longer satisfy his needs and he requires another.

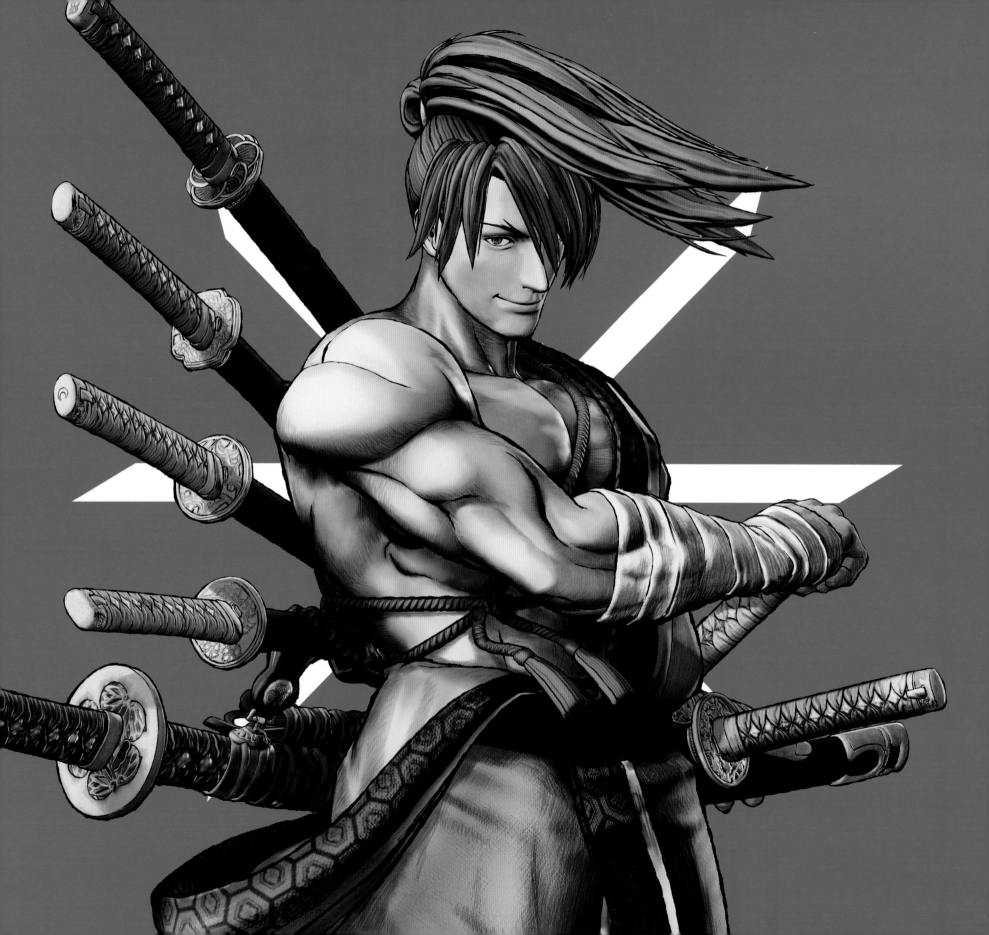

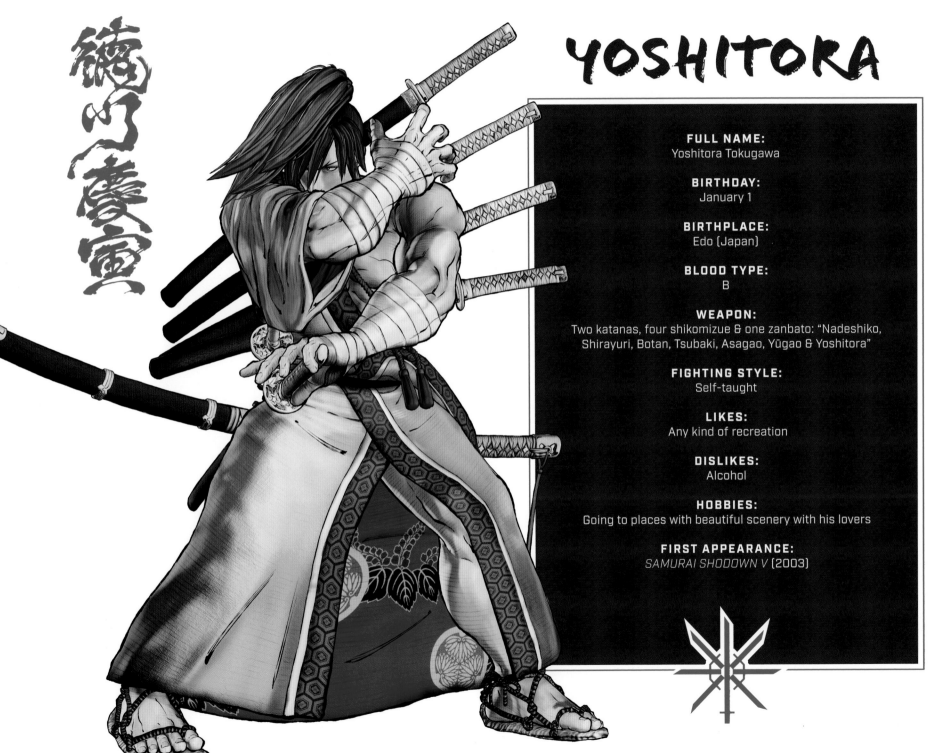

徳川慶寅

YOSHITORA

FULL NAME:
Yoshitora Tokugawa

BIRTHDAY:
January 1

BIRTHPLACE:
Edo (Japan)

BLOOD TYPE:
B

WEAPON:
Two katanas, four shikomizue & one zanbato: "Nadeshiko,
Shirayuri, Botan, Tsubaki, Asagao, Yūgao & Yoshitora"

FIGHTING STYLE:
Self-taught

LIKES:
Any kind of recreation

DISLIKES:
Alcohol

HOBBIES:
Going to places with beautiful scenery with his lovers

FIRST APPEARANCE:
SAMURAI SHODOWN V (2003)

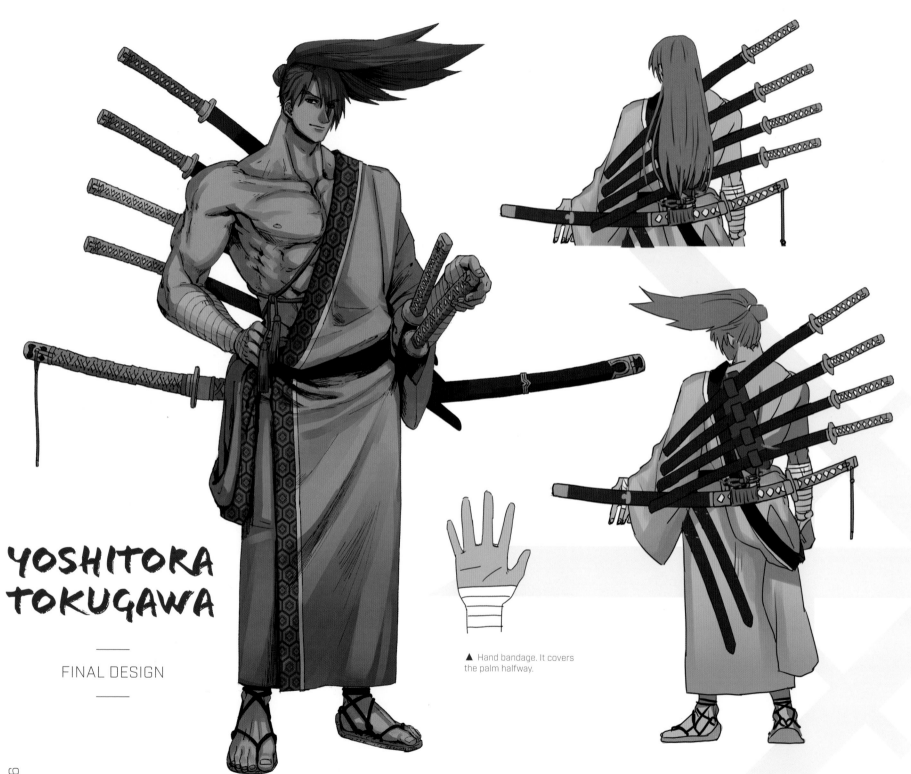

YOSHITORA TOKUGAWA

FINAL DESIGN

▲ Hand bandage. It covers the palm halfway.

▶ Except for Yoshitora (the tachi* sword), all swords have the same dimensions.

*Literally "long sword," sword with a curved blade of about 70 cm

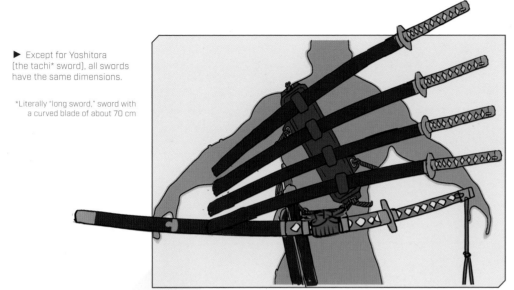

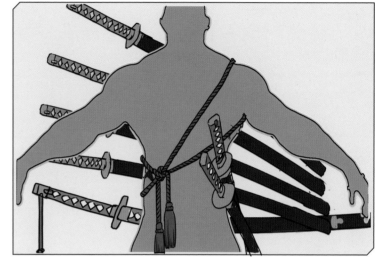

Goes under the left armpit.

Part of the cord from the tachi's sheath is attached to it.

Goes around the right hip.

Goes under the right armpit.

FACE DESIGN & ACCESSORY

Goes over the top of the left shoulder.

■ DORSAL KATANA HOLDER

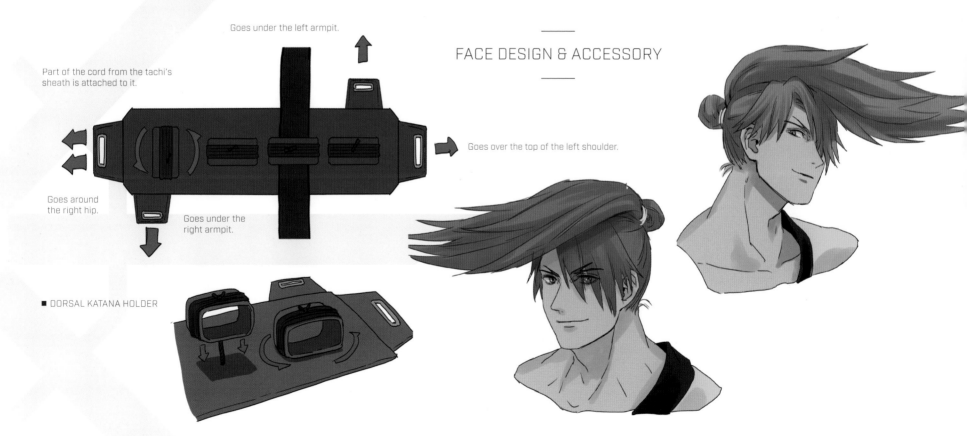

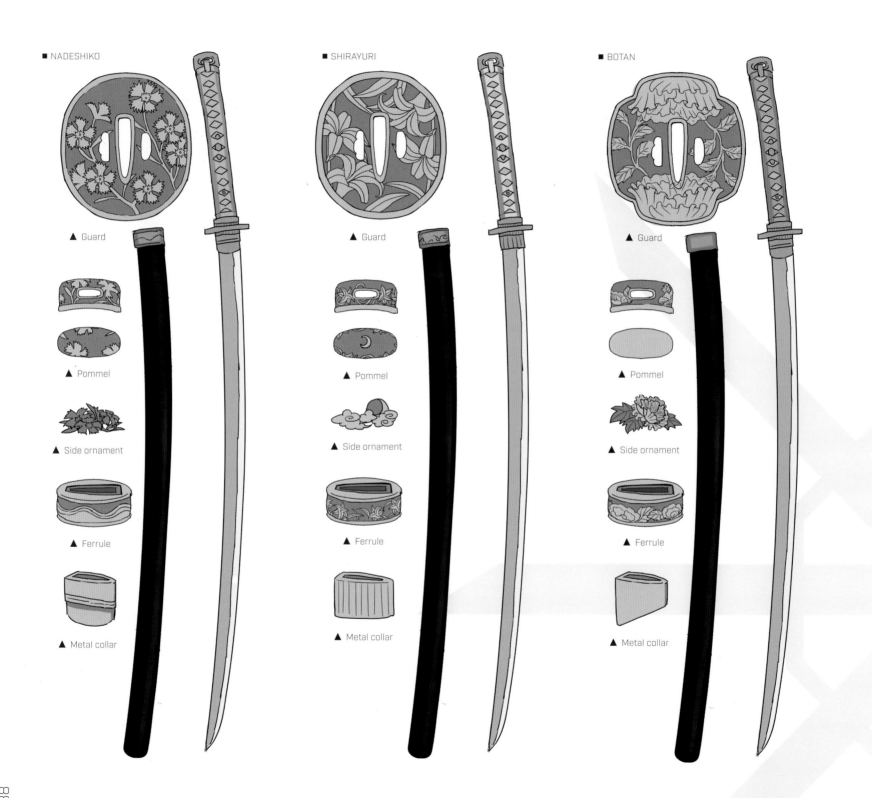

■ NADESHIKO

▲ Guard

▲ Pommel

▲ Side ornament

▲ Ferrule

▲ Metal collar

■ SHIRAYURI

▲ Guard

▲ Pommel

▲ Side ornament

▲ Ferrule

▲ Metal collar

■ BOTAN

▲ Guard

▲ Pommel

▲ Side ornament

▲ Ferrule

▲ Metal collar

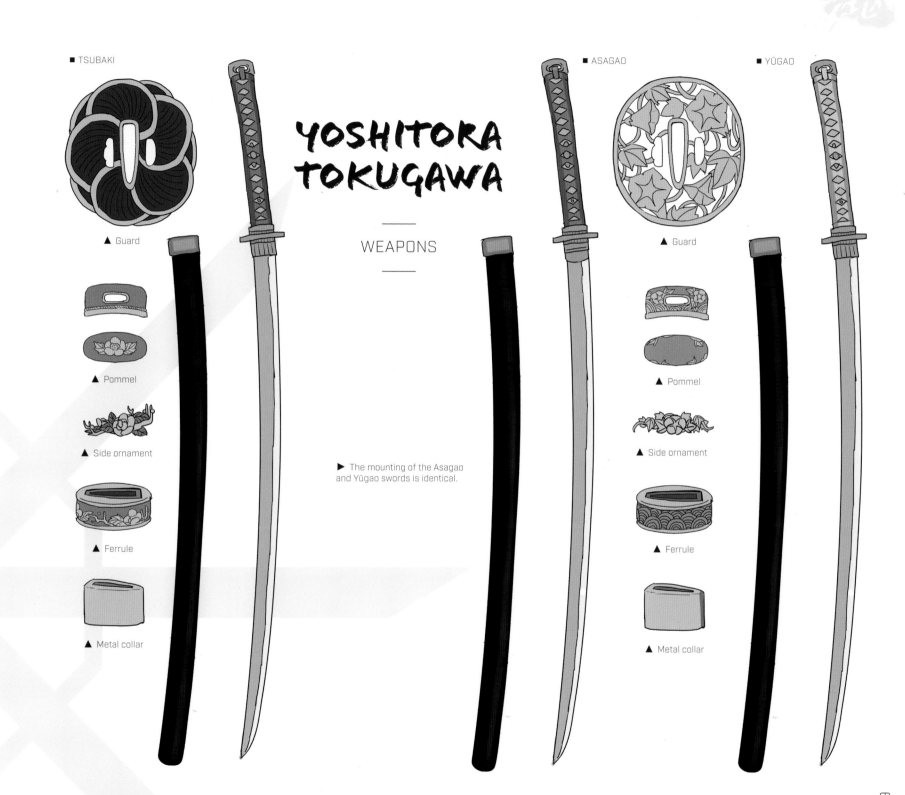

■ TSUBAKI

▲ Guard

▲ Pommel

▲ Side ornament

▲ Ferrule

▲ Metal collar

YOSHITORA TOKUGAWA

WEAPONS

▶ The mounting of the Asagao and Yūgao swords is identical.

■ ASAGAO

■ YŪGAO

▲ Guard

▲ Pommel

▲ Side ornament

▲ Ferrule

▲ Metal collar

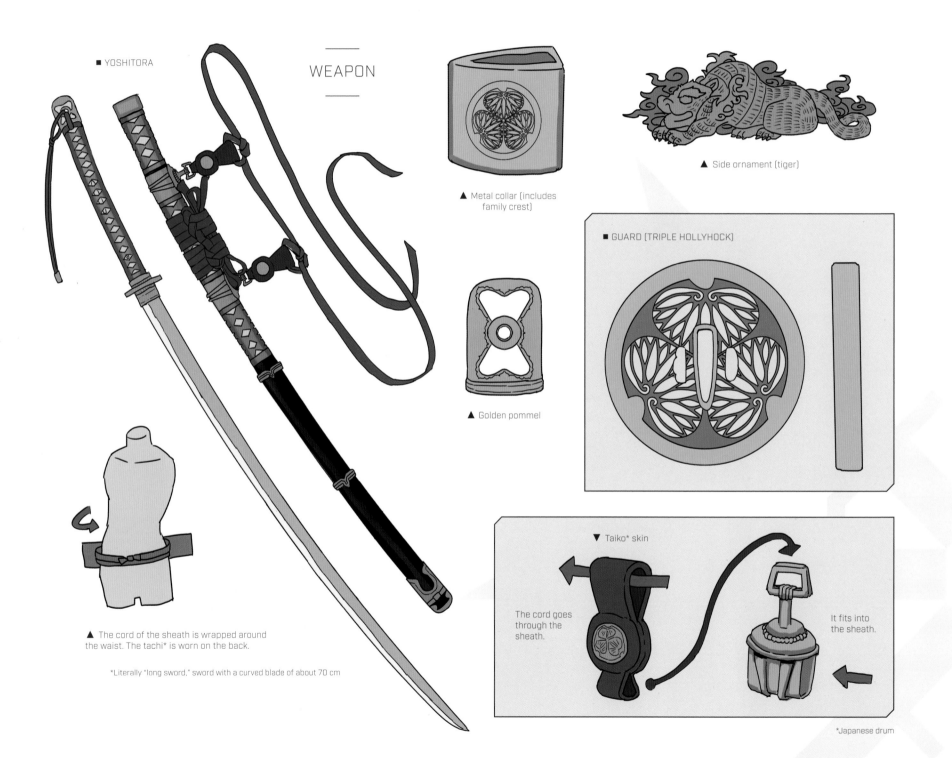

■ YOSHITORA

WEAPON

▲ Metal collar (includes family crest)

▲ Side ornament (tiger)

▲ Golden pommel

■ GUARD (TRIPLE HOLLYHOCK)

▲ The cord of the sheath is wrapped around the waist. The tachi* is worn on the back.

*Literally "long sword," sword with a curved blade of about 70 cm

▼ Taiko* skin

The cord goes through the sheath.

It fits into the sheath.

*Japanese drum

YOSHITORA TOKUGAWA

—

CLOTHES

—

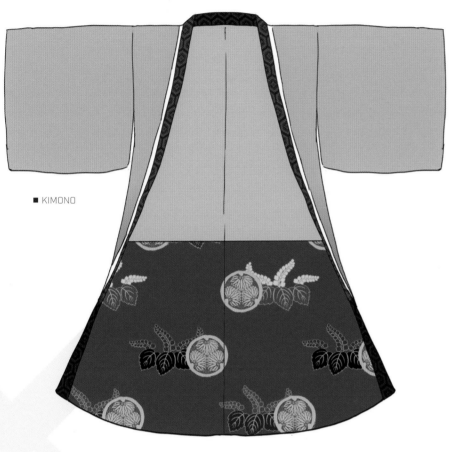

■ KIMONO

■ HANDAKO*

*Type of shorts

◄ Yoshitora wears the handako under his kimono. When he spreads his legs, you don't see a fundoshi* but a handako.

*Traditional underwear

► Hollyhock pattern appearing on the kimono

► Flower pattern appearing on the kimono

EPILOGUE

YOSHITORA TOKUGAWA

C01

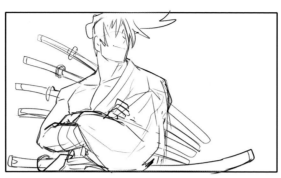

The evil that possessed Shizuka Gozen is vanquished and Yoshitora is free to return to Edo.

As the evil loosens its malevolent grip on the Land of the Rising Sun, the familiar blue color can be seen in the sky.

Whether it's due to the aftereffects of the purification, or perhaps to celebrate the passing of evil, the surrounding area is an endless parade of cherry blossom petals.

C02

Some time later, Yoshitora gathers his lovers to indulge in some well-deserved socializing.

One after the other, they tell him of what transpired across the land in his absence.

Violence among the townsfolk, poverty spreading from village to village . . . The common people continue to suffer as the embers of the scourge still flicker in the dark.

And as if to provoke a reaction in the indifferent Yoshitora, the women question him in regard to his future plans.

C03

In that moment, Yoshitora cannot help but recall a vow he once made to a dear friend:

"I will lead this country to greatness."

Although he has distanced himself from it for so long, the Tokugawa bloodline still courses through his veins.

No matter what dangers lie ahead, the path he is on is the path he shall walk.

As he watches the reflection of the moon in his cup, he quietly says to himself:

"I think it's time the rest of the world finally met me."

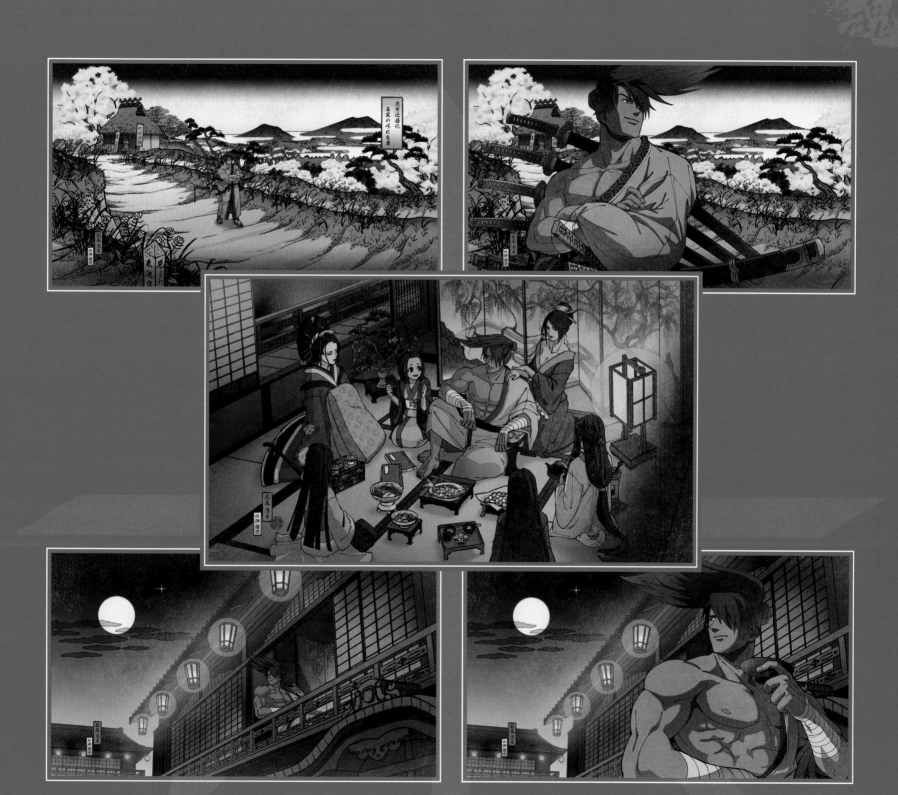

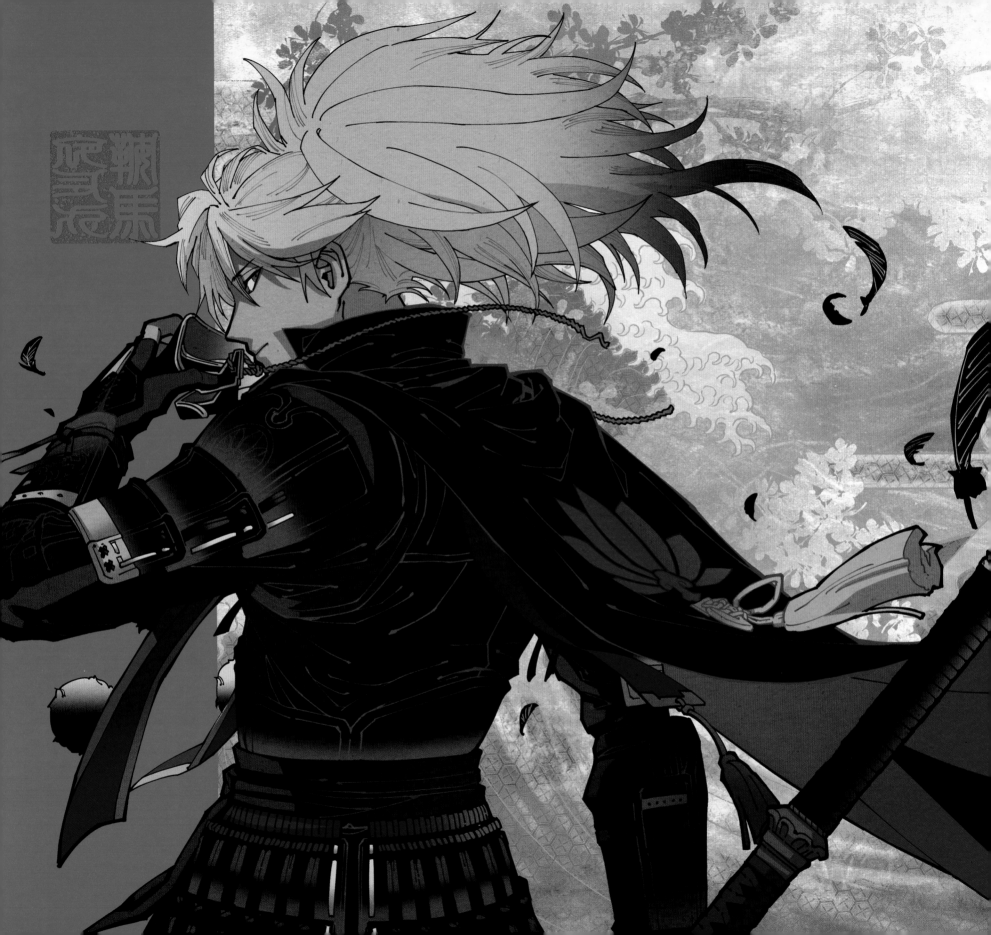

YASHAMARU

Voice Actor: Kouhei Amasaki

Operating in the shadows of the capital as the virtuous bandit Karasu Tengu, Yashamaru Kurama laments the growing divide between rich and poor throughout the Japanese archipelago.

Upon learning that the land's unrest is the result of an evil force, Yashamaru turns his attention to saving the common folk from the impending doom and despair.

夜叉丸

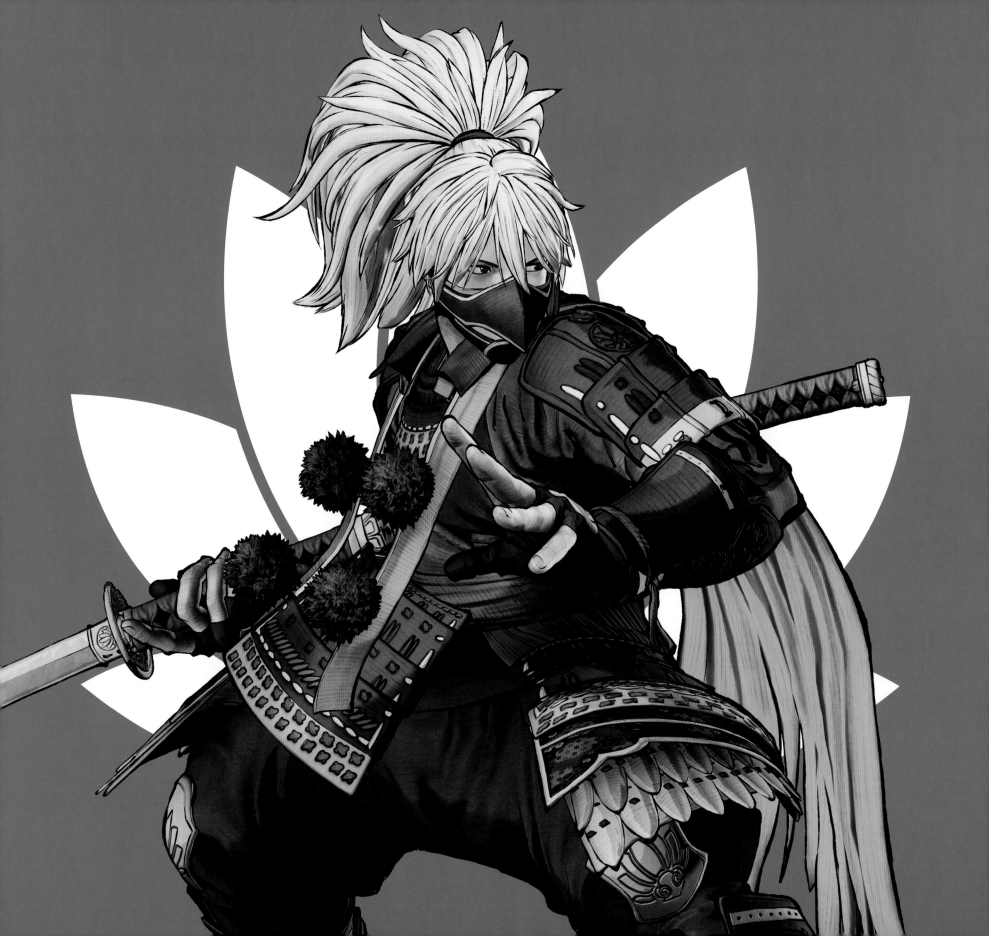

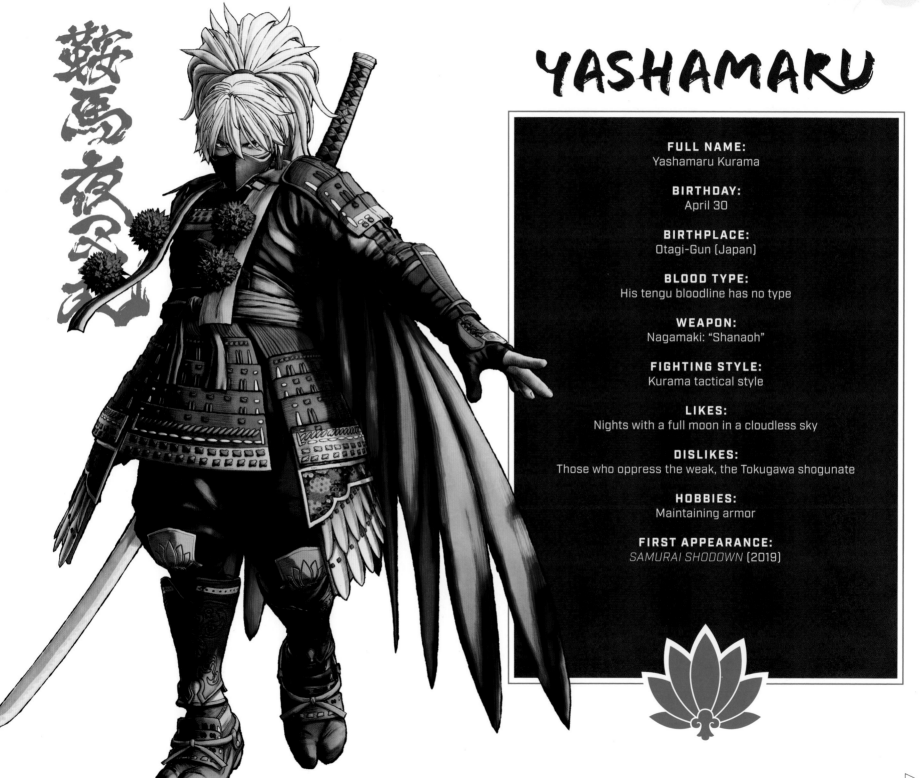

鞍馬夜叉丸

YASHAMARU

FULL NAME:
Yashamaru Kurama

BIRTHDAY:
April 30

BIRTHPLACE:
Otagi-Gun (Japan)

BLOOD TYPE:
His tengu bloodline has no type

WEAPON:
Nagamaki: "Shanaoh"

FIGHTING STYLE:
Kurama tactical style

LIKES:
Nights with a full moon in a cloudless sky

DISLIKES:
Those who oppress the weak, the Tokugawa shogunate

HOBBIES:
Maintaining armor

FIRST APPEARANCE:
SAMURAI SHODOWN (2019)

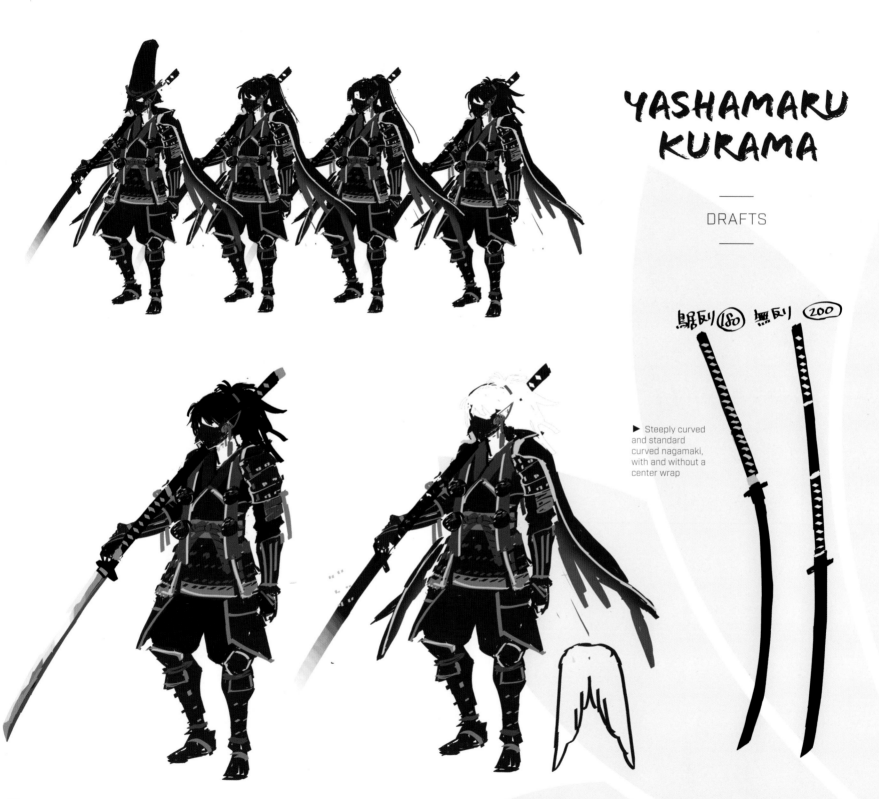

YASHAMARU KURAMA

DRAFTS

► Steeply curved and standard curved nagamaki, with and without a center wrap

FINAL DESIGN

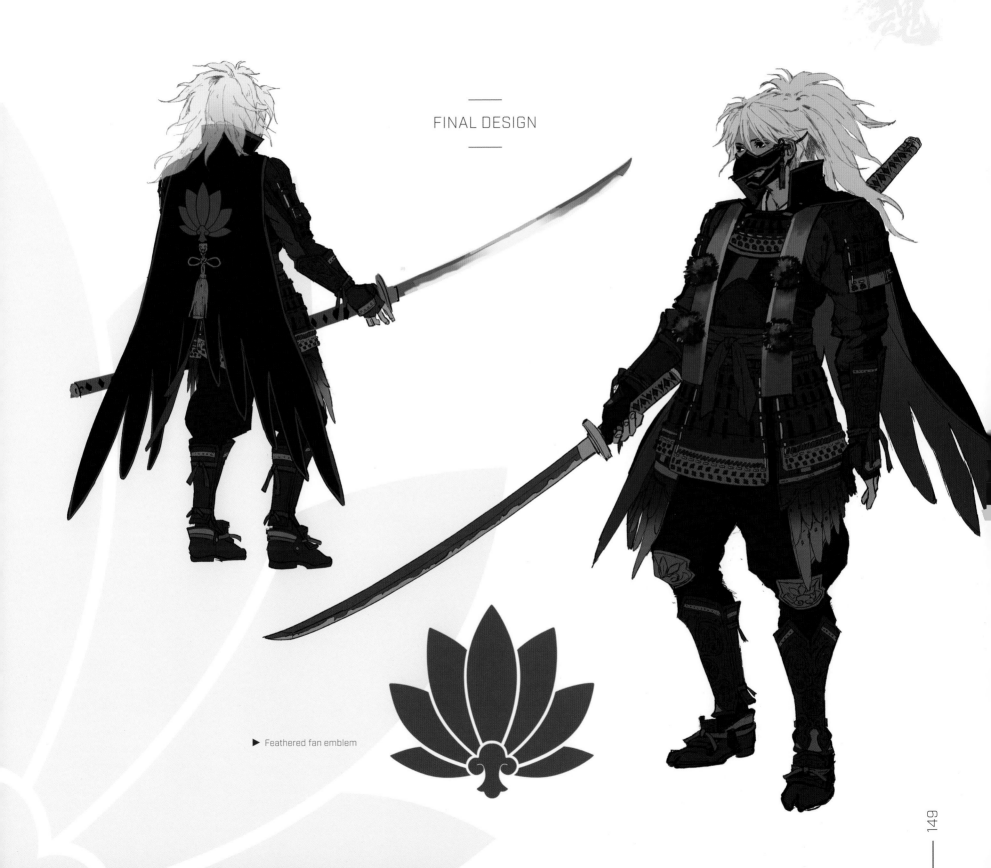

▶ Feathered fan emblem

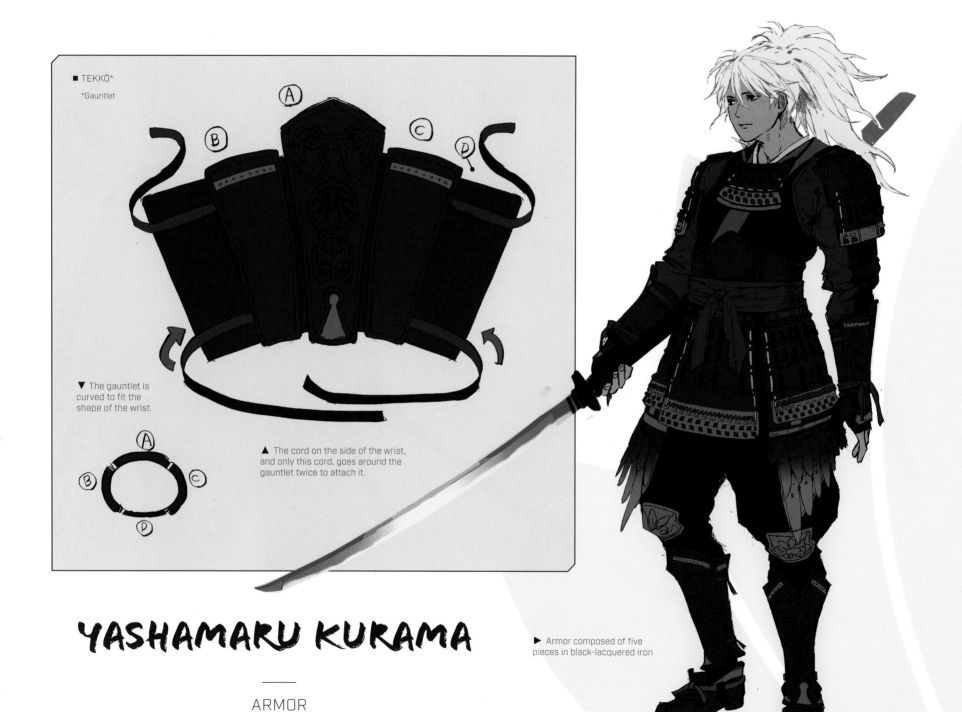

■ TEKKŌ*

*Gauntlet

Ⓐ Ⓑ Ⓒ Ⓓ

▼ The gauntlet is curved to fit the shape of the wrist.

▲ The cord on the side of the wrist, and only this cord, goes around the gauntlet twice to attach it.

Ⓐ Ⓑ Ⓒ Ⓓ

YASHAMARU KURAMA

ARMOR

▶ Armor composed of five pieces in black-lacquered iron

■ KUSAZURI*

*Skirt of a samurai's armor

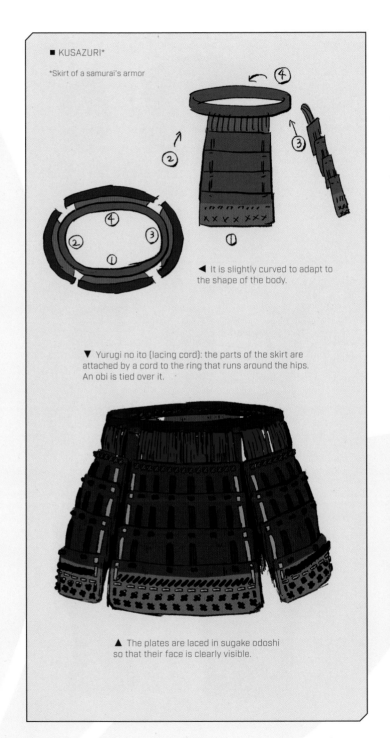

◀ It is slightly curved to adapt to the shape of the body.

▼ Yurugi no ito (lacing cord): the parts of the skirt are attached by a cord to the ring that runs around the hips. An obi is tied over it.

▲ The plates are laced in sugake odoshi so that their face is clearly visible.

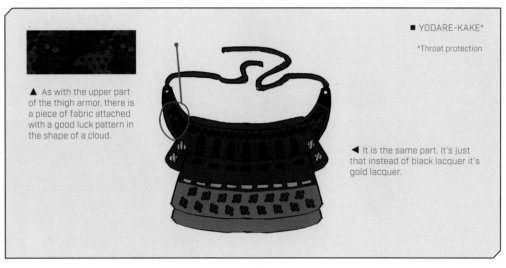

■ YODARE-KAKE*

*Throat protection

▲ As with the upper part of the thigh armor, there is a piece of fabric attached with a good luck pattern in the shape of a cloud.

◀ It is the same part. It's just that instead of black lacquer it's gold lacquer.

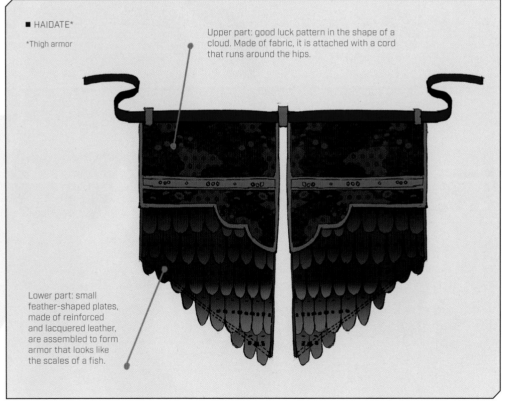

■ HAIDATE*

*Thigh armor

Upper part: good luck pattern in the shape of a cloud. Made of fabric, it is attached with a cord that runs around the hips.

Lower part: small feather-shaped plates, made of reinforced and lacquered leather, are assembled to form armor that looks like the scales of a fish.

■ YUIGESA*

It is worn around the neck, above the kimono but under the cape.

*Stole with pompoms worn by itinerant Buddhist monks

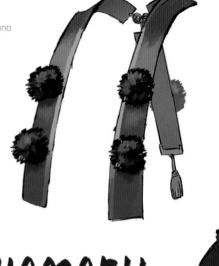

YASHAMARU KURAMA

CLOTHES

▲ Attaches with cords that go through holes in the sleeves (invisible from the outside).

■ TATEAGE*

*Knee protection

Sewn directly onto the momohiki.*

*Traditional Japanese pants that can also be worn as underwear

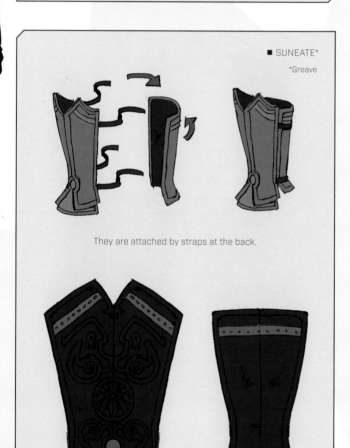

■ SUNEATE*

*Greave

They are attached by straps at the back.

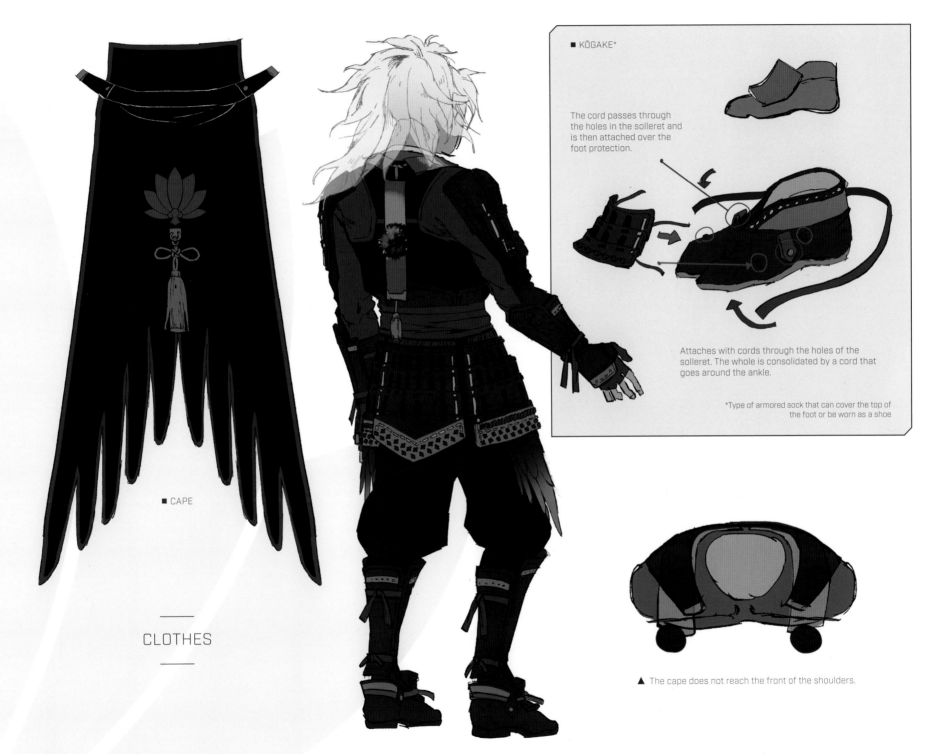

■ KŌGAKE*

The cord passes through the holes in the solleret and is then attached over the foot protection.

Attaches with cords through the holes of the solleret. The whole is consolidated by a cord that goes around the ankle.

*Type of armored sock that can cover the top of the foot or be worn as a shoe

■ CAPE

CLOTHES

▲ The cape does not reach the front of the shoulders.

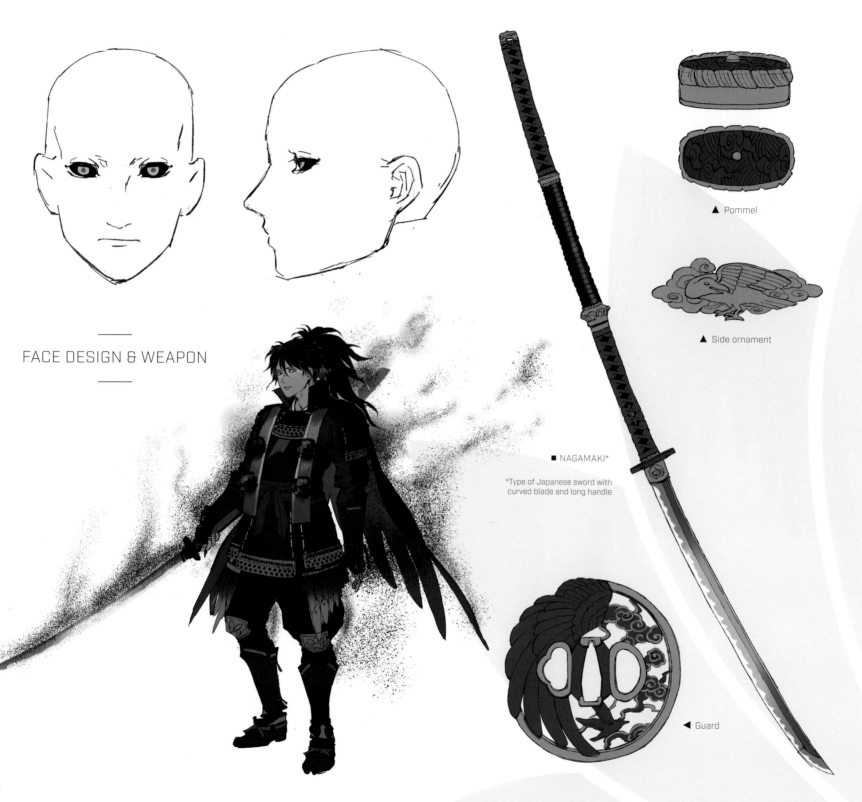

FACE DESIGN & WEAPON

▲ Pommel

▲ Side ornament

■ NAGAMAKI*

*Type of Japanese sword with curved blade and long handle

◄ Guard

YASHAMARU KURAMA

FACE DESIGN

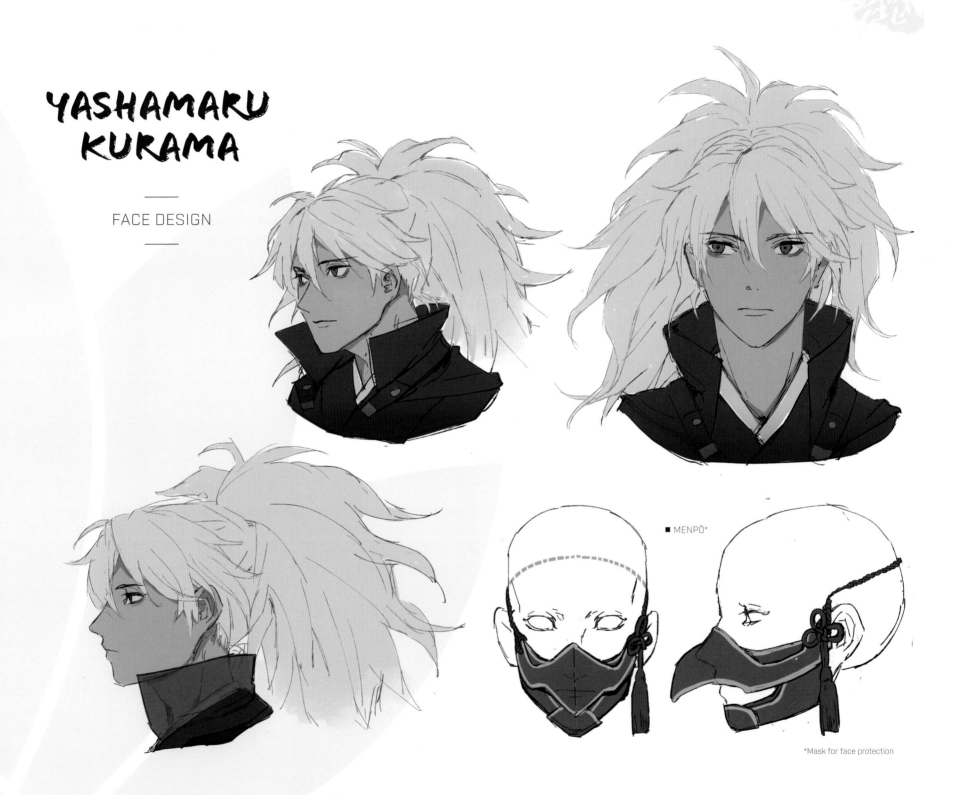

■ MENPÔ*

*Mask for face protection

EPILOGUE

YASHAMARU KURAMA

C01

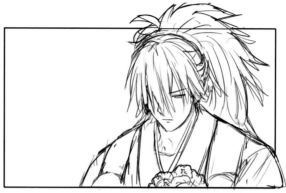

Several days have passed since the evil wrought upon this world was vanquished.

Yashamaru has returned to his home village to pay his respects at his father's grave.

Four years ago, his father left for Edo to find a solution to their village's famine, only to return as a severed head after he was executed as the ringleader in a riot.

"Why do good people like my father suffer such terrible fates?"

Yashamaru swore to himself he would bring down the bakufu as he stood there weeping at the loss of his father.

C02

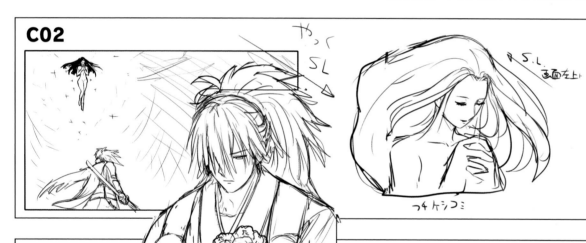

And for the longest time, he had not one regret over the vow he made that day.

However, the final words of the dying Shizuka Gozen remain etched in his memory.

"Cherish that love in your heart and never let it go."

He swears he saw his father ushering her into the next world as she faded away.

C03

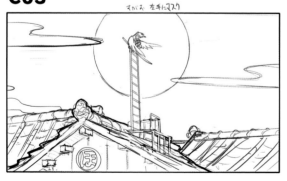

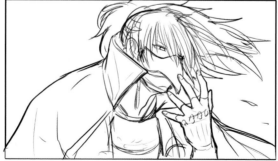

Heeding the cries of those who have been wronged, Karasu Tengu stalks the night delivering justice to those who would escape unpunished.

Whether heaven or hell, he cares not where his calling takes him.

But his vendetta against the bakufu must continue.

And though a life of bloodshed is a heavy burden to bear, it is one Yashamaru accepts willingly . . .

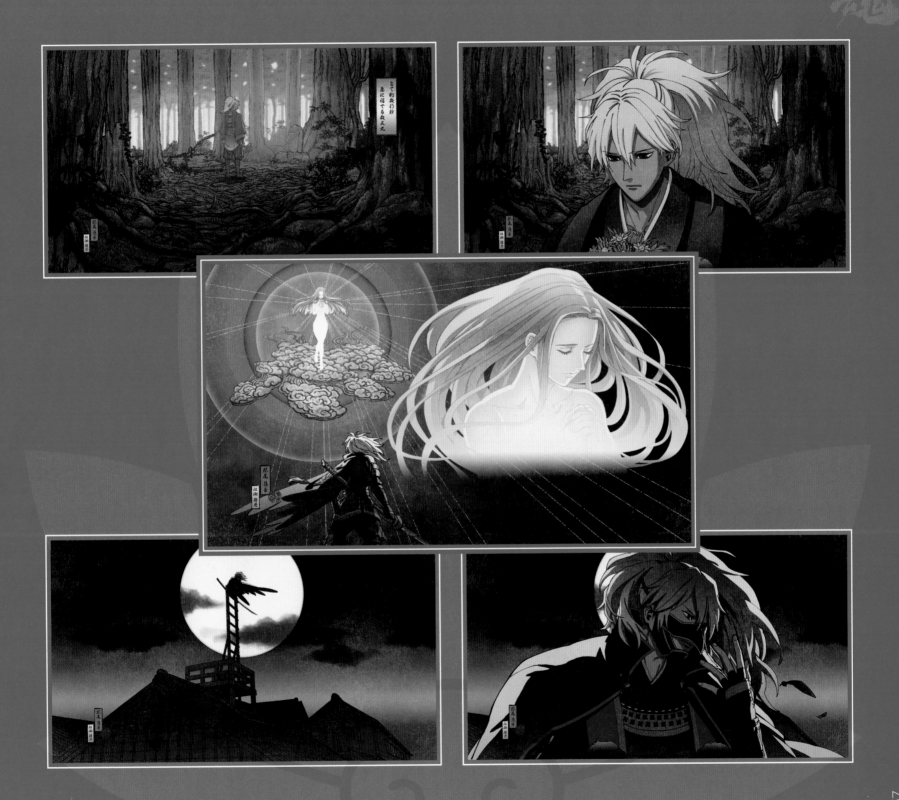

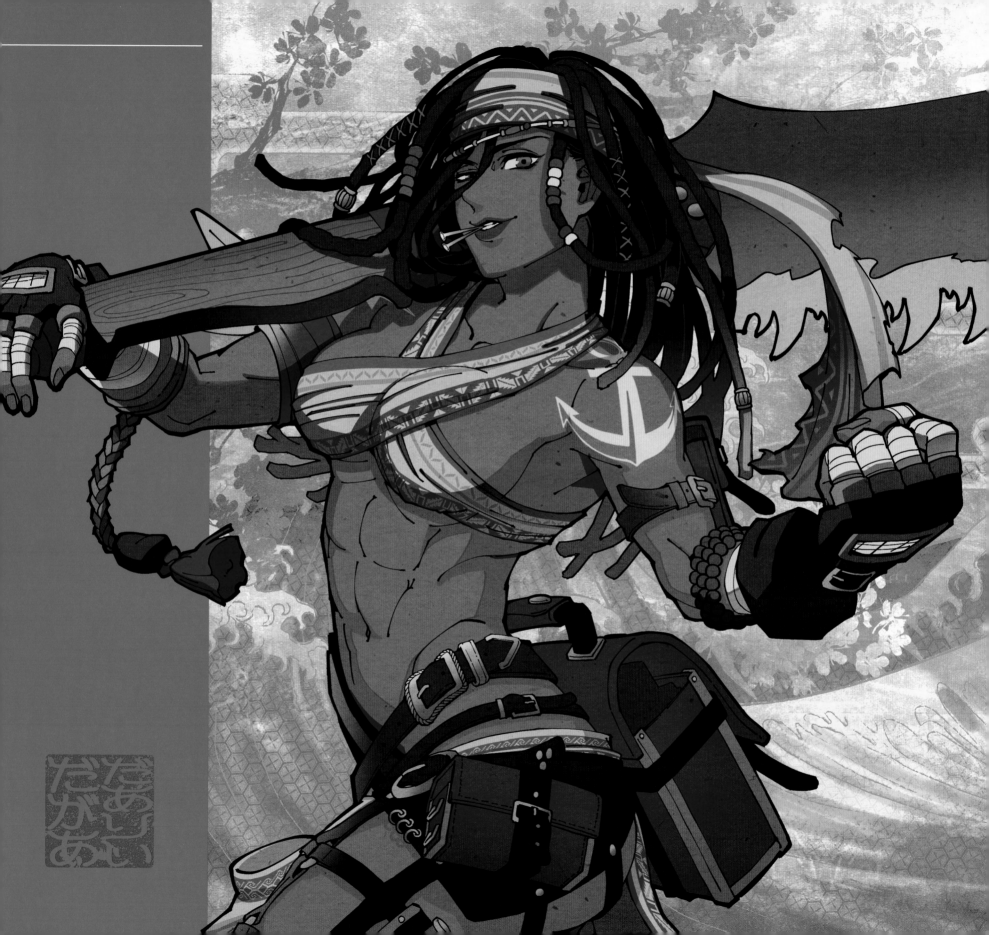

DARLI

Voice Actor: Yu Kobayashi

Darli Dagger is the owner of a shipyard on an island far from Japan. One night, one of the boats being built in her yard is sabotaged by an unknown intruder.

Witnesses report that a strange masked man was seen at the yard that night, and that he stowed away on a ship destined for a foreign land. This marks the start of Darli's journey to demand restitution from this masked culprit, as well as answers.

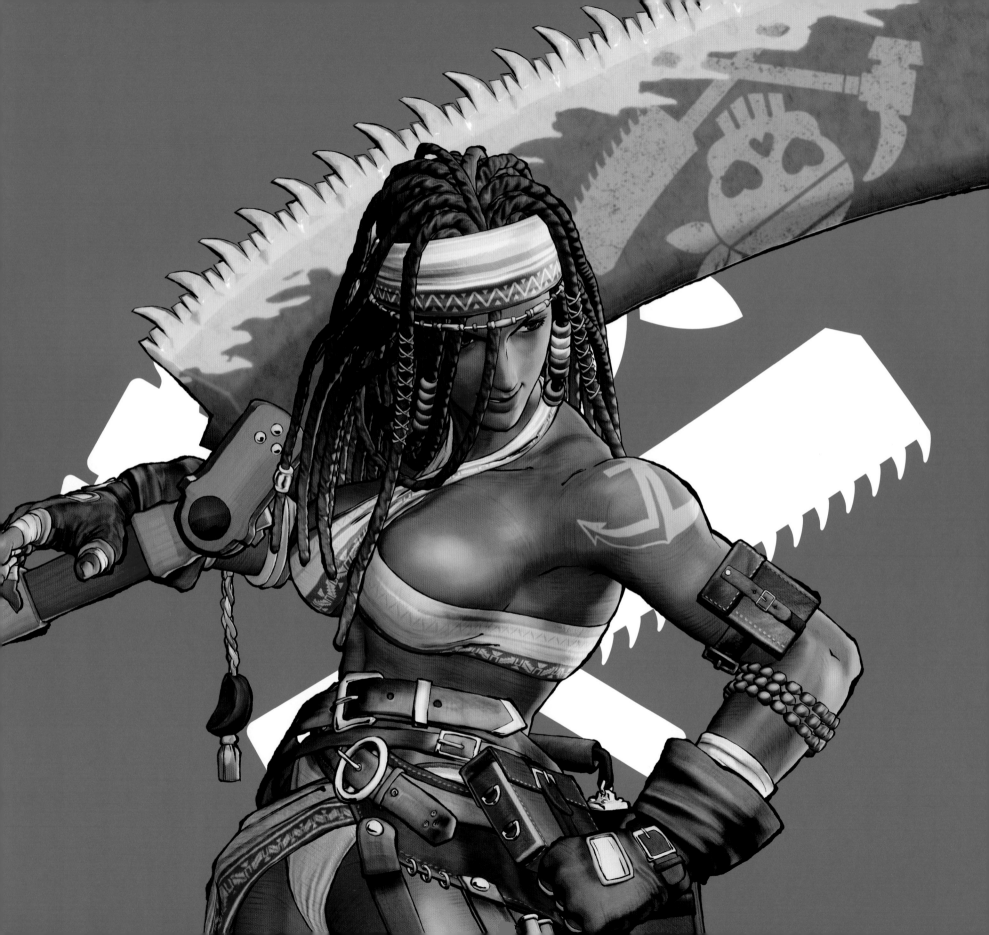

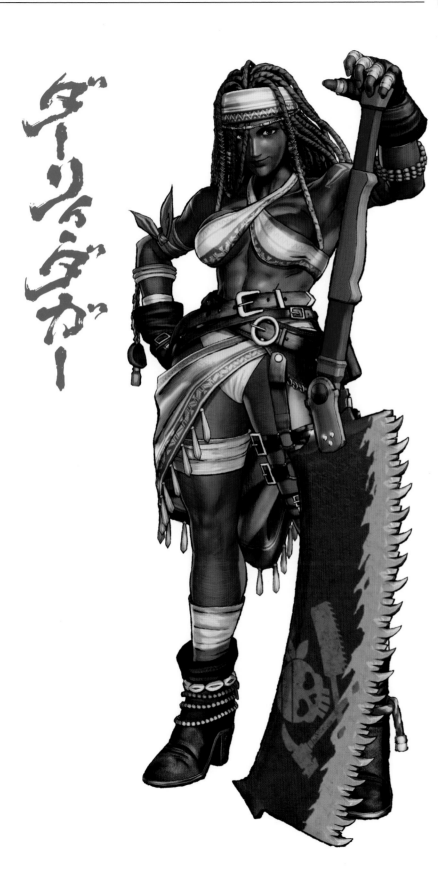

ダーリィ・ダガー

DARLI

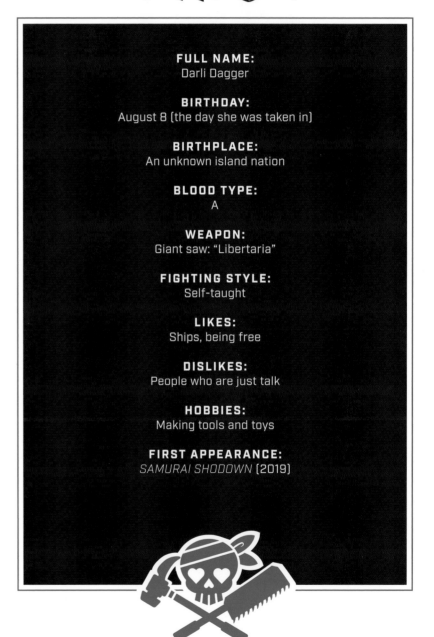

FULL NAME:
Darli Dagger

BIRTHDAY:
August 8 (the day she was taken in)

BIRTHPLACE:
An unknown island nation

BLOOD TYPE:
A

WEAPON:
Giant saw: "Libertaria"

FIGHTING STYLE:
Self-taught

LIKES:
Ships, being free

DISLIKES:
People who are just talk

HOBBIES:
Making tools and toys

FIRST APPEARANCE:
SAMURAI SHODOWN (2019)

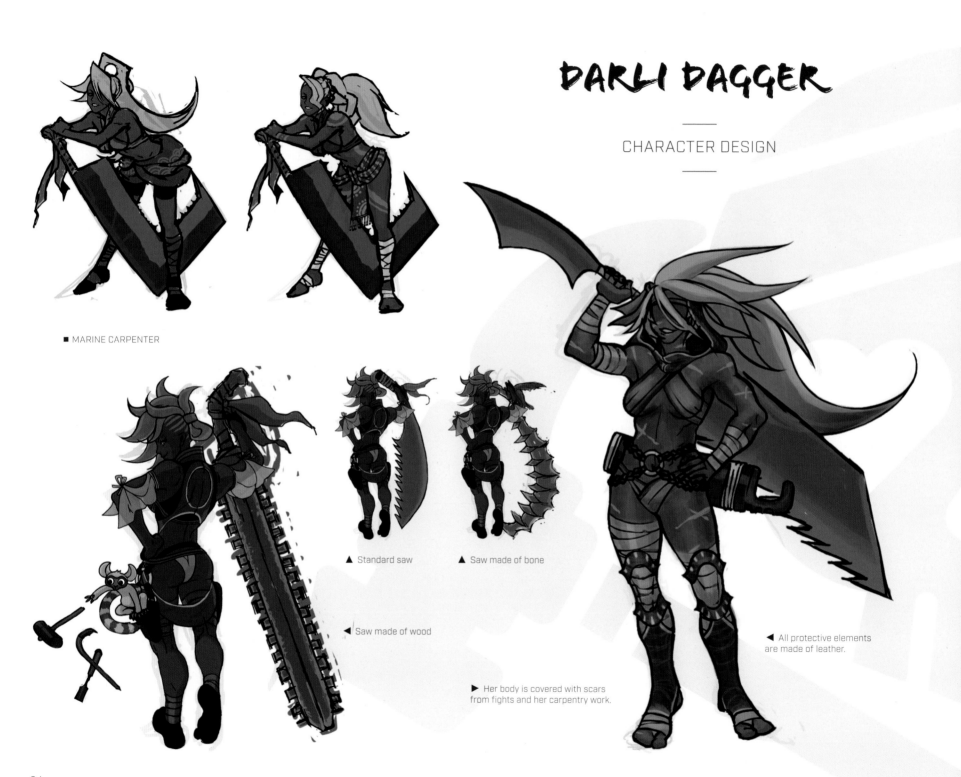

DARLI DAGGER

CHARACTER DESIGN

■ MARINE CARPENTER

▲ Standard saw

▲ Saw made of bone

◄ Saw made of wood

◄ All protective elements are made of leather.

▶ Her body is covered with scars from fights and her carpentry work.

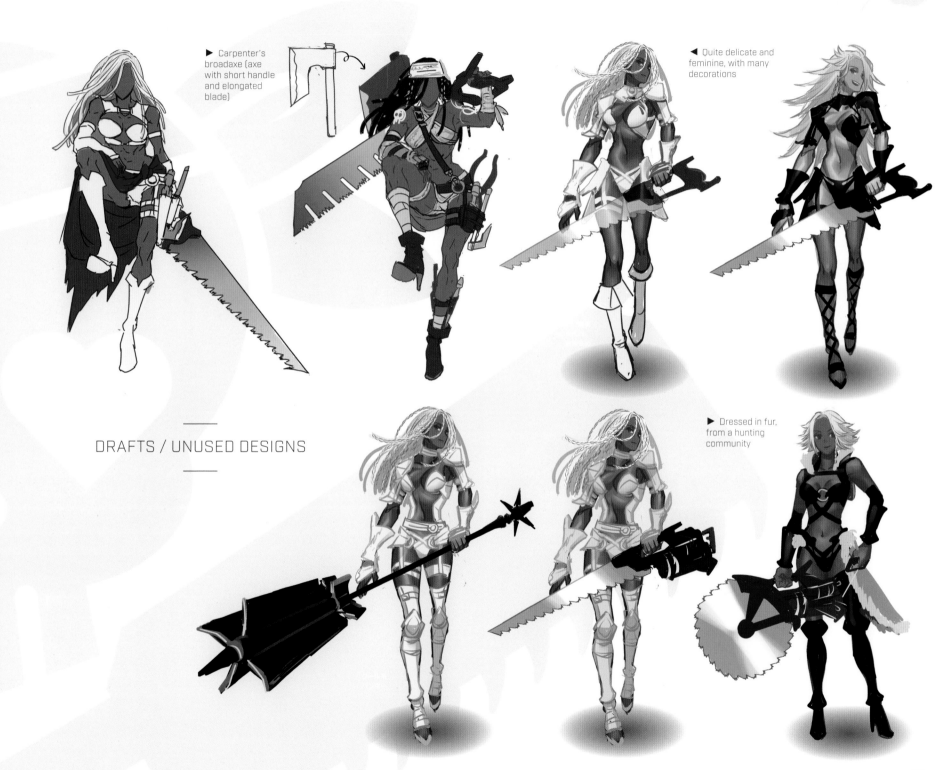

▶ Carpenter's broadaxe (axe with short handle and elongated blade)

◀ Quite delicate and feminine, with many decorations

DRAFTS / UNUSED DESIGNS

▶ Dressed in fur, from a hunting community

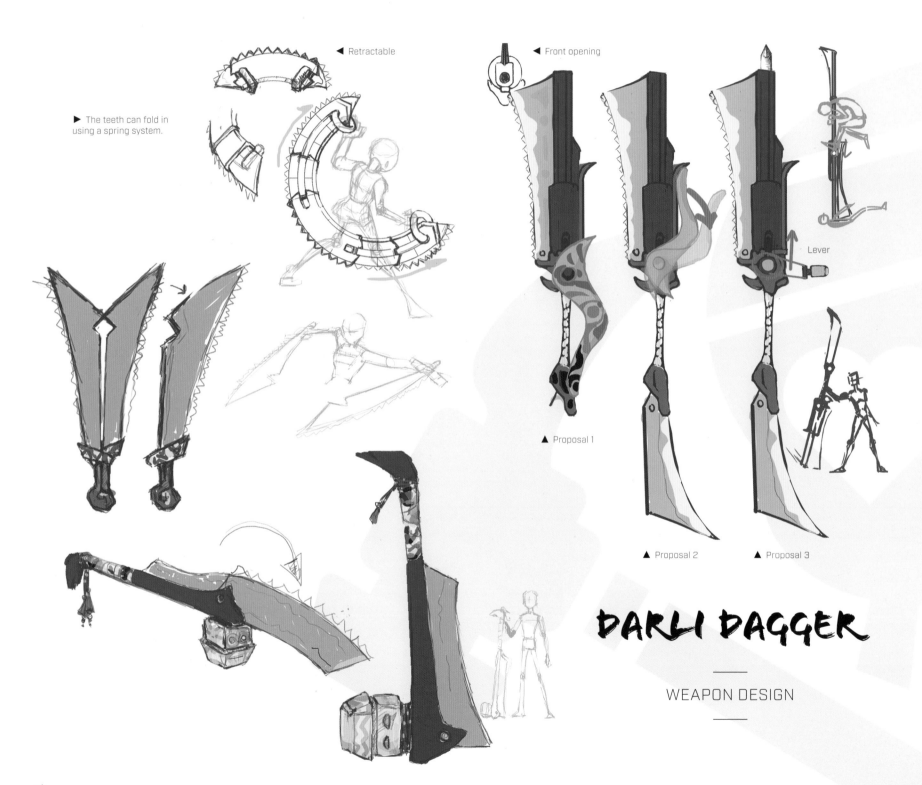

◄ Retractable

► The teeth can fold in using a spring system.

◄ Front opening

Lever

▲ Proposal 1

▲ Proposal 2

▲ Proposal 3

DARLI DAGGER

WEAPON DESIGN

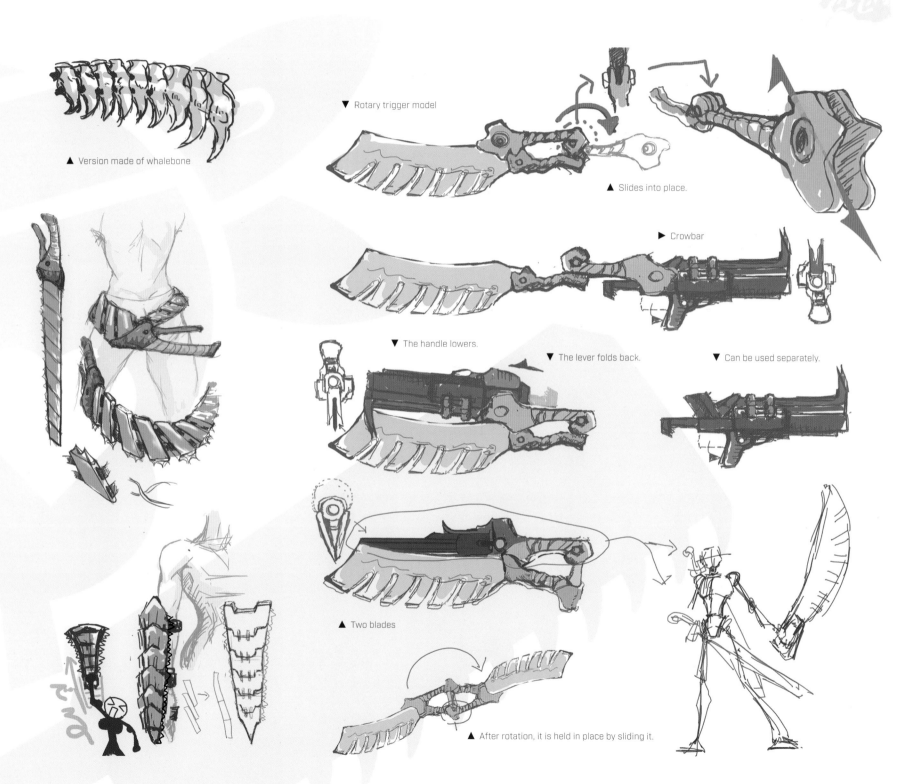

▲ Version made of whalebone

▼ Rotary trigger model

▲ Slides into place.

▶ Crowbar

▼ The handle lowers.

▼ The lever folds back.

▼ Can be used separately.

▲ Two blades

▲ After rotation, it is held in place by sliding it.

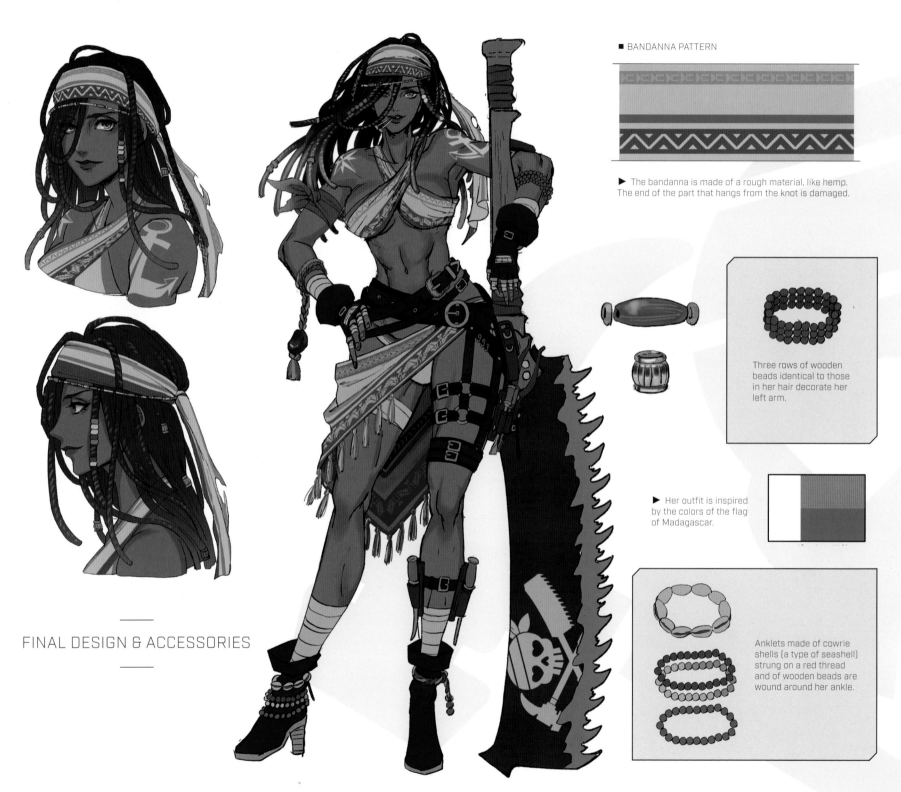

▶ The bandanna is made of a rough material, like hemp. The end of the part that hangs from the knot is damaged.

Three rows of wooden beads identical to those in her hair decorate her left arm.

▶ Her outfit is inspired by the colors of the flag of Madagascar.

Anklets made of cowrie shells (a type of seashell) strung on a red thread and of wooden beads are wound around her ankle.

FINAL DESIGN & ACCESSORIES

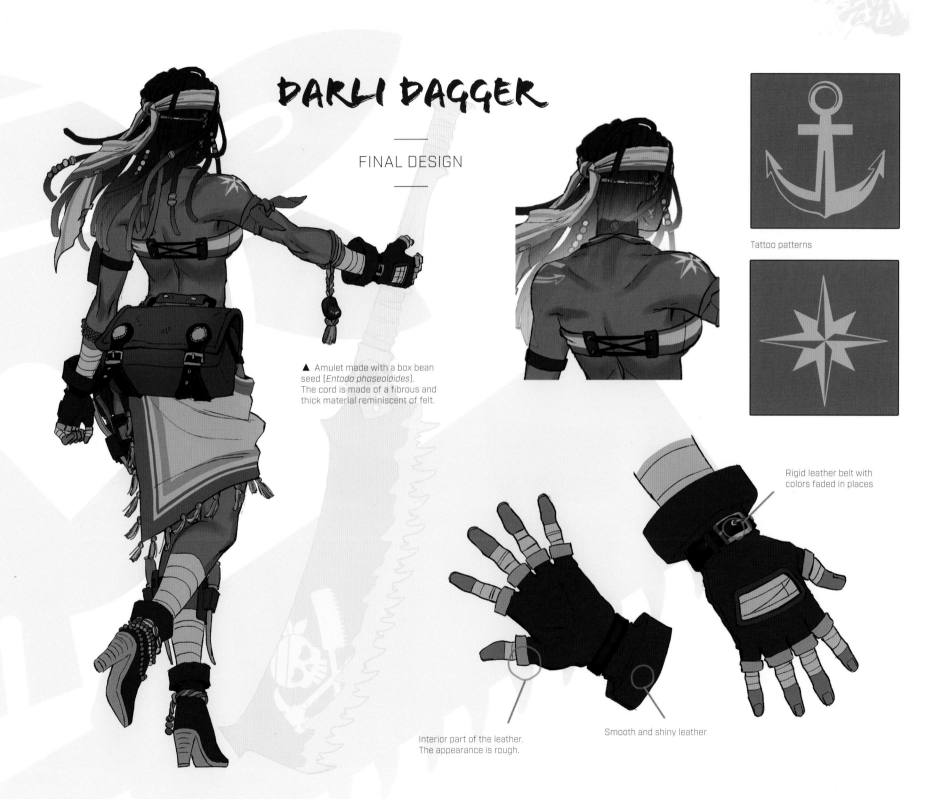

DARLI DAGGER

FINAL DESIGN

▲ Amulet made with a box bean seed (*Entada phaseoloides*). The cord is made of a fibrous and thick material reminiscent of felt.

Tattoo patterns

Rigid leather belt with colors faded in places

Interior part of the leather. The appearance is rough.

Smooth and shiny leather

DARLI DAGGER

ACCESSORIES

Attaches around the waist.

Attaches around the thigh.

■ TOOL BELT

Attaches around the thigh.

Can be worn on the calf.

◄ Trowel-shaped chisel

◄ Wide chisel

► Chisel with guard

► Double-bladed chisel

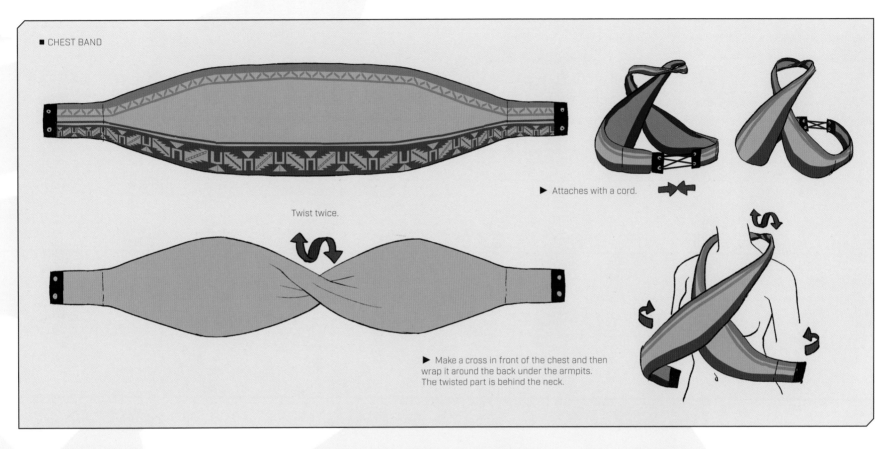

■ CHEST BAND

Twist twice.

▶ Attaches with a cord.

▶ Make a cross in front of the chest and then wrap it around the back under the armpits. The twisted part is behind the neck.

■ SARONG

■ THONG

CLOTHES

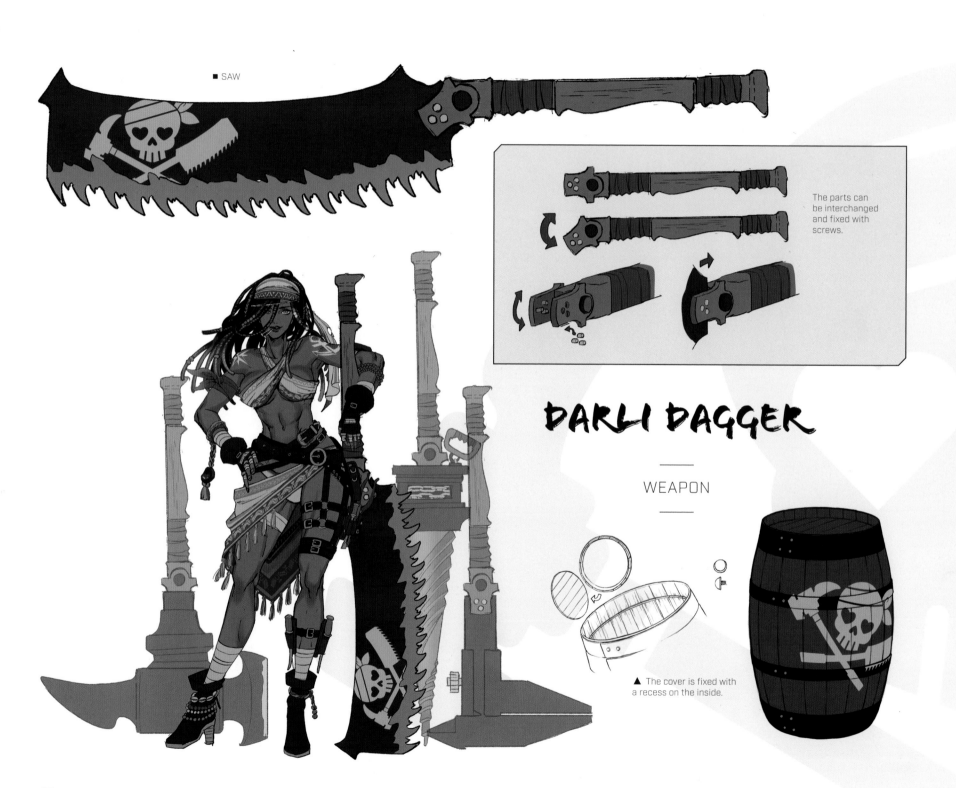

■ SAW

The parts can be interchanged and fixed with screws.

DARLI DAGGER

WEAPON

▲ The cover is fixed with a recess on the inside.

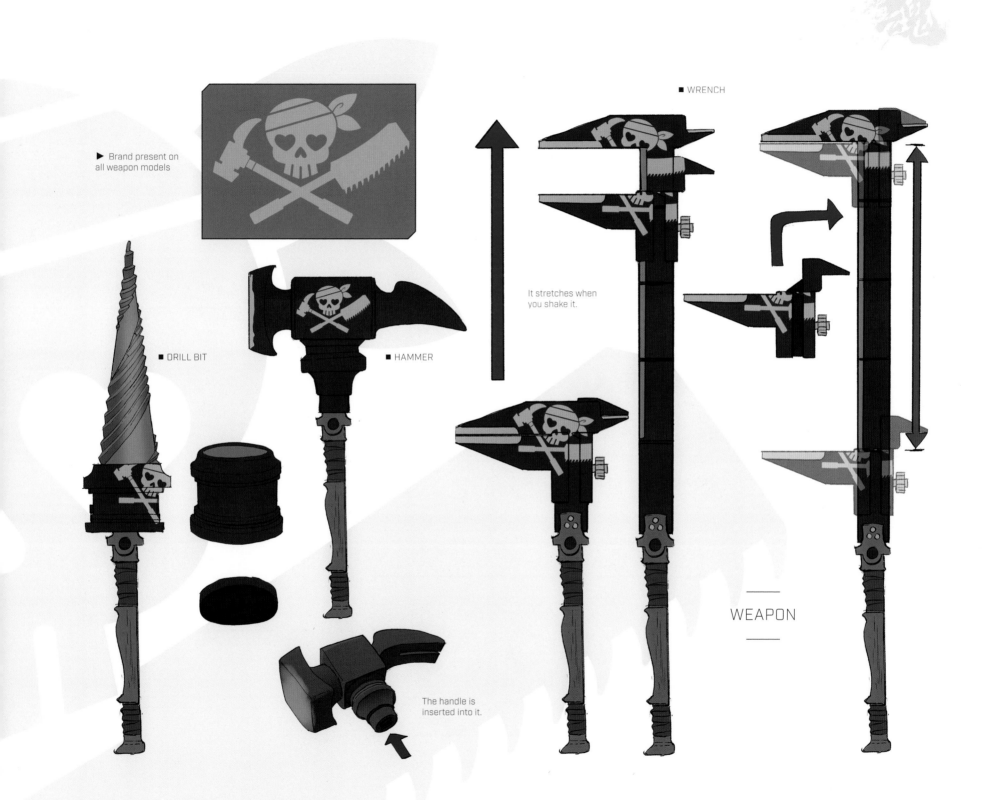

▶ Brand present on all weapon models

■ WRENCH

■ DRILL BIT

■ HAMMER

It stretches when you shake it.

The handle is inserted into it.

WEAPON

DARLI DAGGER

C01

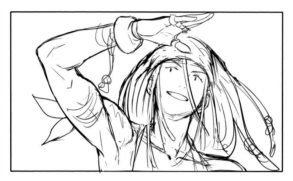

As the battle ends, Darli cannot believe her eyes. She sees an ocean of glimmering petals that stretches as far as the eye can see.

As the warm spring breeze brushes past her face, she lets slip a smile.

Though she may not have apprehended the criminal who ruined her ship, she is satisfied with the prize of a beautiful view.

And so Darli prepares to head for home, where friends await her return.

C02

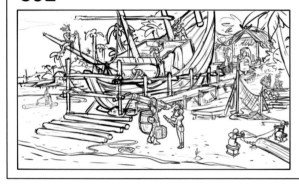

舟　もっと大きく‥

There are many at the shipyard eager to see dear Darli again.

Darli thanks each and every one of them for helping her rebuild her ship, and loses no time in returning to work.

With every roar of a saw meeting wood, a sense of normality returns to the yard.

Indeed, Darli works twice as fast to make up for the time lost on her travels.

C03

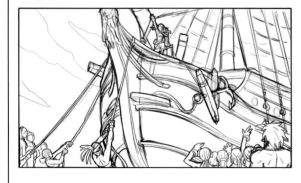

Several months have passed since her return. Today is the day of her ship's maiden voyage.

As the crowds gather for the ceremony, there he is—the masked man. The anger she felt that fateful day gushes forth like it was yesterday.

But he is no match for the gang of female workers who seize him and prevent his escape.

Witnesses tell of the events that transpired next.

Darli exacted her "justice" on him for three days and three nights. His cries could be heard in every port, town, and village on the island.

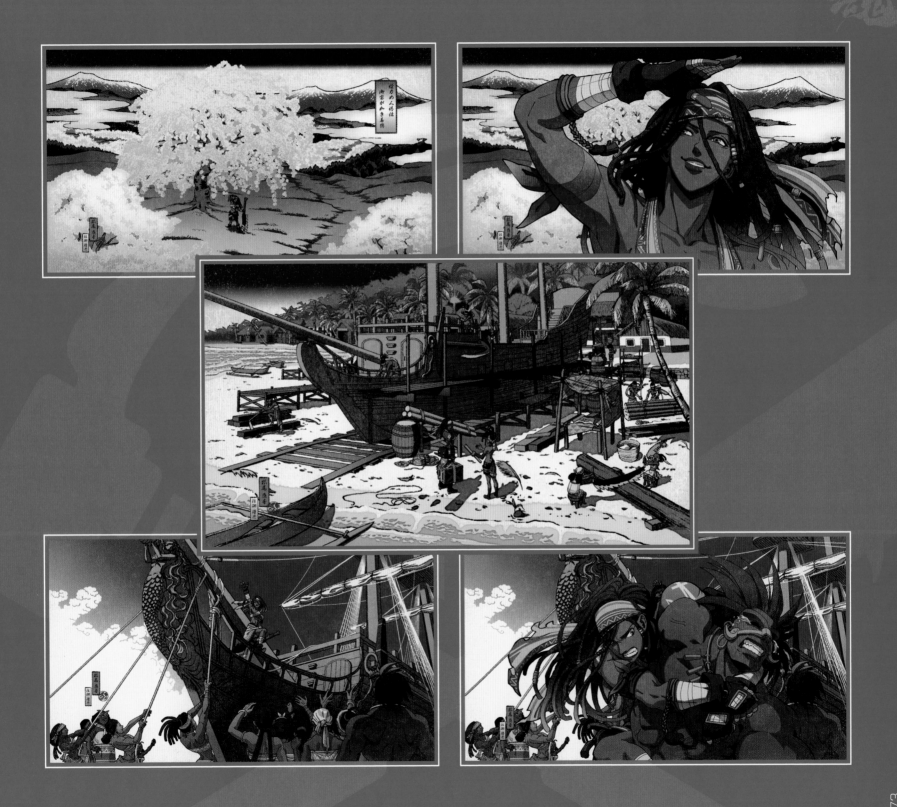

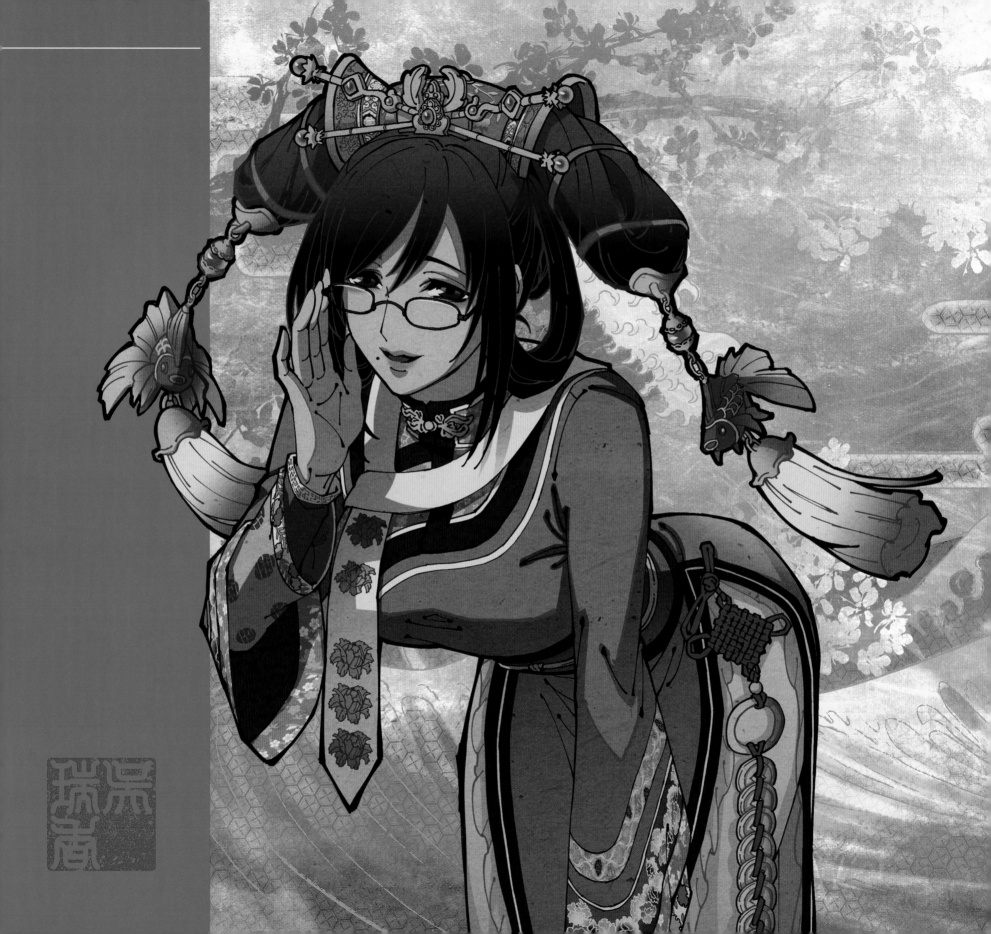

RUIXIANG

Voice Actor: Seira Ryu

The terror plaguing the Qing Empire for the past year continues to cast a long and dark shadow over its borders. With each passing day, anti-imperial sentiment grows and leads to uprisings throughout the land.

Concerned this state of affairs may grow worse still, the emperor turns to the greatest feng shui master of the period—Wu-Ruixiang—and orders her to rid the empire of this evil. With her grandfather's feng shui luopan in hand, Wu-Ruixiang ventures into the heart of the darkness, eager to restore peace to the empire.

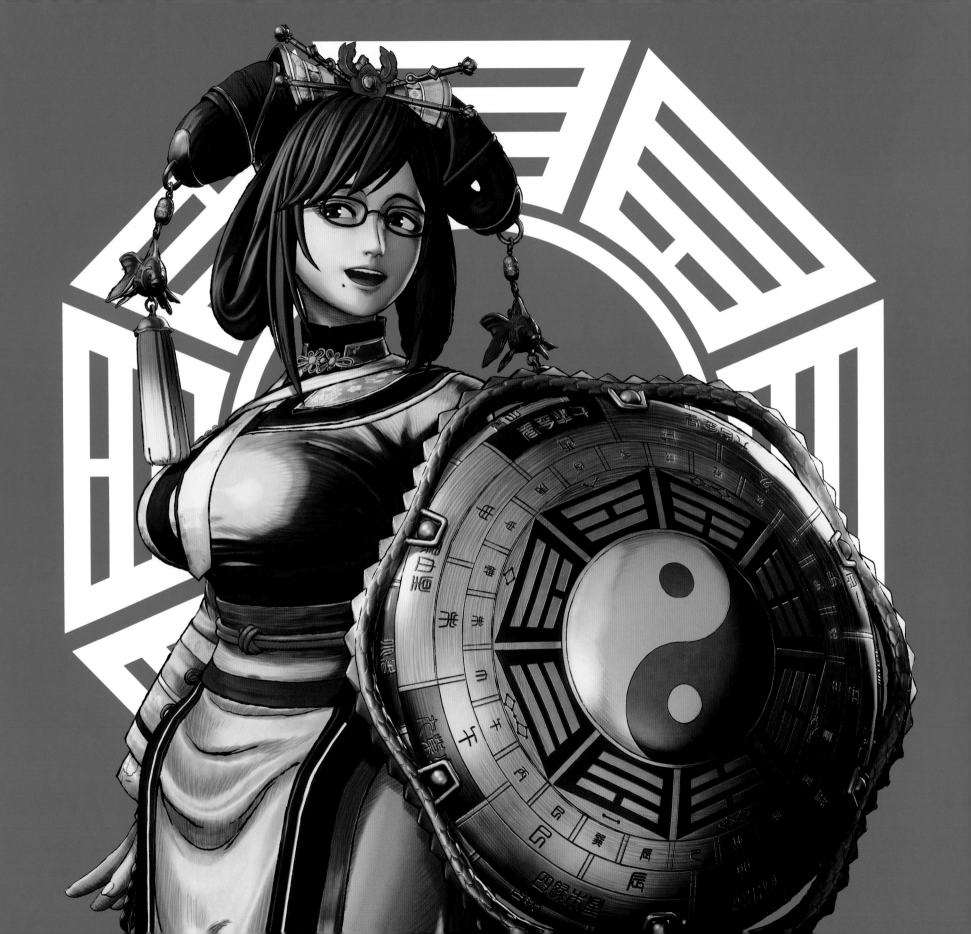

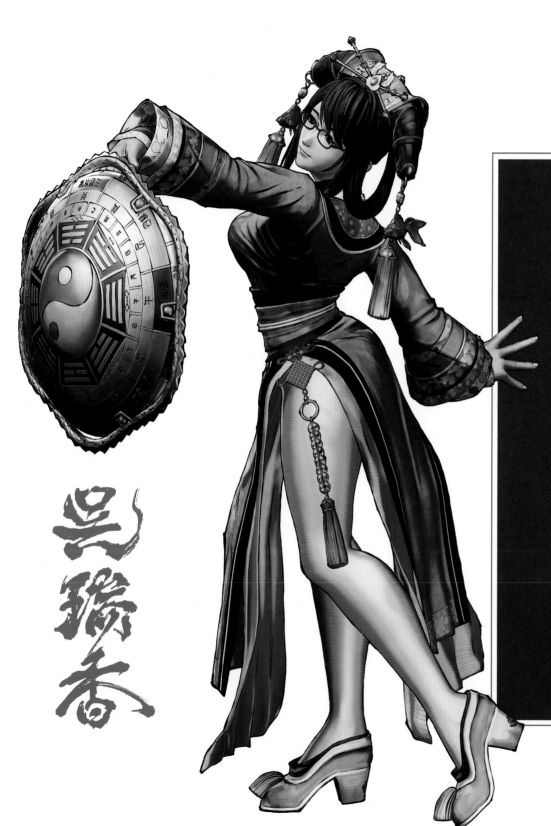

RUIXIANG

FULL NAME:
Wu-Ruixiang

BIRTHDAY:
May 5

BIRTHPLACE:
Beijing (China)

BLOOD TYPE:
O

WEAPON:
Luopan: "Advanced Zhaolong Luopan"

FIGHTING STYLE:
Wu-style feng shui

LIKES:
Her sister's cooking

DISLIKES:
Lectures from her grandfather, sore muscles

HOBBIES:
Collecting lucky accessories

FIRST APPEARANCE:
SAMURAI SHODOWN (2019)

WU-RUIXIANG

DRAFTS

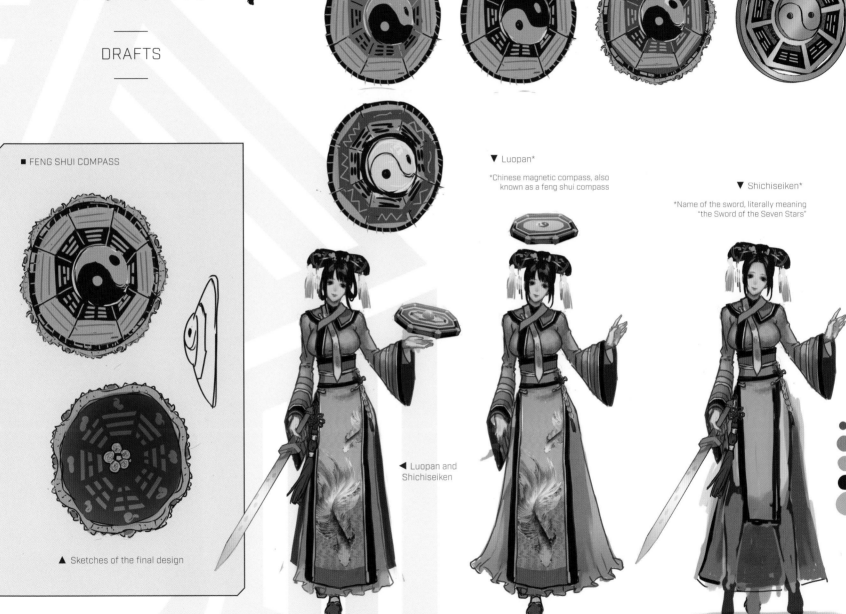

- FENG SHUI COMPASS

▲ Sketches of the final design

▼ Luopan*

*Chinese magnetic compass, also
known as a feng shui compass

▼ Shichiseiken*

*Name of the sword, literally meaning
"the Sword of the Seven Stars"

◄ Luopan and
Shichiseiken

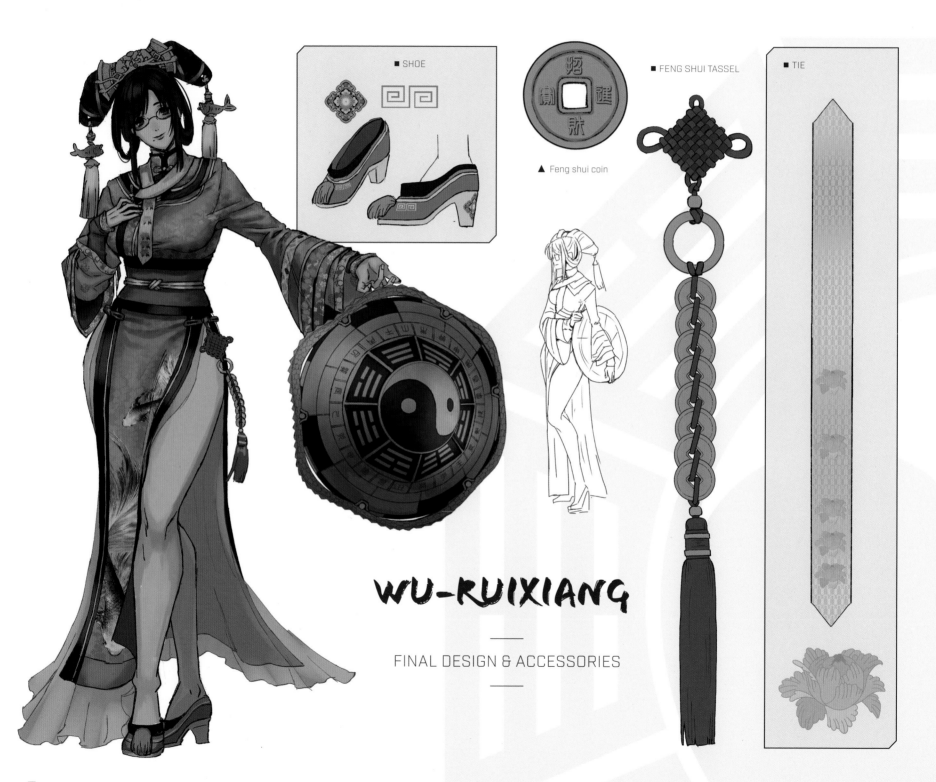

■ SHOE

■ FENG SHUI TASSEL

▲ Feng shui coin

■ TIE

WU-RUIXIANG

FINAL DESIGN & ACCESSORIES

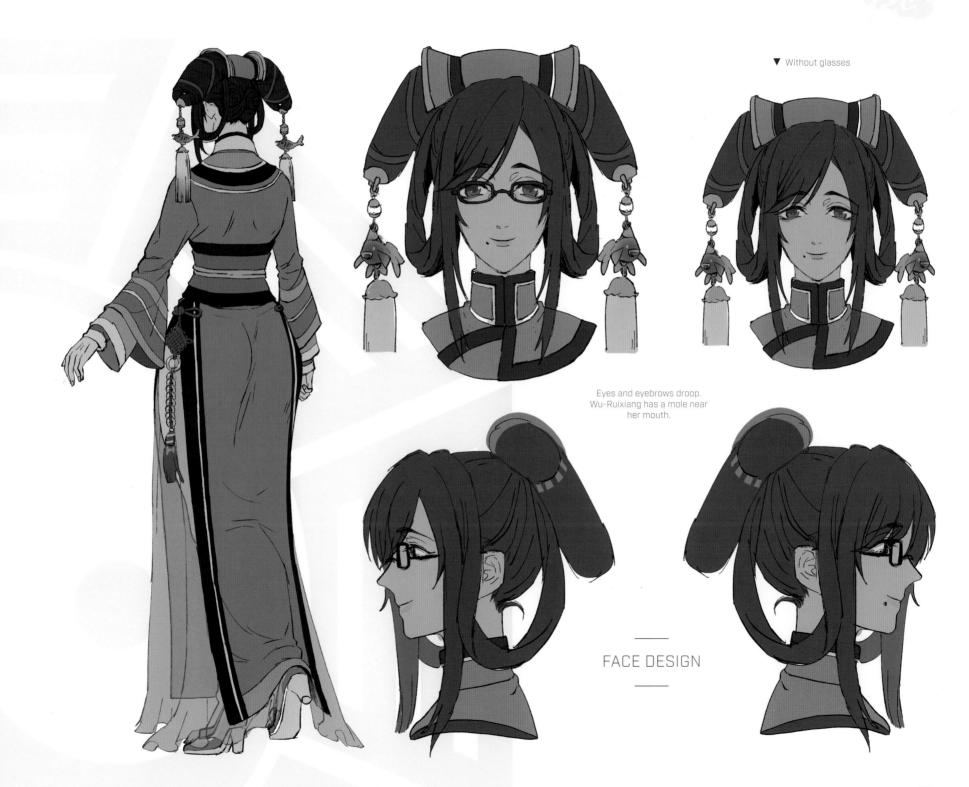

▼ Without glasses

Eyes and eyebrows droop.
Wu-Ruixiang has a mole near
her mouth.

FACE DESIGN

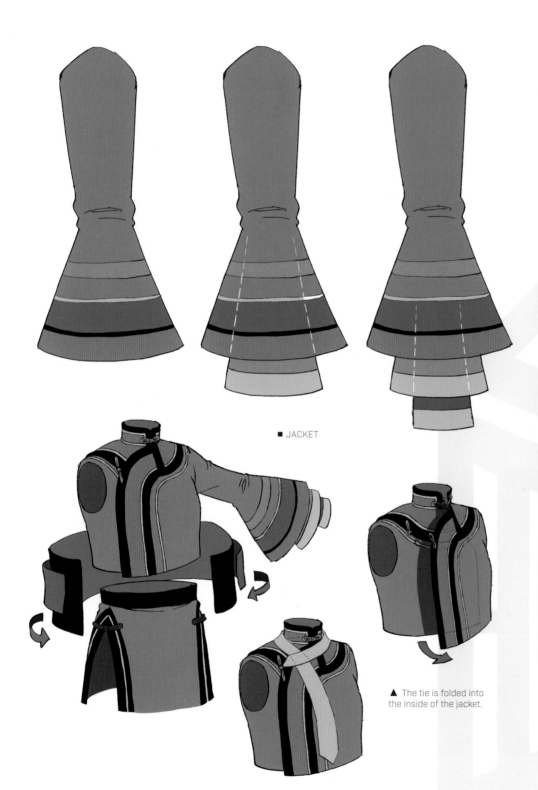

■ JACKET

▲ The tie is folded into the inside of the jacket.

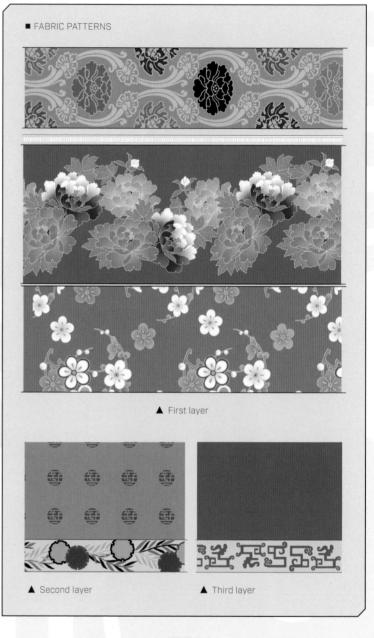

■ FABRIC PATTERNS

▲ First layer

▲ Second layer

▲ Third layer

CLOTHES

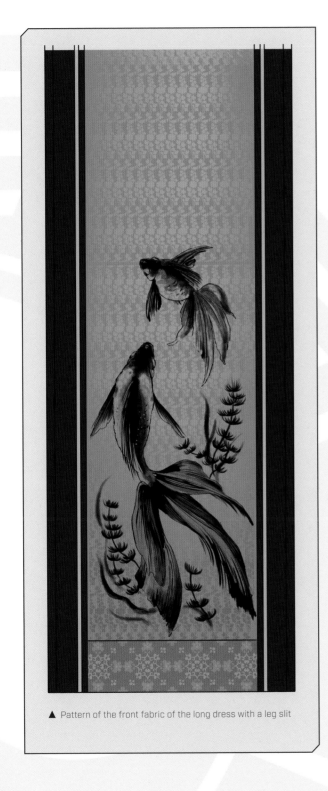

▲ Pattern of the front fabric of the long dress with a leg slit

WU-RUIXIANG

WEAPON

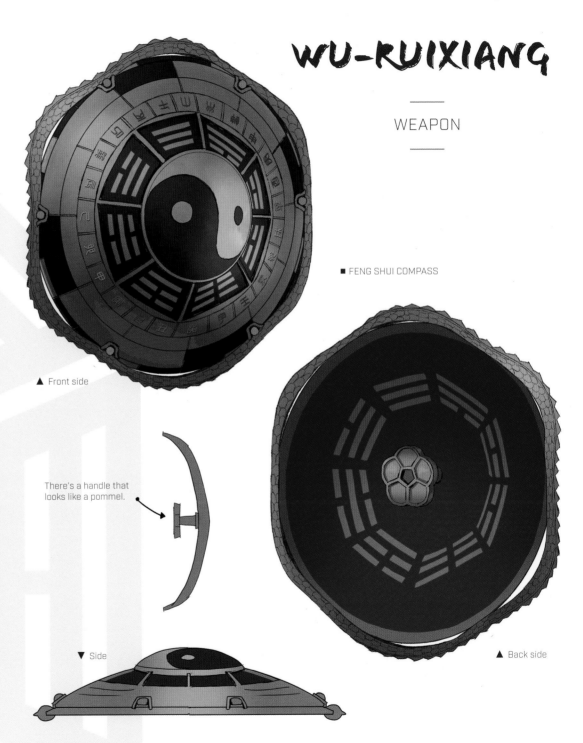

■ FENG SHUI COMPASS

▲ Front side

There's a handle that looks like a pommel.

▼ Side

▲ Back side

⬚ The upper part is divided in two sections, on the left and on the right.

⬚ A ring is formed in the upper back of the skull.

⬚ A section of the rest of the hair is taken and wrapped around the ring (side view).

⬚ The bottom hair is braided and wrapped around the base of the hairstyle.

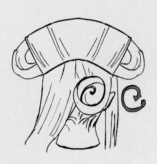

⬚ Everything is tied up.

⬚ The back of the hair is separated in half and then rolled up while twisting it (side view).

⬚ Some of the hair is taken from the side and tied up by pulling it into the base of the hairstyle.

WU-RUIXIANG

HAIRSTYLE

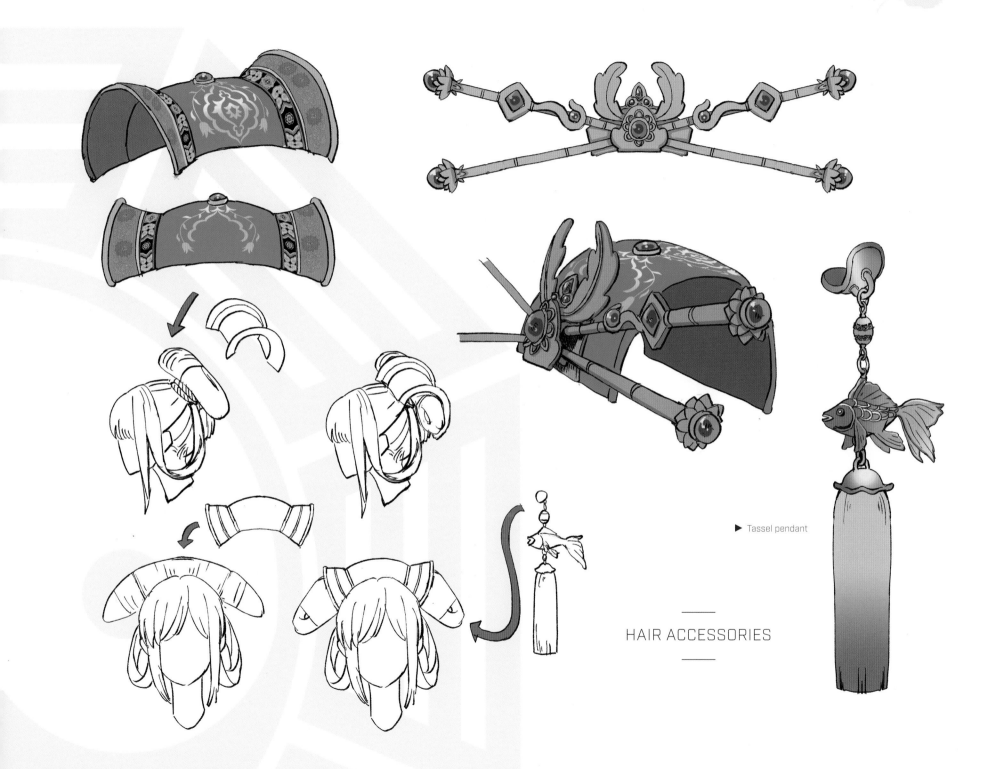

► Tassel pendant

HAIR ACCESSORIES

EPILOGUE

C01

Ruixiang observes the passing of Shizuka Gozen and finds herself awestruck by the tempest of cherry blossoms before her.

And perhaps in honor of Shizuka Gozen's liberation from the malevolent force, the petals dance upon the breeze before floating off into the distance.

The earth regains its steady and vibrant pulse once more.

Ruixiang, basking in the glow of her success, begins her journey home with a spring in her step.

C02

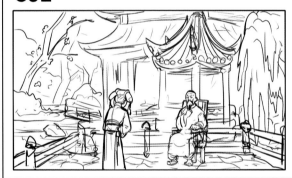

Upon her arrival, she receives some welcome news: the end of the blight in Japan has strangely coincided with the calming of the rebellion at home.

Her grandfather listens as, barely able to hide her excitement, she regales him with tales of her escapades across the sea.

Her perilous journey has come to an end. Now her attention must turn to sovereign soil, and protecting the empire with her feng shui.

C03

One day, about a month after the events in Japan, Ruixiang is summoned to the royal audience chamber.

"By order of His Imperial Majesty, you are hereby commanded to venture forth to foreign lands and investigate the source of this ancient malevolence."

Ruixiang can barely believe her ears as she hears the emperor's new orders.

As her newfound hopes and dreams crumble away and are replaced by despair at what is to come, she nonetheless heeds her ruler's call to duty and sets forth on her mission.

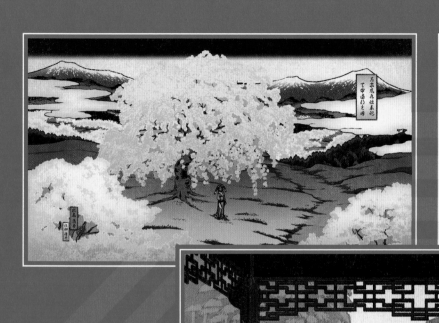

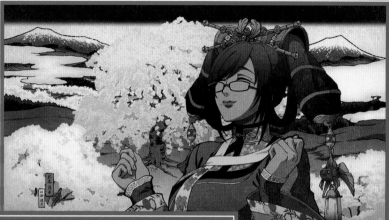

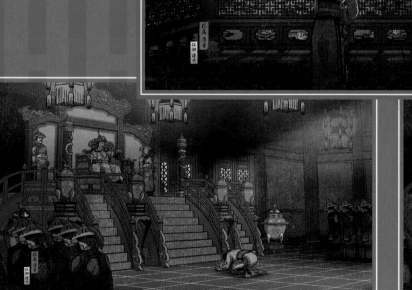

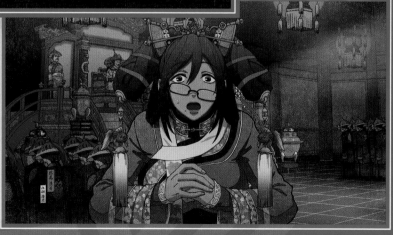

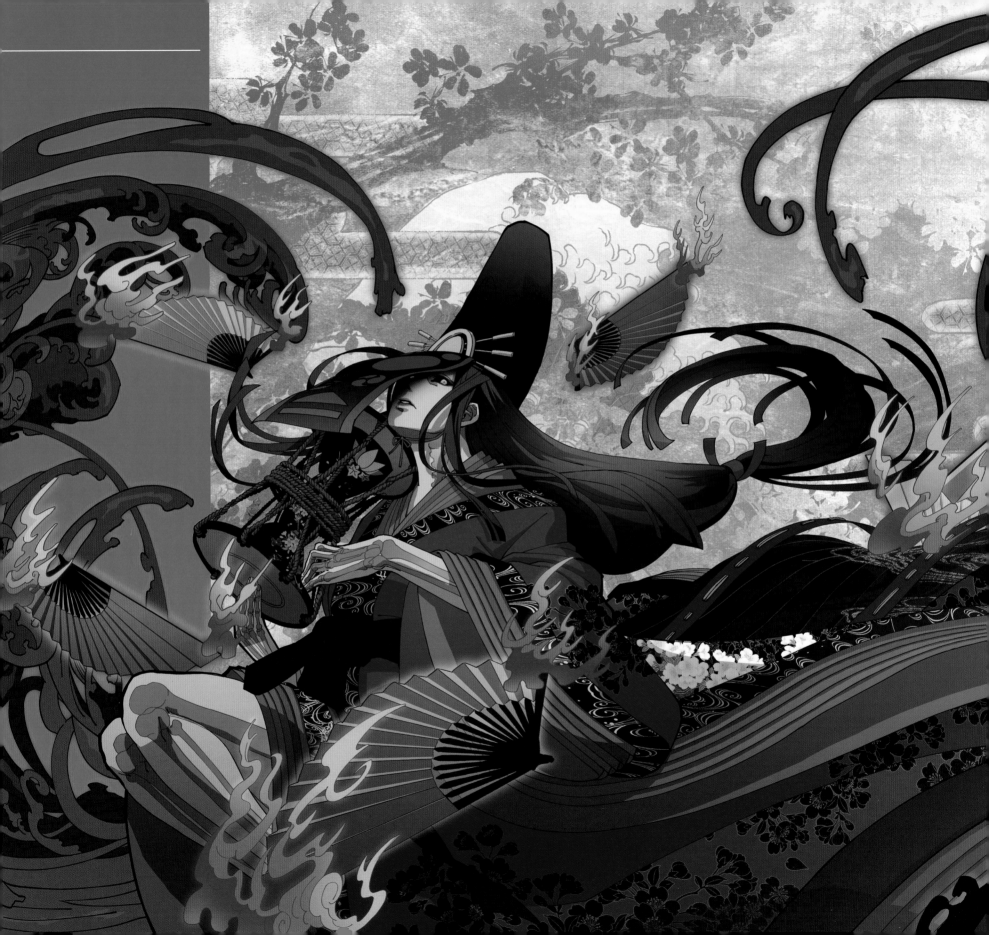

SHIZUKA

Voice Actor: Junko Ueda

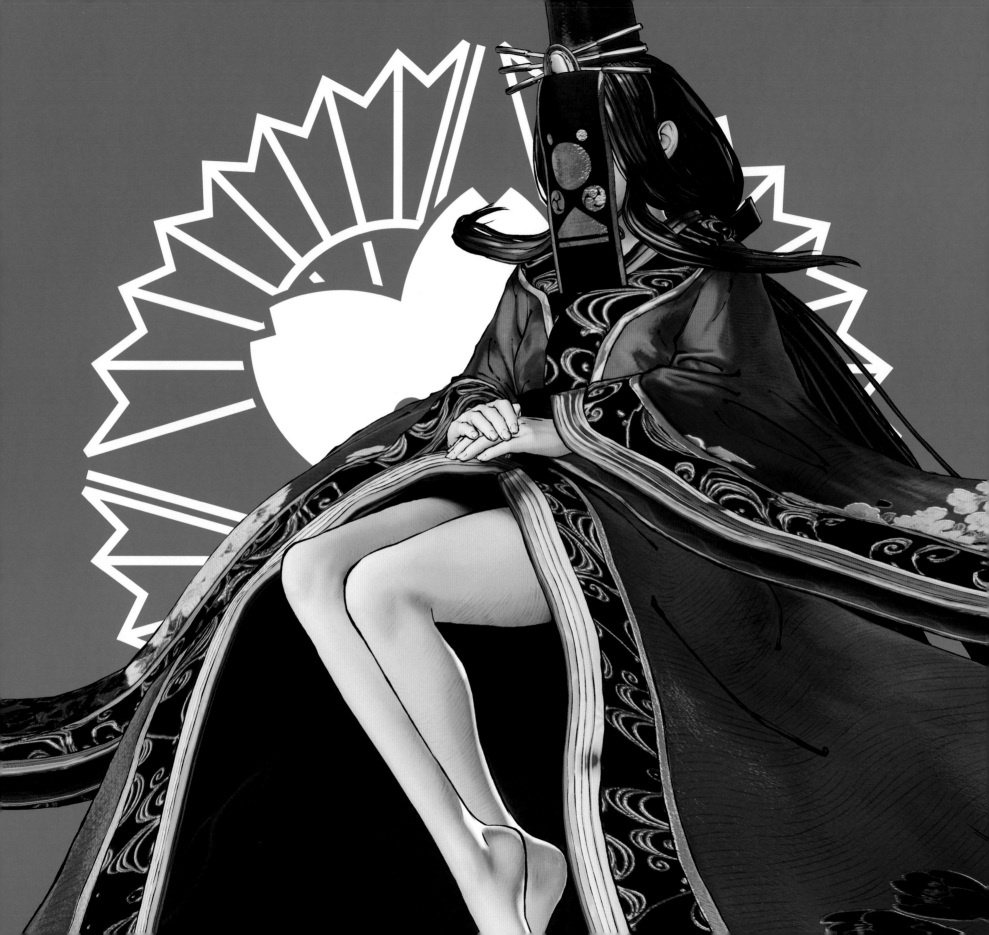

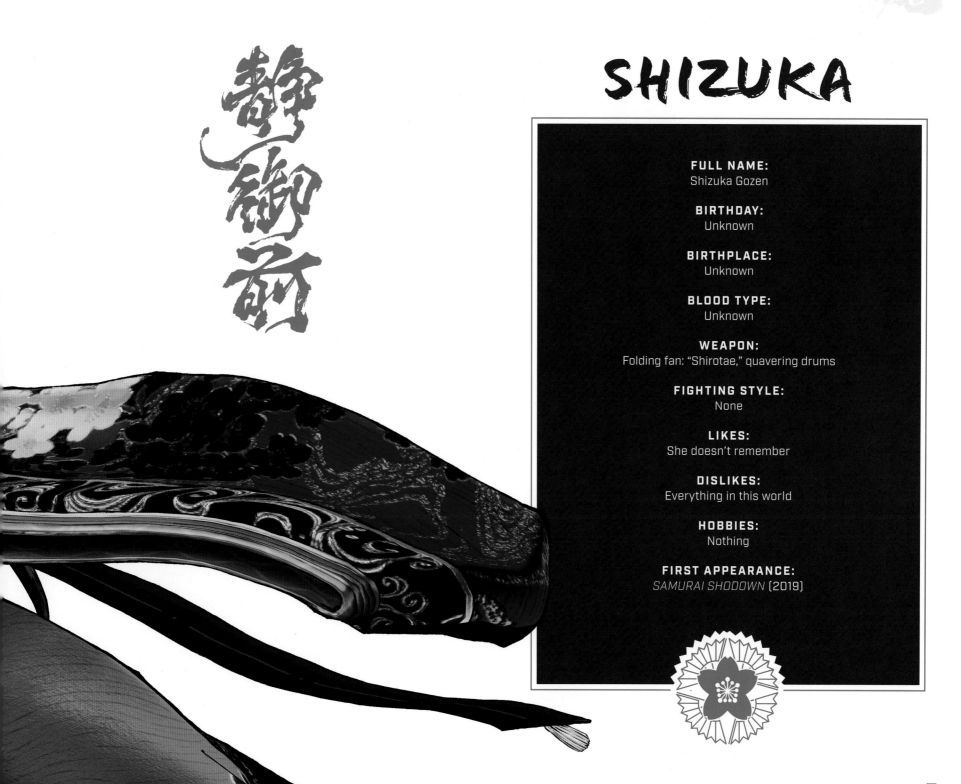

静御前

SHIZUKA

FULL NAME:
Shizuka Gozen

BIRTHDAY:
Unknown

BIRTHPLACE:
Unknown

BLOOD TYPE:
Unknown

WEAPON:
Folding fan: "Shirotae," quavering drums

FIGHTING STYLE:
None

LIKES:
She doesn't remember

DISLIKES:
Everything in this world

HOBBIES:
Nothing

FIRST APPEARANCE:
SAMURAI SHODOWN (2019)

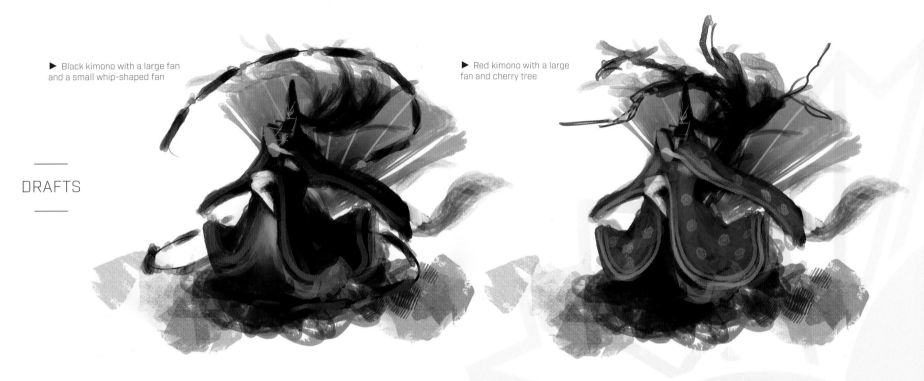

► Black kimono with a large fan and a small whip-shaped fan

► Red kimono with a large fan and cherry tree

DRAFTS

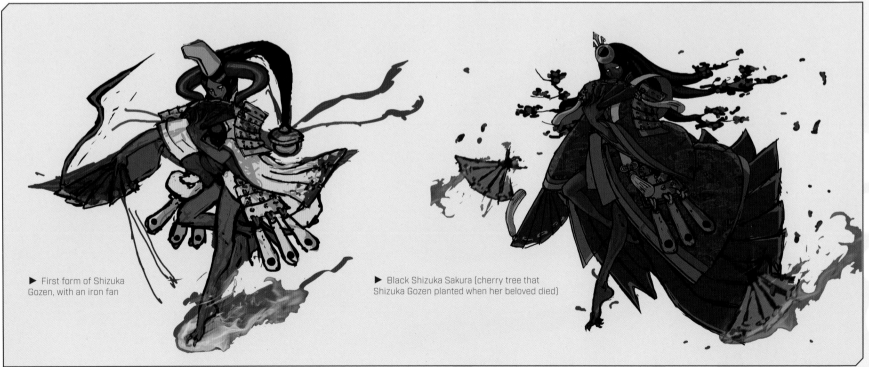

► First form of Shizuka Gozen, with an iron fan

► Black Shizuka Sakura (cherry tree that Shizuka Gozen planted when her beloved died)

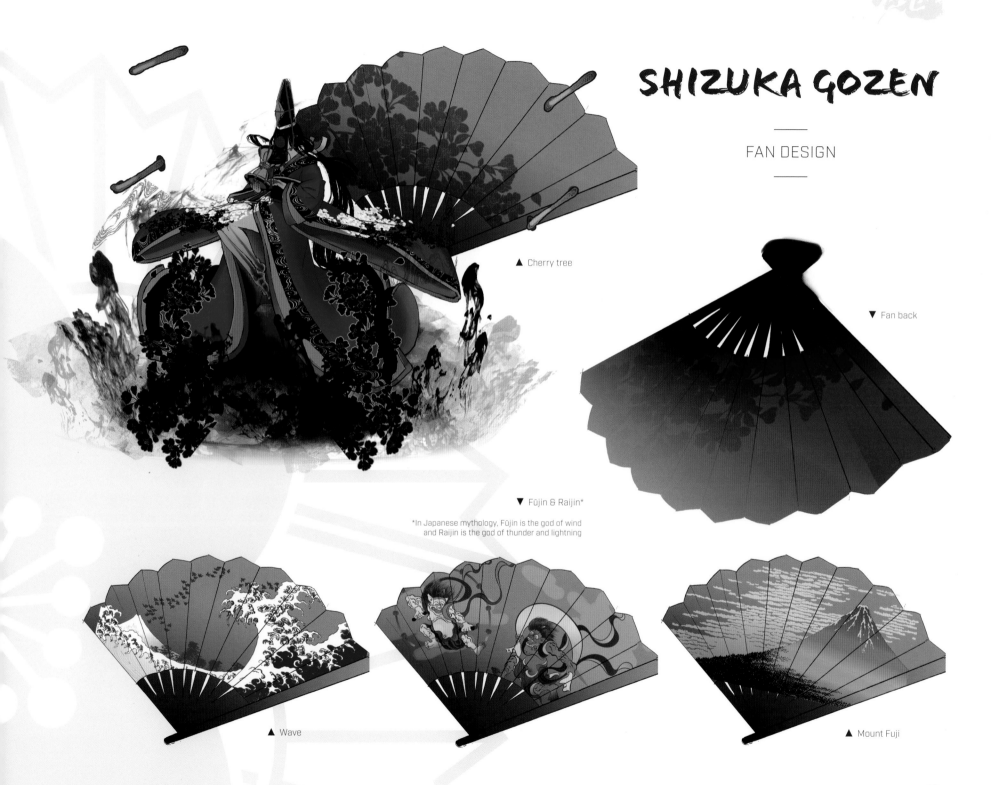

SHIZUKA GOZEN

FAN DESIGN

▲ Cherry tree

▼ Fan back

▼ Fūjin & Raijin*

*In Japanese mythology, Fūjin is the god of wind
and Raijin is the god of thunder and lightning

▲ Wave

▲ Mount Fuji

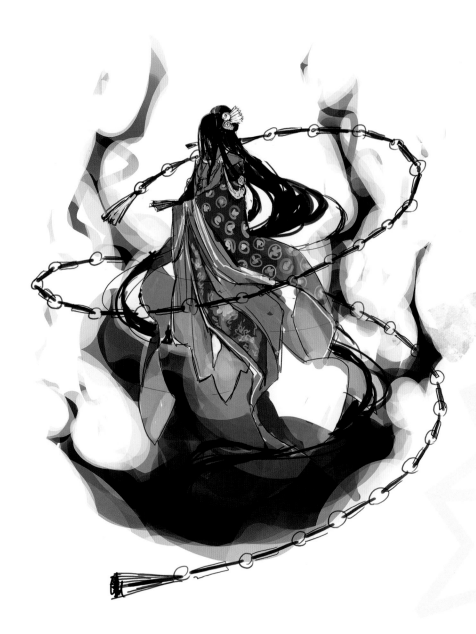

SHIZUKA GOZEN

KIMONO DESIGN

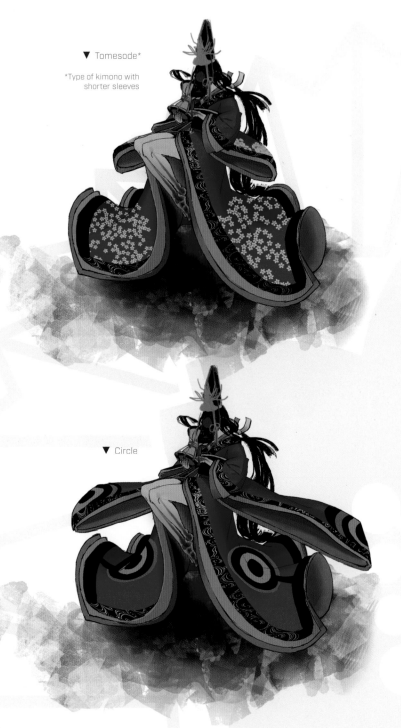

▼ Tomesode*

*Type of kimono with shorter sleeves

▼ Circle

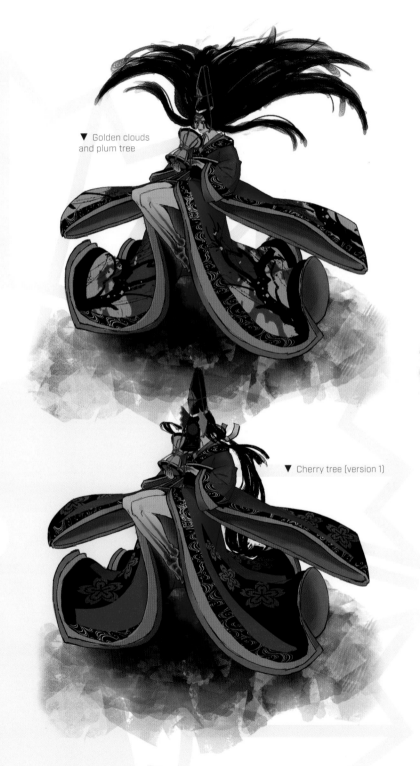

▼ Golden clouds and plum tree

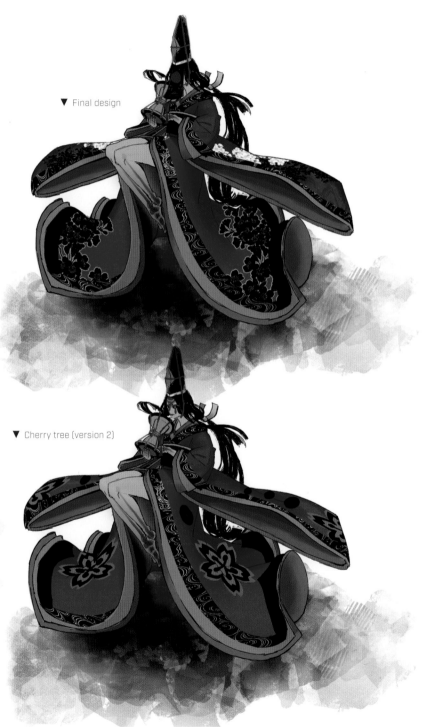

▼ Final design

▼ Cherry tree (version 1)

▼ Cherry tree (version 2)

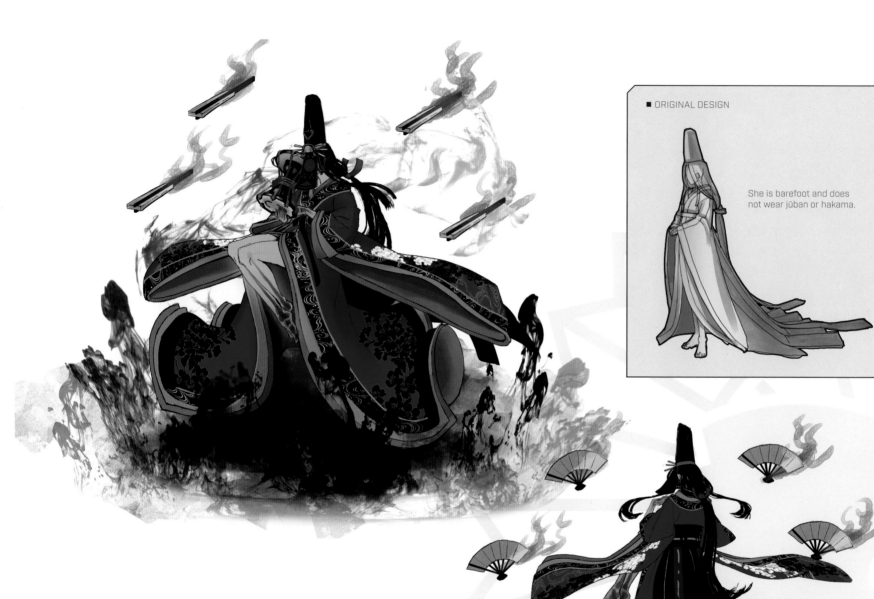

She is barefoot and does not wear jūban or hakama.

SHIZUKA GOZEN

FINAL DESIGN (PHASE 1)

SHIZUKA GOZEN

FINAL DESIGN (PHASE 2)

■ TRANSFORMATION

The spiritual body is naked and blue. It is translucent and you can see its bones (the body itself is not transparent; you can't see through it, only inside it). The skull does not seem to disappear (so as not to appear too scary). The exterior of the body is vaguely brightened to give the impression that it emits light.

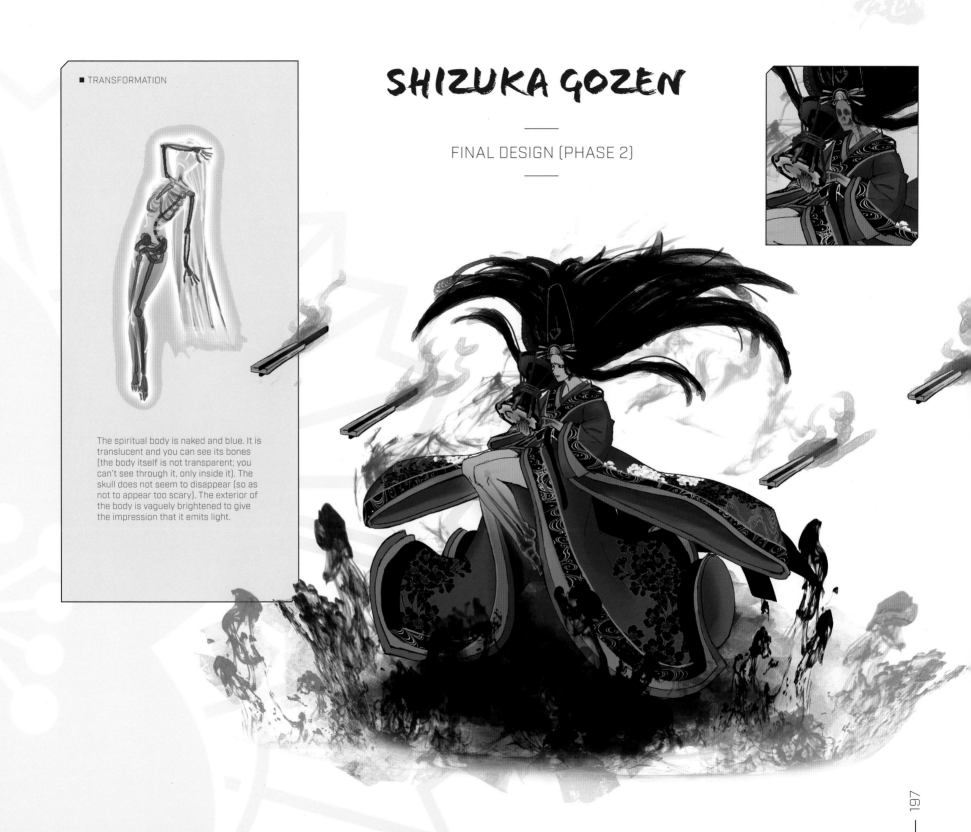

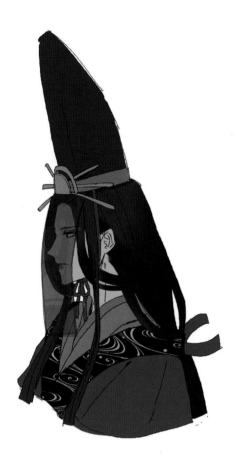
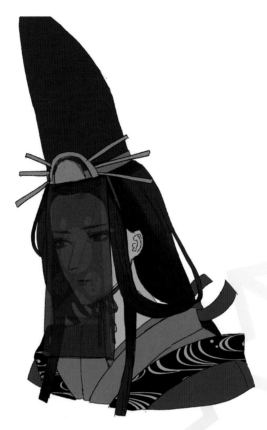
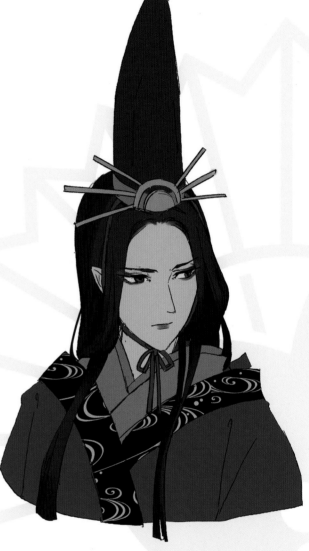

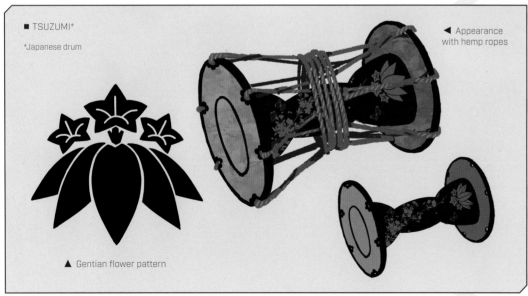

■ TSUZUMI*

*Japanese drum

◄ Appearance
with hemp ropes

▲ Gentian flower pattern

SHIZUKA GOZEN

—

FACE DESIGN & ACCESSORY

—

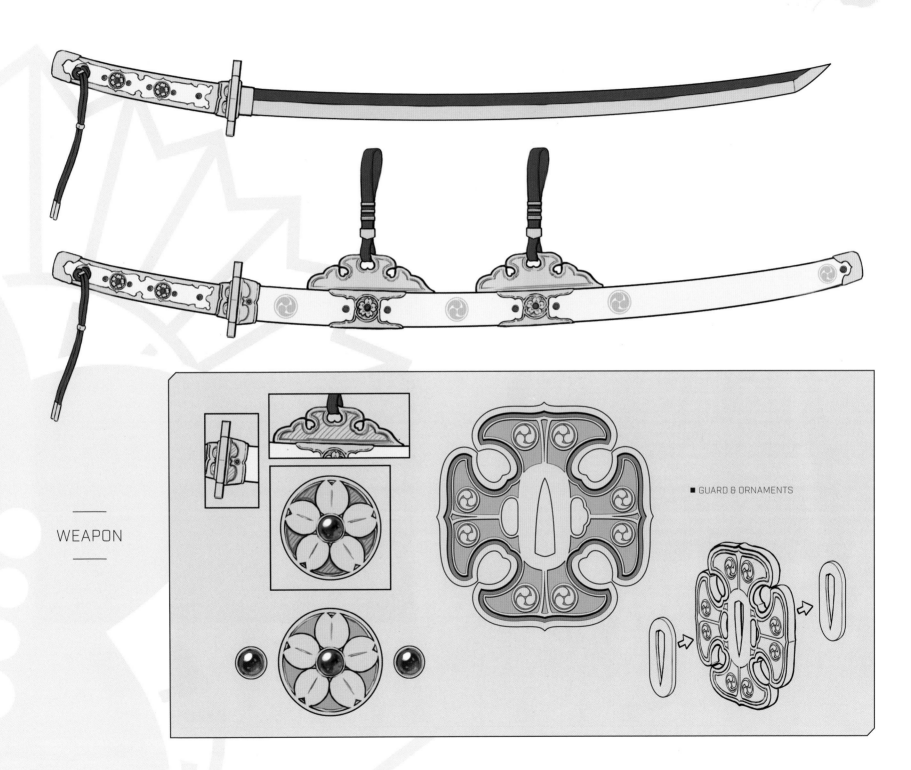

WEAPON

■ GUARD & ORNAMENTS

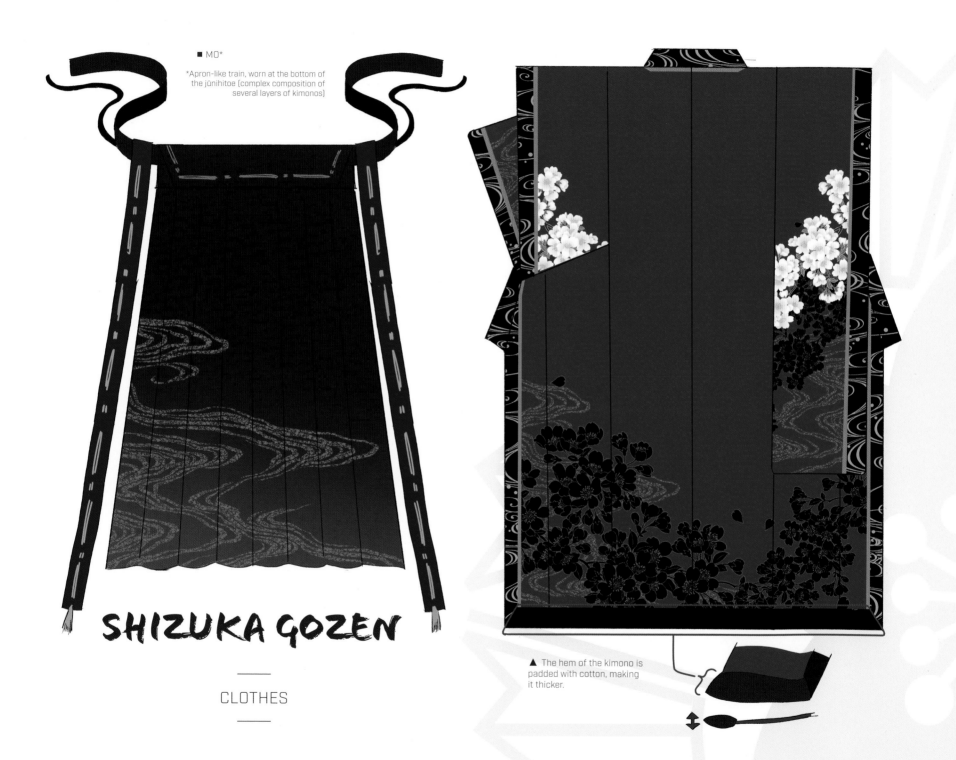

■ MO*

*Apron-like train, worn at the bottom of the jūnihitoe (complex composition of several layers of kimonos)

SHIZUKA GOZEN

CLOTHES

▲ The hem of the kimono is padded with cotton, making it thicker.

CLOTHES & ACCESSORIES

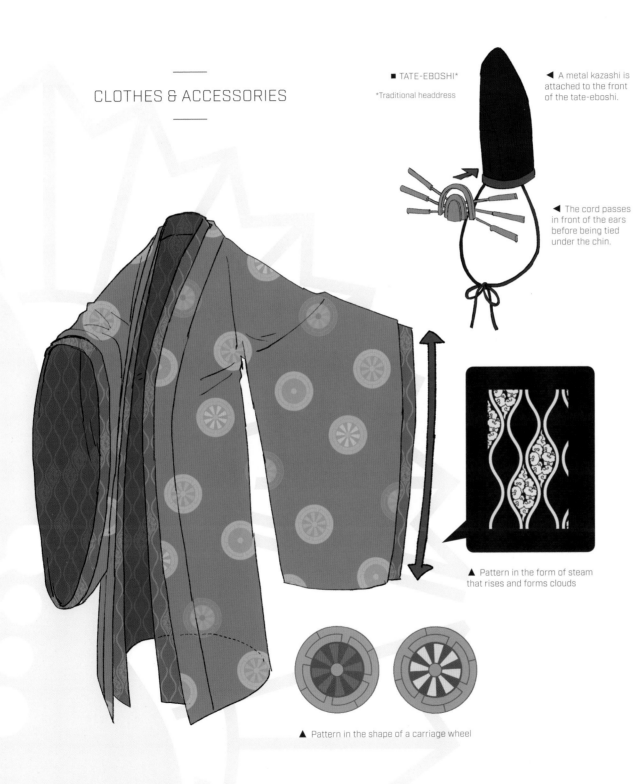

▲ Pattern in the shape of a carriage wheel

■ TATE-EBOSHI*

*Traditional headdress

◄ A metal kazashi is attached to the front of the tate-eboshi.

◄ The cord passes in front of the ears before being tied under the chin.

■ KAZASHI*

*Hairpin

▼ Slightly curved

▲ Pattern in the form of steam that rises and forms clouds

■ ZŌMEN*

*Fabric or paper mask used in traditional bugaku dance

CANCELED CHARACTERS

DRAFTS

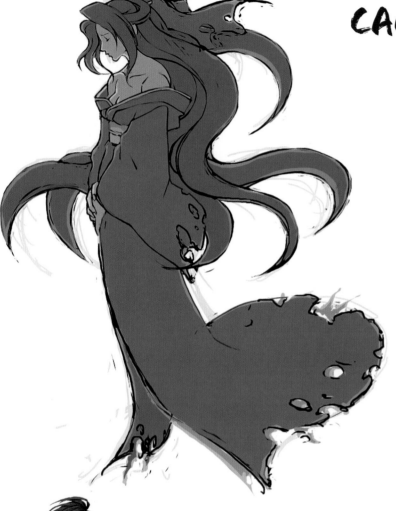

■ KAGARIBI (GHOST OF BASARA'S WIFE)

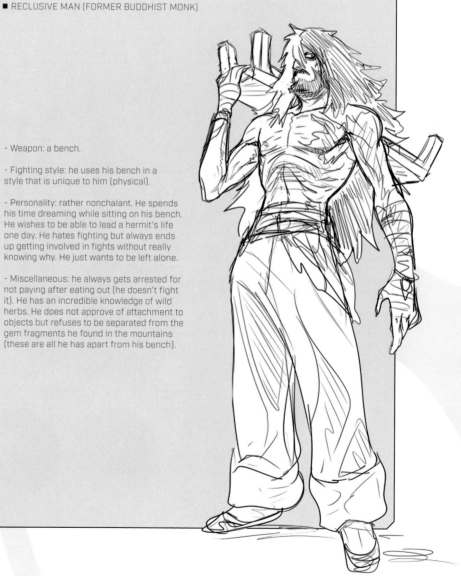

■ RECLUSIVE MAN (FORMER BUDDHIST MONK)

- Weapon: a bench.

- Fighting style: he uses his bench in a style that is unique to him (physical).

- Personality: rather nonchalant. He spends his time dreaming while sitting on his bench. He wishes to be able to lead a hermit's life one day. He hates fighting but always ends up getting involved in fights without really knowing why. He just wants to be left alone.

- Miscellaneous: he always gets arrested for not paying after eating out (he doesn't fight it). He has an incredible knowledge of wild herbs. He does not approve of attachment to objects but refuses to be separated from the gem fragments he found in the mountains (these are all he has apart from his bench).

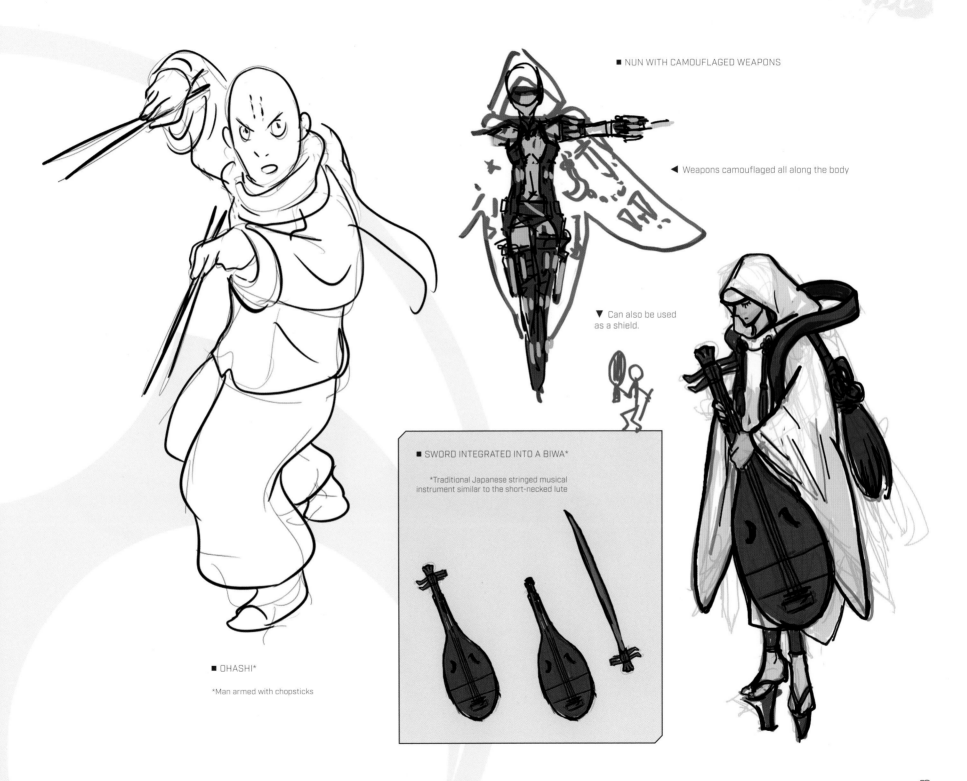

■ NUN WITH CAMOUFLAGED WEAPONS

◀ Weapons camouflaged all along the body

▼ Can also be used as a shield.

■ SWORD INTEGRATED INTO A BIWA*

*Traditional Japanese stringed musical instrument similar to the short-necked lute

■ OHASHI*

*Man armed with chopsticks

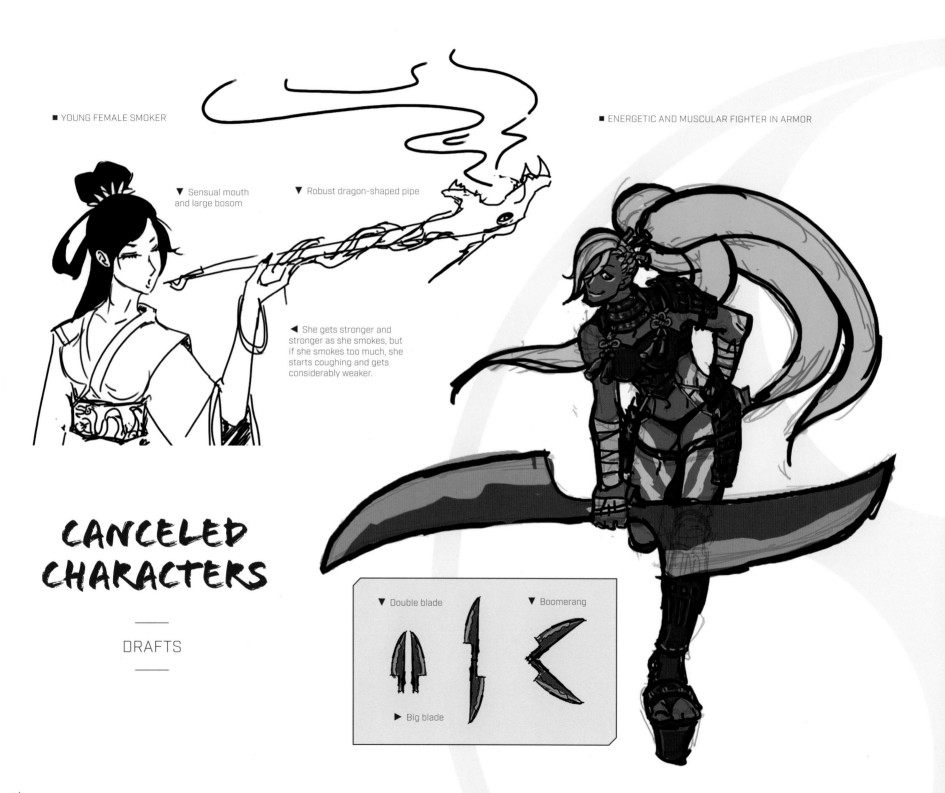

■ YOUNG FEMALE SMOKER

■ ENERGETIC AND MUSCULAR FIGHTER IN ARMOR

▼ Sensual mouth and large bosom

▼ Robust dragon-shaped pipe

◄ She gets stronger and stronger as she smokes, but if she smokes too much, she starts coughing and gets considerably weaker.

CANCELED CHARACTERS

DRAFTS

▼ Double blade

▼ Boomerang

► Big blade

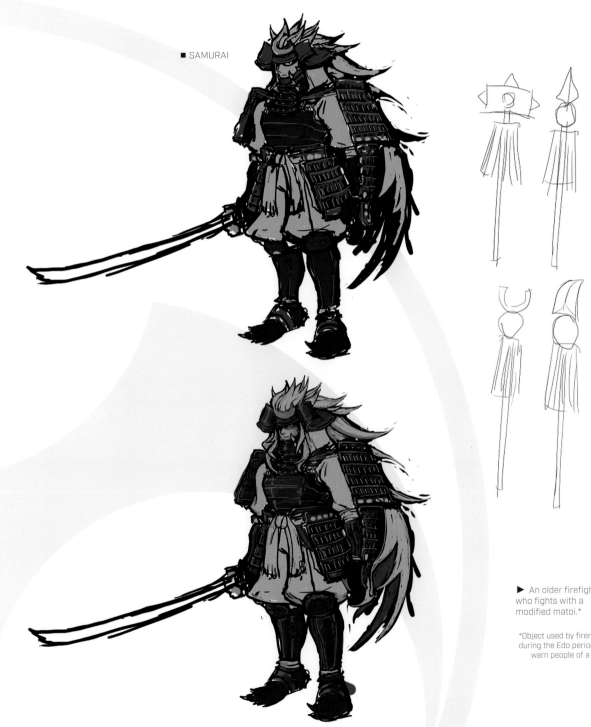

■ SAMURAI

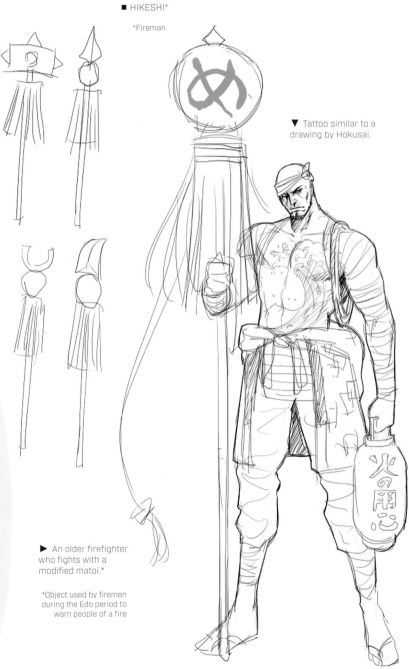

■ HIKESHI*

*Fireman

▼ Tattoo similar to a drawing by Hokusai.

► An older firefighter who fights with a modified matoi.*

*Object used by firemen during the Edo period to warn people of a fire

BACKGROUND
CHARACTERS

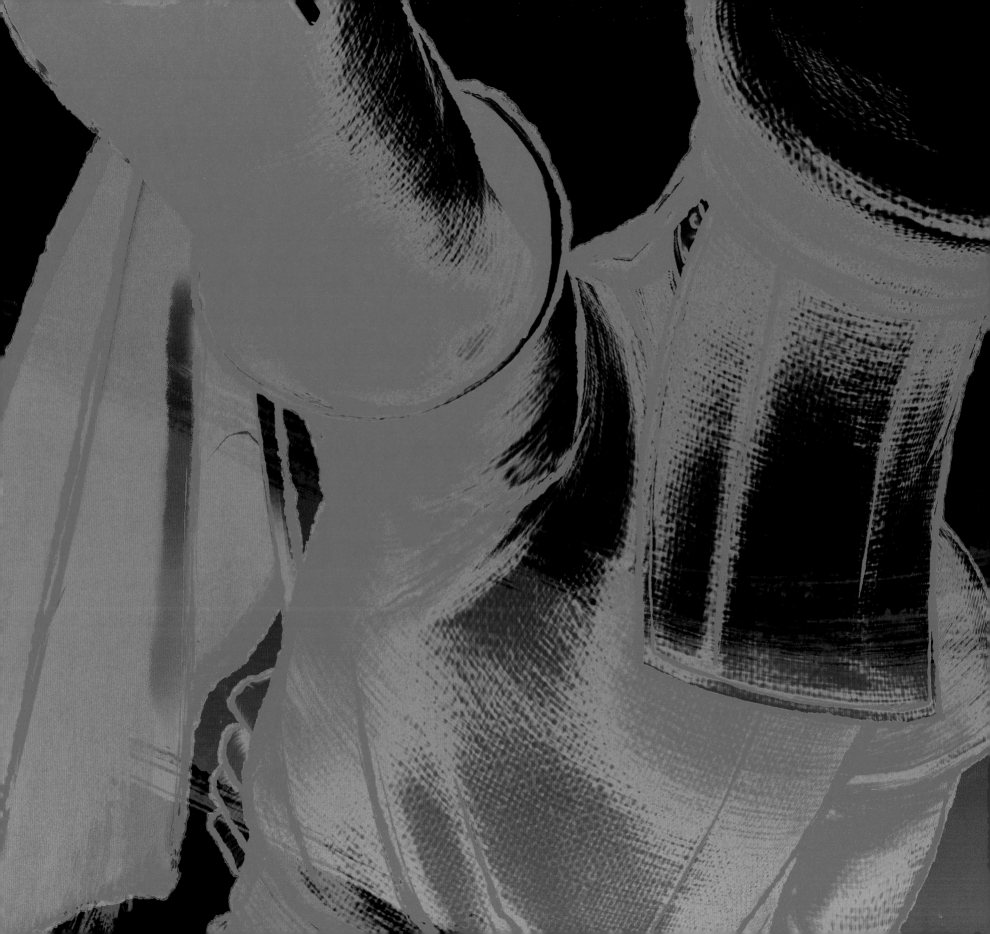

KUROKO

FINAL DESIGN & SKETCHES

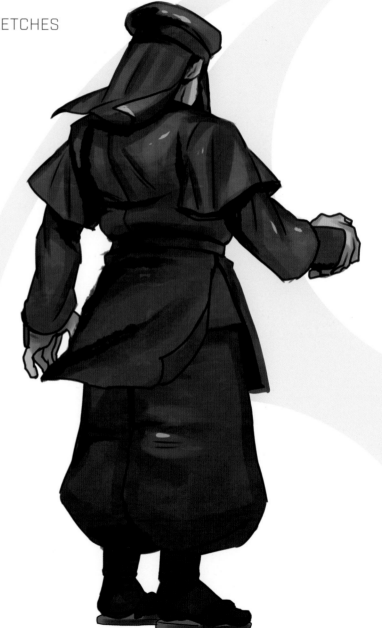

◀ He holds a white flag in his right hand and a red flag in his left hand.

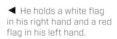

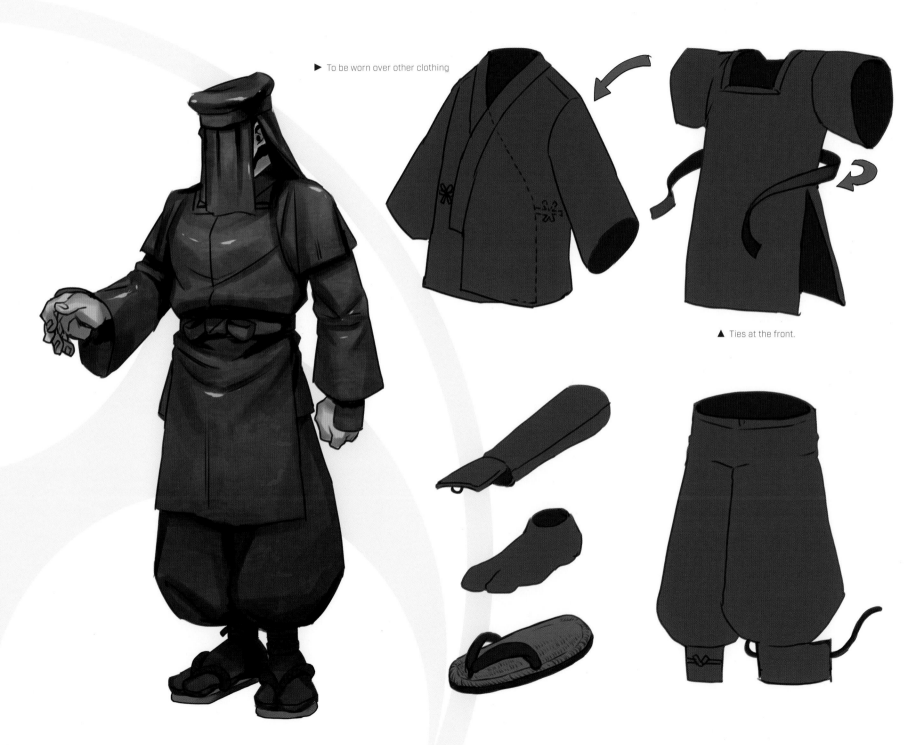

► To be worn over other clothing

▲ Ties at the front.

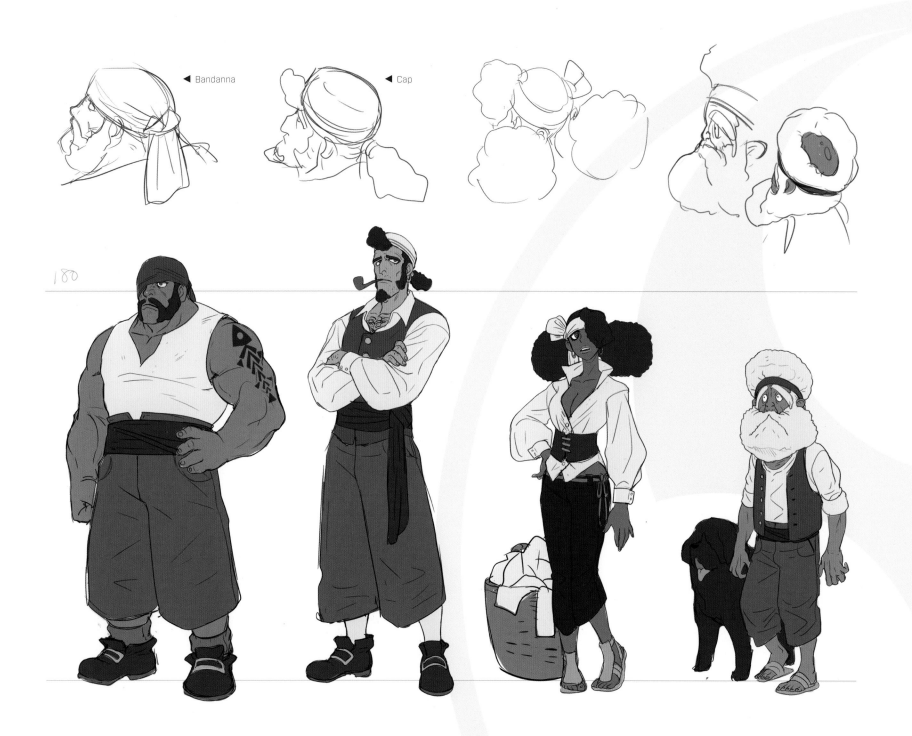

◄ Bandanna

◄ Cap

180

▼ Braid on one side only

► Turban shaped

▲ Coral

◄ Screw

THE SAN FRANCISCO STAGE

—

CHARACTER SKETCHES

—

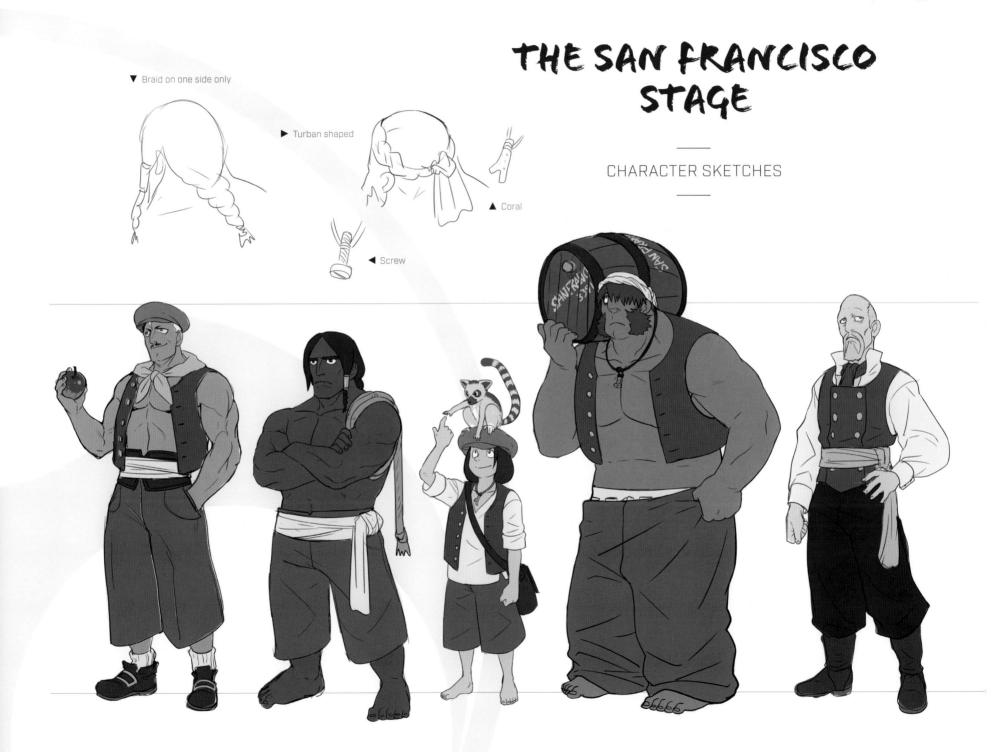

JAPANESE POSTMAN

REJECTED DESIGN

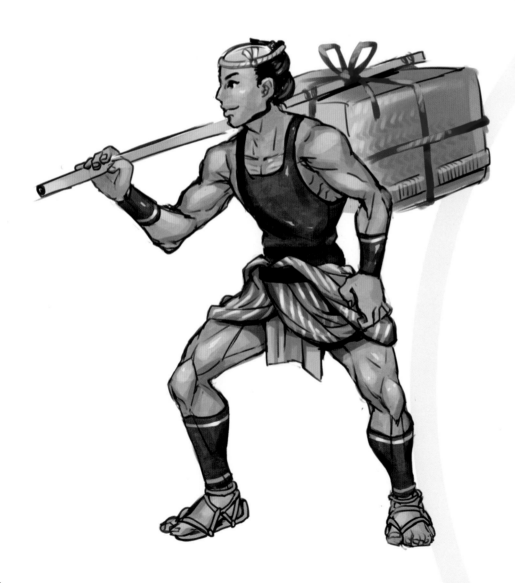

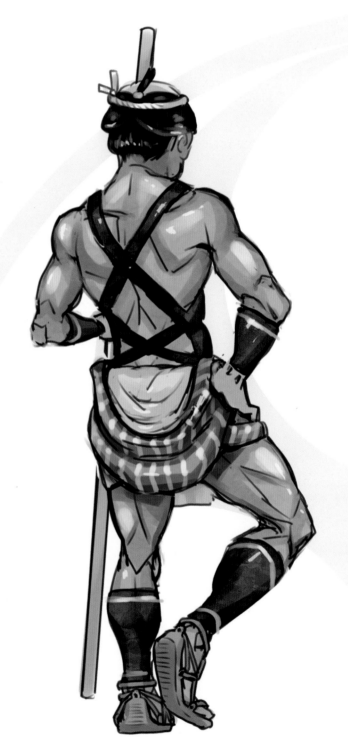

EARTHQUAKE'S HENCHMEN

SKETCHES

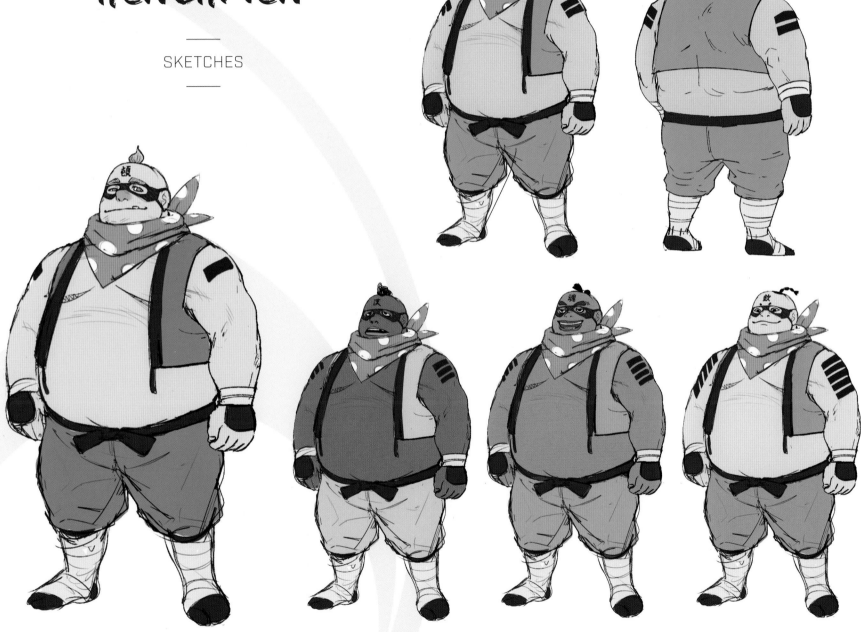

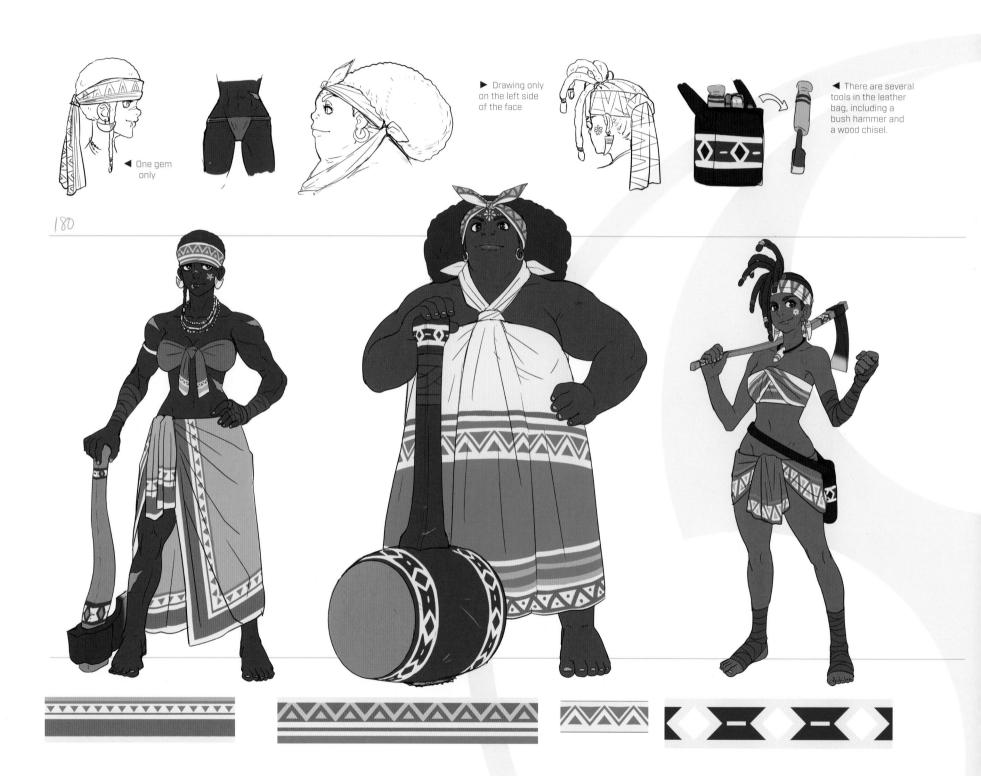

◀ One gem only

▶ Drawing only on the left side of the face

◀ There are several tools in the leather bag, including a bush hammer and a wood chisel.

180

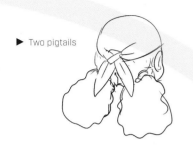

▶ Two pigtails

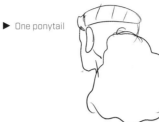

▶ One ponytail

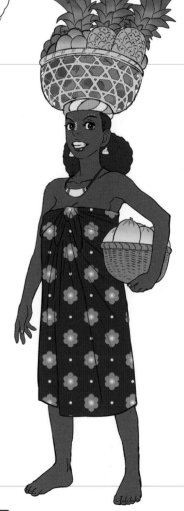

THE MADAGASCAR STAGE

CHARACTER SKETCHES

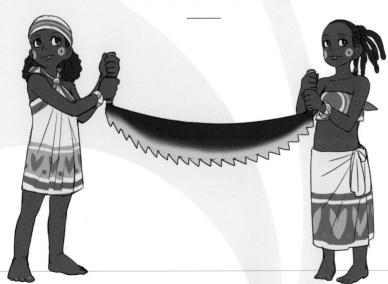

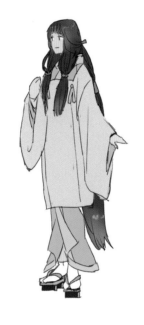

■ SHIRAYURI

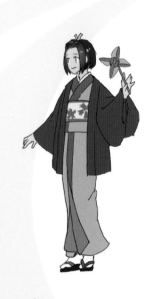

■ NADESHIKO

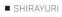

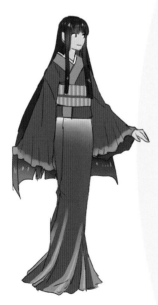

■ ASAGAO

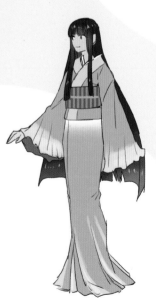

■ YŪGAO

YOSHITORA'S GIRLS

—

SKETCHES

—

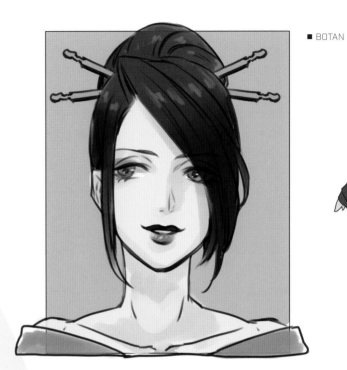

■ BOTAN

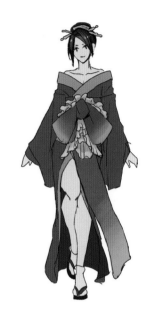

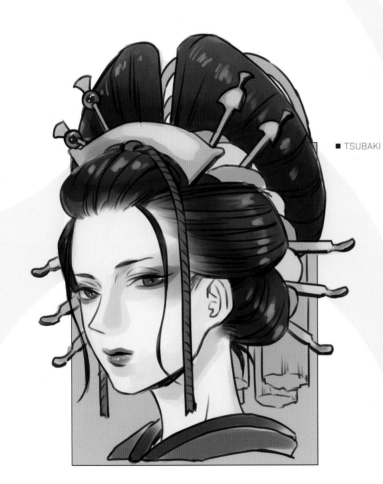

■ TSUBAKI

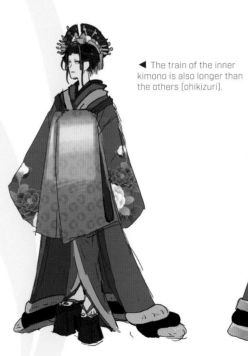

◄ The train of the inner kimono is also longer than the others (ohikizuri).

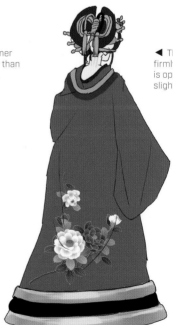

◄ The front of the collar is firmly closed. The back collar is open so that the back is slightly visible.

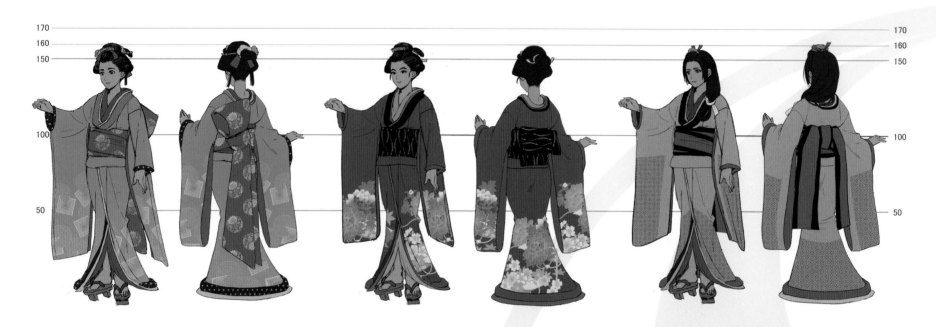

UKYO'S FANGIRLS

SKETCHES

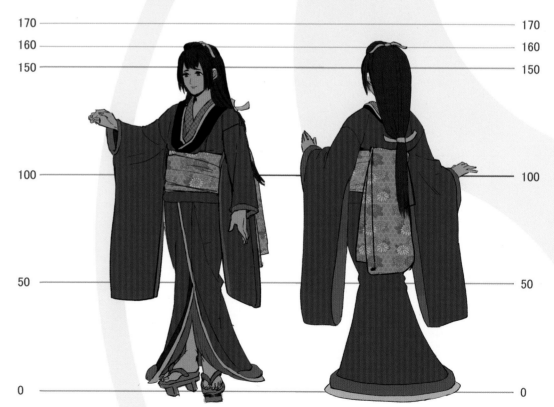

YOSHITORA'S STAGE

—

REJECTED DESIGNS

—

▼ Traveler's outfit (merchant): middle-aged man in the style of the characters of *Mito Kōmon* (a classic Japanese TV series)

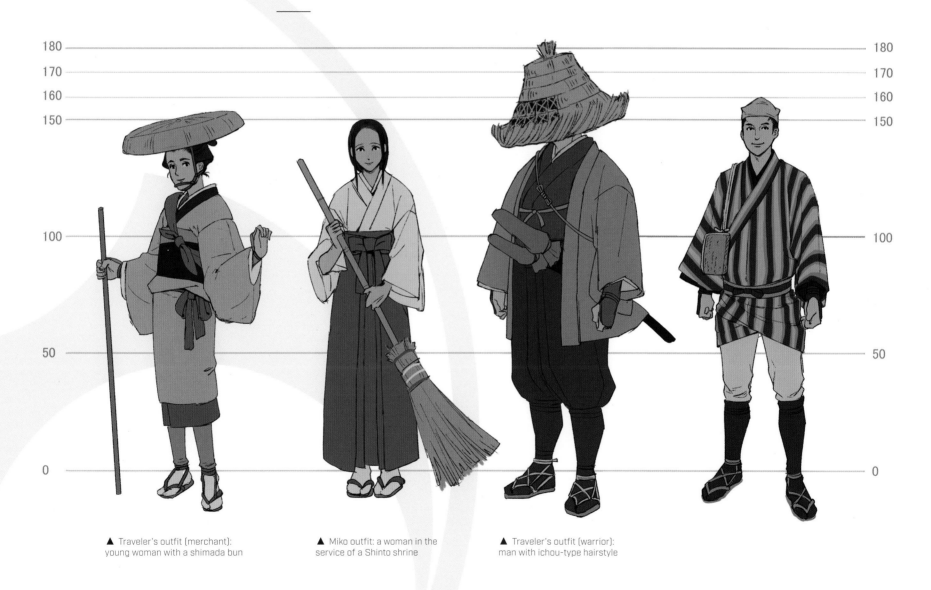

▲ Traveler's outfit (merchant): young woman with a shimada bun

▲ Miko outfit: a woman in the service of a Shinto shrine

▲ Traveler's outfit (warrior): man with ichou-type hairstyle

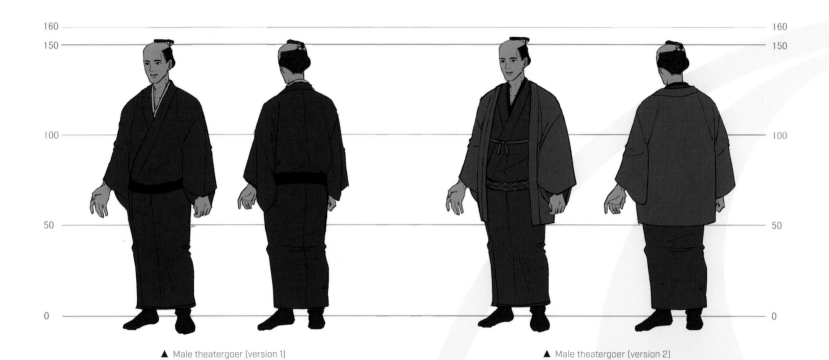

▲ Male theatergoer (version 1)

▲ Male theatergoer (version 2)

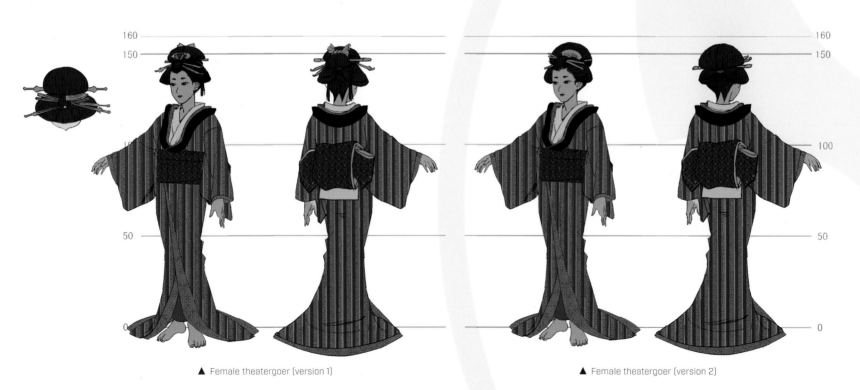

▲ Female theatergoer (version 1)

▲ Female theatergoer (version 2)

THE KABUKI STAGE

CHARACTER SKETCHES

■ AKAHIME*

*Traditional costume of princesses in Kabuki theater

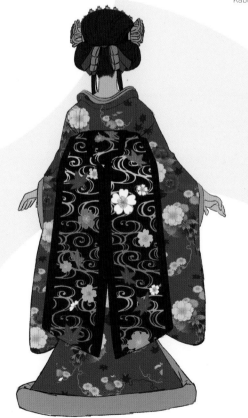

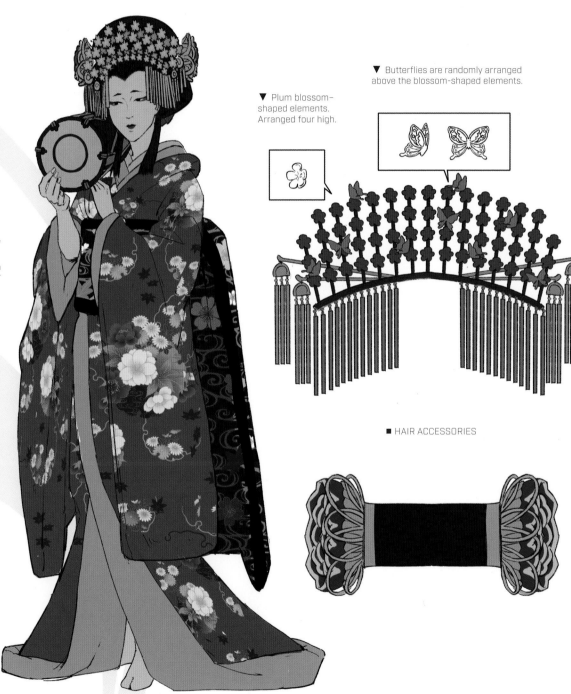

▼ Plum blossom-shaped elements. Arranged four high.

▼ Butterflies are randomly arranged above the blossom-shaped elements.

■ HAIR ACCESSORIES

STAGES

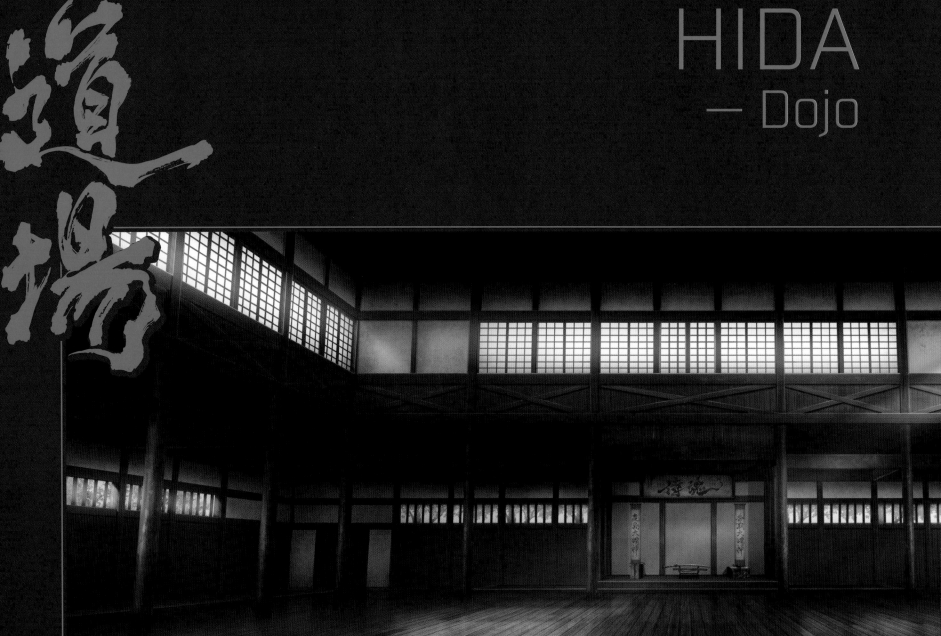

道場

HIDA
— Dojo

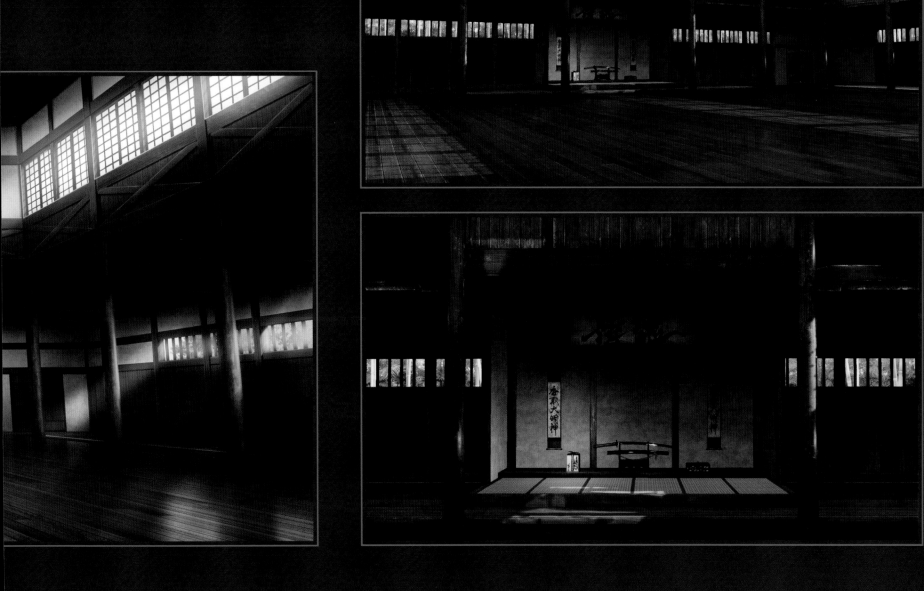

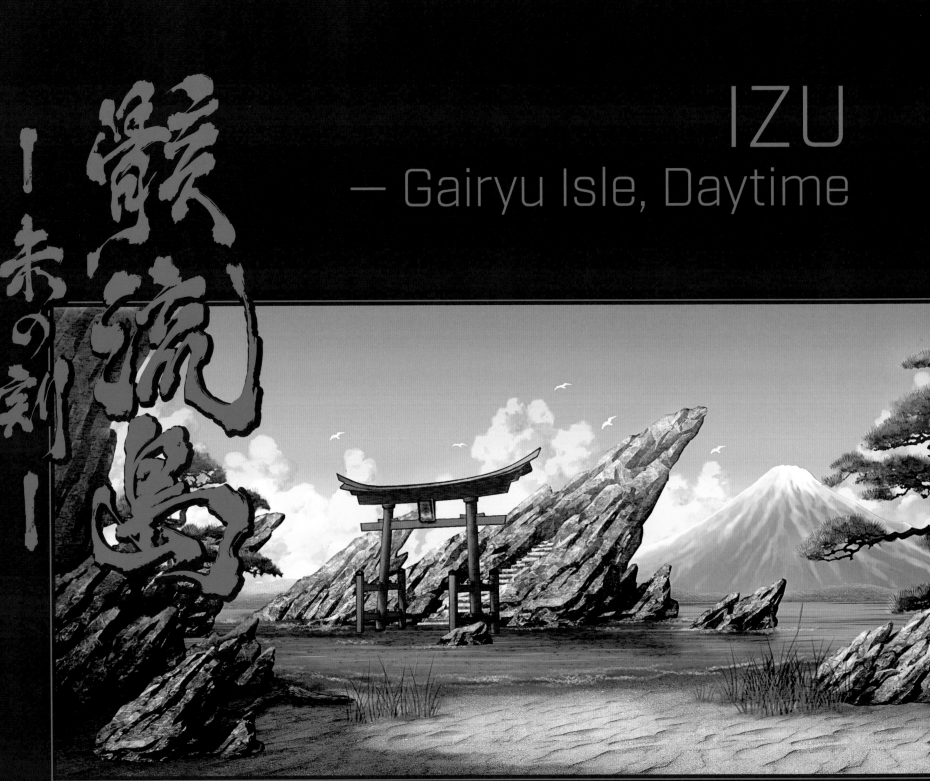

IZU
— Gairyu Isle, Daytime

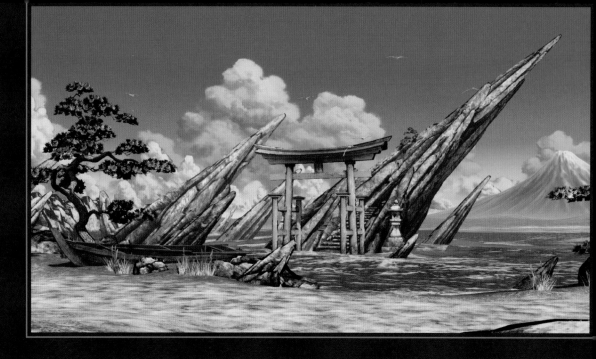

■ Haohmaru's stage, located on the Izu Peninsula in Japan

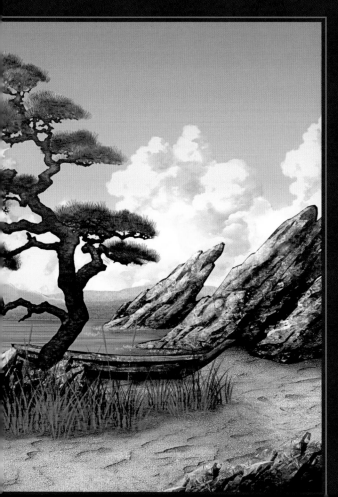

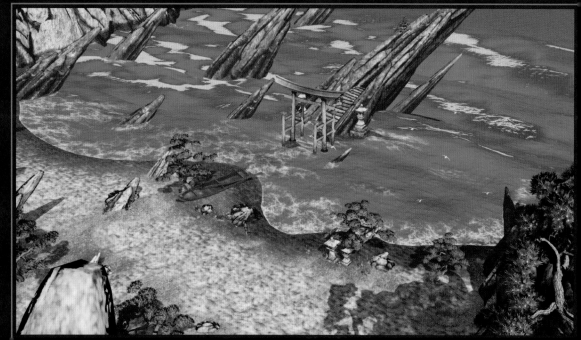

EZO
— Kamui Kotan

■ Nakoruru's stage, located in Ezo (former name of the island of Hokkaidō) in Japan

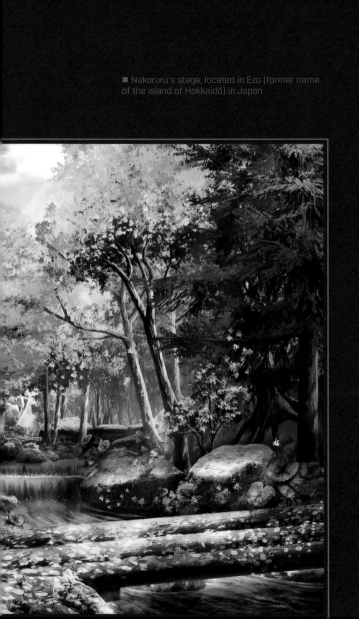

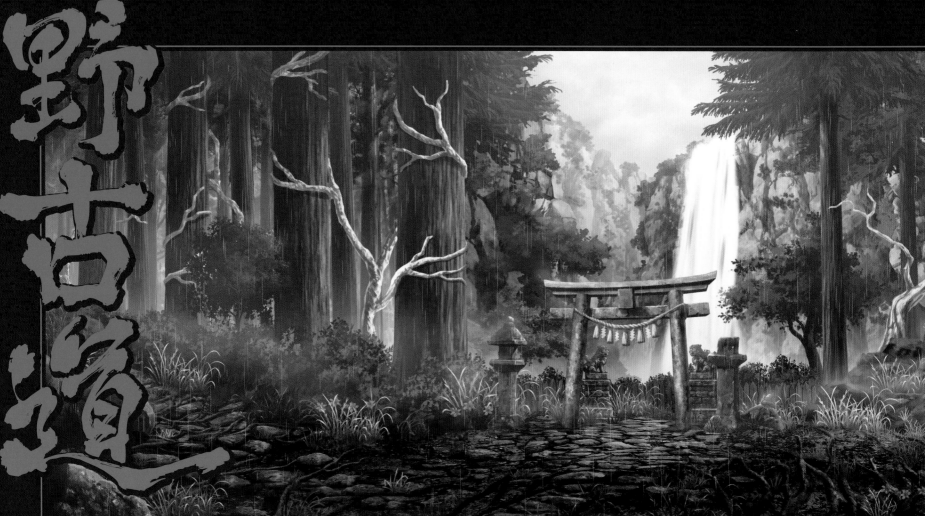

KISHŪ
— Kumano Kodo

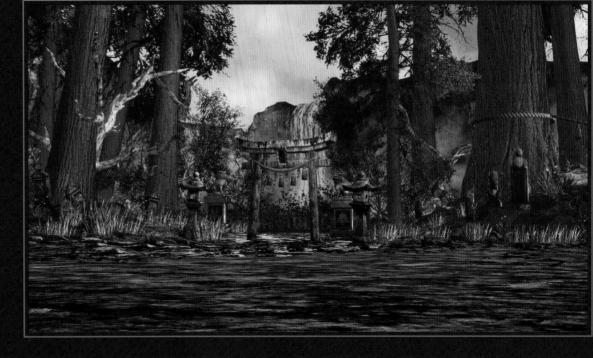

■ Hanzo's stage, located in the former province of Kishū in Japan

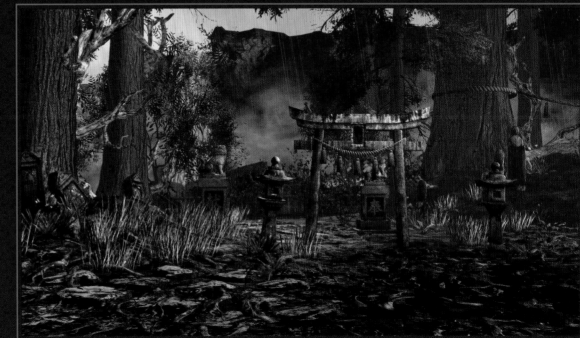

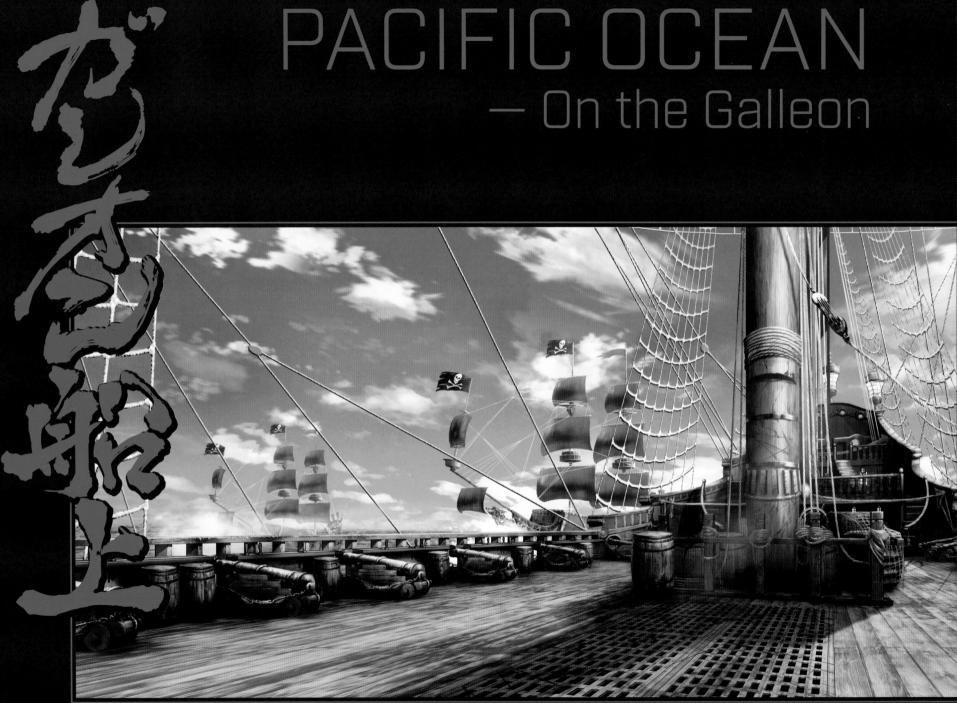

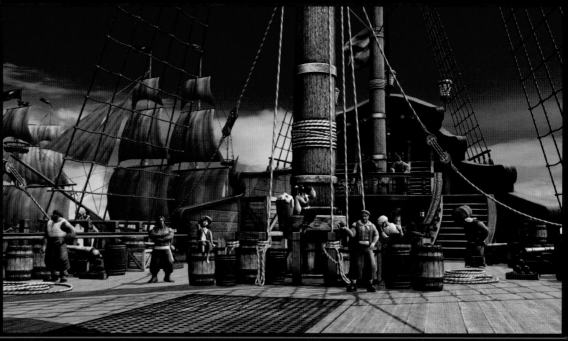

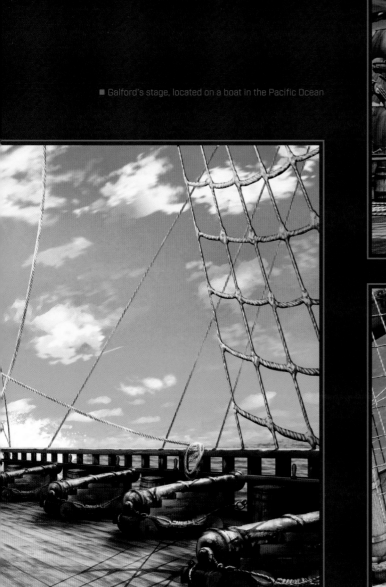

■ Galford's stage, located on a boat in the Pacific Ocean

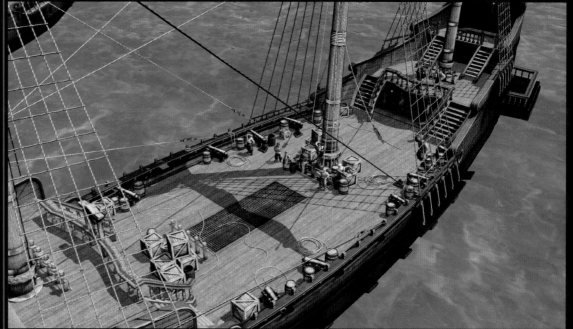

IZU
— Gairyu Isle, Night

骸流島
－丑の刻－

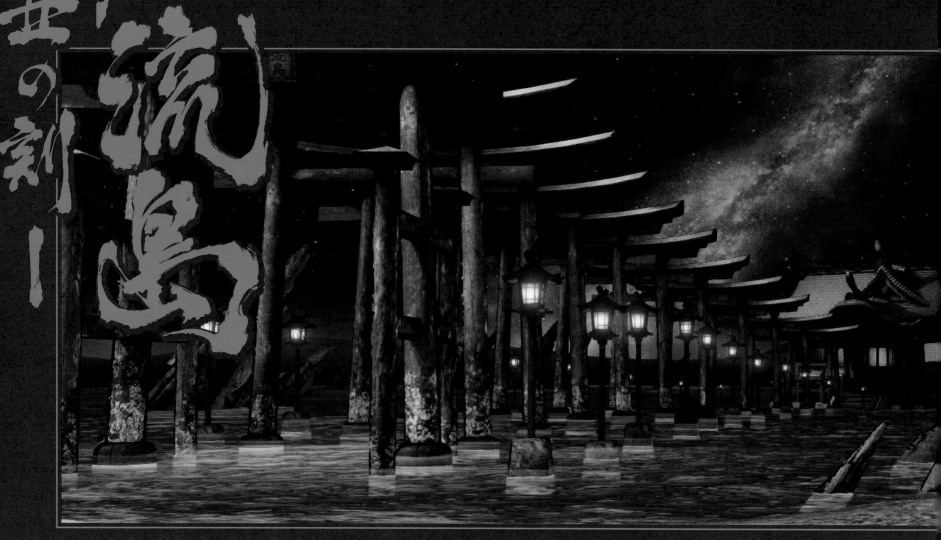

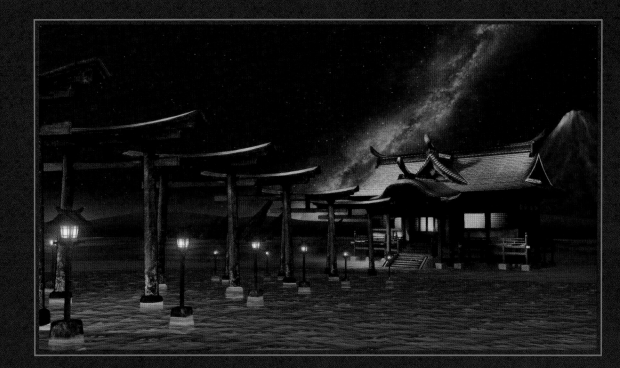

Ukyo's stage, located on the Izu Peninsula in Japan

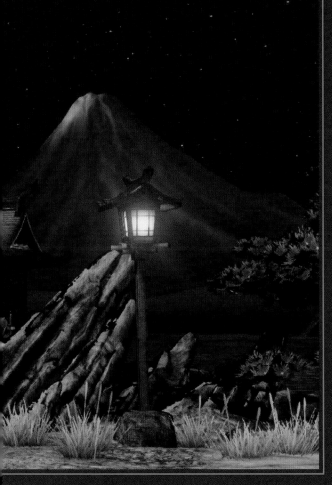

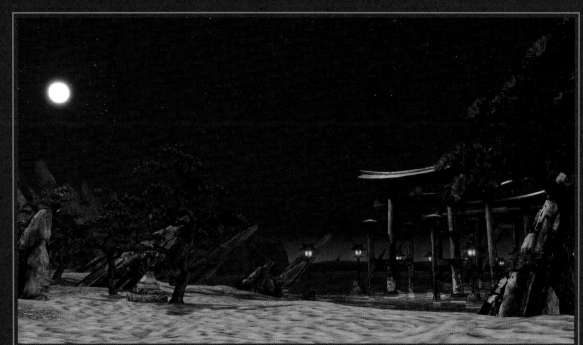

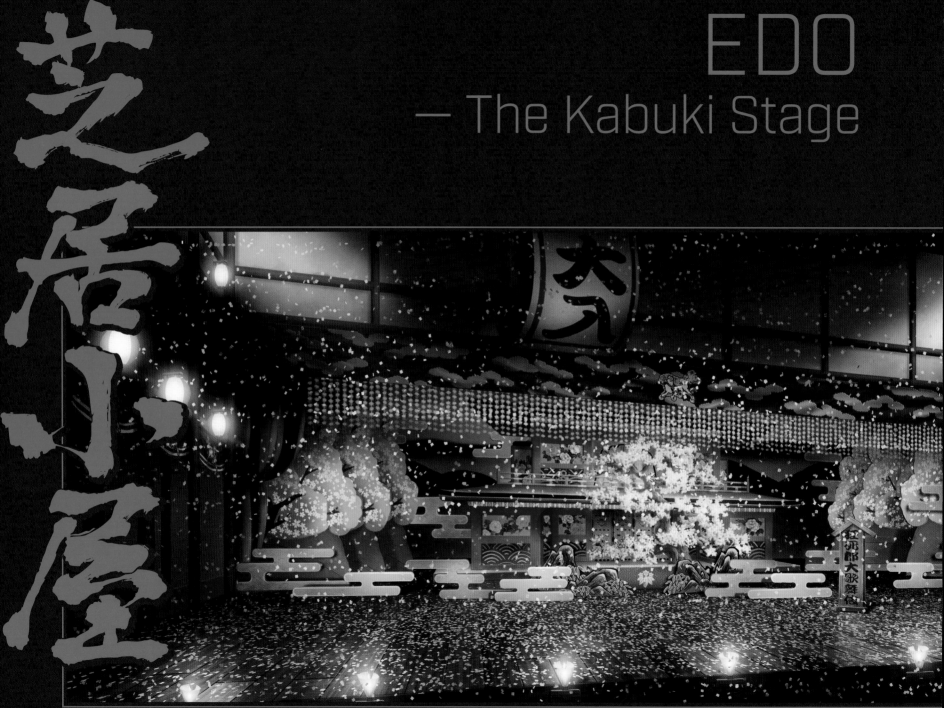

EDO
— The Kabuki Stage

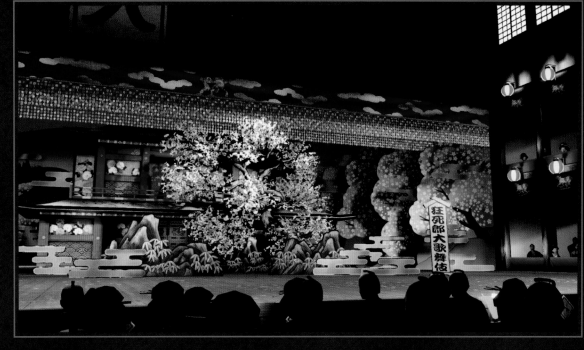

■ Kyoshiro's stage, located in the city of Edo (former name of Tokyo) in Japan

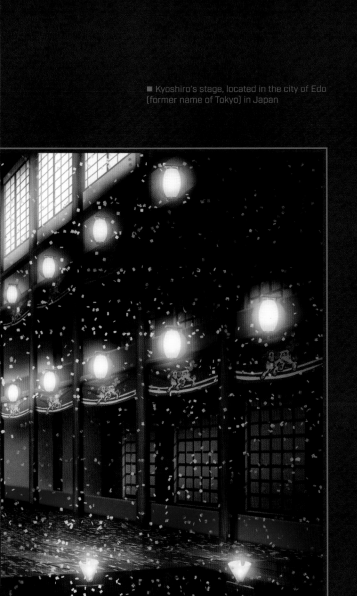

TOSA
— Early Summer

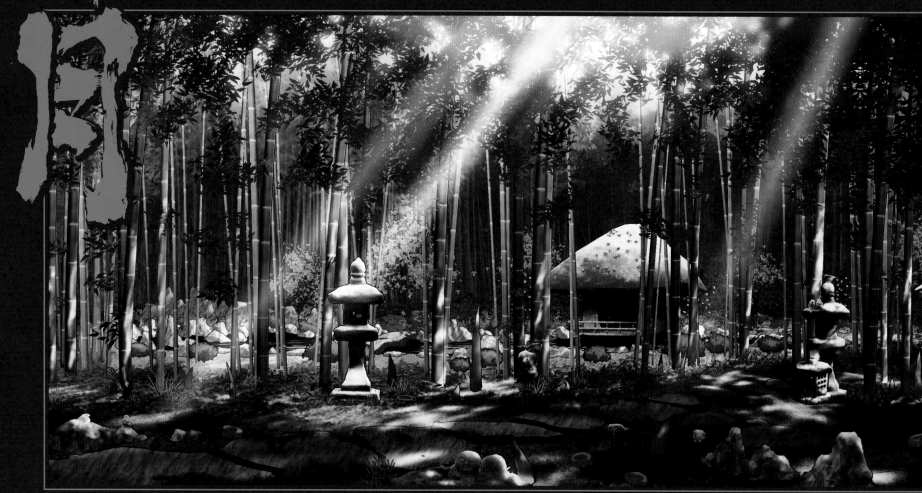

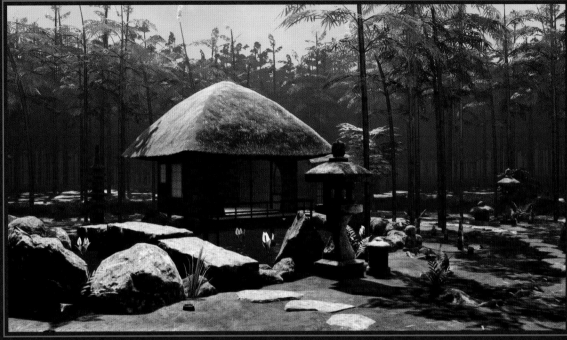

■ Jubei's stage, located in the city of Tosa in Japan

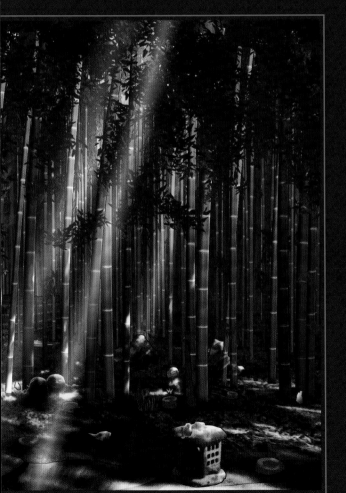

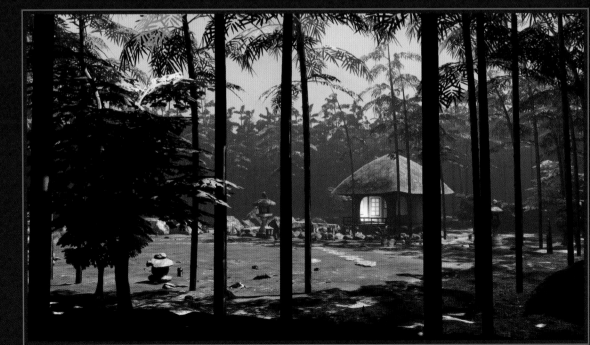

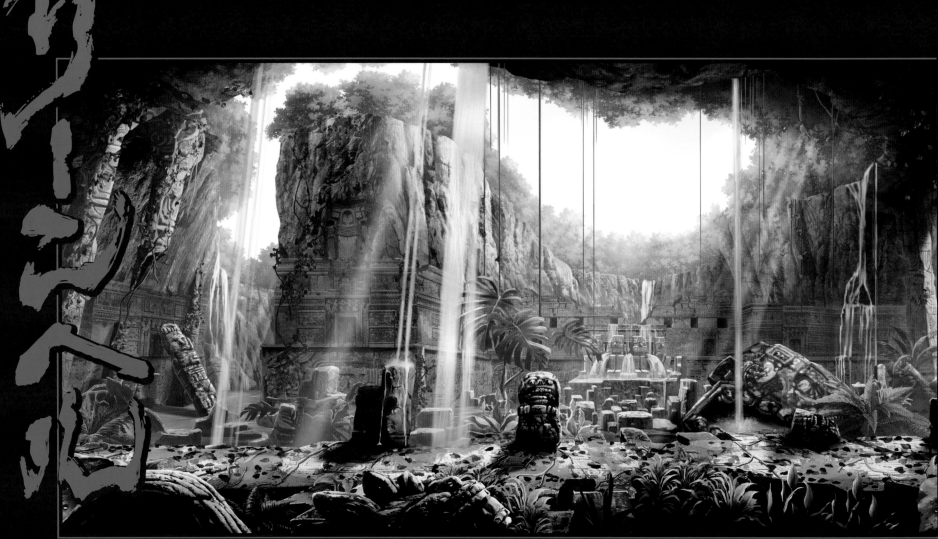

MAYA
— Green Hell

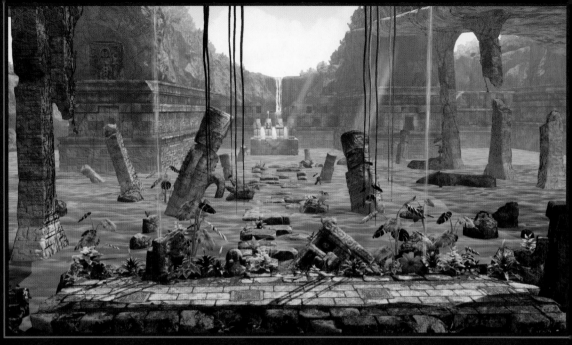

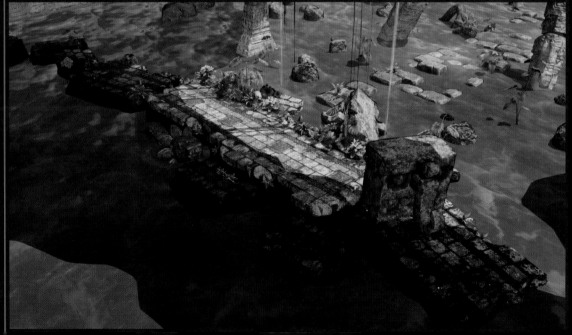

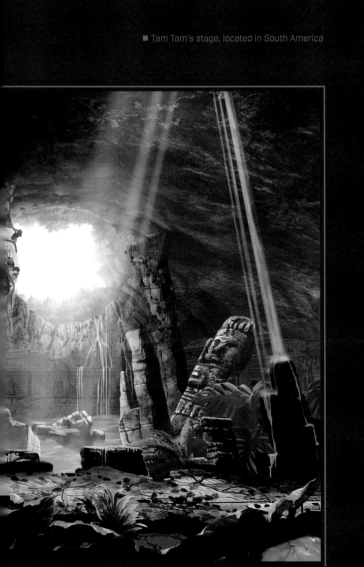

■ Tam Tam's stage, located in South America

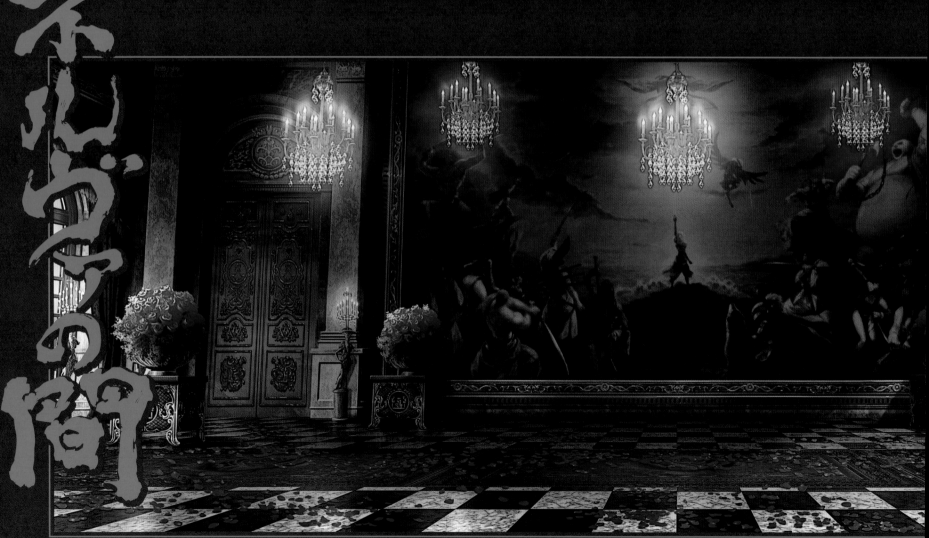

FRANCE
— Hall of Minerva

ネロの間

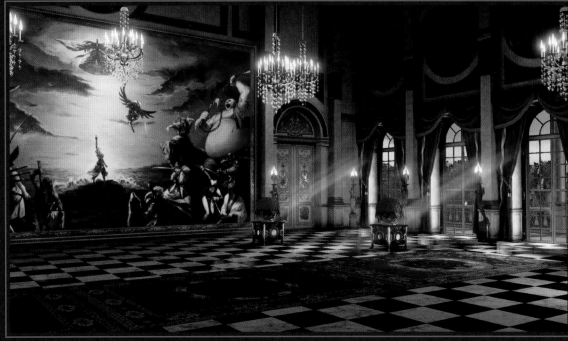

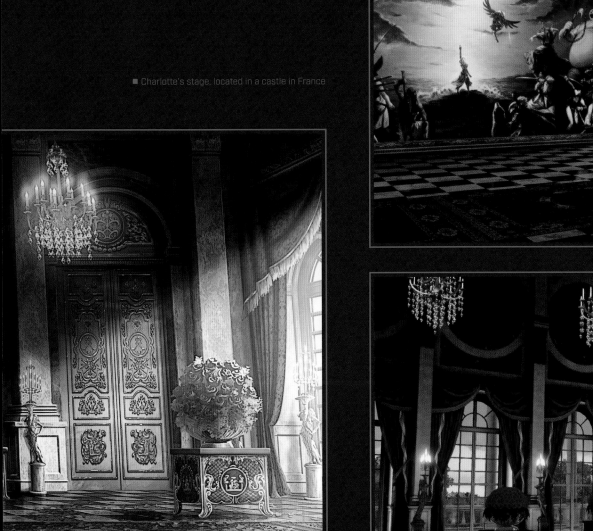

■ Charlotte's stage, located in a castle in France

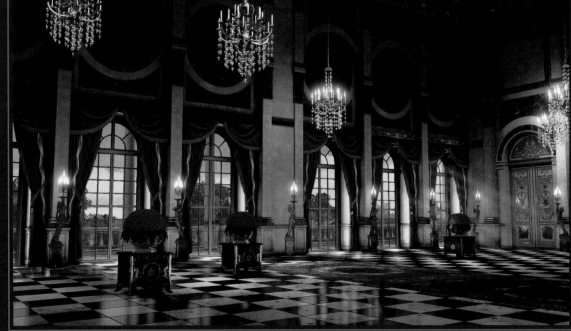

TOTOUMI
— Mikatagahara Field

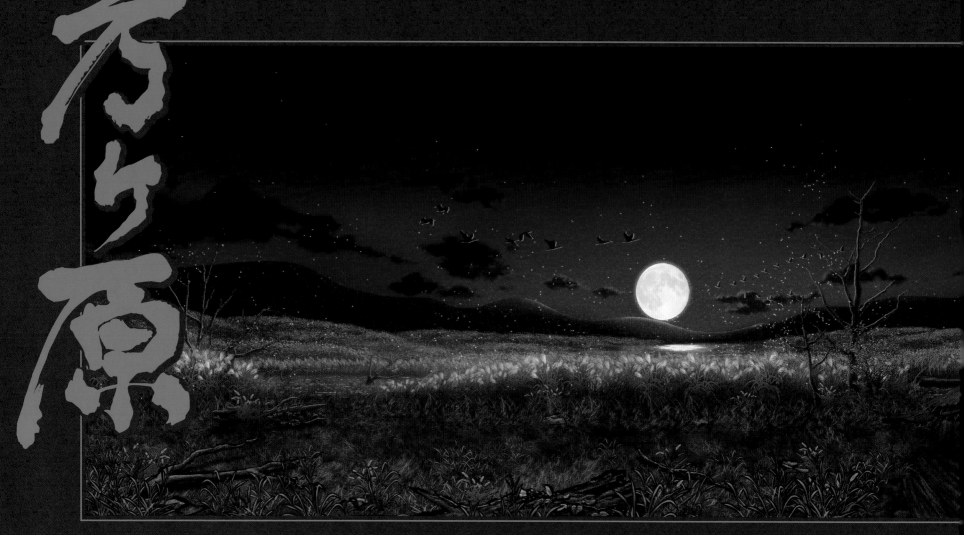

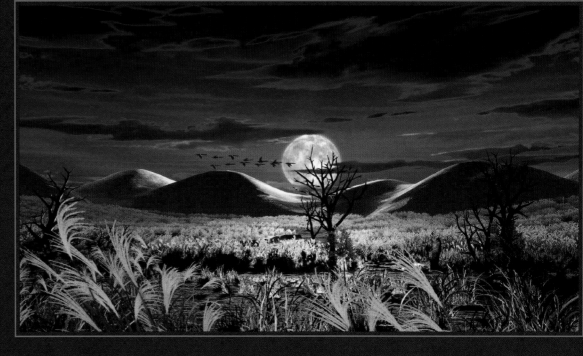

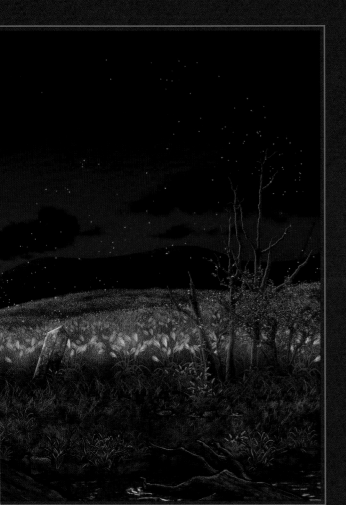

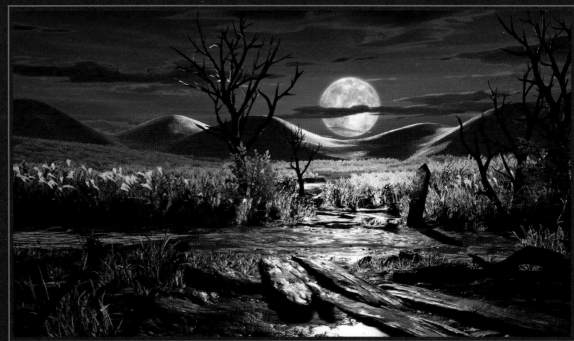

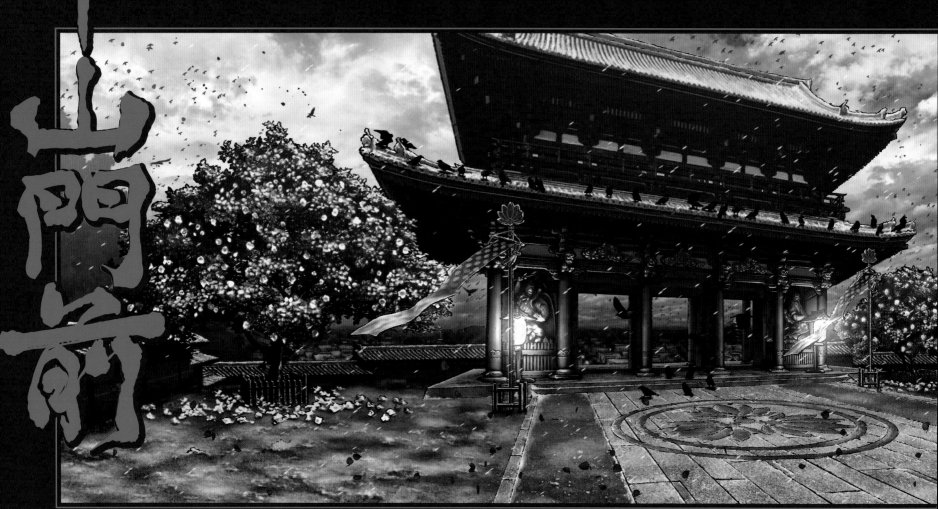

洛中門前

KYOTO
— Before the Temple Gate

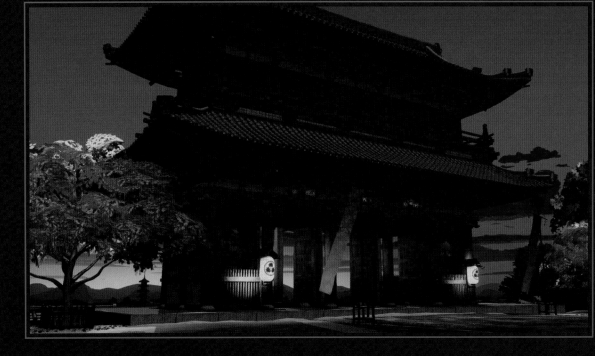

■ Yashamaru's stage, located in Kyoto, Japan

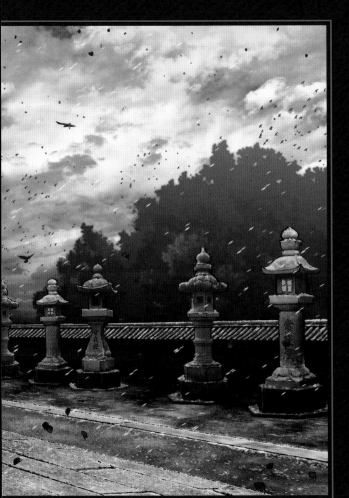

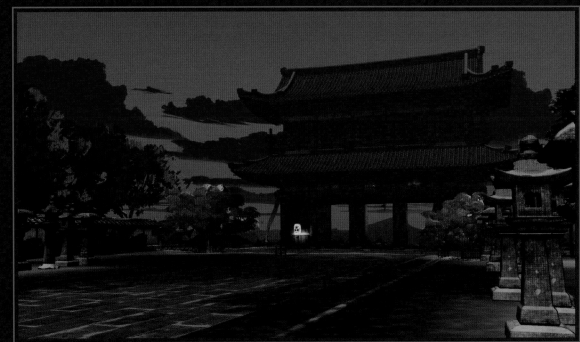

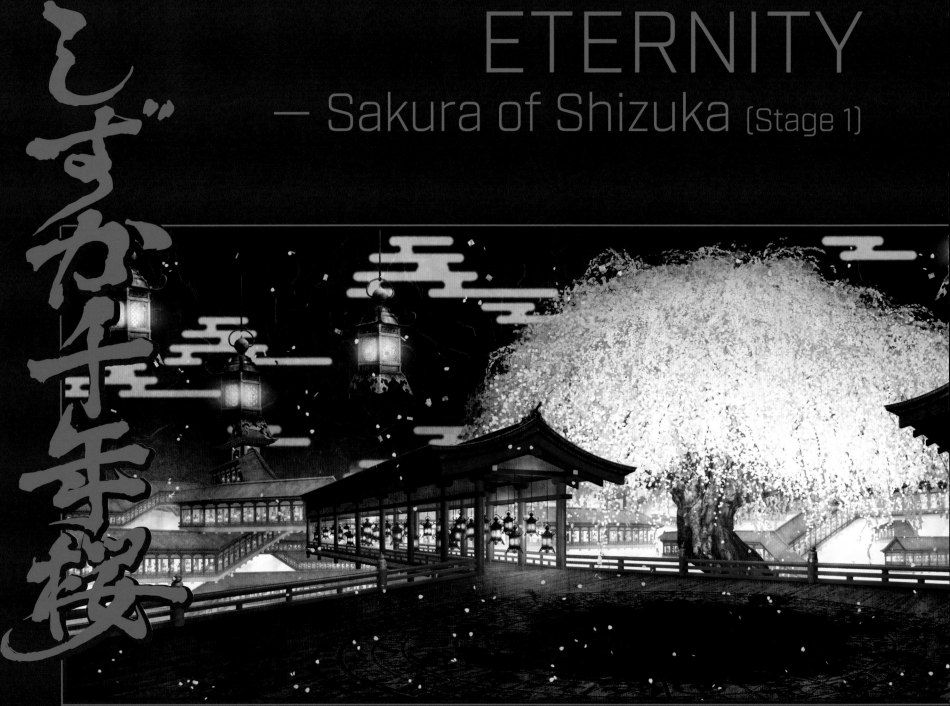

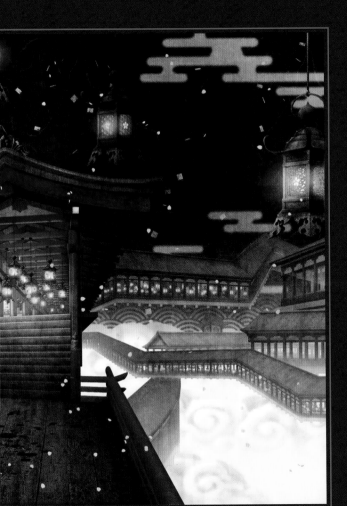

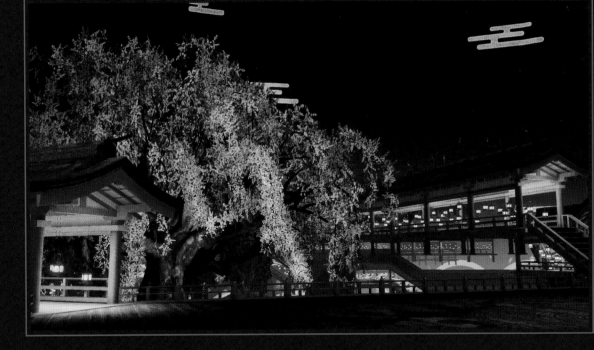

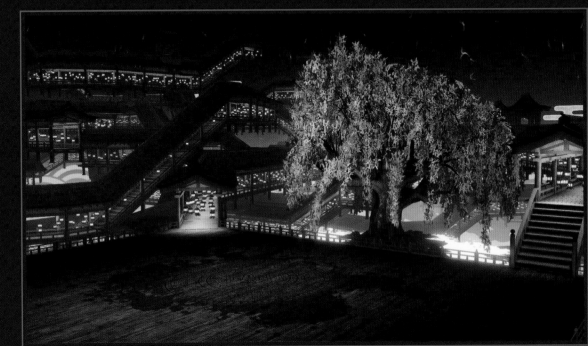

■ First version of the stage of *Samurai Shodown*'s final boss, Shizuka, located in Japan

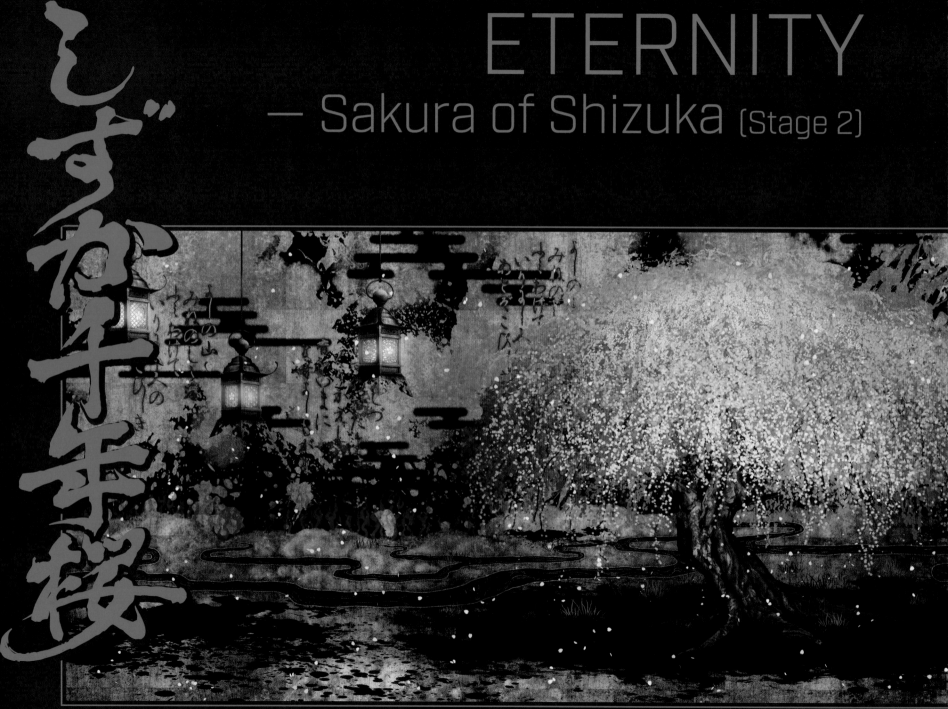

ETERNITY
― Sakura of Shizuka (Stage 2)

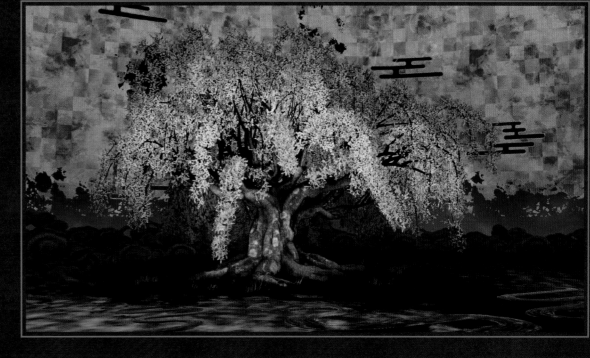

■ Second version of the stage of *Samurai Shadown*'s final boss, Shizuka, located in Japan

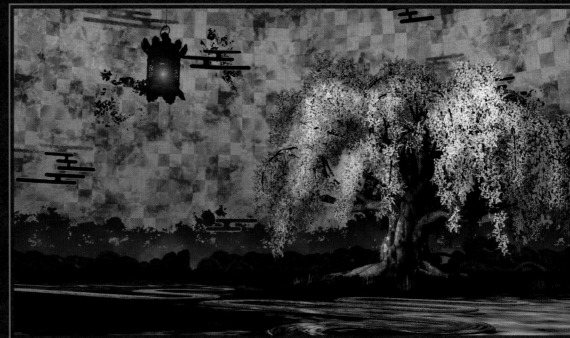

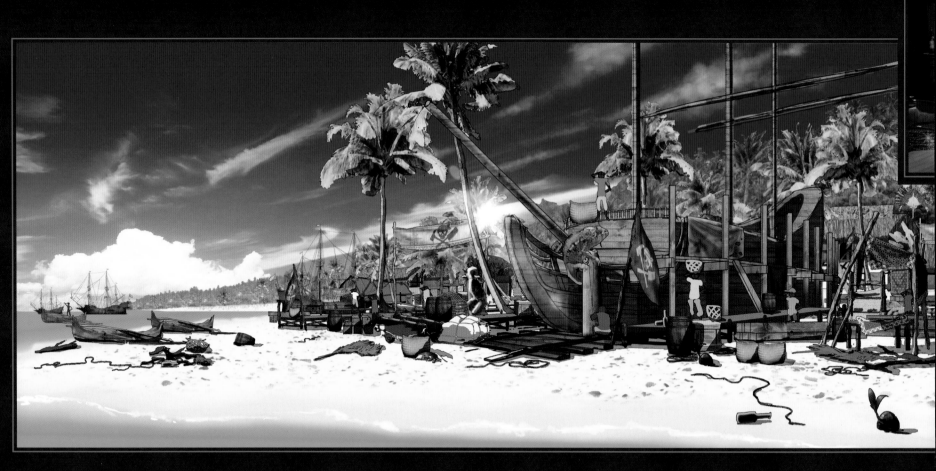

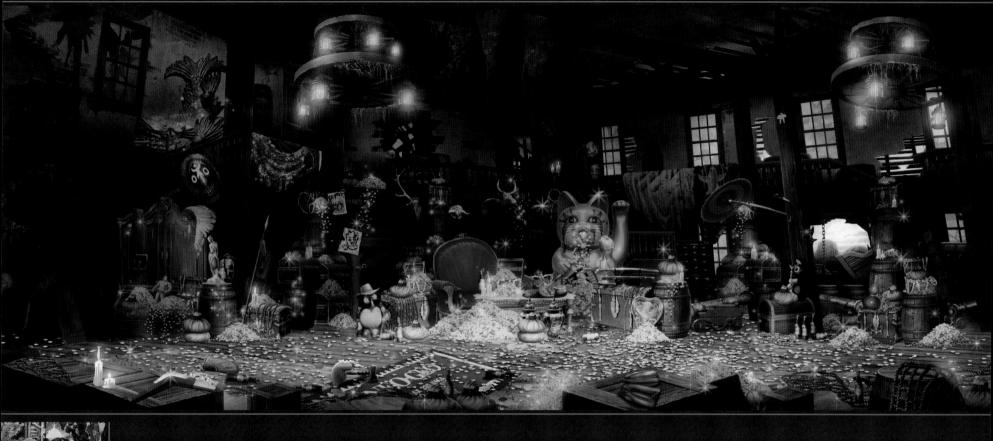

▲ Earthquake's stage, located in a ruined house full of treasures in the state of Texas, USA

◀ Darli's stage, located on a beach in Madagascar

ICONOGRAPHY

▲ Regular KO

▲ KO with weapon destruction

▲ Secret KO

▲ Finish KO

▲ KO with damage

▲ Victory over time

TSUBA

—

END OF BATTLE ICONS

—

▲ Draw

SENSU

ICONS UNDER THE LIFE BAR

▼ Regular KO

▼ KO with weapon destruction

▼ Secret KO

▼ Finish KO

▼ KO with damage

▼ Victory over time

▼ Draw

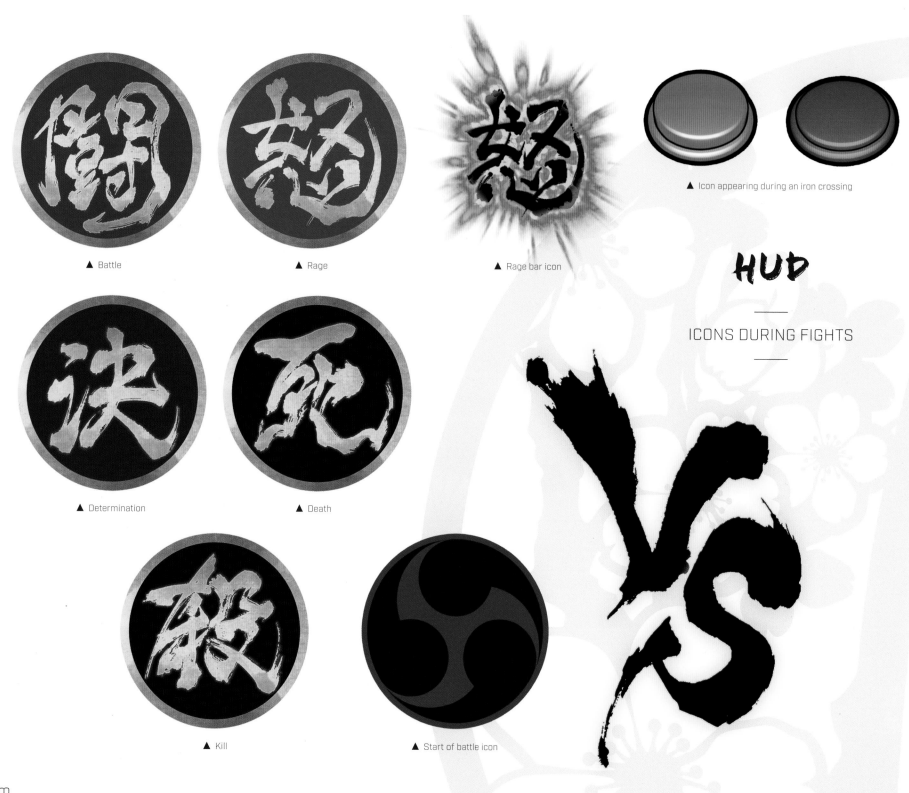

▲ Battle

▲ Rage

▲ Rage bar icon

▲ Icon appearing during an iron crossing

▲ Determination

▲ Death

▲ Kill

▲ Start of battle icon

HUD

ICONS DURING FIGHTS

Loading... Searching... Saving...

MISCELLANEOUS

—

STEAM ICONS & FONTS

—

◄ Steam icons

INTERVIEWS
NOBUYUKI KUROKI
YUMI SAJI

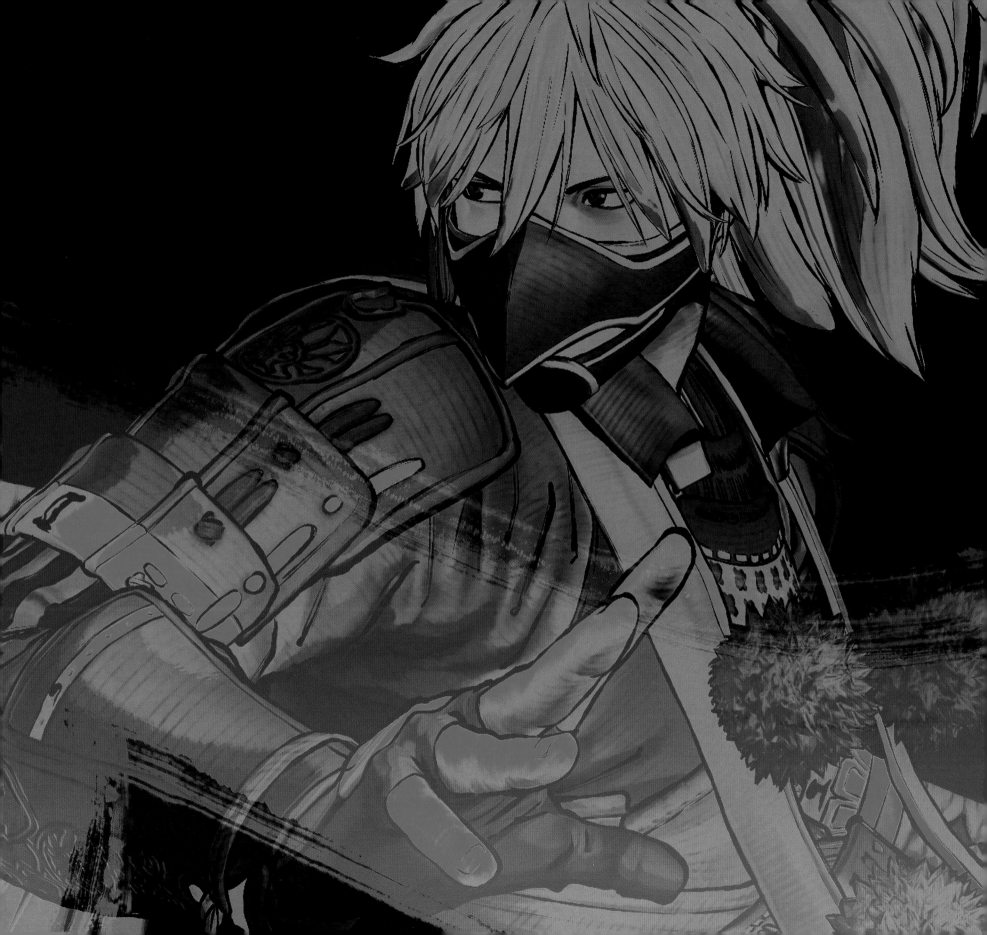

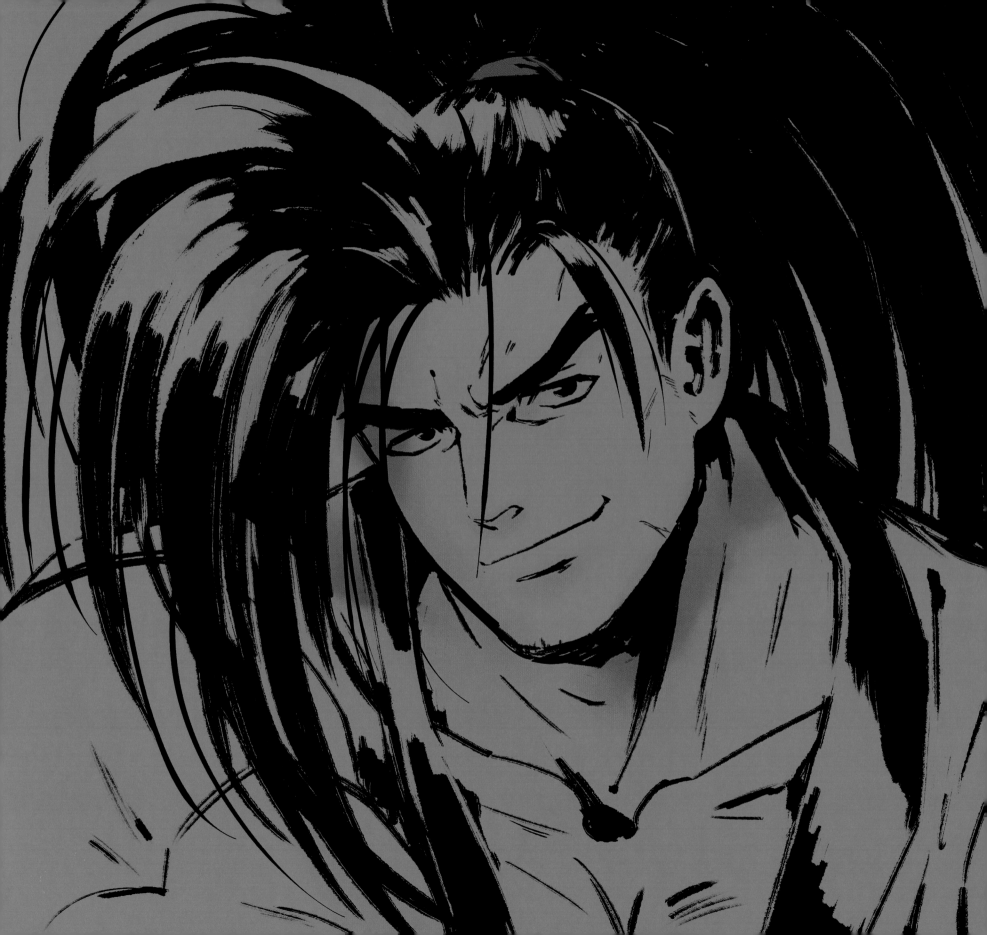

NOBUYUKI KUROKI

DIRECTOR AND ART DIRECTOR

■ **Could you please start by introducing yourself?**

My name is Nobuyuki Kuroki, and I'm part of Studio 1 at SNK. I'm the art director and director for *Samurai Shodown*. I joined SNK in 1993, and worked there until 2000. During my time with the company, I mainly worked on the *Fatal Fury* and *Art of Fighting* series. The best-known characters that I worked on are the Jin brothers from *Fatal Fury 3*, Wolfgang Krauser and Rick Strowd from *Real Bout Fatal Fury*, Ryo from *Art of Fighting 3: The Path of the Warrior*, and Rock Howard and Bonne Jenet from *Garou: Mark of the Wolves*. There are many other characters as well, of course, but these are the ones who are deeply memorable for me. In 2014 I returned to SNK and served as the art director for *The King of Fighters XIV*.

■ **How did you get started in video games? How old were you? What was the first game that you played?**

There is a tradition in Japan where children receive money from their parents and relatives as a New Year's gift. When I was thirteen years old, I used that money to purchase an NES (Famicom) and a copy of *Super Mario Bros.* It was just so much fun, and I played stages 1-1 and 1-2 until I got to where I could have cleared speed runs for both with my eyes closed. With *Mario* as my entry point, I became more and more engrossed in the medium, and my deep respect for Mr. Shigeru Miyamoto continues to this day.

■ What led you to work in the video game industry? What was the first project that you participated in?

When I was a student, my aim was to work as an animator or as a designer at an advertising company. Advertising is actually what I studied. Looking at a job-hunting information board on campus one day, I saw a notice for an opening at SNK. At that point in my life, I had never given any thought to working in video games. I hadn't even heard of SNK before. Still, my curiosity led me to join a tour of the company. I may have signed up for that tour in a casual manner, but it ended up having a major impact on me. I saw the SNK employees creating this incredibly beautiful pixel art. I was surprised to see that this was a job that existed! Looking at that pixel art, I decided then and there that I wanted to work for a video game company. My first assignment after joining SNK in 1993 was working on debugging *Fatal Fury Special*. I played it endlessly, day to night, hunting for bugs in the game. Even though we were all playing the game so much as part of our job, the other new employees and I still held *Fatal Fury Special* tournaments during our lunch breaks. Looking back on it now, that game really was a masterpiece. There were six new team members at that time, one of whom, Mr. Yasuyuki Oda, is now a producer.

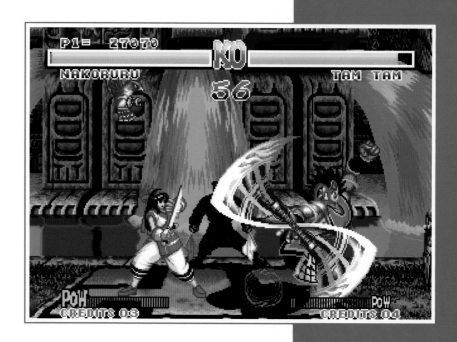

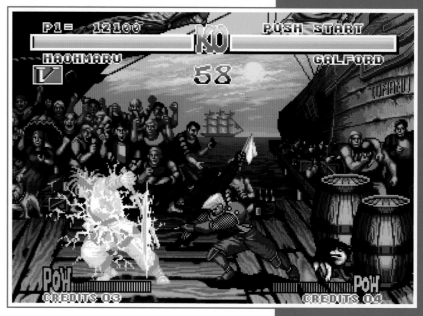

▲ Nakoruru versus Tam Tam (*top*) and Haohmaru versus Galford D. Weller (*bottom*) in *Samurai Shodown* (Neo Geo, 1993)

■ You were already working at SNK when *Samurai Shodown* was released for the Neo Geo system. Do you have any memories from that time?

When *Samurai Shodown* was released, I was already working on the *Fatal Fury* team. *Fatal Fury* had already gained quite a bit of market popularity by that point, and I was proud to have been involved with it. When I first saw *Samurai Shodown*, however, I was really shocked. Experiencing the title's intense feel and

gameplay left me with a complicated mix of emotions. Part of me felt like we had simply been defeated. Another part of me felt like I was learning about another approach for creating a game, something that I could reference later on. Even now, more than twenty years later, I can still vividly remember how I felt at that time. Later on, I was able to make a few contributions to the development of *Samurai Shodown* on the Hyper Neo Geo 64. Being able to do so made me really happy.

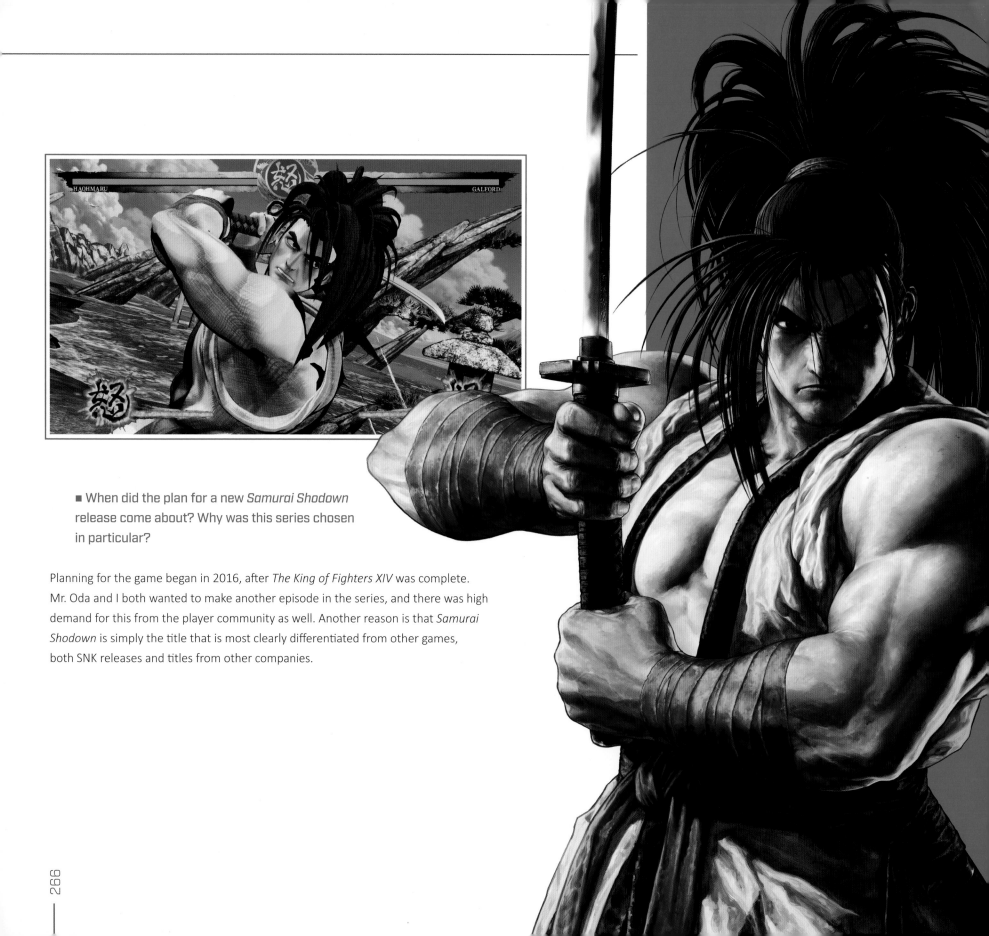

■ When did the plan for a new *Samurai Shodown* release come about? Why was this series chosen in particular?

Planning for the game began in 2016, after *The King of Fighters XIV* was complete. Mr. Oda and I both wanted to make another episode in the series, and there was high demand for this from the player community as well. Another reason is that *Samurai Shodown* is simply the title that is most clearly differentiated from other games, both SNK releases and titles from other companies.

◄ Haohmaru in *Samurai Shodown*
(PlayStation 4 / Xbox One, 2019)

▼ Nakoruru versus Galford D. Weller
(*top*) and Kyoshiro Senryo versus Ukyo
Tachibana (*bottom*) in *Samurai Shodown*
(PlayStation 4 / Xbox One, 2019)

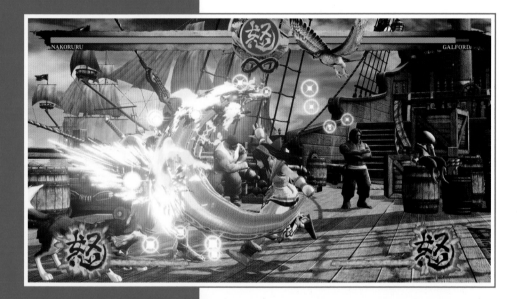

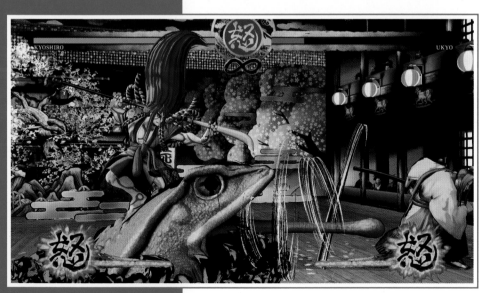

■ **What were the key points in the artistic direction
of this new *Samurai Shodown* game?**

There were many key points, but the one that I paid the most
attention to was making sure to produce images that could
never be mistaken for those from another title. People who
work in the video game industry are experts in the medium and
are able to tell the difference between titles at a single glance.
For ordinary players, however, I think that differentiating titles
with similar imagery can be difficult. For a triple-A release or an
entry in a popular series, I think that players will be interested
even if they don't really see the differences. With *Samurai
Shodown*, on the other hand, it may be a popular series, but it's
also a series that's had a ten-year gap without a single release.
Going with a realistic appearance or an anime style would
lead to *Samurai Shodown* being buried by its competitors. I
don't think that the game occupies that strong of a position in
players' memories.

Since *Samurai Shodown* is a Japanese-style title with its own
unique style and individuality, we worked in that direction.
Still, I do think that what Japanese and non-Japanese players
think of as "Japanese style" can be quite different. The type
of Japanese art that's shown in art museums is exquisite, but
rather than aiming for that style, I felt that one that simply
"felt Japanese" would be the best choice here. For people
who aren't particularly interested in Japanese culture, a purely
Japanese style might feel like an imposition. We created the
imagery in this title by combining the feel of a manga, which
has become a globally popular medium, and this "Japanese
feel." When a player sees a game and can tell that there
is something "different" about it, it's proof of the title's
uniqueness and individuality. I consider this to be the highest
form of praise there is.

■ Was it difficult to take a series with an established art direction, and then adopt a new design and render it in 3D? Also, were there other methods that you tried as well?

To be perfectly honest, it was indeed difficult. However, I think that the *Samurai Shodown* that's best remembered by players is the *Samurai Shodown* from twenty years ago, with its pixel art imagery. If we were to focus too heavily on that particular period, I feel that many players who have never played a *Samurai Shodown* title before wouldn't be interested in this game either. A half-done game would be the worst outcome. With that in mind, we designed this game from the ground up, in order to produce a *Samurai Shodown* designed for 2019. The head-to-toe character heights worried me. The illustrations in *Samurai Shodown* all contain a lot of characters who appear quite tall in this sense, and they look very cool. When you try to put them into the game unaltered, though, their shapes become hard to distinguish, their facial expressions become difficult to read, and overall it becomes hard for players to feel any sort of empathy with the characters. Conversely, if they're made too short, they might be easier to understand at first glance, but they would end up looking comical. We did a series of tests, and the results led us to choose a 65 percent head-to-toe height for the characters. This makes them easy to read, and also maintains their overall style.

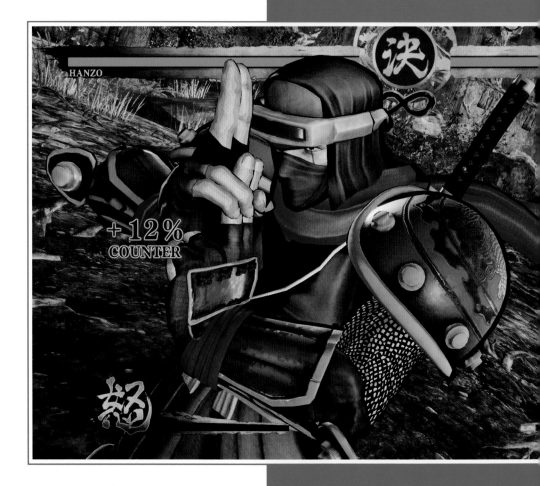

▲ Hanzo Hattori in *Samurai Shodown* (PlayStation 4 / Xbox One, 2019)

▶ Galford D. Weller (*left*) and Shiki (*right*) in *Samurai Shodown* (PlayStation 4 / Xbox One, 2019)

■ The character design for the fighters is one major factor of this title's appeal. Can you tell us how the character modeling was carried out, as well as how many polygons they are made up of?

We began working on *Samurai Shodown* in late 2016. However, most of the staff at that time were developing the *King of Fighters XIV* DLC and *SNK Heroines: Tag Team Frenzy*. I was only responsible for direction for the *King*

of Fighters XIV DLC, and I had a full year where I could focus strictly on *Samurai Shodown*. At that time, I used the 3D application ZBrush for almost all of the character concept modeling. At that point, the character imagery was almost complete, so our attention was focused on using the ZBrush data with a modeler, further improving quality. The number of polygons differs depending on the character, but I think that it's generally around 90,000 to 110,000.

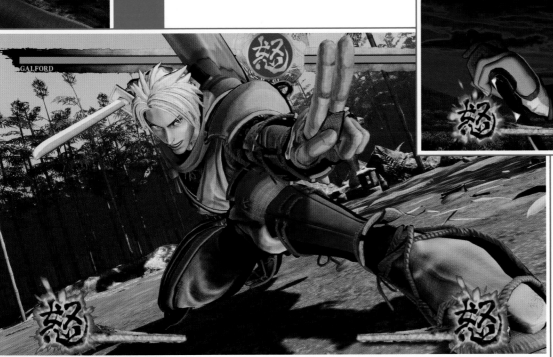

■ Can you please tell us about any previous *Samurai Shodown* titles that had a major influence on the development of this episode?

In terms of gameplay, it would be *Samurai Shodown II*. That title contains everything that I consider to be "*Samurai Shodown*," all combined into a single release.

■ The game will contain sixteen characters and one boss. How did you decide who would appear? Also, was there an advantage in keeping the number of characters low?

The *Samurai Shodown* series contains a large number of popular characters, so choosing the roster was quite a challenging task. The sixteen warriors were ultimately selected based on both popularity and the idea of having a combination of characters that would provide a strong variety of fighting styles. I think that *Samurai Shodown* warriors are relatively difficult to make. It would have been possible to include more characters if we had been okay with having a lower quality for each character, but that wasn't something that I wanted to do. By limiting the total number of characters to seventeen, I think that we were able to ensure consistency and complexity for each one. I mean this both in terms of how they look as well as how they play. I believe that this choice will lead to players feeling greater affection for each character individually.

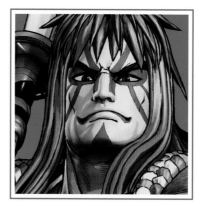

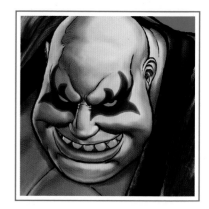

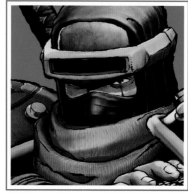

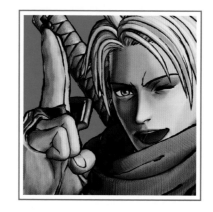

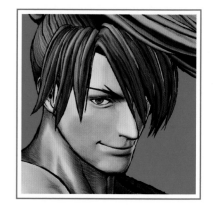

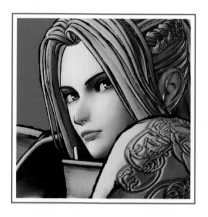

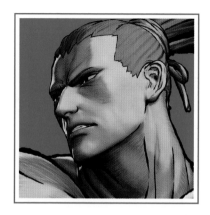

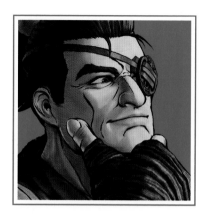

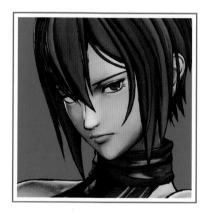

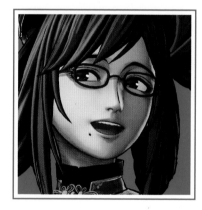

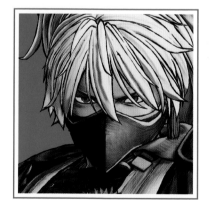

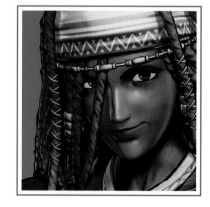

■ Among the sixteen fighters, there are three new characters that are playable. Can you tell us more about these three characters?

Ruixiang: My aim was to create a character that all of our players would love, through details such as the clumsy elements that accompany her attacks, the fact that when she loses her weapon she also loses her glasses, her standby motion that changes, etc.

Darli: We wanted to show her as having superhuman strength and came up with a variety of ideas to do so. There's a moment in the game where a barrel falls and she catches it, but we also considered the idea of having it be a boulder or ship that fell down, as these ideas seemed like they would be interesting for players. In any event, we wanted to show her superhuman strength, and gave a lot of thought to how to go about doing so.

Yashamaru: What I first asked Ms. Yumi Saji, our character designer, for was a handsome armored warrior, a fighter that would be so cool that he could easily be the main character in the game. From his settings to his movements, Yashamaru was created in the image of what would be known in Japan as "chuni" (a term for a young person going through a somewhat delusional phase). Yashamaru's creation brought back recollections of Rock Howard from *Garou: Mark of the Wolves*, for some reason.

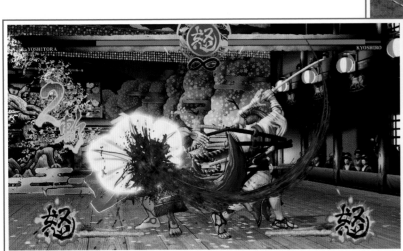

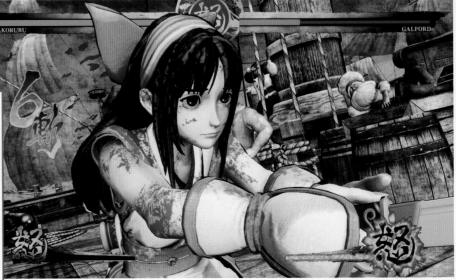

■ Can you share any anecdotes from the character development stage, or tell us about characters that ended up not being selected for the final version of the game?

One in-game component that we were very particular about was the blood splatters. In-game blood is set to disappear after eight seconds. However, the game is also designed so that if a round finishes with blood still splattered onscreen, it will stay that way through the victory animation. The initial design was for the character to appear covered in blood on the results screen that follows the victory animation. It was too horrible looking, though, so we eventually set it so that the blood disappears. Personally, I wanted to see the blood-covered character appear on the results screen no matter what, but many people persuaded me to have it disappear, which is now the case. Even now, I'm still a little disappointed about it. Also, I personally wanted Sieger to be in the game, but he unfortunately didn't make it past the selection stage. I'd like him to appear as DLC at some point, if we get the chance.

■ *Samurai Shodown* differs from other fighting titles in that it's not a combo-based game. What are the most essential points in making the fights more of an intense and brilliant show?

- Animation with weight
- *Samurai Shodown*'s unique hitstop mechanism
- Flashy and showy blood splatters
- Damage reactions
- Facial expressions
- Audio that sounds good

I think that when all of these elements are combined with proper timing, it will result in an intense attack. When you watch people playing *Samurai Shodown*, you can hear a lot of reactions like "Ouch!" or "That's gonna hurt . . ." I think that this is proof of the previously mentioned elements combining into a seamless whole, resulting in the player experiencing an empathetic response.

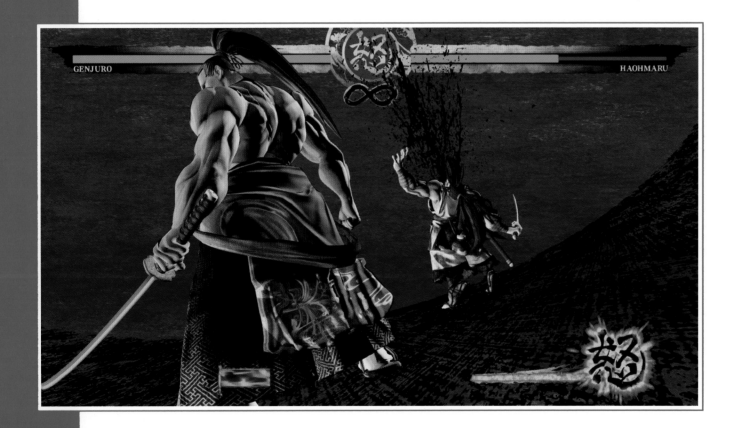

■ Do you have any favorite characters for this episode?

I've been a fan of Haohmaru for quite a long time now. With this title in particular, I found myself liking Earthquake and Yashamaru.

■ What was the biggest obstacle during development?

Putting out a game that would hit 60 frames per second without a drop in graphic quality. I think that reaching this was an enormously difficult challenge for the programmers, background team, and effects team. Given that *Samurai Shodown*'s gameplay takes place in 2D, adjusting how the characters looked from each side also proved to be difficult. Yoshitora carries seven swords, and his costume itself is also asymmetrical, so modifying and fine-tuning his appearance when viewed from each side was a challenge.

■ How would you sum up this game in a single word or phrase?

"Single attack kill"!

■ Do you have any messages for our readers?

I consider your purchase of this book to mean that you're interested in the art in *Samurai Shodown*. As an art director, nothing could make me happier. On behalf of all the artists who worked together to create this title, I would like to offer our thanks to all of you. Thank you very much. ■

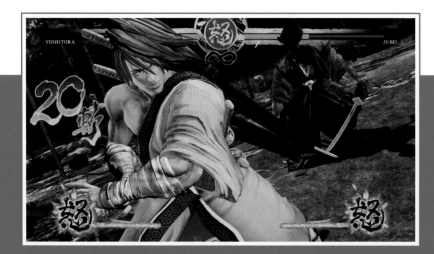

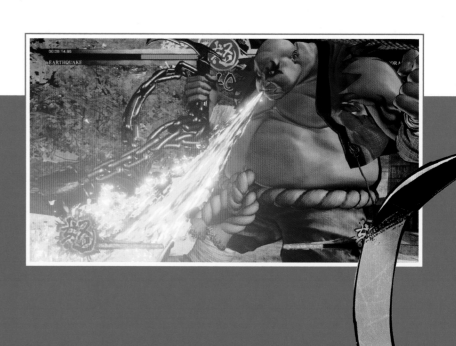

▲ Yoshitora Tokugawa versus Jubei Yagyu (*left*) and Earthquake (*right*) in *Samurai Shodown* (PlayStation 4 / Xbox One, 2019)

▶ Artwork of Yashamaru Kurama

- FIN -

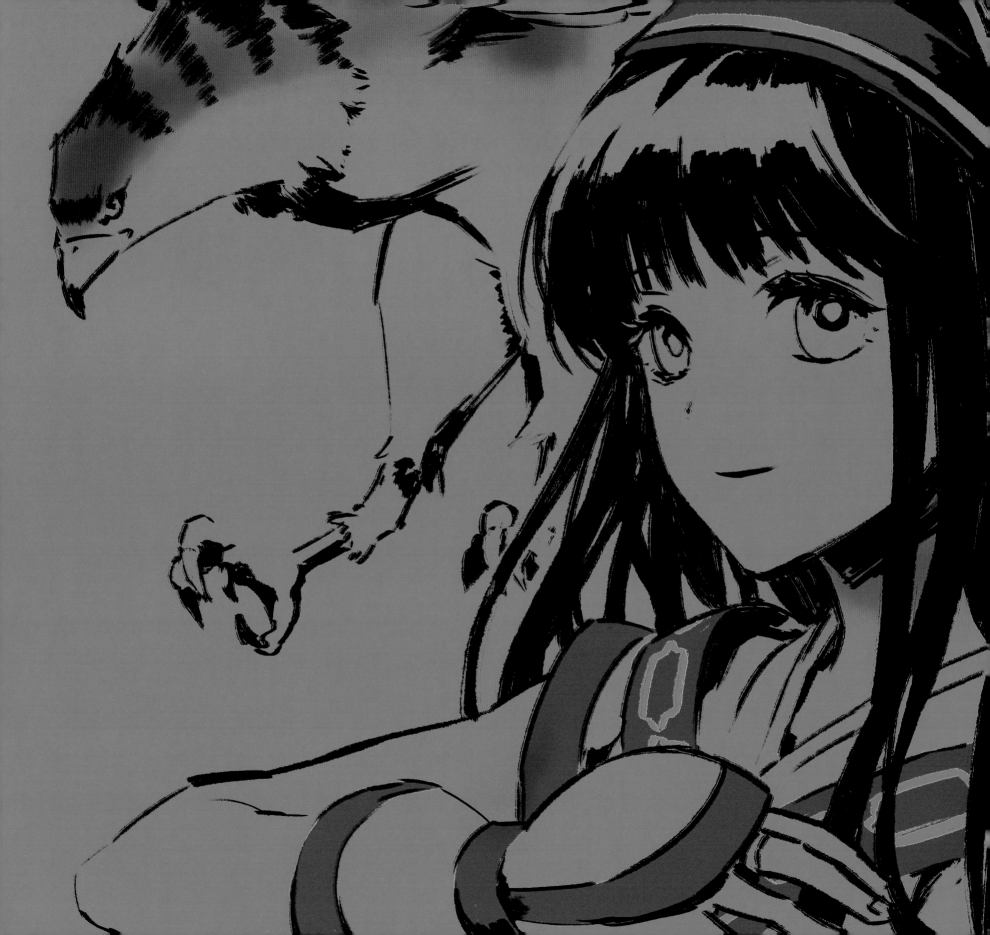

YUMI SAJI
CHARACTER DESIGNER

■ **Can you please start by introducing yourself?**

My name is Yumi Saji, and I'm in charge of character design for this episode in the *Samurai Shodown* series.

■ **When did you begin drawing these types of images? Also, how did you get started working as an illustrator?**

There was a manga creation club at my alma mater. I think that's where I got my start, working with friends to develop pieces that were inspired by copyrighted works, etc. I was working as a 3D modeler and was occasionally allowed to design

clothing and accessories. I started doing more and more of it, and it eventually got to the point where my main focus was 2D work, which is the case today.

■ **What artists have had the biggest influence on you?**

I'm not sure if I have been influenced by them or not, but I personally like the artists Yu Ito [translator's comment: artist of the *Tokyo Broker*, *Kōkoku no shugosha*, and *Shut Hell* manga] and Aki Irie [translator's comment: to whom we owe, among others, the manga *Gunjō gakusha* and *Ran to haiiro no sekai*]. As far as Japanese painters go, I like Utagawa Kuniyoshi and Tsukioka Yoshitoshi.

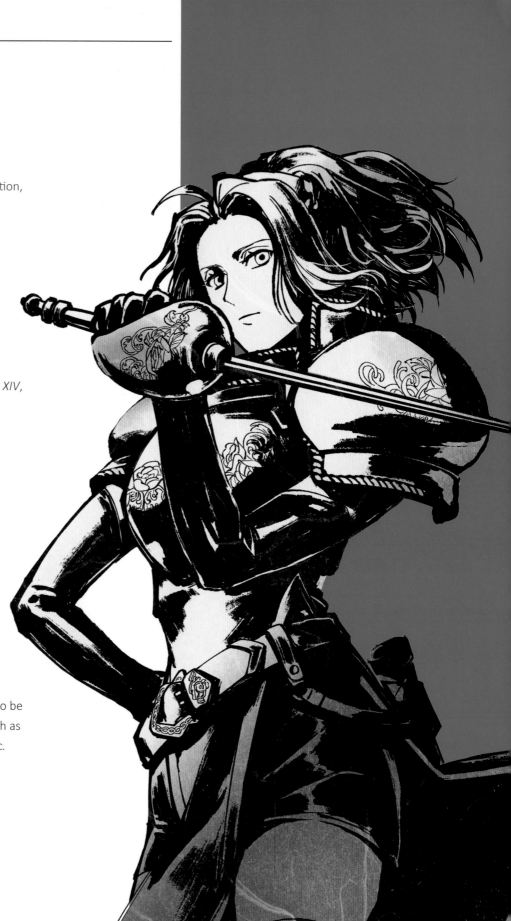

■ What led you to begin working in the video game industry?

In college, I studied with the intention of becoming a doll maker. Just before graduation, however, I started realizing that it would be difficult to earn a living doing that, so I decided to find a job (as a 3D modeler) where I could use my knowledge of how to handle 3D objects. This, along with the fact that I was already a fan of video games, led to me choosing to join this industry.

■ When did you join SNK? What was
the first project you worked on after joining the company?

I joined SNK in 2014. The first project that I was involved in was *The King of Fighters XIV*, and I initially joined the project as a 3D modeler.

■ How did you get involved in this *Samurai Shodown* project?

Mr. Nobuyuki Kuroki, the art director, told me that my designs might be a good match for the overall ambiance and feel of *Samurai Shodown*, and I joined the project, working on design.

■ Were you given any specific instructions regarding
character design (things to focus on, things that wouldn't be
allowed, etc.)?

For existing characters, I was told not to make any major changes that would be a significant departure from their original designs. On the other hand, I was told not to be overly constrained by the restrictions stemming from the game's period setting, such as how clothing in the Edo period was quite plain in appearance, didn't use folding, etc.

▼ Galford D. Weller versus Charlotte C. Colde in
Samurai Shodown (Neo Geo, 1993, *top*)
and Charlotte C. Colde in *Samurai Shodown*
(PlayStation 4 / Xbox One, 2019, *bottom*)

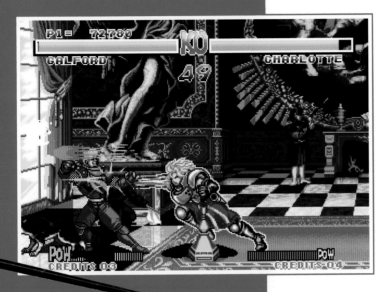

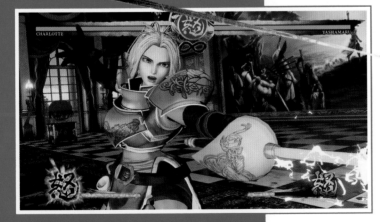

■ What kind of tools did you use?

I used Clip Studio Paint and Photoshop CC 2019.

■ Charlotte appeared in the original game, then disappeared, and is now making her return in this episode. She appears to have undergone a number of changes. Can you please share the details behind these design revisions?

When she was first developed, we were using pixel imagery, and I also think that we were limited in terms of how we could use detailed decorative items. Conversely, larger screens are used these days, and characters need to have a certain presence onscreen. Given this, the entire design was updated. We also made adjustments to certain pronounced components that were trendy and popular at the time, such as large shoulder armor, etc. We've given them a better balance here, which players will find more in tune with modern designs, and thus easier to grow accustomed to. For Nakoruru and Charlotte, since we're working with female characters, I suggested revising their designs to make them more beautiful and striking, such as shapes that are created by lace innerwear and skirts, etc.

■ The new character Wu-Ruixiang is a woman who has an extremely graceful and refined appearance. How did her layered, multicolored sleeves, extremely elaborate hairstyle, etc., come about? Can you please tell us about character design methods you used, what inspired you during the process, etc.?

We consulted and referenced clothing actually worn during the Qing dynasty when designing her lisui-adorned dalachi hairstyle and her qipao dress with large standup collar. Historically speaking, the high slit in the skirt would have appeared later, with the influence of Western dress, but we included it here because emphasis was placed on appearance. We decided to include as many feng shui–related motifs as possible, including lucky coins, goldfish, etc.

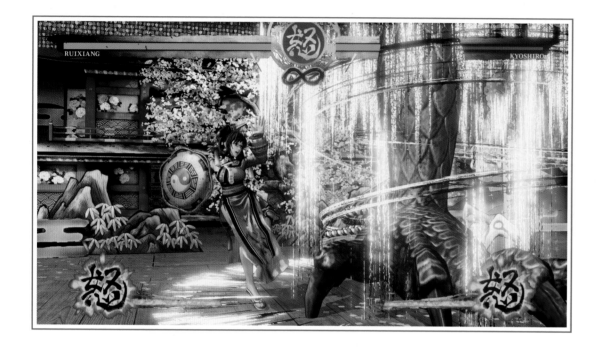

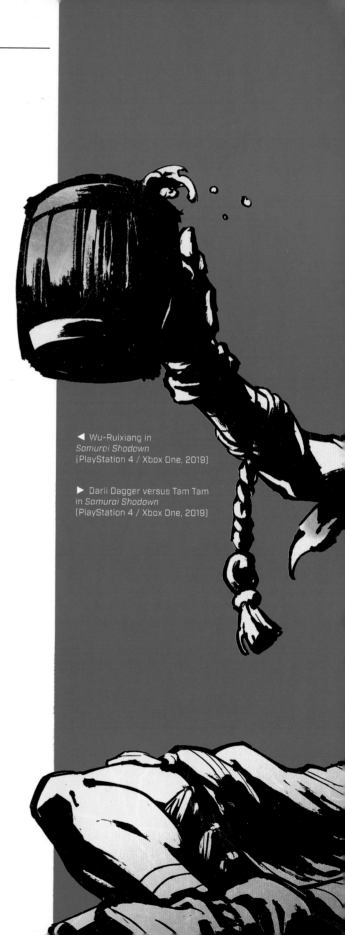

■ Another new character, Darli Dagger, is very individualistic (particularly with her weapons). Can you share some details behind the conception and creation of this unique and creative character?

The first thing that was specified regarding her weapons is that they would be large in scale and would change form. We actually imagined a number of ways we could design her weapons to change, as a unique character trait. In the end, though, we settled on a simpler design, one where she would be recognizable just from her silhouette alone. The reasoning behind this is that overly mechanical weapons would be out of place given the game's period setting, as well as the fact that *Samurai Shodown* is a game where it is necessary to move on to the next action within a certain number of frames.

■ Yashamaru Kurama may be a traditional character, but he also gives off a particularly mysterious aura. Can you please share a few details regarding how you settled on his final design, or about the mysteries surrounding him (his mask, costume, hairstyle, the look in his eyes, etc.)?

The specific instructions I received were to design a "handsome warrior," and my initial image was a design where the face was obscured by armor and a helmet. Out of a desire to reach more players, though, I ended up giving Yashamaru a design that is not overly somber or grim, with a helmet that only covers half of his face. For the same reason, I went with a karasu tengu (crow goblin) motif that I felt might be better known and more familiar to players. Regarding his hair color changes, when we created our overall color scheme variations, they occasionally had two types of hair, black and white. From there, we decided to give Yashamaru hair that changes color, as a way of expressing his dual nature.

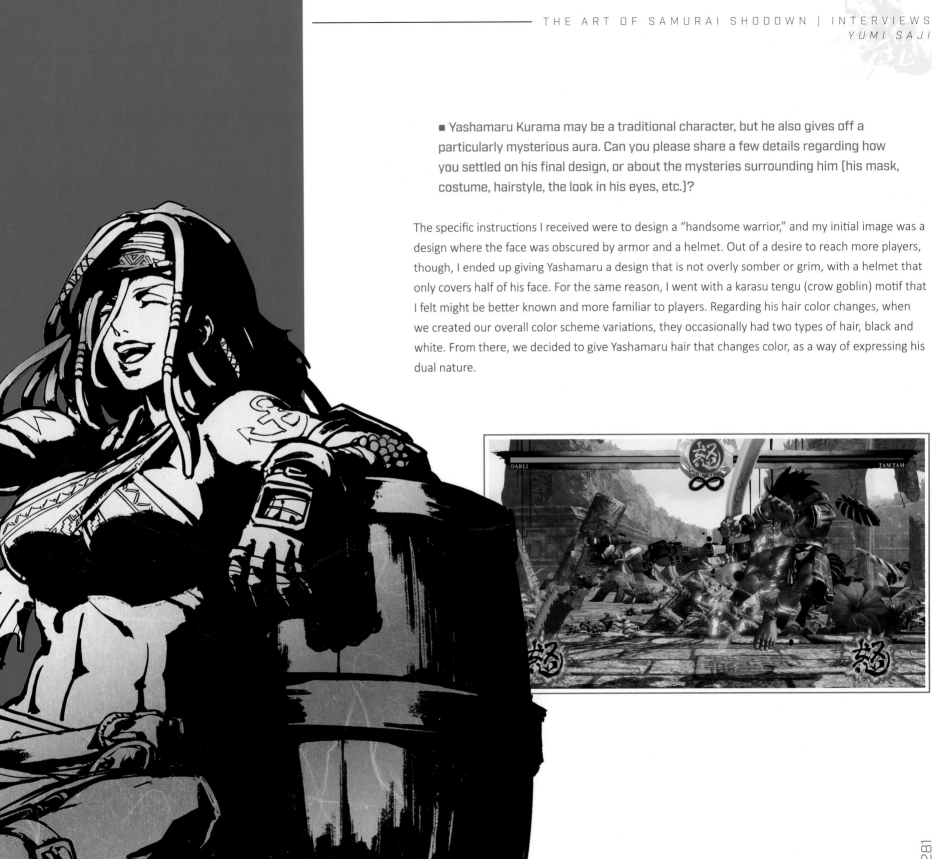

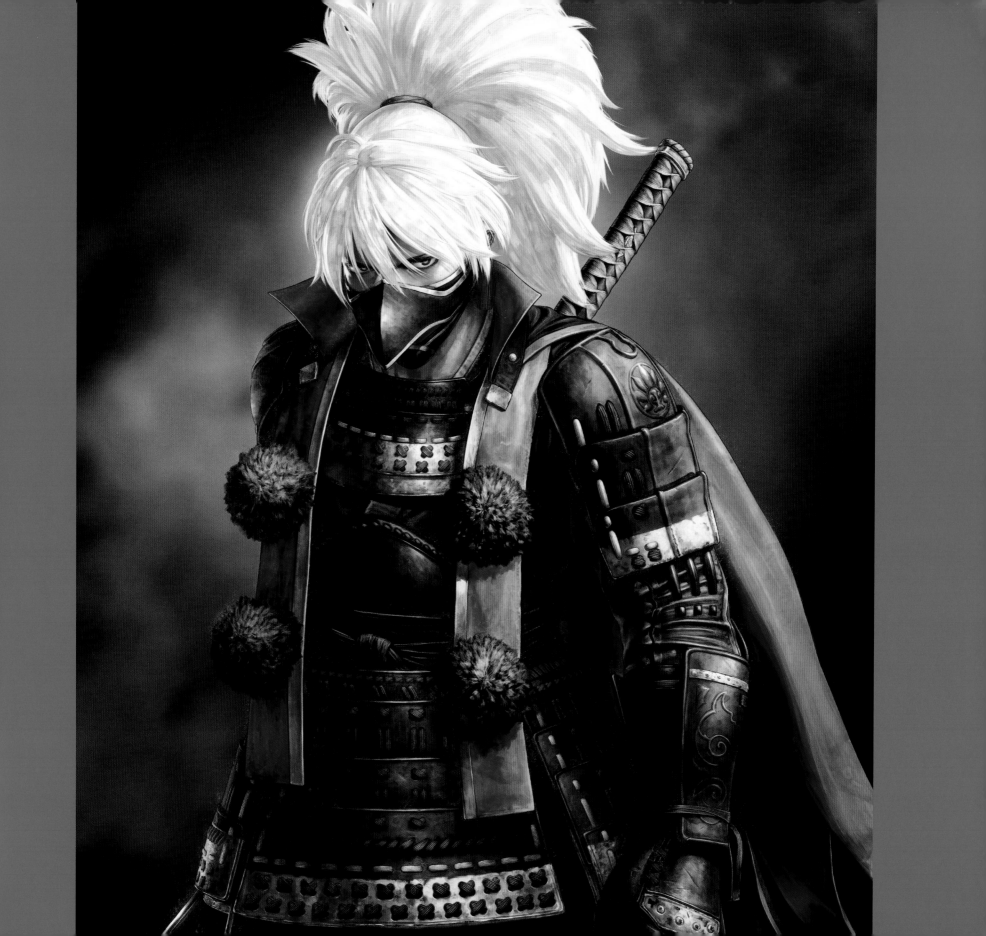

■ From the very first *Samurai Shodown*, all of the face-offs with final bosses have been "historical" moments. Can you give some insight into what led to the Shizuka Gozen design?

When you hear "Shizuka Gozen," I think that what immediately comes to mind for most people is the image of a shirabyoushi court dancer. I was told to avoid this, though, precisely because of that common association. We settled on a layered clothing design with brilliant shades of red and other colors, like a ceremonial court robe, rather than an eerie design with a black base. Traditionally with this type of costume, a hakama (pants) worn underneath an unlined kimono ensures that there's absolutely no way that any bare leg would peek through. With this design, though, it's worn in a way that's similar to how a modern kimono is worn, with a normal stance that results in a bit of the legs being visible.

■ Can you please share a little about any original ideas for decorations, characters, etc., that couldn't be included due to not fitting in with the game's overall feel?

For Darli, we chose not to use circular saws, chainsaws, etc., since they didn't fit with the time period. We also created a leather pirate-type outfit at the beginning, but it was too fantasy-like and we chose not to use it in the end. There was also a hikeshi (a firefighter from the Edo period) character that was also ultimately not included, out of concern that the concept likely wouldn't translate outside of Japan. However, this character's direct and frank style and personality were inherited by Darli. There was also a proposal to have Ruixiang carry a seven-star sword, but it looked like it would be cutting her, so this was modified to be a feng shui board.

▲ Yashamaru Kurama (*top*) and Yashamaru versus Hanzo Hattori (*bottom*) in *Samurai Shodown* (PlayStation 4 / Xbox One, 2019)

◄ Artwork of Yashamaru Kurama

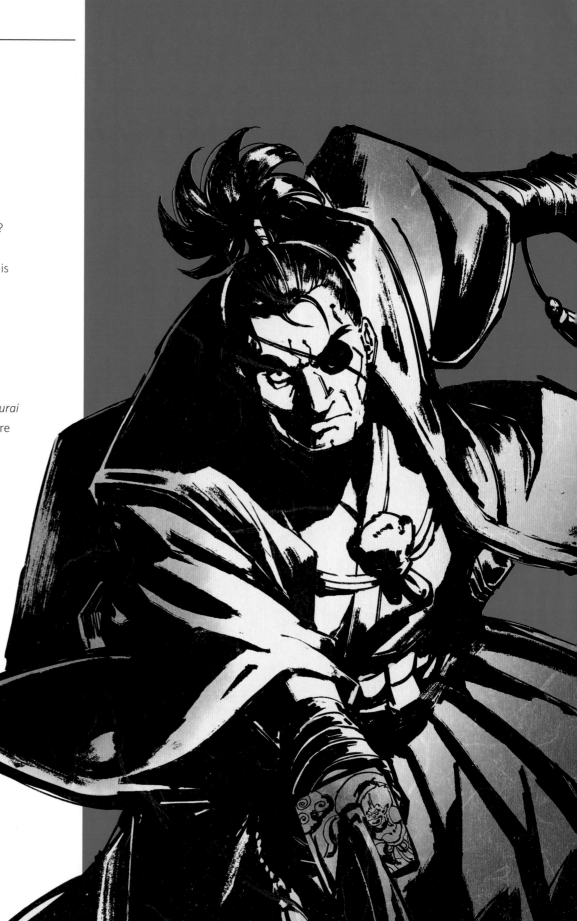

■ What aspect of the *Samurai Shodown* character design process was the most fun? Also, who is your favorite character?

As for who was fun to draw, it would have to be Charlotte, wouldn't it? Female characters are easier to create more varied costumes for, and Charlotte was fun to work on. The character that I personally like best is Jubei Yagyu. He's something of a somber older man and is pretty cool.

■ Finally, we'd appreciate it if you could give our readers a message.

I'd like to begin by thanking you for picking up this work all about *Samurai Shodown*. There's a long history behind the series, and I think that there are many players out there who have been enamored with it for quite a long time now. It would make me really happy to hear that longtime fans of the series who pick up the new episode find it both nostalgic and refreshing in its new, updated form. ■

▶ Galford D. Weller
versus Jubei Yagyu in
Samurai Shodown
(PlayStation 4 /
Xbox One, 2019)

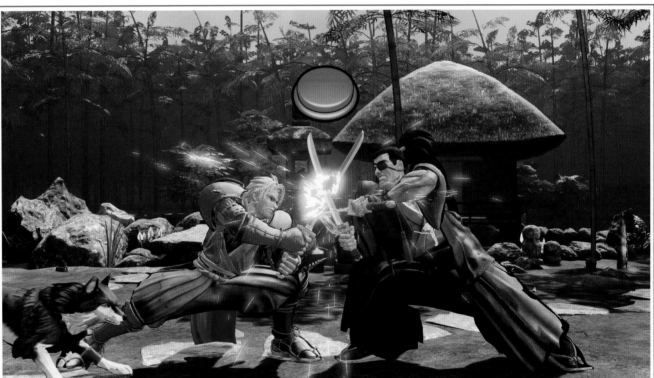

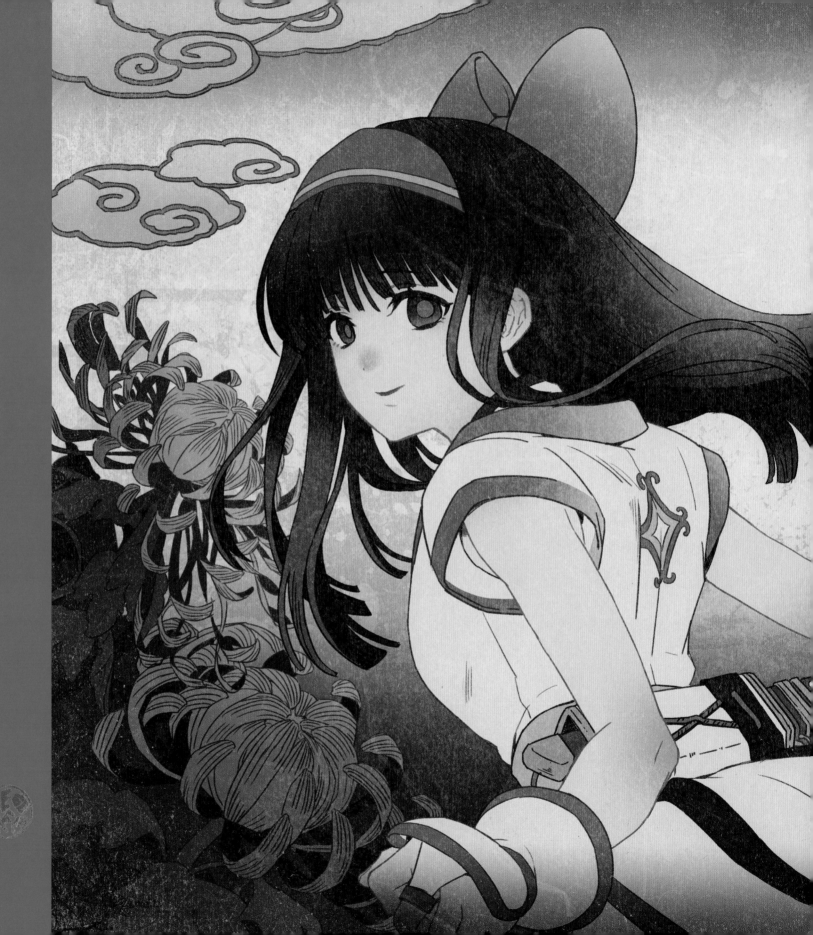

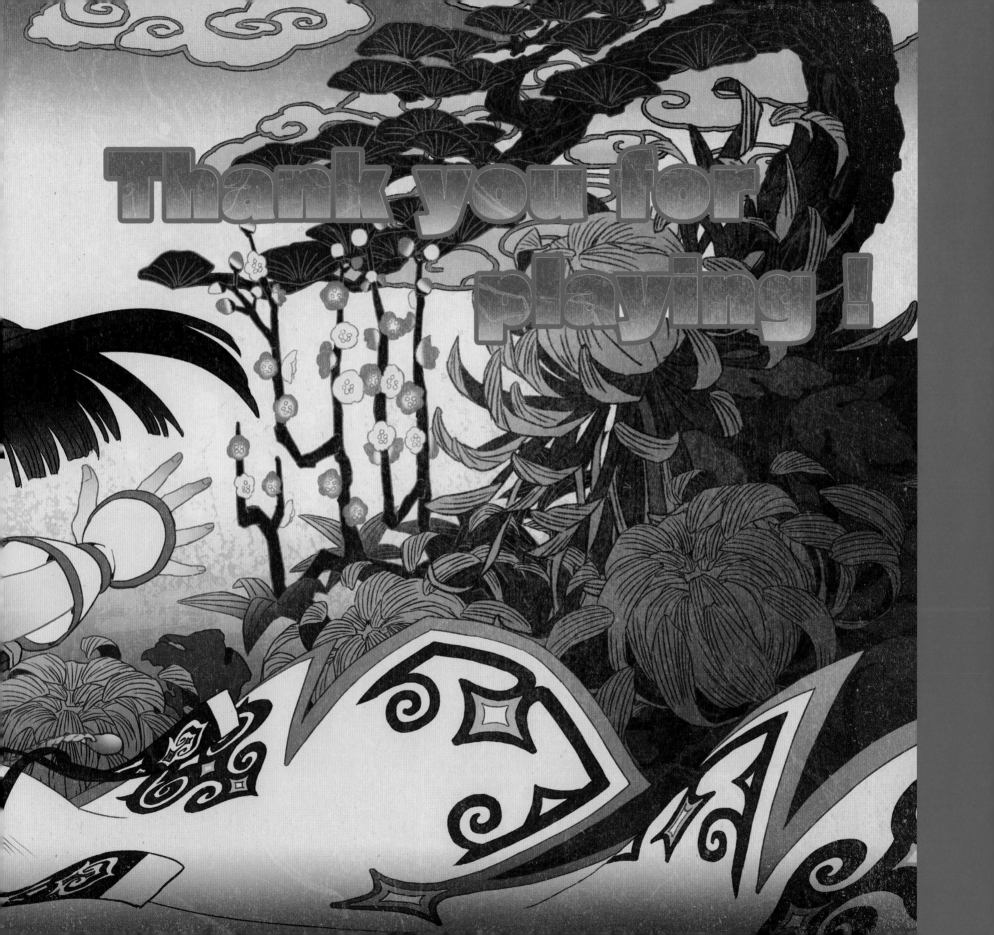

SNK®

3 1333 05245 2818

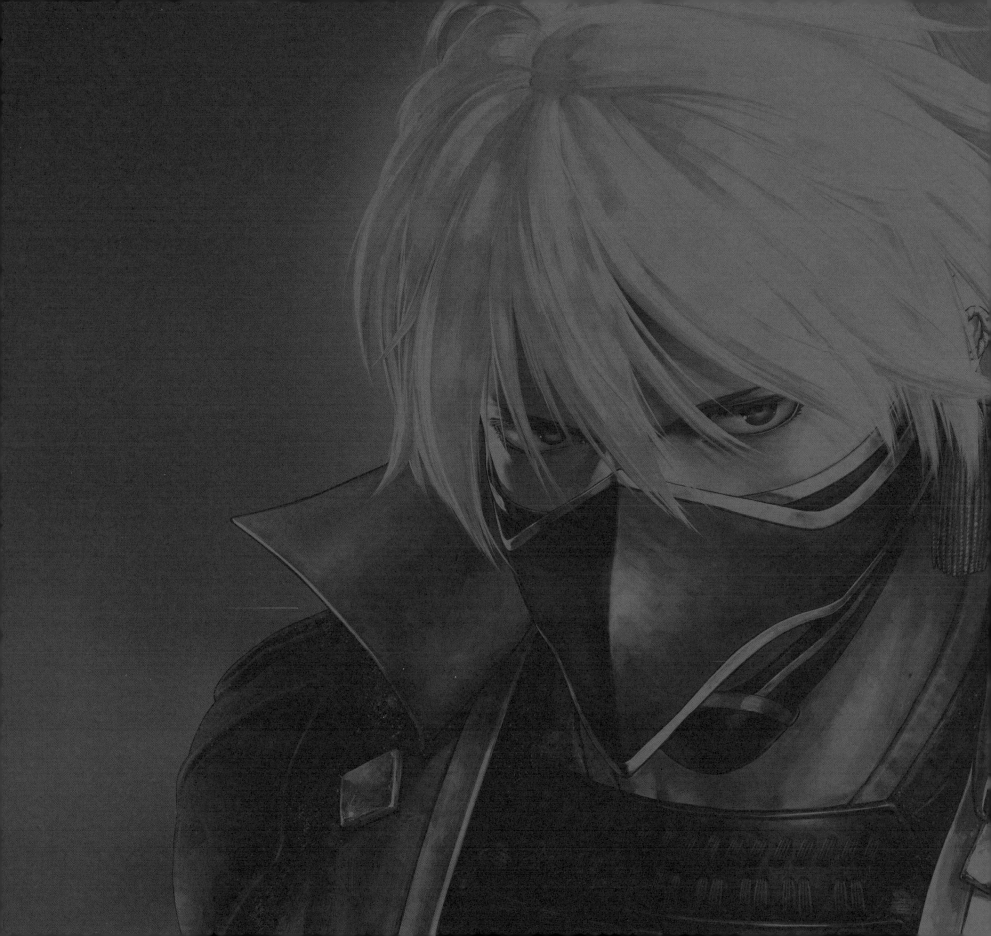

THE ART OF
SAMURAI SHODOWN

A glorious hardcover tome collecting concept art and creator commentary from the development of the newest entry in the *Samurai Shodown* saga, including:

- **Nearly 700 official illustrations!**
- **All the original characters, weapons, costumes, and backgrounds!**
- **Storyboards and epilogues for each fighter!**
- **Interviews with character designer Yumi Saji and director Nobuyuki Kuroki!**

Dark Horse Books and SNK welcome you to explore this beautiful and dangerous world with this striking, in-depth look at the game that embodies the samurai spirit!

ART - VIDEO GAME ART

$39.99 US $53.99 CAN

DarkHorse.com
PixnLovePublishing.com
SNK-Corp.co.jp

ISBN 978-1-50672-241-2

9 781506 722412

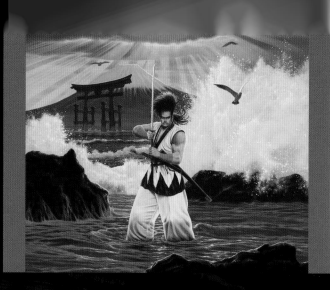

SAMURAI SHODOWN:
THE ORIGINS

Founded in 1978 in Osaka on the Japanese archipelago, SNK pioneered a new phenomenon in the early 1990s: the one-on-one fighting game. This extremely popular genre quickly flooded arcades around the world. It also reflected both the competitions between players and the competitions between the companies that created the games.

SNK's various products led to its position as a challenger on the market. They tested many new ideas and introduced major advances in gaming: special super attacks with gauges, taunting, dodges, and close-up shots are just a few of the innovations the company introduced.

With titles such as *Art of Fighting* and *Fatal Fury*, SNK's development teams helped create the language and environment that many of today's productions still draw from.

Despite its popularity, the genre, inspired by American cinema and entrenched in contemporary street fighting and underground tournaments, soon ran the risk of becoming stale. Something needed to change. The summer of 1993 brought a breath of fresh air to the gaming world, in the shape of a game that would, in fact, stand out from the rest of the video game landscape and would see unexpected critical and commercial success. Named *Samurai Shodown*.

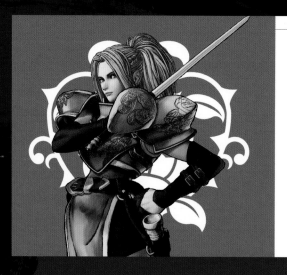

CHARLOTTE

FULL NAME:
Charlotte Christine Colde

BIRTHDAY:
February 4

BIRTHPLACE:
Paris (France)

BLOOD TYPE:
B

WEAPON:
Sword: "La Roche"

FIGHTING STYLE:
Self-taught

LIKES:
Crimson roses

DISLIKES:
Rodents

HOBBIES:
Embroidery

FIRST APPEARANCE:
SAMURAI SHODOWN (1993)

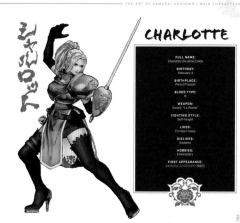

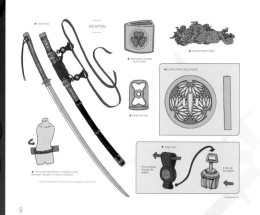

YOSHITORA TOKUGAWA

WEAPON

CLOTHES

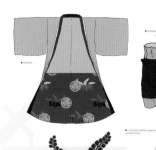

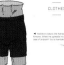